Italian Paintings

VENETIAN SCHOOL

Italian Paintings

A Catalogue of the Collection of
The Metropolitan Museum of Art

VENETIAN SCHOOL

Federico Zeri

WITH THE ASSISTANCE OF

Elizabeth E. Gardner

The Metropolitan Museum of Art

Distributed by New York Graphic Society, Greenwich, Connecticut

1973

NERI POZZA EDITORE, VICENZA

Printed in Italy

Library of Congress Cataloging in Publication Data

New York (City). Metropolitan Museum of Art.
 Italian paintings.

 Includes bibliographical references.
 1. Paintings, Venetian — Catalogs. 2. Paintings —
New York (City) — Catalogs. I. Zeri, Federico.
II. Gardner, Elizabeth E. III. Title.
ND621.V5N49 1973 759.5'31 73-9831
ISBN 0-87099-079-9
ISBN 0-87099-080-2 (pbk.)

STAMPATO DALLA TIPOGRAFIA A. DAL MOLIN & FIGLI - ARZIGNANO (VICENZA)

Contents

Preface vii

Map x

*Paintings, arranged alphabetically by
artist*

 Antonello da Messina 1

 Antonello de Saliba 3

 Giovanni Bellini 4

 Giovanni Bellini & Workshop 6

 Workshop of Giovanni Bellini 7

 Jacopo Bellini 9

 Bernardo Bellotto 11

 Bonifazio Veronese 12

 Canaletto 13

 Vittore Carpaccio 14

 Francesco Casanova 17

 Vincenzo Catena 17

 Giovanni Battista Cima 19

 Carlo Crivelli 21

 Gasparo Diziani 25

 Michele Giambono 26

 Jacopo Guarana 27

 Francesco Guardi 27

 Guardi (?) 33

 Jacometto Veneziano 34

 Antonio Ioli 36

 Alessandro Longhi 37

 Pietro Longhi 37

 Lorenzo Lotto 40

 Maggiotto (?) 41

 Master of Helsinus 42

 Giustino Menescardi 43

 Francesco Montemezzano 44

 Niccolò di Pietro 44

 Jacopo Palma the Younger 45

 Paolo Veneziano 47

 Piazzetta 48

 Saraceni 49

 Andrea Schiavone 50

 Sebastiano del Piombo 52

 Lambert Sustris 53

 Giovanni Battista Tiepolo 55

 Workshop of G. B. Tiepolo 63

 Giovanni Domenico Tiepolo 65

 Tintoretto 69

 Titian 73

 Veronese 83

 Antonio Vivarini 88

 Workshop of Antonio Vivarini 90

 Bartolomeo Vivarini 90

 Francesco Zuccarelli 93

 Unknown Painter,
 second quarter, xv century 94

 Unknown Painter,
 late xvii century 95

List of Plates 97

Books and Periodicals Abbreviated 101

Index of Former Owners 103

Index 111

Preface

This is the second volume of Dr. Zeri's catalogue of the Italian paintings in The Metropolitan Museum of Art. The first volume on the Florentine school was published in 1971. A volume on the North Italian and one on the Sienese, Central and Southern Italian schools will follow in the near future.

The present volume differs from the first in format: the artists are arranged in alphabetical order rather than in chronological sequence, and the paintings are arranged numerically by accession number rather than grouping them according to their possible sequence within the artist's career. Finally, the reproductions of all the paintings are placed at the back of the volume in approximately the same order as the catalogue entries. Each picture is given a full-page illustration, sometimes with a detail.

The preface to the first volume described the lengthy preparations that Dr. Zeri, Elizabeth E. Gardner, Curator of European Paintings, and many others have made to the catalogue of the Museum's Italian paintings. To those thanked in the first volume should be added our gratitude to Katharine Baetjer for her dedicated assistance in double-checking innumerable details and help in preparing the manuscript for publication.

EVERETT FAHY
Curator in Charge, Department of European Paintings

July 30, 1973

Italian Paintings

VENETIAN SCHOOL

Map of Italy where the Venetian territory is shown

Antonello da Messina

Real name Antonello di Giovanni d'Antonio. Born in Messina, Sicily, about 1430; died 1479. Antonello worked mostly in his birthplace but his apprenticeship, according to Pietro Summonte (1524), was undertaken with Colantonio in Naples, where he must have examined pictures by Jan van Eyck and Rogier van der Weyden. His portrait heads show Rogier's influence, and also recall the paintings of Petrus Christus, and his use of geometrical forms may be due to his knowledge of the work of Piero della Francesca or his followers. In 1456 Antonello was in Messina; he was in Venice in 1475 and 1476. Only fragments remain of the large altarpiece of the Madonna and Child with Saints that he painted there for the church of San Cassiano (Kunsthistorisches Museum, Vienna). This altarpiece, with its composition of figures set in an architectural frame, was an influential prototype that was followed by late fifteenth-century painters such as Giovanni Bellini and Alvise Vivarini. Antonello's son, Jacobello, and his nephew, Antonello de Saliba, were deeply influenced by his work.

Portrait of a Young Man
14.40.645 (Plate 1)

This picture was long known as a self-portrait, but when Antonello was as young as this sitter appears to be, he had not yet achieved such an accomplished style. A possible date is around 1470. The painting has been somewhat damaged by early overcleaning, but the most important parts are intact.

Oil on wood. H. 10 5/8, w. 8 1/8 in. (27 × 20.6 cm.).

REFERENCES: The authorities cited below attribute this painting to Antonello da Messina. B. Berenson (in a letter, 1912); *Ven. Ptg. in Amer.* (1916), pp. 30 f., fig. 16, suggests that it was painted in Milan in 1476; *Dedalo*, VI (1925-1926), p. 638, ill. p. 645; *Ital. Pictures* (1932), p. 25; and *Ven. School* (1957), p. 6 / / M. J. Friedländer (in a letter, 1912) / / A. Venturi, *Storia*, VII, part IV (1915), p. 28, fig. 13 / / F. Monod, *Gaz. des B.-A.*, ser. 5, VIII (1923), pp. 188 f., ill. / / J. Lauts, *Jahrb. der Ksthist. Smlgn.*, VII (1933), p. 56, fig. 54; and *Antonello da Messina* (1940), pp. 20, 36, pl. 33, dates it about the time of the portraits in the Johnson collection in the Philadelphia Museum (about 1470), and in the Berlin Museum (1474) / / L. Venturi, *Ital. Ptgs. in Amer.* (1933), pl. 379, dates it after the portrait

by Antonello in the Johnson collection in Philadelphia / / R. van Marle, *Ital. Schools*, XV (1934), pp. 495 f., fig. 298, dates it between 1465 and 1470 / / H. Tietze, *Meisterwerke Europäischer Malerei in Amerika* (1935), p. 328, pl. 66 / / S. Bottari, *Antonello da Messina* (1939), pp. 75 f., 82, 137, 145, pl. XLI, dates it 1472 or 1473; and *Antonello* (1953), pp. 23, 97, pl. LXXIV / / *Art Treasures of the Metropolitan* (1952), p. 225, pl. 84 (in color) / / G. Vigni, *Tutta la pittura di Antonello da Messina* (1952), p. 22, pl. 17, dates it about 1470 / / L. Coletti, *Pittura veneta del quattrocento* (1953), p. LXV, dates it in the Venetian period of the artist, after 1475.

EXHIBITED: Royal Academy, London, 1879, *Old Masters*, no. 196 (as a self-portrait, lent by Henry Willett); New Gallery, London, 1893-1894, *Early Italian Art*, no. 132 (as a self-portrait, lent by Henry Willett); Rijksmuseum, Amsterdam, 1911, no. 367 A (lent by C. Hoogendijk); Metropolitan Museum, New York, 1952-1953, *Art Treasures of the Metropolitan*, no. 84.

EX COLL.: Henry Willett, Arnold House, Brighton (by 1879-before 1896); [Sedelmeyer, Paris, 1896, Cat., no. 64, as Portrait of the Artist]; [C. Hoogendijk, The Hague, by 1911-1912; sale, Frederik Muller's, Amsterdam, May 14, 1912, no. 61, as attributed to Antonello da Messina]; [Kleinberger Galleries, New York, 1912]; Benjamin Altman, New York (1912-1913).

In the Altman Galleries.

BEQUEST OF BENJAMIN ALTMAN, 1913.

Christt Crowned with Thorns
32.100.82 (Plate 2)

This picture is almost certainly the Ecce Homo that was in the collection of Giulio Alliata of Palermo in the seventeenth century. At that time the date 1470 was said to have been visible on the cartellino at the bottom, which is now almost illegible. This would make it the earliest of the known versions of this subject by Antonello. Three others, resembling each other in composition but different from this, are in the Museo Civico in Piacenza (dated 1472), the Kunsthistorisches Museum in Vienna (dated 1474), and the National Gallery of the Palazzo Spinola in Genoa.

Signed (at lower center): ANTONELLUS MESS. N. . . ME PIN. . T.

Oil, perhaps over tempera, on wood. H. 16 3/4, w. 12 in. (42.5 × 30.5 cm.).

REFERENCES: The authorities cited below attribute this painting to Antonello. V. Auria, *Il Gagino redivivo* (1698), p. 17, describes the Alliata Ecce Homo and reads the cartellino as ANTONELLUS DE MESSINA ME FECIT 1470 // G. B. Cavalcaselle (ms., ca. 1858, Biblioteca Marciana, Venice) notes this picture in the Lazzari collection in Naples, giving its provenance from the collections of the Prince of Tarsia and the Duke of Gresso; with J. A. Crowe, *Les Anciens Peintres flamands*, I (1862), p. 227, mention the Alliata picture among the lost works of Antonello; and *Ptg. in N. Italy* (1871), II, p. 85, identify our picture with the one described by Auria and read the cartellino as: 1.7. NTONELLUS MESSA . . . // A. Michiels, *Histoire de la peinture flamande*, II (1866), p. 398 // G. Morelli, *Italian Masters in German Galleries* (1883), p. 382; and I. Lermolieff [G. Morelli], *Kstkrit. Studien-München und Dresden* (1891), pp. 245 f., dates it in the artist's early Flemish period, 1465-1470 // G. di Marzo, *La Pittura in Palermo nel Rinascimento* (1899), p. 197, identifies our picture, then lost, with the one described by Auria; *Archivio storico messinese*, III (1903), pp. 176 f., quotes the description given by Auria; and *Di Antonello da Messina e dei suoi congiunti* (1903), pp. 41 f., mistrusts Auria's reading of the inscription // G. La Corte Cailler, *Archivio storico messinese*, IV (1903), pp. 362 ff., discusses the origin of the picture / / A. D'Amico, *Archivio storico messinese*, V (1904), pp. 95, 125 f., mentions the painting as unknown to him // L. Venturi, *Origini pitt. ven.* (1907), p. 224, refers to our picture as lost, and dates it in Antonello's first period; *L'Arte*, XI (1908), pp. 443 f., ill., reproduces Cavalcaselle's sketch of it when it was in the Lazzari collection, notes that Cavalcaselle read the car-

tellino as 147. ANTONELLUS MESSANUS ME . . ., interprets it himself as ANTONELLUS MESSANEN, and considers this picture the earliest of Antonello's Ecce Homos; and *Ital. Ptgs. in Amer.* (1933), pl. 377 // T. Borenius, ed., in Crowe and Cavalcaselle, *Ptg. in N. Italy* (1912), II, pp. 418 f., note 1, notes that the picture belonged to the collection of Baron Schickler in 1908 // A. Venturi, *Storia*, VII, part IV (1915), pp. 54 ff., fig. 30, identifies our picture with the one described by Auria and finds the date 1470 inconsistent with the style // B. Berenson (in a letter, 1925); *Ital. Pictures* (1932), p. 25; and *Ven. School* (1957), p. 6, pl. 275, accepts the date 1470 // W. Bode, *Mein Leben* (1930), I, p. 80, mentions seeing this painting in 1872 or 1873 in the Zir collection in Naples, later in the Schickler collection // B. Burroughs and H. B. Wehle, *Met. Mus. Bull.*, XXVII (1932), Nov., sect. II, p. 34 // J. Lauts, *Jahrb. der Ksthist. Smlgn.*, VII (1933), pp. 33, 68 f., fig. 31, identifies it with the picture mentioned by Auria and considers it Antonello's earliest extant version of the theme; and *Antonello da Messina* (1940), pp. 15, 34, pl. 15, accepts the date 1470 // R. van Marle, *Ital. Schools*, XV (1934), pp. 476, 496 f., fig. 300, mistrusts Auria's reading of the date // S. Bottari, *Critica d'arte*, II (1937), p. 106; *Antonello da Messina* (1939), pp. 132 f., 144, pl. XXIV; and *Antonello* (1953), pp. 22, 89 f., pl. LX, accepts the date 1470 // G. Vigni, *Tutta la pittura di Antonello da Messina* (1952), pp. 11, 22, pl. 18; and *Boll. d'arte*, XXXVII (1952), p. 303, dates it 1470 // R. Longhi, *Paragone*, IV (1953), no. 47, p. 28, accepts the date 1470 // E. E. Gardner, *Saggi e Memorie di storia dell'arte*, VIII (1972), pp. 69 ff., figs. 1-5, identifies the brand on the reverse as the mark of the collection of the Marquis of Carpio, publishes the reference to it in the Carpio inventory of 1687, identifies other owners, and notes that it was exhibited in Naples in 1877.

EXHIBITED: Naples, 1877, *Esposizione d'arte retrospettiva*, no. 10 (lent by the Zir heirs).

EX COLL.: Don Gaspar de Haro y Guzmán, Marquis of Carpio, Count Duke of Olivares, Rome and Naples (until 1687; unpublished inventory, in the Alba archives, 1687, no. 770); Don Giulio Alliata, Palermo (1698); Ferdinando Maria Spinelli, Prince of Tarsia, Naples (until 1780); Duke of Gresso; Conte Giacomo Lazzari, Naples (*Notamente ed Estimazione della Quadreria*, 1843, no. 61); Don Dionisio Lazzari, Naples (after 1843-about 1850); Gaetano Zir, Naples (by 1871-before 1877; Cat., 1874, p. 10, no. 110); Signora Eleonora Torazzini (widow of Gaetano Zir), Naples (about 1877); [Haro, Paris]; Baron Arthur de Schickler, Martinvast, Manche (by 1908); Countess Hubert de Pourtalès, Martinvast, Manche (until 1920); [Duveen Brothers, Paris and London, 1920-1927]; [Dr. Hans Wendland, Lugano, 1927]; [Kleinberger Galleries, Paris and New York]; Michael Friedsam, New York (until 1931).

THE MICHAEL FRIEDSAM COLLECTION. BEQUEST OF MICHAEL FRIEDSAM, 1931.

Antonello de Saliba

Known activity 1480-1535. Antonello de Saliba was a nephew of Antonello da Messina and, like him, worked for the most part in Sicily. He copied paintings by his famous uncle and studied with the latter's son, Jacobello. Some of his formative years must have been spent in Venice as his pictures show a close dependence on Giovanni Bellini and the painters of Bellini's school. The style of his older brother, Pietro de Saliba, is similar to his, and their paintings, though far less distinguished than those of Antonello da Messina, resemble them enough to have been sometimes mistaken for Antonello's work.

The Madonna Adoring the Child
30.95.249 (Plate 3)

The figure of the Madonna is taken directly from a painting by Giovanni Bellini now in a private collection in Switzerland (formerly in the Moll and Wittgenstein collections in Vienna; G. Gronau, *Giovanni Bellini* (*Kl. der Kst.*), 1930, p. 111). The same model was used again by Antonello de Saliba in another panel, belonging to the Musée Jacquemart-André in Paris (no. 943), which is almost identical to ours except that a curtain interrupts the landscape background; a similar picture attributed to Pietro de Saliba is in a private collection (S. Bottari, *Pittura del Quattrocento in Sicilia*, 1953, pl. CXLV, fig. 172). The figure of the Child also follows the type painted by Giovanni Bellini during the last decade of the fifteenth century.

Tempera and oil on wood. H. 26 5/8, w. 19 1/2 in. (67.6 × 49.5 cm.).

REFERENCES: J. Breck, *Rass. d'arte*, XI (1911), p. 112, calls this painting a work by Antonello de Saliba // B. Berenson, *Rass. d'arte*, XIII (1913), pp. 57 ff., ill., attributes it to Antonello de Saliba and dates it about 1487-1488; *Ven. Ptg. in Amer.* (1916), p. 41, fig. 21; *Ital. Pictures* (1932), p. 496; and *Ven. School* (1957), p. 8 // A. Venturi, *Storia*, VII, part IV (1915), pp. 94 ff., attributes it to Antonello de Saliba // E. Sandberg-Vavalà, *Boll.*

d'arte, VI (1926-1927), p. 565, calls it a work related to both Antonello and Pietro de Saliba and mentions other versions of the same composition, one signed by Pietro in the church of Santa Maria Formosa in Venice, others in the Museo Civico in Padua, the Musée Jacquemart-André in Paris, and the Minturn collection in New York (now in Santa Barbara) // W. Suida, *Belvedere*, VIII (1929), p. 255, accepts the attribution to Antonello de Saliba and compares it to a Madonna in the Museum in Brno // G. Gronau, *Giovanni Bellini* (*Kl. der Kst.*) (1930), p. 218, no. 192, mentions it as a copy by Antonello de Saliba after Giovanni Bellini and compares it with the Jacquemart-André version // S. Bottari, *Boll. d'arte*, X (1931), pp. 309 ff., attributes it to Antonello de Saliba and notes that it was repeatedly copied by Pietro de Saliba // B. Burroughs, *Met. Mus. Bull.*, XXVI (1931), Mar., sect. II, p. 14, attributes it to Antonio de Saliba // R. Langton Douglas, *Burl. Mag.*, LX (1932), p. 288, attributes it to Antonello de Saliba, and compares it to a similar Madonna in the Locker-Lampson collection; and *Italian Pictures Collected by Godfrey Locker-Lampson* (n.d.), p. 8 // R. van Marle, *Ital. Schools*, XV (1934), p. 567, note 3, attributes it to Pietro de Saliba // R. Longhi (unpublished opinion, 1937) attributes it to Antonello de Saliba // G. Vigni and G. Carandente, *Catalogo della mostra di Antonello da Messina e della pittura del '400 in Sicilia* (1953), p. 80, call it a work by Pietro de Saliba // F. Heinemann, *Giovanni Bellini e i Belliniani* (1962), p. 11, no. 40k, calls it a work by Antonello de Saliba.

EX COLL.: private collection, Florence (1902, as Pietro de Saliba); Theodore M. Davis, Newport (1902-1915).

THE THEODORE M. DAVIS COLLECTION. BEQUEST OF THEODORE M. DAVIS, 1915.

Giovanni Bellini

Sometimes called Giambellino. Born about 1430; died 1516. Giovanni Bellini is supposed to have spent some of his formative years in Padua, working under his father, Jacopo Bellini, and his ascetic early style also shows the powerful influence of paintings by his brother-in-law Mantegna and of the sculptures by Donatello in Padua. The effect of these influences is seen in a number of his early paintings of the Madonna and Child and is even more evident in his Agony in the Garden in the National Gallery in London. He went to Venice some time before 1460, and there he gradually developed a new style, characterized by an increasingly lyrical expression of human feeling. His pictures began to show a new comprehension of space and color, due probably to the influence of Antonello da Messina and perhaps that of Piero della Francesca as well. By about the beginning of the 1480's Bellini had become the accepted leader of the Venetian school. He had a large workshop and a number of followers, who based their paintings on his designs. Among his pupils were two of unquestioned genius, Giorgione and Titian, and in his latest period Bellini shows to some degree the influence of Giorgione. In 1506, when Bellini was in his middle seventies, Dürer wrote of him from Venice, "He is very old but he is still the best painter of them all." Bellini was one of the greatest painters of the Italian Renaissance and indeed of all Christian art.

The Madonna and Child
08.183.1 (Plate 4)

The listening attitude of the Child in this picture is very much like that of the Child in a similar painting in the Accademia in Venice (no. 612), in which a choir of cherubim hovers overhead. Our picture was the model for a number of workshop replicas: one was formerly in the Cook collection, Richmond, and another is recorded in the Harrach Gallery in Vienna. The style, particularly the color and the handling of the paint, as well as the rendering of the landscape, indicates a date close to 1490.

Signed (at lower center): IOANNES BELLINVS.

Oil on wood. H. 35, w. 28 in. (88.9 × 71.1 cm.).

REFERENCES: The authorities cited below, with the exception of Bernath, attribute this painting to Giovanni Bellini. R. E. Fry (in a letter, 1908);

and *Met. Mus. Bull.*, III (1908), pp. 180 ff., ill. p. 179, dates it about 1480 // J. Breck, *Der Cicerone*, I (1909), pp. 291 ff., ill. // T. Borenius, ed., in Crowe and Cavalcaselle, *Ptg. in N. Italy* (1912), I, p. 156, note 2 // M. H. Bernath, *New York und Boston* (1912), p. 76, fig. 78, considers it a work of very good quality done shortly before 1500 in Bellini's shop, under his direction, and perhaps based on a drawing by him // B. Berenson, *Ven. Ptg. in Amer.* (1916), pp. 86 ff., fig. 37, dates it about 1483; *Ital. Pictures* (1932), p. 71; and *Ven. School* (1957), p. 32 // G. Gronau, *Giovanni Bellini* (*Kl. der Kst.*) (1930), p. 210, ill. p. 118, dates it about 1490 // G. M. Richter, *Art Bull.*, XV (1933), pp. 280 ff., fig. 7, dates it probably about 1490 and calls the Cook picture a school version, perhaps by Niccolò Rondinelli // L. Venturi, *Ital. Ptgs. in Amer.* (1933), pl. 394, dates it about 1490 // L. Dussler, *Giovanni Bellini* (1935), pp. 77, 137, dates it about 1485; and *Giovanni Bellini* (1949), pp. 34 f., 91, pl. 65, dates it about 1490, judging the Cook picture a workshop replica // R. van Marle, *Ital. Schools*, XVII (1935), p. 290, fig. 175, dates it between 1485 and 1490 or shortly thereafter // C. Gamba, *Giovanni Bellini* (1937), p. 114, fig. 119 // P. Hendy and L. Goldscheider, *Giovanni Bellini* (1945), pl. 61 // R. Pallucchini, *Giovanni Bellini* (1959), pp. 80, 144, fig. 134, dates it toward the end of the century, considering the Cook picture, now in a private collection in Switzerland, a variation of

the same composition // F. Heinemann, *Giovanni Bellini e i Belliniani* (1962), p. 9, no. 37, fig. 67, dates it tentatively about 1490 // S. Bottari, *Tutta la pittura di Giovanni Bellini* (1963), I, p. 44, pl. 164, dates it before 1485 // G. Robertson, *Giovanni Bellini* (1968), p. 96, pl. LXXIX b, dates it in the 1490's.

EXHIBITED: California Palace of the Legion of Honor, San Francisco, 1938, *Venetian Painting*, no. 6; Dallas Museum of Art, 1947.

EX COLL. [Georges Brauer, Florence, 1908].

PURCHASE, ROGERS FUND, 1908.

The Madonna Adoring the Sleeping Child
30.95.256 (Plate 5)

This painting is accepted by most scholars as one of the earliest surviving works by Giovanni Bellini, and it must have been painted at the beginning of the 1460's, or even before. The theme, the Madonna in prayer with the sleeping Child on the parapet before her, was often used by Antonio Vivarini and his circle. The placing of the Child on the marble and his deathlike stillness allude to the Pietà. The surface of this picture has suffered from loss of paint, the precious ultramarine blue of the Virgin's mantle, for instance, having been almost entirely removed. The landscape background, however, and the nobility and reserve of the Virgin make it one of the most significant of Bellini's works.

Tempera on wood. H. 28 1/2, w. 18 1/4 in. (72.4 × 46.3 cm.).

REFERENCES: The authorities cited below attribute this painting to Giovanni Bellini. J. P. Richter, *Zeitschr. für bild. Kst.*, V (1894), p. 148, ill. p. 147, dates it about 1470; (in a letter, 1895) dates it about 1450-1455; and *Mond Collection* (1910), I, p. 67, dates it before 1460 and notes that it was attributed to Alvise Vivarini when it was owned by Fol // C. J. Ffoulkes, *Arch. stor. dell'arte*, VII (1894), pp. 260 f.; and n.s., I (1895), p. 72, fig. 1, tentatively suggests dating it before 1470 // G. Gronau, *Gaz. des B.-A.*, ser. 3, XIII (1895), pp. 215 f., calls it an early work, notes the connection with Mantegna and the Vivarini; *Die Künstlerfamilie Bellini* (1909), p. 56, fig. 41; in Thieme-Becker, III (1909), p. 259; and *Giovanni Bellini (Kl. der Kst.)* (1930), p. 200,

ill. p. 14 // B. Berenson, *Ven. Ptrs.* (1895), p. 86, lists it as an early work; *Study and Criticism*, I (1901), p. 122; *Ven. Ptg. in Amer.* (1916), pp. 63 ff., frontis., considers it Giovanni Bellini's earliest extant Madonna, the best of his first period, notes that it is free from Mantegna's influence, and observes the connection with the Vivarini; *Ital. Pictures* (1932), p. 71; *Lotto* (1955), p. 8, quotes Morelli as attributing this painting, which he calls one of the earliest works by Giovanni Bellini, to Alvise Vivarini; and *Ven. School* (1957), p. 32, lists it as an early work // R. E. Fry, *Giovanni Bellini* (1900), pp. 17 f., considers it the earliest of Bellini's known Madonnas and the only one in which the motif of the sleeping Child occurs // L. Venturi, *Origini pitt. ven.* (1907), p. 359, notes its similarity in style to Mantegna, especially in the figure of the Madonna; and *Ital. Ptgs. in Amer.* (1933), pl. 384, notes the influence of Jacopo Bellini and Mantegna // J. Breck, *Rass. d'arte*, XI (1911), p. 111, dates it about 1460 // T. Borenius, ed., in Crowe and Cavalcaselle, *Ptg. in N. Italy* (1912), I, p. 141, note, dates it in his early period // A. Venturi, *Storia*, VII, part III (1914), p. 432, fig. 335, notes the influence of Mantegna; and part IV (1915), p. 272, fig. 151, dates it close to the Madonna now in the Lehman collection in New York // B. Burroughs, *Met. Mus. Bull.*, XXVI (1931), Mar., sect. II, p. 14, ill. p. 17 // L. Dussler, *Giovanni Bellini* (1935), pp. 25 f., 137, fig. 1, dates it about 1460; and *Giovanni Bellini* (1949), pp. 13, 87, pl. 6, dates it around 1460-1465 // R. van Marle, *Ital. Schools*, XVII (1935), pp. 218 f., fig. 122, dates it soon after 1462 and notes the influence of Mantegna // F. J. Mather, in *The Cannon Collection of Italian Paintings of the Renaissance* (1936), p. 41, notes that the painting by Andrea da Murano in the Cannon collection is derived from our painting, which he calls the finest example of the motif of the Madonna with the sleeping Child // C. Gamba, *Giovanni Bellini* [1937], p. 43, fig. 3, calls it a very early work // B. Degenhart, *Jahrb. der Preuss. Kstsmlgn.*, LXI (1940), p. 46, fig. 11 (detail), notes the similarity to a drawing in the Print Room of Rome; and *Zeitschr. für Kst.*, IV (1950), p. 6 // G. Firestone, *Marsyas*, II (1942), p. 47, pl. 20, fig. 4, dates it between 1450 and 1460 and discusses the motif of the sleeping Child and its symbolic relationship with the Pietà // V. Moschini, *Giambellino* (1943), p. 12, pl. 8, calls it an early work and dates it in the 1460's // P. Hendy and L. Goldscheider, *Giovanni Bellini* (1945), pl. 3 // R. Longhi, *Viatico per cinque secoli di pittura veneziana* (1946), p. 55, dates it tentatively before 1460, close to the Madonnas in the Kessler, Johnson, and Lehman collections and to the one in the Museo del Castello Sforzesco in Milan; *Arte veneta*, I (1947), p. 87; and *Burl. Mag.*, XCI (1949), p. 278, suggests dating it between 1450 and 1455 // A. M. Brizio, *Arte veneta*, III (1949), pp. 26 f., fig. 34, dates it near 1460 // G. Mariacher, *Boll. d'arte*, XXXVII (1952), p. 264, dates it before 1470 // *Art Treasures of the Metropolitan* (1952), p. 224, pl. 83 (in color) // T. Rousseau, *Met. Mus. Bull.*, n.s., XII (1954), p. 17, ill. // R. Pallucchini, *Giovanni*

Bellini (1949), pp. 20, 128, fig. 14, dates it before 1460 and observes its connections with Antonio and Bartolomeo Vivarini // G. Robertson, *Journal of the Warburg and Courtauld Institutes*, XXIII (1960), p. 40, note 13, calls it a very early work; and *Giovanni Bellini* (1968), pp. 36 f., 120, pl. XIX b, notes the influence of Mantegna, Antonio Vivarini, and Jacopo Bellini, and dates it in the early 1460's // F. Heinemann, *Giovanni Bellini e i Belliniani* (1962), p. 3, no. 10, fig. 20, dates it between 1465 and 1470, and notes a number of old copies // S. Bottari, *Tutta la pittura di Giovanni Bellini* (1963), I, p. 23, pl. 9 // N. Huse, *Studien zu Giovanni Bellini* (1972), pp. 4 f., 13, pl. 3, calls it an early work and groups it with the Madonna in the Lehman collection, New York, and the Pietà in the Correr Museum in Venice.

EXHIBITED: Royal Academy, London, 1893, *Old Masters*, no. 142 (lent by Jean Paul Richter); New Gallery, London, 1894-1895, *Venetian Art*, no. 67 (lent by Jean Paul Richter); Museum of Fine Arts, Boston, 1903 (lent by Theodore M. Davis); Palazzo Ducale, Venice, 1949, *Mostra di Giovanni Bellini*, no. 5; Metropolitan Museum, New York, 1952-1953, *Art Treasures of the Metropolitan*, no. 83.

EX COLL.: Walther Fol, Rome (until 1890; as Alvise Vivarini); Jean Paul Richter, London and Florence (by 1893-1895); Theodore M. Davis, Newport (1895-1915).

THE THEODORE M. DAVIS COLLECTION. BEQUEST OF THEODORE M. DAVIS 1915.

Giovanni Bellini & Workshop

The Madonna and Child with Saints
49.7.1 (Plate 6)

The saints are, left to right, Peter, Catherine of Alexandria, Lucy, and John the Baptist. This painting shows all the characteristics of Bellini's last period, and pentimenti around the heads of the two female saints indicate that the design is Bellini's own, but the execution is clearly only in part by him. Many areas, especially in the draperies of the saints, were carried out by assistants or pupils. None of the inferior details, however, are individual enough to be ascribed to any particular painter in Bellini's workshop, and it is not even clear whether one or more helpers were involved. The face of Saint John is similar to that of the same saint in the altarpiece of the Baptism of Christ (1500-1502) in the church of Santa Corona in Vicenza, but the Giorgionesque quality of the sunset light and the blue mountains in the far background indicate a date later than that of the Baptism, toward 1510 or even slightly later. The figure of Saint Catherine also suggests a late date since a figure of the same type reappears, with some variations, in a few other late

works from Bellini's workshop, for instance, in a painting in the Morgan Library in New York.

Signed (on cartellino at lower center): IOANNES BELLINVS.

Inscribed (on scroll held by Saint John the Baptist): ECCE AGNVS DEI.

Tempera and oil on wood. H. 38 1/4, w. 60 1/2 in. (97.2 × 153.7 cm.).

REFERENCES: I. Lermolieff [G. Morelli], *Kstkrit. Studien-Berlin* (1893), p. 89, ill. opp. p. 88, attributes this painting to Francesco Bissolo, though signed Giovanni Bellini // B. Berenson, *Ven. Ptrs.* (1894), p. 82, lists it as by Marco Basaiti; *Study and Criticism*, I (1901), pp. 110 ff., ill., rejects the attribution to Bissolo, ascribing it to Basaiti and dating it around 1510, doubts the authenticity of the signature and suggests that Basaiti was employed in Giovanni Bellini's workshop; *Ven. Ptg. in Amer.* (1916), pp. 126, 135, rejects his previous attribution to Basaiti and calls it a work of the studio of Giovanni Bellini, painted not before 1510 and probably not even before 1512; (in a letter, 1927) lists it as a late work by Giovanni Bellini; *Ital. Pictures* (1932), p. 71; and *Ven. School* (1957), p. 32, pl. 243 // G. Gronau, *Gaz. des B.-A.*, ser. 3, XIII (1895), p. 262, attributes it to the workshop of Bellini; in

Thieme-Becker, IV (1910), p. 68, rejects the attribution to Bissolo, calling it the work of some other pupil of Giovanni Bellini; (unpublished opinion, 1928) attributes it to Giovanni Bellini, dating it about 1504-1505; *Pinacoteca*, I (1928), p. 120, fig. 16; *Spätwerke des Giovanni Bellini* (1928), pp. 19 ff., pl. XVII, calls it a work by Giovanni Bellini; and *Giovanni Bellini (Kl. der Kst.)* (1930), p. 214, pl. 153, calls it a work by Giovanni Bellini, observing its relation to the painting in the Morgan Library and to the early work of Vincenzo Catena // W. von Seidlitz, *Repert. für Kstwiss.*, XVIII (1895), p. 211, rejects Morelli's attribution to Bissolo and Berenson's to Basaiti, ascribing it merely to an imitator of Giovanni Bellini // L. Cust, *Les Arts*, VI (1907), Oct., pp. 3 f., ill. p. 8, attributes it to Giovanni Bellini around 1505 // A. von Beckerath, *Repert. für Kstwiss.*, XXXIII (1910), p. 283, hesitantly accepts Morelli's attribution to Bissolo // C. J. Ffoulkes, *L'Arte*, XIII (1910), p. 305, attributes it to the school of Giovanni Bellini // D. von Hadeln (unpublished opinion, 1927) calls it a very late work by Bellini, close to the Feast of the Gods, dated 1514 // A. L. Mayer, *Pantheon*, VI (1930), pp. 541 f., attributes it to Giovanni Bellini // R. van Marle, *Ital. Schools*, XVII (1935), p. 330 f., attributes it to Bellini, dating it around 1510 // L. Dussler, *Giovanni Bellini* (1935), p. 148, attributes it to the workshop of Giovanni Bellini, around 1505-1510, stating that the types and the composition have an eclectic character and suggesting that for the figures of the Madonna and Child a cartoon by Giovanni Bellini was probably used; *Giovanni Bellini* (1949), p. 100, pl. 135 // G. M. Richter, *Burl. Mag.*, LXIX (1936), p. 3, pl. II A (detail), attributes it to Giovanni Bellini, comparing the Saint Catherine with a portrait of a woman in a London private collection // F. J. Mather, *Venetian Painters* (1936), pp. 119 f., calls it a late work by Giovanni Bellini // C. Gamba, *Giovanni Bellini* (1937), pp. 174 f., pl. 192, attributes it to Giovanni Bellini and dates it in his late period, comparing it with the Feast of the Gods in the Widener collection (now National Gallery of Art, Washington) // *Duveen Pictures* (1941), no. 90, ill., attributes it to Giovanni Bellini, and dates it about 1510 // H. B. Wehle, *Met. Mus. Bull.*, n.s., I (1943), p.

285, calls it a late work by Bellini // R. Pallucchini, *Giovanni Bellini* (1959), pp. 106, 156, fig. 216, attributes it to Bellini, assisted by his workshop, dates it before 1510, and observes that the type of the female saint on the left reappears in the Feast of the Gods in Washington // F. Heinemann, *Giovanni Bellini e i Belliniani* (1962), pp. 35 f., no. 131, fig. 249, notes that the composition is derived from a model by Bellini but that the execution is that of his workshop in large part, dates it between 1502 and 1513 // F. Gibbons, *Arte veneta*, XVI (1962), pp 47 f., fig. 54, attributes it to the late period of Marco Bello, working under Giovanni Bellini's guidance, and notes that the figure of Catherine of Alexandria is a type that occurs in a number of works from Bellini's studio // S. Bottari, *Tutta la pittura di Giovanni Bellini* (1963), II, p. 36, pl. 147, lists it among the authentic works by Giovanni Bellini, dating it 1510-1512.

EXHIBITED: Royal Academy, London, 1879, *Old Masters*, no. 203 (as Giovanni Bellini, lent by William Graham); New Gallery, London, 1894-1895, *Venetian Art*, no. 107 (as Giovanni Bellini, lent by Mrs. R. H. Benson); Royal Academy, London, 1910, *Old Masters*, no. 27 (as Giovanni Bellini, lent by R. H. Benson); Burlington Fine Arts Club, London, 1912, *Pictures of the Early Venetian School*, no. 58 (as Giovanni Bellini, lent by R. H. Benson); Manchester Art Gallery, 1927, *The Benson Collection*, no. 49 (as Giovanni Bellini, lent by R. H. Benson); Metropolitan Museum, New York, 1943, *The Bache Collection*, no. 1 (as Giovanni Bellini, lent by Jules S. Bache).

EX COLL.: Wynn Ellis, London (after 1854-1876; sale, Christie's, London, June 17, 1876, no. 55); [Waters, London, 1876]; William Graham, London (by 1879-1886; sale, Christie's, London, April 2-3, 8, 1886, no. 486); [M. Colnaghi, London, 1886]; Robert H. and Evelyn Benson, London (by 1894-1927; Cat. 1914, no. 74); [Duveen Brothers, New York, 1927]; Jules S. Bache, New York (1927-1944; Cat., 1929, no. 1).

THE JULES S. BACHE COLLECTION, 1949.

Workshop of Giovanni Bellini

The Madonna and Child
49.7.2 (Plate 8)

This picture is a good product of Giovanni Bellini's workshop, and was painted toward 1510. The execution is too stiff to be Bellini's and the handling of the paint does not show his typical treatment. The composition of the figures, however, is clearly a Bellinesque invention. The castle in the

background, which is taken from one of the best works of Bellini's late period, the Madonna of the Meadow (National Gallery, London, no. 599), was also used by a number of his pupils and followers, appearing in paintings in the Johnson collection in the Philadelphia Museum (no. 183), the National Gallery of Canada (no. 328), the collection of Lord Wemyss, and elsewhere. A weak copy after this picture, made only slightly later, is in the Ca' d'Oro, Venice.

Formerly attributed by the Museum to Giovanni Bellini.

Tempera and oil on wood. H. 13 3/8, w. 10 7/8 in. (34 × 27.7 cm.).

REFERENCES: G. F. Waagen, *Art and Artists* (1838), III, p. 118, attributes this painting to Cordelle Agi (Andrea Previtali) // B. Berenson *Ven. Ptrs.* (1894), p. 82, lists it as a work by Marco Basaiti; (unpublished opinion, 1927) calls it a genuine work by Giovanni Bellini, rejecting his former attribution to Basaiti; *Ital. Pictures* (1932), p. 71, lists it as a late work of Giovanni Bellini; and *Ven. School* (1957), p. 32, pl. 245 // G. Gronau, *Giovanni Bellini* (*Kl. der Kst.*) (1930), p. 216, pl. 168, considers this painting by Giovanni Bellini, compares the landscape with the one in the Madonna in the Brera in Milan, dates it around 1510, and mentions a copy in the Ca' d'Oro in Venice // A. L. Mayer, *Pantheon*, VI (1930), p. 541, attributes it to Giovanni Bellini // L. Dussler, *Giovanni Bellini* (1935), p. 148, attributes it to the shop of Giovanni Bellini, dating it after 1510, and notes the connection of the landscape with the painting in the National Gallery in London, mentioning the copy in the Ca' d'Oro in Venice; and *Giovanni Bellini* (1949), p. 101, pl. 140, calls it a workshop product from Giovanni Bellini's late period, executed after a drawing by him, and observes the similarity of the type of the Child to that in the painting of 1509 in the Institute of Arts, Detroit // R. van Marle, *Ital. Schools*, XVII (1935), p. 330, attributes it to Giovanni Bellini, dates it between 1510 and 1516, and mentions the copy in the Ca' d'Oro // C. Gamba, *Giovanni Bellini* (1937), p. 160, pl. 175, calls it a work by Giovanni Bellini, dating it about 1505-1507, mentioning the picture in the Ca' d'Oro as a studio version // *Duveen Pictures* (1941), no. 92, ill., lists it as Giovanni Bellini, about 1510 // H. B. Wehle, *Met. Mus. Bull.*, n.s., I (1943), p. 285, calls it a late work by Bellini // V. Moschini, *Giambellino* (1943), p. 33, calls it a work by Bellini in collaboration with his workshop // H. Friedmann, *The Symbolic Goldfinch* (1946), p. 83, attributes it to Bellini and notes that the Child is holding a

swallow // M. Davies, *The Earlier Italian Schools* (*National Gallery Catalogue*) (1951), p. 45, mentions it as one of the paintings with the background of the National Gallery Madonna of the Meadow // A. T. Gardner, *Met. Mus. Bull.*, n.s., XIII (1954), p. 48, notes that it was in the collection of William Beckford, and that it was then attributed to Cima // R. Pallucchini, *Giovanni Bellini* (1959), pp. 105, 155, fig. 210, considers it possibly a workshop product after a cartoon by Giovanni Bellini, dating it about 1506-1509 and observing the connection with the painting in the National Gallery in London // F. Heinemann, *Giovanni Bellini e i Belliniani* (1962), p. 21, no. 64 b, fig. 230, calls it a copy of a lost original dating from about 1510, considers it totally repainted and perhaps a forgery // S. Bottari, *Tutta la pittura di Giovanni Bellini* (1963), II, p. 40, pl. 168, lists it among attributed works, and considers it a school product, based upon a model by Bellini that Pietro de Saliba also used.

EXHIBITED: New Gallery, London, 1894-1895, *Venetian Art*, no. 146 (as Cima da Conegliano, lent by Sir Michael Shaw-Stewart); Metropolitan Museum, New York, 1943, *The Bache Collection*, no. 2 (as Giovanni Bellini, lent by Jules S. Bache).

EX COLL.: private collection, Venice (according to a label on the back, from the collection of the Papal Nuncio of Verona, about 1770); John Strange, Venice and London (about 1770-1799; sale, European Museum, London, December 10 ff., 1789, no. 141, as Cima, bought in; and May 17 ff., 1799, no. 179, as Cima); William Beckford, Fonthill Abbey, Tisbury, Wilts., and Lansdown Tower, Bath (by 1822-1844; sale, Christie's, Fonthill Abbey, September 24, 1822, no. 41, as Cima, bought in; sale, English and Fasana, Bath, Jan. 4 ff., 1841, no. 14, bought in); Duchess of Hamilton (Susan Euphemia Beckford), Hamilton Palace, Lanark (1844-1859); 11th Duke of Hamilton, Hamilton Palace, Lanark (1859-1863); 12th Duke of Hamilton, Hamilton Palace, Lanark (1863-1882; sale, Christie's, London, June 17-July 20, 1882, no. 395, as Cima); [Thos. Agnew and Sons, London, 1882]; Sir Michael Robert Shaw-Stewart, Ardgowan, Greenock (by 1894-1903); Walter Richard Shaw-Stewart, Fonthill Abbey, Tisbury, Wilts. (1903-1927; sale, Sotheby's, London, December 7, 1927, no. 44, as Cima); [Paterson, London, 1927]; [Duveen Brothers, London and New York, 1927-1928]; Jules S. Bache, New York (1928-1944; Cat., 1929, no. 2).

THE JULES S. BACHE COLLECTION, 1949.

The Presentation in the Temple
68.192 (Plate 7)

This painting is derived from an original of Giovanni Bellini, which must have been

executed around 1490, and is known today through a number of more or less contemporary copies and adaptations. There are at least twenty-nine versions of varying quality, some anonymous, and others attributed to specific masters; certain versions show a number of changes and in others only some details are borrowed from the entire composition (see Refs., F. Heinemann, 1962). Our painting is among the best examples, and the careful execution and faithful rendering of Bellini's types and forms suggest that it was painted in his workshop. The attribution to Girolamo da Santa Croce, however, is not supported by any technical or stylistic evidence, and must be rejected. The painting has suffered from ancient overcleaning.

Inscribed (on cartellino lower center): IOANNES BELLINVS.

Oil on wood. H. 29 1/4, w. 39 1/4 in. (74.3 × 99.4 cm.).

REFERENCES: W. Bode (in a letter, 1922) attributes this painting to Giovanni Bellini and considers it the prototype for the various school versions and copies // L. Venturi (in a letter, 1924) attributes it to Bellini, and notes that it is superior in quality to the other known versions // G. Gronau (in a letter, 1931) considers the Vienna picture the finest version of this composition, suggests that our version, known to him through photographs only, might also be by Bellini, and identifies it with the painting formerly in the collection of the Landgrave of Hesse at Schloss Barchfeld // E. Borchard, *Vassar Journal of Undergraduate Studies*, VI (1932), pp. 84 ff., pl. I, calls it a late work by Bellini, quotes the opinions of scholars cited above, and mentions a number of other versions // L. Dussler (in a letter, 1935) judging from a photograph, calls this picture the best of the known versions; *Giovanni Bellini* (1935), pp. 153 f., considers the Vienna picture the finest and ours the next best in quality, but notes that neither is by Bellini himself; and *Giovanni Bellini* (1949), p. 99 // P. Hendy, *Burl. Mag.*, LXVI (1935), pp. 122, 127, ill. opp. p. 122, attributes it to Bellini // A. Frankfurter, *Art News*, XXXVI (1937-1938), p. 8, ill. p. 10, attributes it to Bellini // C. L. Ragghianti, *Miscellanea minore di critica d'arte* (1946), pp. 125 f., considers the Vienna picture the finest and lists ours among other replicas and variations // J. Byam Shaw, *Festschrift Friedrich Winkler* (1959), pp. 340 ff., fig. 2, attributes it to Bellini and publishes a drawing after it by Domenico Tiepolo in the Ionides collection in the Victoria and Albert Museum, London // R. Pallucchini, *Giovanni Bellini* (1959), p. 148, attributes the Vienna version to Bellini, and quotes Dussler's opinion on our painting // F. Heinemann, *Giovanni Bellini e i Belliniani* (1962), p. 42, no. 144n, fig. 644, lists it as one of a number of copies of a lost work by Giovanni Bellini, painted around 1490, and probably executed in his workshop by Girolamo da Santa Croce // S. Bottari, *Tutta la pittura di Giovanni Bellini* (1963), I, p. 43, considers the Vienna picture the prototype and lists our painting among other versions of the composition.

EXHIBITED: Detroit Institute of Arts, 1933, *Italian Paintings of the XIV to XVI Century*, no. 98 (lent by Stuart and Evelyn Borchard); California Palace of the Legion of Honor, San Francisco, 1938, *Venetian Painting*, no. 7 (lent by Stuart J. Borchard).

EX COLL.: Prince Chlodwig of Hesse, Cassel (Cat., 1783, no. 10, p. 86); the Princes of Hesse, Cassel (1783-1890); Prince Chlodwig of Hesse, Philippstal (1890-before 1922); [Haberstock, Berlin, by 1922-before 1924]; Samuel Borchard, New York (by 1924-before 1931); Stuart J. and Evelyn Borchard, New York (by 1931-before 1965); Evelyn B. Metzger, New York (by 1965-1968).

ANONYMOUS GIFT, 1968.

Jacopo Bellini

Known activity 1424-1470; mentioned as dead in a document of 1471. Jacopo Bellini was the father of Gentile and Giovanni Bellini and the father-in-law of Andrea Mantegna. Nothing is known of his early training, but he has been tentatively identified with a Jacopo of Venice who was recorded in Florence in 1423 as a *famulus* (servant) of Gen-

tile da Fabriano. In fact Jacopo signed himself as Gentile's pupil on some of his early works, such as an altarpiece painted in 1430 for a church in Padua and a large Crucifixion executed in 1436 for the cathedral of Verona. Both of these paintings are now lost. In 1440 Jacopo formed a partnership with Donato Bragadin, and a year later he was in Ferrara, where he triumphed over Pisanello in a contest to make a portrait of Lionello d'Este. An altarpiece, now lost, made in 1460 for the church of Saint Anthony in Padua, was signed with his name and those of his sons Gentile and Giovanni. Only a few paintings by Jacopo Bellini have survived, and of these only one is dated, the Madonna of 1448 in the Brera in Milan. His style is more fully seen in a large number of drawings, mainly preserved in two books in the Louvre and the British Museum, which show the broad range of his interests and suggest the probable themes of lost larger compositions. Jacopo was deeply influenced by Gentile da Fabriano and perhaps by Pisanello. His style remained fundamentally Gothic, although his drawings and some of his paintings show his familiarity with works by such contemporary Florentine artists as Masolino and Andrea del Castagno, and by Florentine sculptors working in Venice.

The Madonna and Child
59.187 (Plate 9)

painted surface, h. 30 1/2, w. 21 3/4 in. (77.5 × 55.2 cm.).

This panel is a typical work by Jacopo Bellini and shows a close affinity to his representations of the same subject in the Accademia in Venice, in the Uffizi, and in the Tadini Gallery in Lovere. Gentile da Fabriano's influence is apparent in the composition of the group, in the type of the blond Virgin, and in the soft modeling of the flesh. In his way of rendering the Child's left leg Jacopo Bellini was apparently trying to resolve a problem of perspective with the empirical methods of contemporary Florentine artists. The gold ground and the archaic simplicity of the composition suggest an early date, before 1448. The surface of this picture has suffered from loss of paint, particularly in the figure of the child.

Inscribed along the Virgin's dress: . . . MARIA.

Tempera on wood; gold ground. Over-all size, h. 34 1/2, w. 25 in. (87.6 × 63.5 cm.);

REFERENCES: The authorities cited below, with the exception of M. Röthlisberger, attribute this painting to Jacopo Bellini. L. Venturi, *L'Arte*, XXXIII (1930), p. 180, fig. 7; and *Ital. Ptgs. in Amer.* (1933), p. 333 // B. Berenson, *Ital. Pictures* (1932), p. 75; and *Ven. School* (1957), p. 38, pl. 65, wrongly mentions it as belonging to the Fine Arts Gallery of San Diego, California // R. van Marle, *Ital. Schools*, XVII (1935), pp. 105 f., fig. 62, notes Gentile's influence and dates it in a comparatively early period // M. Gregori, *Paragone*, III (1952), no. 35, pp. 59 f., dates it between 1440 and 1448 // M. Röthlisberger, *Saggi e Memorie di storia dell'arte*, II (1959), pp. 78, 88, calls it a work from the shop of Jacopo Bellini of the late period, wrongly locating it in the Percy Straus collection in the Museum of Fine Arts in Houston, Texas.

EXHIBITED: California Palace of the Legion of Honor, San Francisco, 1938, *Venetian Painting*, no. 9 (lent by Mrs. J. I. Straus); World's Fair, New York, 1939, *Masterpieces of Art*, no. 11 (lent by Mrs. J. I. Straus).

EX COLL.: [Count Carlo Foresti, Carpi]; [Eugenio Ventura, Florence, 1928]; Jesse Isidor Straus, New York (1928-1936); Mrs. Jesse Isidor Straus, New York (1936-1959).

GIFT OF IRMA N. STRAUS, 1959.

Bernardo Bellotto

Bernardo Bellotto. Born 1720; died 1780. Bellotto was the pupil in Venice of his more famous uncle, Antonio Canal, called Canaletto. Although Bellotto often signed his pictures with the same name, "Canaletto", only his early paintings could be easily confused with those of his master. When he was about twenty he began to travel extensively. He worked in Rome, and also in many of the cities of northern Italy. Afterward he traveled to Munich and about 1746 settled in Dresden, where he became court painter and spent most of his active years, painting handsome views of the city and also of Pirna and Vienna. In 1766 he went to St. Petersburg and in the following year to Warsaw, where he was court painter from 1770 until his death. Bellotto employed many of Canaletto's conventions, but late in life Canaletto was in turn influenced by his nephew. Bellotto's own style is characterized by a lower scale of values and greater contrasts of light and shadow. His landscapes show clear drawing and rendering of perspective and skillful effects of atmosphere and distance.

Vaprio d'Adda

39.142 (Plate 10)

Vaprio d'Adda is a small town not far from Bergamo and Milan at the junction of the Adda and Brembo rivers. On the right of our painting is the small village of Canonica d'Adda and in the center is the Villa Melzi, where Leonardo da Vinci frequently went to visit his pupil Francesco Melzi. Bellotto made drawings after our picture[1] and its pendant, now in the Crespi collection, Milan, labeling them copies of scenes he painted in 1744 for Count Simonetta in Milan. Thus the view of Vaprio d'Adda is a relatively early work, done shortly before the artist's Dresden period. A third picture of the Villa Melzi and Canonica d'Adda is missing, but is recorded in a drawing in the National Museum in Warsaw (inv. no. 126750; Rys. Pol. 2039); according to the artist's inscription it was in Dresden, but not in the royal collection.

Oil on canvas. H. 25 1/4, w. 39 1/4 in. (64.1 × 99.7 cm.).

1. D. von Hadeln, *The Drawings of Antonio Canal* (1929), pl. 72, illustrates the drawing connected with our picture (Darmstadt, Hessisches Landesmuseum, AE2215).

REFERENCES: The authorities cited below attribute this painting to Bellotto. H. A. Fritzsche, *Bernardo Belotto gennant Canaletto* (1936), pp. 27, 106, no. VG 22, catalogues this painting and its pendant and the two drawings after them in Darmstadt // L. Burroughs, *Met. Mus. Bull.*, XXXV (1940), pp. 32 ff., ill. // R. Pallucchini, *La Pittura veneziana del settecento* (1961), p. 223, pl. 580, compares it with two views of Lombard localities in the Brera in Milan; and *Vedute del Bellotto* (1962), p. 10, pl. III (Crespi painting), mentions two views of Vaprio d'Adda of 1744, calling them pendants painted for Count Simonetta // S. Lorentz and S. Kozakiewicz, *Bellotto a Varsavia* (1955), pp. 55, 64 f., relate the Warsaw drawing to the lost painting formerly in Dresden; *Bernardo Bellotto 1720-1780* (Liverpool, 1957), p. 25, no. 30, discuss the three views of Vaprio, including the Dresden picture, now lost, and the related drawings in Warsaw and Darmstadt; and S. Kozakiewicz, *Bernardo Bellotto gennant Canaletto in Dresden und Warschau* (Dresden, 1963-1964), p. 70, no. 70, erroneously reproduces the Darmstadt drawing as the one in Warsaw; (Warsaw, 1964), pp. 80 f., no. 70; and (Vienna, 1965), p. 82, no. 95 // P. Zampetti (in a letter, 1968) suggests that the figures in the foreground are by another hand.

EXHIBITED: Nassauisches Landesmuseum, Wiesbaden, 1935, *Italienische Malerei des 17. und 18. Jahrhunderts*, no. 17 (lent anonymously [Jacob M. Heimann]); Honolulu Academy of Arts, Honolulu, Hawaii, 1949-1950, *Four Centuries of European Painting*, no. 14; Art Gallery of Toronto, 1950, *Four Centuries of European Painting*, no. 14; Detroit Institute of Arts, 1951; Art Gallery of Toronto, 1951; City Art Museum, St. Louis, 1952; Seattle Art Museum, 1952; Baltimore Museum of Art,

1959, *Age of Elegance: The Rococo and its Effect*, no. 179; Palazzo Ducale, Venice, 1967, *Vedutisti Italiani del Settecento*, no. 90.

EX COLL.: Count Antonio Simonetta, Milan (1744); the Simonetta family, Milan; the Quintavalle family (?), Milan; [Jacob M. Heimann, New York, 1935-1939].

PURCHASE, JOSEPH PULITZER BEQUEST FUND, 1939.

Bonifazio Veronese

Real name Bonifazio de' Pitati; also called Bonifazio Veneziano. Born 1487; died 1553. Bonifazio was born in Verona but spent most of his life in Venice. His style is derived from that of Palma Vecchio, whom he assisted in the painting of the Last Supper in Santa Maria Mater Domini in Venice, and, like most of his contemporaries, he felt the influence of Giorgione. Later Bonifazio assimilated the mannerist forms imported into Venice through the painters of Parma and through Francesco Salviati, and some of his late works show a close similarity to the early style of Tintoretto. His major work was the series of pictures (now scattered) painted as decoration for the Palazzo dei Camerlenghi. At his best Bonifazio was a lively painter of narrative, but after 1540 his pictures, especially those with religious subjects, became repetitious and less interesting.

A Miracle of Saint Ambrose
32.100.78 (Plate 11)

This little scene may have decorated a chest, some other piece of furniture, or an overdoor, and was probably one of a series, now dispersed or lost. The painting shows the legend of the newborn Saint Ambrose (as related by Paulinus, Vita S. Ambrosii, 3, P.L. xiv, 28), on whose cradle a swarm of bees alighted without causing him any harm. The crowned personages in the center are Ambrose's father, who was Prefect of the Praetorium in Gaul, and his mother. This painting belongs to Bonifazio's mature period, and the elongated mannerist figures show a close affinity to Lambert Sustris and Andrea Schiavone.

Formerly called by the Museum the Infant Moses in Pharaoh's Palace (Cat., 1940).

Oil on canvas, H. 10 1/2, w. 40 1/4 in. (26.7 × 102.2 cm.).

REFERENCES: The authorities cited below attribute this painting to Bonifazio Veronese. *The Athenaeum*, no. 2778 (Jan. 22, 1881), p. 139, calls it wholly Venetian in character // B. Berenson, in Cat. of Friedsam Coll. (unpublished, n.d.), p. 99, dates it in Bonifazio's late period, notes the strong influence of Antonio Palma and Andrea Schiavone, and calls the subject the Infant Moses in Pharaoh's Palace; *Ital. Pictures* (1932), p. 95, lists it as Moses in the Palace of Pharaoh; and *Ven. School* (1957), p. 43, calls it a cassone and tentatively identifies the subject as the Birth of Saint Ambrose // B. Burroughs and H. B. Wehle, *Met. Mus. Bull.*, XXVII (1932), Nov., sect. II, p. 40.

EXHIBITED: Royal Academy, London, 1881, *Old Masters*, no. 202 (lent by Charles Butler); Kleinberger Galleries, New York, 1917, *Loan Exhibition of Italian Primitives*, no. 97 (lent by Michael Friedsam).

EX COLL.: Charles Butler, Warren Wood, Hatfield, Herts. (by 1881-1911; sale, Christie's, London, May

25-26, 1911, no. 106); [P. and D. Colnaghi and Co., London, 1911]; private collection, London (sale, Amer. Art Assoc., New York, April 16-17, 1917, no. 139); [Kleinberger Galleries, New York, 1917];

Michael Friedsam, New York (1917-1931).

Canaletto

Real name Antonio Canal, also spelled Canale. Born 1697; died 1768. After studying with his father, a designer for the theater, Canaletto went to Rome in 1719. There he must have met Pannini, who was at that time painting his imaginative views of Rome and its ruins. On his return to Venice several years later, Canaletto became familiar with the landscapes and architectural pictures of Carlevarijs and Marco Ricci and began to paint views of the city, depicting with faithful accuracy its canals, palaces, and churches. Owing to the popularity of these scenes, Canaletto had many imitators, and even artists of such independent merit as Guardi, Marieschi, and Bernardo Bellotto, Canaletto's nephew, were strongly indebted to him. He was also an able engraver. His great patron Joseph Smith, the British consul in Venice, ordered many paintings from him and also a series of engravings. In 1746 Canaletto went to London and worked there for several years.

Venice: the Piazzetta
10.207 (Plate 12)

This view of the entrance to the Grand Canal shows Sansovino's Libreria Vecchia at the right and the lower part of the Piazzetta. Beyond lies the Fondaco della Farina and across the canal are the Dogana (Customs Office) and Santa Maria della Salute. Canaletto painted this same view several times, and the best example belongs to the Royal Collection at Windsor (M. Levy, *The Later Italian Pictures in the Collection of Her Majesty the Queen*, 1964, pl. 139, no. 383). Other versions are recorded in many private collections. Views similar to ours are in the collection of the Duke of Devonshire at Chatsworth and elsewhere; the one most like ours is a canvas that in 1953 was in the London art market. Our view, a relatively early work, was probably painted during the second half of the 1720's. A drawing for this composition was in the

possession of Valentino Bernardi of Bergamo in 1913.

Oil on canvas. H. 51 1/2, w. 51 1/4 in. (130.7 × 130.1 cm.).

REFERENCES: The authorities cited below attribute this painting to Canaletto. B. B[urroughs], *Met. Mus. Bull.*, VI (1911), p. 13, ill. p. 1 // G. Fogolari, *L'Arte*, XVI (1913), p. 253, fig. 13 // G. A. Simonson, *Art in Amer.*, II (1914), pp. 362 ff., ill., dates the picture in Canaletto's middle period // A. McComb, *Baroque Ptrs. of Italy* (1934), pp. 109, 123 // M. Goering, *Italienische Malerei des siebzehnten und achtzehnten Jahrhunderts* (1936), p. 18, pl. 98 // K. Clark (verbally, 1936) dates it at the time of the pictures painted for Joseph Smith and now in Windsor Castle // W. G. Constable (verbally, 1938) dates it between 1742 and 1744, comparing it with the paintings at Windsor; and *Canaletto* (1962), II, pp. 245 f., no. 148, pl. 35, fig. 148, dates it probably around 1726-1728, comparing it with the painting in Windsor Castle, mentioning other versions, similar views, and related compositions // *Met. Mus. Bull.*, n.s., X (1952), June, ill. opp. p. 265, and cover (detail in color) // *Art Treasures of the Metropolitan* (1952), p. 231, pl. 131 (in color) //

F. Watson (in a letter, 1952) dates it about 1725-1727, noting another version, probably a contemporary copy from the studio, then in the art market // V. Moschini, *Canaletto* (1954), p. 20, pl. 39, dates it around 1727-1729 // C. Donzelli, *I Pittori veneti del settecento* (1957), p. 40 // R. Pallucchini, *La Pittura veneziana del settecento* (1960), p. 76, pl. XII (in color), calls it an early work, after 1726-1727, close to the Stonemason's Yard in the National Gallery in London // E. Martini, *La Pittura veneziana del settecento* (1964), p. 249, note 210, dates it before 1727.

EXHIBITED: Royal Academy, London, 1907, *Old Masters*, no. 77 (lent by Sir George Donaldson); City Art Museum, St. Louis, 1936, *Venetian Painting*, no. 4; Metropolitan Museum, New York, 1938, *Tiepolo and His Contemporaries*, no. 21; Yale University Art Gallery, New Haven, Connecticut, 1940, *Eighteenth-Century Landscape Painting*, no. 6; Metropolitan Museum, New York, 1952-1953, *Art Treasures of the Metropolitan*, no. 131; Museum of Fine Arts, Boston, 1970, *Masterpieces of Painting in The Metropolitan Museum of Art* (Cat., p. 29).

EX COLL.: F. H. Ward, London (1900): [Thos. Agnew & Sons, London, 1900-1901]; Sir George Donaldson, London (1901-before 1910); [Dowdeswell and Dowdeswell Ltd., London, 1910].

PURCHASE, KENNEDY FUND, 1910.

Venice: Santa Maria della Salute
59.38 (Plate 13)

This painting shows the entrance of the Grand Canal in Venice, looking east, with the domed church of Santa Maria della Salute on the right. Beyond, in the middle distance, is the Dogana. At the left, across the canal, are the Zecca (Mint) and the Sansovino Library, one of the pillars of the Piazzetta, the Ducal Palace, the Prison, and the Riva degli Schiavoni. This is one of the most familiar views in Venice, very popular with foreign visitors, and Canaletto painted it a number of times. The best-known version is the one in the Royal Collection in Windsor Castle (M. Levey, *The Later Italian Pictures in the Collection of Her Majesty the Queen*, 1964, pl. 175, no. 407), painted in 1744. Of the numerous others (see Refs., W.G. Constable, 1962), one formerly in the London art market had a pendant showing the Riva degli Schiavoni (see *Connoisseur*, CIII, 1939, p. ix, no. 5). Our picture also probably had such a pendant, or one showing the entrance to the Grand Canal looking west. The style of the painting suggests a date about 1740, in Canaletto's middle period.

Oil on canvas, H. 18 3/4, w. 31 1/4 in. (47.6 × 79.3 cm.).

REFERENCES: The authorities cited below attribute this painting to Canaletto. *Bulletin of the Minneapolis Institute of Arts*, XXVII (1938), pp. 147 f., ill. p. 149 // W. G. Constable, *Canaletto* (1962), II, p. 257, no. 175, compares it with the Windsor Castle version and lists other pictures showing almost the same view, of which there are many school repetitions and copies.

EXHIBITED: California Palace of the Legion of Honor, San Francisco, 1941, *Italian Baroque Paintings*, no. 9 (lent by the Minneapolis Institute of Art.)

EX COLL.: [Caspari Galleries, Munich, 1926]; [P. and D. Colnaghi, London, 1926-1927]; [Leggatt Bros., London, 1927-1928]; Mrs. Whitelaw Reid, Ophir Hall, Purchase, New York (sale, American Art Association-Anderson Galleries, New York, May 14-18, 1935, no. 1157); [Julius H. Weitzner, New York, 1935-1938]; Alfred Pillsbury, Minneapolis (1938); Minneapolis Institute of Arts (1938-1957); [Rosenberg and Stiebel, Inc., New York, 1959].

PURCHASE, GEORGE T. DELACORTE, JR., FUND, 1959.

Vittore Carpaccio

Vittore Carpaccio, surname variously spelled. Born about 1455; died between 1523 and 1526. Carpaccio was apparently a follower of Gentile Bellini, and Gentile's influence is particularly marked in the great historical and legendary scenes that he painted for the Scuola di San Giorgio degli Schiavoni, the Scuola degli Albanesi, and the Scuola di

Sant'Orsola. This last cycle, considered his finest work, is now in the Accademia in Venice. His style shows a definite relationship to Lazzaro Bastiani and Marco Basaiti, and he was also influenced by Giovanni Bellini, and, to some degree, by Giorgione. Carpaccio's glowing and transparent color, his neat definition of forms, and his love for minute detail make him one of the most significant representatives of the naturalistic trend of the Italian Renaissance.

The Meditation on the Passion
11.118 (Plate 14)

The key to the interpretation of this scene of the dead Christ attended by Job (right) and Saint Jerome, with his lion, is provided by the distorted Hebrew characters on the stone block on which Job is sitting. In these, scholars have deciphered the phrase "that my Redeemer liveth" and the number "19", referring to the nineteenth chapter of the Book of Job, in which those words appear. Through Saint Jerome's interlinear commentary on the Book of Job, the sufferings of this Old Testament character came to be accepted as prefiguring the Passion of Christ (see Refs., F. Hartt, 1940). At the left a dry tree grows out of crags in a barren wilderness, and a panther is bringing down a stag (perhaps a symbol of the human soul). At the right a green tree flourishes in the luxuriant country outside a prosperous fortified town, and here a stag appears to be successfully eluding a leopard. The two sages, Job and Jerome, who by their experiences and writings announced the Resurrection and its meaning in human life, sit here together in meditation upon the Passion of Christ.

The style of the picture suggests a date at the end of the fifteenth century. It shows, especially in the figure of Job, in the ruined architecture of Christ's throne, and in the structure of the hill on the left, the obvious influence of the major painters of the late fifteenth-century school of Ferrara, particularly Tura and Roberti. Perhaps this indicates that the *Meditation* was painted in Ferrara and, like the *Death of the Virgin* by Carpaccio, about 1508. Although no documentation exists, it is highly probable that Carpaccio went to Ferrara to paint the *Death of the Virgin*, formerly in the church of Santa Maria del Vado and now in the local gallery. In the seventeenth century the *Meditation on the Passion* and the *Entombment of Christ*, also by Carpaccio, now in the Dahlem Museum, Berlin (no. 23 A), were together in Ferrara in the collection of Roberto Canonici, and both paintings bore the false signature of Mantegna. In 1945 the Museum discovered that the signature of Carpaccio lay beneath the Mantegna signature, which was then removed (see Refs., M. Pease, 1945).

Signed (at lower right): vjctorjs carpattjj venettj opus; inscribed with phrases in distorted Hebrew letters (on throne of Christ): "with a cry," "Israel," and "crown"; (on stone block at right): "Israel," "that my Redeemer liveth," and "19".

Tempera on wood. H. 27 3/4, w. 34 1/8 in. (70.5 × 86.7 cm.).

REFERENCES: The authorities cited below, with the exception of Campori, Richter, and Kristeller, attribute this painting to Carpaccio. Inventory of the collection of Roberto Canonici (1632), in G. Campori, *Raccolta di cataloghi ed inventarii inediti* (1870), p. 117, lists this painting as a work by Mantegna // J. P. Richter (in a letter, 1881, in *Italienische Malerei der Renaissance . . .*, 1960, p. 142) calls it a very early work by Cima // P. Kristeller, *Andrea Mantegna* (1901), p. 455, lists it among works attributed to Mantegna and calls the figure at the right Isaiah // C. Phillips, *Burl. Mag.*, XIX (1911), pp. 144 ff., ill. p. 148, calls it *Meditation on the Passion* // B. Berenson (verbally, 1911); *Ven. Ptg. in Amer.* (1916), pp. 158 f., fig. 63, notes the similarity of the figure of Christ to that in the *Pietà* in the Serristori collection in Florence, and suggests that the figure at the right may be Onuphrius; *Ital. Pictures* (1932), p. 134; and *Ven. School* (1957), p. 58, pl. 426 // B. B[urroughs], *Met. Mus. Bull.*, VI (1911), pp. 191 f., ill. p. 183, notes its similarity to the *Entombment* in Berlin // T. Borenius, ed., in Crowe and Cavalcaselle, *Ptg. in N. Italy* (1912), I, p. 213, note, suggests

that the figure at the right is Isaiah, and notes the similarity to the picture in Berlin // A. Venturi, *Storia*, VII, part IV (1915), p. 758, note // G. Fogolari, *Rass. d'arte*, XX (1920), p. 125, ill. // F. Mather, *History of Italian Painting* (1923), pp. 368 ff., dates it about 1480 // W. Hausenstein, *Das Werk des Vittore Carpaccio* (1925), pp. 138 f., pl. 65, dates it about 1505-1510 // G. Fiocco, *Carpaccio* (1931), pp. 74 f., pl. XCV; and *Carpaccio* (1958), p. 33, pls. 49 A and B, observes the influence of Mantegna, dating it about the time of the cycle of San Giorgio degli Schiavoni of 1502-1507 and the panels in the museums in Berlin and Caen // R. Longhi, *Vita artistica*, IV/I (1932), p. 10, dates the painting about 1500 // L. Venturi, *Ital. Ptgs. in Amer.* (1933), pl. 408, dates it about 1510 // H. Tietze, *Meisterwerke Europäischer Malerei in Amerika* (1935), p. 328, pl. 74, dates it around 1510; and with E. Tietze-Conrat, *The Drawings of the Ven. Ptrs.* (1944), pp. 83, 149, doubts Carpaccio's authorship, questions the connection with a drawing in the Berlin Museum which he attributes instead to Giovanni Bellini or his shop, and notes the relation between this painting and the verso of a drawing in the Fenwick collection at Cheltenham // R. van Marle, *Ital. Schools*, XVIII (1936), pp. 263 ff., 338, 359, fig. 158, notes the influence of Giovanni Bellini, calls the figure at the right Onuphrius, and mentions a drawing in the Kupferstichkabinett in Berlin similar to the figure of Saint Jerome // F. Hartt, *Art Bull.*, XXII (1940), pp. 25 ff., fig. 1, identifies the figure on the right as Job, connects him with Saint Jerome's commentary, and discusses fully the iconography of the painting // M. Pease, *Met. Mus. Bull.*, n.s., IV (1945), pp. 1 ff., detail ill. on cover (in color), discusses the removal of the false signature of Mantegna and the discovery of the genuine one of Carpaccio // H. Friedmann, *The Symbolic Goldfinch* (1946), pp. 83 f., 156, observes that many of the birds and animals may have no iconographical significance; notes that the goldfinch on the back of the throne typically appears with the Infant Christ // A. E. Popham, *Arte veneta*, I (1947), p. 229, suggests that the drawing of a seated male nude in the British Museum might be a preparatory study for this painting; and with P. Pouncey, *Italian Drawings ... in the British Museum (The Fourteenth and Fifteenth Centuries)* (1950), p. 20 // W. Arslan, *Boll. d'arte*, XXXVI (1951), p. 312, fig. 16 (detail) // *Art Treasures of the Metropolitan* (1952), no. 86, ill. (in color) // G. van der Osten, *Westfalen*, XXX (1952), pp. 193 ff., discusses the iconography // L. Coletti, *Pittura veneta del Quattrocento* (1953), p. LXX, pl. 154, compares it with the Berlin Entombment and observes connections with Luca Signorelli // T. Rousseau, *Met. Mus. Bull.*, n.s., XII (1954), p. 225, ill. p. 16 // T. Pignatti, *Carpaccio* (1955), p. 72, figs. 57, 58 (detail), dates it toward the end of

the XV century and notes echoes of Giovanni Bellini's various versions of the Pietà in Stockholm, Toledo, and Florence (Uffizi); and *Carpaccio* (1958), pp. 17, 52 f., ill. p. 53 (in color), observes the influence of Cossa and Roberti // G. Perocco, *Tutta la pittura del Carpaccio* (1960), pp. 23, 64, pls. 122, 123 (detail), observes the influence of Giovanni Bellini in Christ's torso and Flemish influence in the landscape, notes the Ferrarese connection, and suggests that Saint Jerome might be a portrait // J. Lauts, *Carpaccio* (1962), pp. 13 f., 246, no. 63, pls. opp. p. 13 (signature), 3-5, dates it about 1485, on the basis of the close relationship with Giovanni Bellini's paintings of the early 1480's, the Mantegnesque character of the landscape, and the form of the signature, which differs from signatures on works dated 1490 or later // F. Heinemann, *Giovanni Bellini e i Belliniani* (1962), p. 232, no. v.100, fig. 845, notes the influence of Giovanni Bellini, especially in the figure of St. Jerome // P. Zampetti, *Vittore Carpaccio* (1963), p. 233, ill. p. XLIV; and *Vittore Carpaccio* (1966), pp. 40, 43, 64, no. 18, pl. 18, accepts Lauts' date of 1485 or slightly later // M. Muraro, *Carpaccio* (1966), pp. 24, 75, CLX ff., pls. pp. CLXI, CLXIII, CLXV, compares the figure of Christ with works by Bellini in Berlin, London, and Rimini, and dates the painting about the time of the Saint Thomas Aquinas Enthroned (1507) and the Death of the Virgin (1508) // G. Robertson, *Giovanni Bellini* (1968), p. 101, suggests that this painting and Giovanni Bellini's Meditation on the Incarnation (Florence, Uffizi, no. 631) might have been executed for the same patron, who had a particular veneration for Job, as he figures in both pictures and possibly also in the San Giobbe altar (Venice, Accademia, inv. no. 38).

EXHIBITED: Royal Academy, London, 1881, *Old Masters*, no. 188 (as Mantegna, lent by Sir William Abdy); Louvre, Paris, 1885, *Exposition ... des Orphelins d'Alsace-Lorraine*, no. 322 (as Mantegna, lent by Sir William Abdy); Metropolitan Museum, New York, 1952-1953, *Art Treasures of the Metropolitan*, no. 86; Art Institute, Chicago, 1954, *Masterpieces of Religious Painting* (Cat., p. 25); Wildenstein and Co., New York, 1961, *Adele Levy Memorial Exhibition*, no. 4; Museum of Fine Arts, Boston, 1970, *Masterpieces of Painting in The Metropolitan Museum of Art* (Cat., p. 18); Metropolitan Museum, New York, 1970-1971, *Masterpieces of Fifty Centuries*, no. 197.

EX COLL.: Roberto Canonici, Ferrara (in 1632); the Canonici family, Ferrara (until about 1850); Sir William Neville Abdy, London (by 1881-1911; sale, Christie's, London, May 5, 1911, no. 92, as Carpaccio); [Sulley and Co., London, 1911].

PURCHASE, KENNEDY FUND, 1911.

Francesco Casanova

Born 1727; died 1802. Francesco (or François Joseph) Casanova was the brother of the famous Giacomo Casanova and is frequently mentioned in his brother's memoirs. Though born in London of Venetian parents, he was brought up in Venice and studied under Francesco Simonini; in 1742 he was in the workshop of Gianantonio Guardi. Casanova traveled widely through the capitals of northern Europe. After four years in Dresden, he went to Paris in 1757 and stayed there almost twenty years. His landscapes and battle pictures earned him a high reputation in France, and his work was praised by Diderot. In 1783 he went to Vienna, where he spent his last years. During this time he painted for Catherine of Russia a cycle of scenes celebrating the victories of the Russians over the Turks. Casanova's style shows clear reminiscences of Marco Ricci and the Guardis, but in his later work there is a certain international tone and a taste for decorative elegance.

Cavalier and Shepherd
07.225.253 (Plate 15)

Oil on canvas. H. 25 5/8, w. 32 in. (65.1 × 81.3 cm.).

This picture shows, especially in the distant figures, a slight echo of the manner of Francesco Simonini, but the general treatment is obviously affected by Flemish and French paintings of the late seventeenth century. It seems to belong to the mature period of Casanova.

REFERENCE: C. Donzelli, *I Pittori veneti del settecento* (1957), p. 58, fig. 77, lists this painting as a work of Francesco Casanova.

EX COLL. Georges Hoentschel, Paris (before 1906).

GIFT OF J. PIERPONT MORGAN, 1906.

Vincenzo Catena

Real name Vincenzo di Biagio. Active by the end of the fifteenth century; died 1531. His early work was strongly influenced by Giovanni Bellini and Cima. The first documentary record of Catena is an inscription, dated 1506, on the back of a painting by Giorgione indicating that he was Giorgione's partner. Documents from the two following decades show that Catena was a friend of the historian Marcantonio Michiel, the poet and cardinal Pietro Bembo, and the painter Sebastiano del Piombo. Even though Catena was in partnership with Giorgione as early as 1506 his work continued to show the influence of Giovanni Bellini and Cima, and it was not until late in his career that his way of painting was affected by the revolutionary achievements of his great contemporaries Giorgione and Titian. Catena probably visited Rome, perhaps about 1515, and some of his works show the influence of Raphael.

Portrait of a Venetian Senator
30.95.258 (Plate 16)

This portrait has been considered by some critics to be a likeness of Andrea Gritti (1454-1538), who became Doge in 1523, but this identification cannot be accepted. By the time Catena's technique had reached the stage seen here Gritti was a far older man than the subject of our painting; furthermore, a portrait that is surely of Gritti, painted by Catena about 1530 (National Gallery, London, no. 5751), and the portrait of Gritti by Titian in this Museum both show a very different man from the subject of this painting. The composition of this impressive portrait, at one time attributed to Gentile Bellini,[1] demonstrates that Catena was influenced by the late works of Giovanni Bellini and the early works of Titian.

Oil on canvas. H. 27 1/4, w. 24 in. (69.2 × 60.9 cm.).

REFERENCES: The authorities cited below attribute this painting to Catena. B. Berenson (in a letter, 1901) calls it a portrait of Gritti; *Ven. Ptg. in Amer.* (1916), pp. 251 f., fig. 103, dates it between 1508 and 1517, assuming either that it is not a portrait of Gritti or that it is a copy of an earlier likeness of him; *Ital. Pictures* (1932), p. 139; and *Ven. School* (1957), p. 62, lists it as a portrait of Gritti and dates it in Catena's late period // J. Breck, *Rass. d'arte*, XI (1911), p. 112 // K. Cox, *Met. Mus. Bull.*, XII (1917), p. 149, ill. p. 153 // B. Burroughs, *Met. Mus. Bull.*, XXVI (1931), Mar., sect. II, p. 15, ill. p. 20 // L. Venturi, *Ital. Ptgs. in Amer.* (1933), pl. 421, dates it about 1520 // R. van Marle, *Ital. Schools*, XVIII (1936), p. 395, calls it a late work but does not regard it as a portrait of Gritti // G. Robertson, *Vincenzo Catena* (1954), pp. 35, 66, pl. 40, dates it around 1525 and rejects the identification of the sitter as Gritti // F. Heinemann, *Giovanni Bellini e i Belliniani* (1962), p. 103, no. S.109, dates it about 1511.

EXHIBITED: Worcester Art Museum, Worcester, Massachusetts, 1901-1902, *Winter Exhibition*, no. 15 (lent by Theodore M. Davis); Museum of Fine Arts, Boston, 1903 (lent by Theodore M. Davis).

1. E. Andrews (notebook, 1901) notes the acquisition by Theodore M. Davis as a work by Catena, formerly attributed to Gentile Bellini.

EX COLL.: [Georges Brauer, Florence, 1901]; Theodore M. Davis, Newport (1901-1915).

THE THEODORE M. DAVIS COLLECTION. BEQUEST OF THEODORE M. DAVIS, 1915.

The Adoration of the Shepherds
69.123 (Plate 17)

In this large canvas the derivative character of Catena's style is apparent, and the various influences on his work can be identified with precision. As indicated by Robertson (see Refs.), the main group recalls the Allendale Nativity by Giorgione, now in the National Gallery, Washington (Kress coll., K509). The dog is nearly identical to the animal in Albrecht Dürer's Saint Eustace engraving of about 1505, except that the image is reversed, while the kneeling shepherd with the basket of eggs nearby would seem to be adapted from Cima da Conegliano's Nativity in the church of Santa Maria del Carmine in Venice, a work usually dated between 1508 and 1510. The flying angel near the upper left corner is very similar to those in Catena's Madonna and Child formerly in the collection of Richard Auspitzer, New York, and now in the Samuel S. Fleisher Art Memorial in Philadelphia; the figure of the Child is based on the same cartoon that the artist used in paintings in the Berlin Museum (no. 19) and in the Hermitage in Leningrad (no. 9). The architecture of the buildings in the background is characteristically Venetian, but the treatment of the thatched hut and the hilly landscape to the right is reminiscent of Dürer's engravings. The picture should be dated in the early 1520's, possibly around 1521-1523. The allegedly Giorgionesque character of the forms, which was noted by various authorities, was due exclusively to restoration of the surface, and has completely disappeared with the removal of old varnishes and repainting.

Oil on canvas. Over-all, h. 50 5/8, w. 83 1/2 in. (128.6 × 212.1 cm.); painted surface, h. 49 1/2, w. 81 3/4 in. (125.8 × 207.6 cm.).

REFERENCES: C. Phillips, *Gaz. des B.-A.*, ser. 3, IX (1893), p. 227, rejects the attribution to Giovanni Bellini in the Royal Academy exhibition, ascribing it to Catena in his mature period // B. Berenson, *Ven. Ptrs.* (1894), p. 96, lists this painting as a work by Catena; *Venetian Painting, chiefly before Titian, at the Exhibition of Venetian Art, New Gallery, 1895*, reprinted in *Study and Criticism*, I (1901), pp. 132 f., ill. opp. p. 132, rejects the traditional attribution to Bellini and calls it a sure work by Catena, comparing it with several paintings by him, and noting its Giorgionesque character; *Ven. Ptrs.* (1906), p. 102; *Ven. Ptg. in Amer.* (1916), p. 251; and *Ven. School* (1957), p. 62, pl. 608 // G. Gronau, *Gaz. des B.-A.*, ser. 3, XIII (1895), pp. 261 f., ascribes it to Catena // H. Cook, *L'Arte*, V (1902), p. 115, ill. p. 114, accepts the attribution to Catena, and notes similarities to the work of Bellini, Lotto, and Giorgione // R. Fry, *Burl. Mag.*, XVI (1909), p. 9, ill. p. 7, compares it with a Judgment of Solomon at Kingston Lacy, attributing both pictures to Catena // T. Borenius, ed., in Crowe and Cavalcaselle, *Ptg. in N. Italy* (1912), I, p. 261, note, lists it as Catena, and places it in his Giorgionesque phase; and *Burl. Mag.*, XXIII (1913), p. 35, notes that it is related to the Allendale Adoration of the Shepherds, which he attributes to Cariani // D. von Hadeln, in Thieme-Becker, VI (1912), p. 183, lists it as a work of Catena's middle period // A. Venturi, *Storia*, VII, part IV (1915), pp. 578 f., fig. 361, ascribes it to the late period of an anonymous follower of Catena, whom he calls Anonimo Belliniano, and to whom he attributes other works, including the Holy Family with Saint George in the Museum in Messina, and the Holy Family with a Knight in the National Gallery in London, and notes the influence of Giorgione; and *Storia*, IX, part III (1928), pp. 60 f., fig. 40, calls it the work of an anonymous Giorgionesque painter, and connects it with a drawing in the Royal Library at Windsor // C. Holmes, *Burl. Mag.*, XLII (1923), p. 232, attributes it to Palma Vecchio, notes the influence of Jacopo Bellini and Giorgione, and suggests a date around 1503 // C. H. Collins Baker, *Burl. Mag.*, XLII (1923), pp. 245 f., lists it among works wrongly ascribed to Catena // R. Offner (unpublished opinion, 1928) attributes it to Catena // G. Fiocco, *Giorgione* (1941), p. 18, pl. 96, attributes it to Catena, and notes the influence of the Allendale Nativity by Giorgione; and *Giorgione* (1948),

p. 21, pl. 96 // A. Morassi, *Giorgione* (1942), pp. 147, 185, pl. 176, attributes it to Catena, and notes the connections with the Allendale Nativity of Giorgione // H. Tietze and E. Tietze-Conrat, *The Drawings of the Venetian Painters* (1944), p. 176, accept Venturi's grouping and attribution to Catena, noting the connection with the Allendale Nativity by Giorgione // G. Robertson, *Vincenzo Catena* (1954), pp. 32 ff., no. 36, pl. 32, accepts it as a genuine work by Catena, observes the derivation from the Allendale Nativity, notes borrowings from Cima and Dürer, and dates it in the artist's late period, after 1520.

EXHIBITED: Royal Academy, London, 1879, *Old Masters*, no. 142 (as Giovanni Bellini, lent by Earl Brownlow); and 1893, *Old Masters*, no. 161 (as Giovanni Bellini, lent by Earl Brownlow); New Gallery, London, 1894-1895, *Venetian Art*, no. 251 (as Giovanni Bellini, lent by Earl Brownlow); Royal Academy, London, 1902, *Old Masters*, no. 36 (as Giovanni Bellini, lent by Earl Brownlow); Burlington Fine Arts Club, London, 1912, *Pictures of the Early Venetian School*, no. 39 (as Giovanni Bellini, lent by Earl Brownlow); Palazzo Ducale, Venice, 1955, *Giorgione e i Giorgioneschi*, no. 65 (lent by Count A. Contini Bonacossi).

EX COLL.: Giustiniani de' Vescovi, Venice (until about 1790); [Giovanni Maria Sasso, Venice, about 1790-1791]; Sir Abraham Hume, London (1791-1838; Cat., 1824, no. 1); Viscount Alford, London (1838-1851); 2nd Earl Brownlow, Ashridge, Berkhamsted (1851-1867); 3rd Earl Brownlow, Ashridge (1867-1921; sale, Christie's, London, May 4, 1923, no. 11, as Giovanni Bellini, bought in); 5th Baron Brownlow, Ashridge (1923); [Thos. Agnew and Sons, London]; [Count Alessandro Contini Bonacossi, Florence, until 1955]; Count Alessandro Augusto Contini Bonacossi, Florence (1955-1969).

PURCHASE, FROM FUNDS GIVEN OR BEQUEATHED BY GWYNNE M. ANDREWS, LOUIS V. BELL, CHARLES B. CURTIS, HARRIS BRISBANE DICK, WILLIAM EARL DODGE, GUSTAVUS A. PFEIFFER, JOSEPH PULITZER, ALFRED N. PUNNETT, JACOB S. ROGERS, VICTOR WILBOUR, AS WELL AS CONTRIBUTIONS MADE BY GEORGE T. DELACORTE, JR., CHRISTIAN HUMANN, MRS. CHARLES S. PAYSON, AND OTHER FRIENDS OF THE MUSEUM, 1969.

Giovanni Battista Cima

Giovanni Battista Cima; usually called Cima da Conegliano. Born about 1459; died 1517 or 1518. Cima, a native of Conegliano, probably studied painting with Alvise Vivarini in Venice. Although there is no record of his presence there until 1492, it appears that

he visited Venice before that time since an altarpiece by him, dated 1489 (now in Vicenza), is obviously derived from Giovanni Bellini's Madonna of 1488 in the church of the Frari, Venice. Cima's paintings, with their clear colors, dignified figures, and poetic landscapes, follow the art of Giovanni Bellini in his middle period; in spite of the triumph of the new style of Giorgione and Titian, these works hold to the fifteenth-century tradition.

Three Saints: Roch, Anthony Abbot, and Lucy

07.149 (Plate 18)

This small altarpiece is one of the artist's latest works. The somewhat lower quality of certain passages seems to betray the participation of pupils and assistants. The surface of the painting has suffered slightly in the transfer from wood to canvas.

Formerly attributed by the Museum to Girolamo di Bernardino da Udine.

Tempera and oil on canvas, transferred from wood. H. 50 1/2, w. 48 in. (128.2 × 121.9 cm.).

REFERENCES: J. D. Passavant, *The Leuchtenberg Gallery* (1852), p. 8, attributes this painting to Caroto // G. B. Cavalcaselle (undated ms., Biblioteca Marciana, Venice) rejects the attribution to Caroto, finds it closer to the followers of Cima, perhaps Girolamo da Udine; (ms., 1865, Biblioteca Marciana, Venice) suggests Basaiti or Girolamo di Bernardino da Udine as the artist; and with J. A. Crowe, *Ptg. in N. Italy* (1871), I, p. 486, II, p. 188, attributes it tentatively to Girolamo da Udine // G. F. Waagen, *Gemäldesmlg.-St. Petersburg* (1870), p. 375, catalogues it as a work by Caroto but notes some similarity to Previtali // F. Harck, *Repert. für Kstwiss.*, XIX (1896), p. 431, considers it close in style to Cima // A. Néoustroieff, *L'Arte*, VI (1903), p. 345, fig. 14, calls it a work of the school of Cima // *Trésors d'art en Russie*, IV (1904), pl. 27, calls it a work by Caroto // R. Burckhardt, *Cima da Conegliano* (1905), p. 122, calls it a work of the school of Cima // *Met. Mus. Bull.*, II (1907), p. 172, ill., attributes it to Cima // M. H. Bernath, *New York und Boston* (1912), pp. 78 ff., fig. 81, calls it a characteristic work by Cima // B. Berenson, *Ven. Ptg. in Amer.* (1916), pp. 204 ff., calls it a late work by Cima, with the help of assistants; *Ital. Pictures* (1932), p. 147; and *Ven. School* (1957), p. 66 // R. van Marle, *Ital. Schools*, XVII (1935), pp. 443, 476, fig. 264, attributes it to Cima and dates it 1510-1513 // R. Longhi (unpublished opinion, 1937), attributes it to Cima // V. N. Lazarev,

Arte veneta, XI (1957), p. 48, calls it a late work by Cima and dates it not far from 1513 // L. Coletti, *Cima da Conegliano* (1959), p. 93, pl. 128, doubts the attribution to Cima, although observing its close relation to Cima's polyptych in the parish church of San Fior, and notes that in quality it is much superior to the work of Francesco di Simone da Santa Croce, to whom one may be tempted to ascribe it.

EX COLL.: the Dukes of Leuchtenberg, Munich and St. Petersburg (by 1843-after 1904; Cat., 1843, no. 63, as Caroto) [Sulley and Co., London, 1907].

PURCHASE, ROGERS FUND, 1907.

The Madonna and Child with Saint Francis and Saint Clare

41.190.11 (Plate 19)

In this minor but characteristic work Cima arranged some of his most typical motifs within a popular format first used in Venice by Giovanni Bellini. A similar group with slight variations was repeated by Cima many times. Examples are a panel in the Morgan Library in New York and one in the Accademia in Venice (no. 815, the so-called Madonna of the Orange Tree), in which, however, the figures are full length. The style is typical of Cima's late period, about 1510. The female saint was at one time identified as Catherine of Siena but is undoubtedly Saint Clare of Assisi since she wears the habit of a Franciscan nun.

Inscribed (across parapet at the bottom): IOANNES BELLINVS FACIEBAT (this inscription was painted out between 1897 and 1916; a cleaning in the Museum after 1941 made it visible again).

Tempera on wood. H. 8, w. 10 1/2 in. (20.3 × 26.7 cm.).

REFERENCES: The authorities cited below attribute this painting to Cima. U. Thieme in W. Bode, *Cat. of Hainauer Coll.* (1897), no. 61, pl. 17 // B. Berenson, *Ven. Ptg. in Amer.* (1916), p. 204, identifies the female saint as Clare; *Ital. Pictures* (1932), p. 147, lists it as a late work, painted after 1509; and *Ven. School* (1957), p. 66, lists it as a late work, erroneously describing it as signed.

EXHIBITED: Berlin, 1883, *Ausstellung alter Kunstwerke in Berliner Privatbesitz*, no. 11 (as Giovanni Bellini, lent by Oscar Hainauer); Berlin, 1898, *Ausstellung von Kunstwerken des Mittelalters und der Renaissance aus Berliner Privatbesitz*, no. 27 (as Giovanni Bellini, lent by Frau Julie Hainauer); M. Knoedler and Co., New York, 1938, *Venetian Paintings of the XV and XVI Centuries*, no. 6 (lent by Mr. and Mrs. George Blumenthal); California Palace of the Legion of Honor, San Francisco, 1938, *Venetian Painting*, no. 21 (lent by Mr. and Mrs. George Blumenthal).

EX COLL.: Baron de Beurnonville, Paris (sale, Paris, Pillet, May 9-16, 1881, no. 608, as Madonna and Child with Saint Francis and Saint Catherine, by Giovanni Bellini); Oscar Hainauer, Berlin (by 1883-1894); Frau Julie Hainauer (1894-1906); [Duveen Brothers, London and New York, 1906-1912]; George and Florence Blumenthal, New York (1912-1941; Cat., I, 1926, pl. XLI).

BEQUEST OF GEORGE BLUMENTHAL, 1941.

Carlo Crivelli

Active by 1457; died about 1495. Carlo Crivelli was the son of a Venetian painter, Jacopo Crivelli, and the brother of Vittore Crivelli. In a document of 1457 he is mentioned as a master painter in Venice; another document gives evidence that he was in the town of Zara (Zadar) in Dalmatia in 1465. In 1468 he signed an altarpiece for Massa Fermana in the Marches, where he spent the rest of his life, living first in Fermo and then in Ascoli Piceno. His earliest dated extant work is from 1468 and his latest from 1493. Crivelli's painting shows the influence of such Venetians as Antonio Vivarini and the young Giovanni Bellini. An even greater impression was made on his style by the Paduan school of Francesco Squarcione, especially Giorgio Ciulinovitch, called Giorgio Schiavone, whom he may have met in Padua and again in Dalmatia. Crivelli's conception of form remained utterly Gothic. When he adapted Renaissance themes he transposed them into stylized and imaginative visions, the forms outlined by sharp, clear drawing and often emphasized by richly tooled gold grounds. He continued to use a number of traditional religious symbols and the many-paneled form of altarpiece known as the ancona. His archaic style, as well as his admirable craftsmanship, explains his great success in the provincial centers of the Marches, where he had a considerable influence.

Saint Dominic

05.41.1 (Plate 20)

This painting of Saint Dominic and the one of Saint George that follows originally belonged to a polyptych, the central panel of which was a Madonna and Child, signed and dated 1472 (collection of Jack Linsky, New York; formerly Erickson collection, New York). Two other panels by Crivelli, a Saint Nicholas of Bari (Cleveland Museum of Art, no. 52.111) and a Saint James Major (Brooklyn Museum, McDonald loan) were with our panels in the Fesch and Davenport Bromley collections, and accordingly must have belonged to the same polyptych, one of Crivelli's comparatively early works.

Tempera on wood; tooled gold ground. H. 38 1/4, w. 12 3/4 in. (97.2 × 32.4 cm.).

REFERENCES: The authorities cited below, with the exception of Waagen and of Crowe and Cavalcaselle, attribute these paintings to Crivelli. G. F. Waagen, *Treasures-Gr. Brit.* (1854), III, p. 377, calls them works by Jacobello del Fiore // Crowe and Cavalcaselle, *Ptg. in N. Italy* (1871), I, p. 10, note, report Waagen's attribution but admit not having seen the originals // B. Berenson, *Ven. Ptrs.* (1895), p. 99; *Study and Criticism*, I (1912), p. 103, calls them later in date than the Benson (Erickson) Madonna of 1472; *Ven. Ptg. in Amer.* (1916), pp. 21 f., dates them about 1488; *Ital. Pictures* (1932), p. 162; and *Ven. School* (1957), p. 70, pl. 137, accepts their connection with the Madonna of 1472 and with the saints in the Cleveland and Brooklyn Museums, giving a photographic reconstruction of the polyptych // G. Gronau, *Gaz. des B.-A.*, ser. 3, XIII (1895), p. 166, attributes them to the artist's middle period // G. McN. Rushforth, *Carlo Crivelli* (1900), p. 93 // *Met. Mus. Bull.*, I (1906), pp. 29 ff., ill. // L. Venturi, *Origini pitt. ven.* (1907), p. 211; and *Ital. Ptgs. in Amer.* (1933), pl. 365, connects them with the Madonna of 1472 // T. Borenius, ed., in Crowe and Cavalcaselle, *Ptg. in N. Italy* (1912), I, p. 95, note // M. H. Bernath, *New York und Boston* (1912), p. 76, fig. 79 (Saint Dominic) // B. Geiger, in Thieme-Becker, VIII (1913), p. 132, lists them among unsigned works and school pieces // A. Venturi, *Storia*, VII, part III (1914), p. 394, note 1 // L. Testi, *Storia pitt. ven.*, II (1915), p. 688 // F. Drey, *Carlo Crivelli und seine Schule* (1927), p. 141, pl. LXI, suggests a date around 1486 // R. van Marle, *Ital. Schools*, XVIII (1936), p. 60 // H. S. Francis, *Bull. of the Cleveland Mus. of Art*, XXXIX (1952), pp. 187 ff., publishes the Saint Nicholas of Bari, and accepts the connection with the polyptych of 1472 // P. Zampetti, *Carlo Crivelli nelle Marche* (1952), p. 68; and *Carlo Crivelli* (1961), pp. 75 ff., figs. 24, 28, 29, reconstructs the polyptych of 1472 // F. Zeri, *Boll. d'arte*, XXXVIII (1953), p. 241, accepts the reconstruction of the polyptych of 1472 // R. Pallucchini, *La Pittura veneta del quattrocento* (1957-1958), II, p. 17; and *Pantheon*, XIX (1961), p. 274, calls the panels part of the polyptych of 1472 // A. Bovero, *Tutta la pittura del Crivelli* (1961), p. 60, pls. 28, 30 (detail, Saint George), accepts the reconstruction of the polyptych of 1472 and observes in the Saint George some connections with Liberale da Verona's illuminations in the cathedral of Siena and with Giambono's polyptych of Saint James in the Accademia in Venice // B. Sweeny, *John G. Johnson Collection, Cat. of Ital. Ptgs.* (1966), pp. 25 f., mistakenly quotes F. Zeri (in *Arte antica e moderna*, 13/16, 1961, p. 162) as associating the polyptych of 1472 with the Pietà in the Johnson collection.

EXHIBITED: Royal Academy, London, 1884, *Old Masters*, no. 243 (lent by Lady Ashburton); New Gallery, London, 1894-1895, *Venetian Art*, no. 88 (lent by Lady Ashburton); Royal Academy, London, 1904, *Old Masters*, no. 43 (lent by the Marquis of Northampton, property of the late Lady Ashburton); Wildenstein and Co., New York, 1967, *The Italian Heritage*, no. 6 C.

EX COLL.: Cardinal Fesch, Palazzo Falconieri, Rome (until 1839; Cat., 1841, no. 2235; sale, Rome, March 24 ff., 1845, no. 1782); the Rev. Walter Davenport Bromley, Wooton Hall, Ashbourne, Derbyshire (1845-1863; sale, Christie's London, June 12-13, 1863, no. 68); [Goldsmith, 1863]; Louisa, Lady Ashburton, London (by 1871-1903; sale, Christie's, London, July 8, 1905, no. 14); [P. & D. Colnaghi and Co., London, 1905]; [Dowdeswell & Dowdeswell Ltd., London and New York, 1905].

PURCHASE, ROGERS FUND, 1905.

Saint George

05.41.2 (Plate 20)

See comment above under Saint Dominic.

Tempera on wood; tooled gold ground. H. 38, w. 13 1/4 in. (96.5 × 33.7 cm.).

REFERENCES: See above under Saint Dominic.

EXHIBITED: Royal Academy, London, 1871, *Old Masters*, no. 291 (lent by Lady Ashburton), and 1884, *Old Masters*, no. 237 (lent by Lady Ashburton); New Gallery, London, 1894-1895, *Venetian Art*, no. 86 (lent by Lady Ashburton); Royal Academy, London, 1904, *Old Masters*, no. 41 (lent by the Marquis of Northampton, property of the late Lady Ashburton); Wildenstein and Co., New York, 1967, *The Italian Heritage*, no. 6 B.

EX COLL.: Cardinal Fesch, Palazzo Falconieri, Rome (until 1839; Cat., 1841, no. 2236; sale, Rome, March 24 ff., 1845, no. 1779); the Rev. Walter Davenport Bromley, Wooton Hall, Ashbourne, Derbyshire (1845-1863; sale, Christie's, London, June 12-13, 1863, no. 66); [Farrer, London, 1863]; Louisa, Lady Ashburton, London (by 1871-1903; sale, Christie's, London, July 8, 1905, no. 13); [P. & D. Colnaghi and Co., London, 1905]; [Dowdeswell & Dowdeswell Ltd., London and New York, 1905].

PURCHASE, ROGERS FUND, 1905.

The Pietà

13.178 (Plate 21)

This painting, which is said to have come from Ascoli Piceno,[1] clearly belonged to

the upper tier of an ancona, the complex type of late Gothic altarpiece used by Crivelli almost to the end of his life. In 1476 he painted such a two-tiered altarpiece for the high altar of the church of San Domenico at Ascoli Piceno, part of which, now combined with a third tier of standing saints from another work in the same church, is in the National Gallery, London (no. 788), and is known as the Demidoff altarpiece (see F. Zeri, *Arte antica e moderna*, nos. 13/16, 1961, pp. 162 ff.). As our Pietà is very close in style to the lower-tier Demidoff panels, it was undoubtedly the central panel of the second tier of the altarpiece in its original form, placed above the Virgin and Child, with two panels of half-length saints on either side. Like the Demidoff panels, it shows in composition and dramatic tension a close link to the Paduan school and to the paintings of Giovanni Bellini. Furthermore, the embossed and gilded haloes in the Pietà are the same in type as those in the Demidoff panels. The only dissimilarity is that the tooled background in our panel has a different design from that ornamenting the ground of the nine panels of the two lower tiers in London, a discrepancy of relatively minor importance.

Tempera on wood; tooled gold ground. Over-all, h. 28 1/4, w. 25 3/8 in. (71.7 × 64.5 cm.); painted surface (arched top), h. 28, w. 25 1/8 in. (71.1 × 63.8 cm.).

1. G. Cantalamessa, in a marginal note in Rushforth's *Carlo Crivelli* (1900), in the library of the Borghese Gallery, Rome.

REFERENCES: G. Melchiorri, *L'Ape italiana delle belle arti*, II (1836), pp. 11 ff., pl. VII (engraving by N. Consoni and G. Wenzel), attributes this painting (then in the collection of Count Guido di Bisenzo in Rome) to Andrea Mantegna, stating that it came from the Barberini collection // *Kunstblatt*, no. 66, Aug. 17, 1837, p. 275, reviewing Melchiorri, suggests ascribing it to a Venetian artist rather than to Mantegna // G. F. Waagen, *Treasures-Gr. Brit.* (1854), II, p. 235, attributes it to Crivelli // G. S[charf], *Handbook to the Paintings in the Art Treasures Exhibition* (1857), p. 22, attributes it to Crivelli // W. Bürger [E. J. Thoré], *Trésors d'art exposés à Manchester en 1857* (1857), p. 69, attributes it to Crivelli // Crowe and Cavalcaselle, *Ptg. in N. Italy* (1871), I, p. 91, attribute it to Crivelli // G. Milanesi, ed., in Vasari, *Vite*, III (1878), p. 429, note, lists it among paintings doubtfully attributed to Mantegna // G. Gronau, *Gaz. des B.-A.*, ser. 3, XIII (1895), p. 166, attributes it to Crivelli // G. McN. Rushforth, *Carlo Crivelli* (1900), pp. 66 f., 94, ill. opp. p. 66, attributes it to Crivelli and dates it in his late period // L. Venturi, *Origini pitt. ven.* (1907), p. 205, attributes it to Crivelli and dates it about 1486; and *Ital. Ptgs. in Amer.* (1933), pl. 369, dates it about 1485 // B. B[urroughs], *Met. Mus. Bull.*, VIII (1913), pp. 262 f., ill., dates it about the time of the similar painting by Crivelli (1485) in the Museum of Fine Arts, Boston // A. Venturi, *Storia*, VII, part III (1914), p. 391, fig. 298, attributes it to Crivelli and notes its similarity to the Madonnas by Crivelli painted before 1480 // L. Testi, *Storia pitt. ven.*, II (1915), pp. 640, 679, ill. p. 641, attributes it to Crivelli and dates it about 1485 // B. Berenson, *Ven. Ptg. in Amer.* (1916), p. 23, fig. 13, attributes it to Crivelli and notes a certain link with Giovanni Bellini's Pietà in the Brera in Milan; *Ital. Pictures* (1932), p. 162; and *Ven. School* (1957), p. 70 // F. Drey, *Carlo Crivelli und seine Schule* (1927), pp. 73, 139, pl. LIII, attributes it to Crivelli and dates it before 1486 // R. van Marle, *Ital. Schools*, XVIII (1936), pp. 40 f., fig. 29, attributes it to Crivelli, dates it around 1486, and accepts Berenson's hypothesis of a connection with Bellini's Pietà in the Brera // P. Zampetti, *Carlo Crivelli nelle Marche* (1952), p. 68, attributes it to Crivelli; and *Carlo Crivelli* (1961), pp. 34, 83, figs. 75, 74 (drawing, reconstruction of the polyptych), accepts Pallucchini's hypothesis (see below) that this panel was once part of the altarpiece from the church of San Domenico in Ascoli Piceno, now included in the so-called Demidoff altarpiece // R. Pallucchini, *La Pittura veneziana del quattrocento* (1957-1958), II, pp. 25 f., attributes this painting to Crivelli and considers it part of the Demidoff altarpiece, stating that it was originally placed above the central panel of the Madonna and Child; and *Pantheon*, XIX (1961), p. 278, calls it part of the Demidoff altarpiece of 1476 // A. Bovero, *Tutta la pittura del Crivelli* (1961), p. 67, pl. 65, attributes it to Crivelli, suggesting that originally it was placed above the Madonna and Child in the Demidoff altarpiece, even though the tooling of the gold ground is somewhat different // E. Hüttinger, *Artis*, XIII (June, 1961), p. 21, fig. 2, dates it about 1485, attributing it to Crivelli // J. F. Omelia (unpublished thesis, 1961), pp. 28 ff., 96, attributes it to Crivelli and considers it part of the Demidoff altarpiece from San Domenico in Ascoli Piceno, notes that Cola dell'Amatrice used elements from the Demidoff altarpiece and our Pietà in a polyptych dated 1509 in the Civica Pinacoteca at Ascoli, thus confirming the origin of our Pietà.

EXHIBITED: Manchester, 1857, *Art Treasures*, no.

94 (lent by Lord Ward); Royal Academy, London, 1871, *Old Masters*, no. 318; and 1892, *Old Masters*, no. 150 (lent by the Earl of Dudley); New Gallery, London, 1894-1895, *Venetian Art*, no. 87 (lent by Robert Crawshay); Castel Sant'Angelo, Rome, 1911-1912, *Esposizione Internazionale di Roma, Mostra Retrospettiva*, p. 194 (lent by Robert Crawshay); Museum zu Allerheiligen, Schaffhausen, 1953, *500 Jahre venezianische Malerei*, no. 13; Rijksmuseum, Amsterdam, 1953, *500 Jahre venezianische Malerei*, no. 13.

PROVENANCE: the church of San Domenico, Ascoli Piceno (?).

EX COLL.: Barberini, Rome (?); Count Guido di Bisenzo, Rome (by 1836-1844, as Mantegna); William Ward, 1st Earl of Dudley, London (1847-1885); William Humble Ward, 2nd Earl of Dudley, London (1885-1892; sale, Christie's, London, June 25, 1892, no. 58); Robert Crawshay, Rome (1892-1913); [Sulley and Co., London, 1913].

PURCHASE, KENNEDY FUND, 1913.

The Madonna and Child
49.7.5 (Plate 22)

This small panel is one of Crivelli's most important and characteristic works. It is executed with the delicacy of a miniature, and the perfect condition of its surface reveals its exquisite quality. The sharp, faultless design, the brilliant colors, and the type of the Madonna and Child suggest a date in the artist's middle period, probably at the beginning of the 1480's. The figures are realistically presented in relation to the landscape background, but the objects near them, the fruit, the fly on the marble parapet, and the strings of the curtain, are outsize, and create the atmosphere of an imaginary world. The haloes, disks of gold set with pearls and cabochon jewels, and the richly ornamented costume give a delicate and precious effect. The picture contains a number of symbols of sin and redemption. The apples in the garland probably allude to original sin, and the cucumber to the story of Jonah (iv:6), which has been linked with the Resurrection since early times. The large fly, representing evil or the devil, is opposed by the goldfinch, a symbol of the Passion, which the infant Christ clutches. This picture can probably be identified with the Madonna and Child recorded in 1790 in the collection of Pier Giovanni Lenti at Ascoli Piceno, which was reported to have borne the same signature (see Refs., B. Orsini, 1790).

Signed (at lower center): OPVS.KAROLI.CRIVELLI.VENETI.

Tempera and gold on wood. Over-all size, h. 14 7/8, w. 10 in. (37.8 × 25.4 cm.); painted surface, h. 14 3/8, w. 9 1/4 in. (36.5 × 23.5 cm.).

REFERENCES: The authorities cited below attribute this painting to Crivelli. B. Orsini, *Descrizione delle pitture, sculture, architetture ... della ... città di Ascoli nelle Marche* (1790), p. 70, mentions a Madonna and Child in the Lenti collection at Ascoli Piceno bearing the same signature as ours // A. Ricci. *Memorie storiche delle Arti e degli Artisti della Marca di Ancona* (1834), I, p. 226, note 11, quotes Orsini's mention of the Madonna in the Lenti collection // G. F. Waagen, *Treasures-Gr. Brit.* (1857), IV, p. 95 // Crowe and Cavalcalselle, *Ptg. in N. Italy*, I (1871), p. 92, compare it with the Madonna now in the Ancona Museum // W. H. J. Weale and J. P. Richter, *Pictures Belonging to the Earl of Northbrook* (1889), p. 126, no. 174, call it one of his earliest works, close to his Virgin and Child in the Verona Gallery // C. J. Ffoulkes, *Arch. stor. dell'arte*, VII (1894), p. 264, calls it an early work // G. Gronau, *Gaz. des B.-A.*, ser. 3, XIII (1895), p. 165, ill. opp. p. 254, dates it shortly after 1480 // G. McN. Rushforth, *Carlo Crivelli* (1900), pp. 44, 95, ill. opp. p. 44, calls it an early work, shortly after the Madonna at Ancona // L. Venturi, *Origini pitt. ven.* (1907), pp. 195 ff.; and *Ital. Ptgs. in Amer.* (1933), p. 363 // T. Borenius, ed., in Crowe and Cavalcaselle, *Ptg. in N. Italy* (1912), I, pp. 85, note, 92, note, calls it an early work // B. Berenson, *Study and Criticism*, I (1912), p. 102, compares it with the Madonna of 1470 in the Museum of Macerata; *Ven. Ptg. in Amer.* (1916), pp. 20 f., dates it about 1476-1482; *Ital. Pictures* (1932), p. 162; *Ven. Ptrs.* (1932), p. 106; and *Ven. School* (1957), p. 70 // A. Venturi, *Storia*, VII, part III (1914), p. 376, fig. 288, dates it shortly before 1476 // L. Testi, *Storia pitt. ven.*, II (1915), pp. 623 f., ill., dates it about 1474 // F. Drey, *Carlo Crivelli und seine Schule* (1927), pp. 128 ff., pl. 25, tentatively identifies it with the painting mentioned by Orsini and Ricci and dates it shortly after 1472 // E. Siple, *Burl. Mag.*, LI (1927), p. 298, dates it between 1470 and 1480 // A. L. Mayer, *Pantheon*, VI (1930), p. 542 // C. J. Holmes, *Burl. Mag.*, LVI (1930), p. 62, ill. opp. p. 551 // H. E. Wortham, *Apollo*, XI (1930), p. 354, ill. (in color) // R. van Marle,

Ital. Schools, XVIII (1936), pp. 8, 10, dates it in the early period of the artist about the time of the Madonna at Ancona // F. J. Mather, *Venetian Painters* (1936), pp. 137 f., fig. 37 // *Duveen Pictures* (1941), pl. 68 // H.B. Wehle, *Met. Mus. Bull.*, n.s., I (1943), p. 285, ill. p. 287 // H. Friedmann, *The Symbolic Goldfinch* (1946), pp. 26 f., 157, pl. 99 (detail) // R. Pallucchini, *Arte veneta*, V (1951), p. 221, fig. 215 (detail) // *Art Treasures of the Metropolitan* (1952), p. 224, pl. 79 (in color) // P. Zampetti, *Carlo Crivelli nelle Marche* (1952), p. 68, no. 81, tentatively identifies it with the picture once in the Lenti collection at Ascoli Piceno, notes its similarity with the Madonna and Child in Ancona, but considers it slightly earlier; and *Carlo Crivelli* (1961), pp. 36, 82 f., figs. 68, 69 (detail), identifies it with the picture formerly in the Lenti collection and dates it about 1474 // A. Bovero, *Tutta la pittura del Crivelli* (1961), p. 72, pl. 86, tentatively identifies it with the Lenti Madonna and dates it about the time of the triptych of 1482 in the Brera in Milan // G. Mariacher, *Acropoli*, II (1961-1962), pp. 40, 45 f., fig. 26, dates it close to the Madonnina Lochis in Bergamo, about 1480 // A. Pigler, *Bulletin du Musée Hongrois des Beaux-Arts*, XXIV (1964), p. 50, fig. 38, discusses the iconographical meaning of the fly painted on the marble parapet, and cites other examples of the same theme.

EXHIBITED: Royal Academy, London, 1872, *Old Masters*, no. 235 (lent by the Earl of Northbrook); and 1894, *Old Masters*, no. 153 (lent by the Earl of Northbrook); New Gallery, London, 1894-1895, *Venetian Art*, no. 42 (lent by the Earl of Northbrook); Burlington Fine Arts Club, London, 1912, *Pictures of the Early Venetian School*, no. 14 (lent by the Earl of Northbrook); Royal Academy, London, 1930, *Italian Art*, no. 201 (lent by Jules S. Bache); Petit Palais, Paris, 1935, *L'Art Italien*, no. 132 (lent by Jules S. Bache); Cleveland Museum of Art, 1936, *Twentieth Anniversary Exhibition*, no. 122 (lent by Jules S. Bache); World's Fair, New York, 1939, *Masterpieces of Art*, no. 64 (lent by Jules S. Bache); Metropolitan Museum, New York, 1943, *The Bache Collection*, no. 5 (lent by Jules S. Bache); Worcester Art Museum, Worcester, Massachusetts, 1951, *Condition: Excellent*, no. 10; Metropolitan Museum, New York, 1952-1953, *Art Treasures of the Metropolitan*, no. 79.

EX COLL.: Pier Giovanni Lenti, Ascoli Piceno (?) (by 1790); William Jones, Clytha, North Wales (sale, Christie's, London, May 8, 1852, no. 103); [Farrer, London, 1852]; 1st Earl of Northbrook, Stratton Park, Hants. (by 1854-1904; Cat., 1885, p. 4); 2nd Earl of Northbrook, Stratton Park, Hants. (1904-1927); [Duveen Brothers, London and New York, 1927]; Jules S. Bache, New York (1927-1944; Cat., 1929, no. 5).

THE JULES S. BACHE COLLECTION, 1949.

Gasparo Diziani

Born 1689; died 1767. Gasparo Diziani was the pupil of Gregorio Lazzarini and was influenced by Sebastiano Ricci. He made many ceiling decorations in Venice; he also worked in Rome and Dresden and spent some time in Russia.

Dawn (ceiling decoration)
06.1335.1 (Plate 24)

This decoration has been installed by the Museum in the room for which it was originally painted, a sumptuous bedroom from the Palazzo Sagredo in Venice. It is surrounded by a rich stucco decoration, without doubt the work of the artisans Abbondio Stazio and Carpoforo Mazzetti-Tencalla, who were employed by Zaccaria Sagredo to redecorate the Palazzo. The allegorical figure of Dawn, surrounded by cupids, is shown rising in the center; at the right is the dark figure of Night pouring dew from a jug. The style of the painting shows the pronounced influence of Sebastiano Ricci.

Oil on canvas. H. 78, w. 94 1/2 in. (198.1 × 240 cm.).

REFERENCES: G. Fiocco (in a letter, 1926) attributes this painting tentatively to Gasparo Diziani // P. Remington, *Met. Mus. Bull.*, XXI (1926), Apr., sect. II, p. 14, attributes it to Diziani // G. Mariacher, *Arte e Artisti dei Laghi Lombardi*, II (1964), p. 83, notes that the stucco decoration of the Palazzo Sagredo was executed in 1718 by Abbondio Stazio and Carpoforo Mazzetti-Tencalla, whose signatures appear in a room above the one where the bedroom was originally // A. P. Zugni-Tauro, *Gaspare Diziani* [1972], pp. 79 f., pl. 217, accepts Fiocco's attribution to Diziani and dates the painting between 1755 and 1760.

PROVENANCE: Palazzo Sagredo, Venice.

EX COLL.: the Sagredo family, Venice (about 1718-1906); [Antonio Carrer, Venice, 1906].

PURCHASE, ROGERS FUND, 1906.

Michele Giambono

Real name Michele Giovanni Bono. Known activity 1420-1462. It is evident from Giambono's signed panels in the National Gallery in Rome and in the Accademia in Venice, as well as others that can be related to them, that he was a painter working in the international Gothic style. His works show the influence of his fellow Venetian Jacobello del Fiore, the Umbrian painter Gentile da Fabriano, and possibly Pisanello. Giambono was not only a painter; he also decorated frames and wood scupture in gold and polychromy and worked in mosaic, as in the cycle illustrating the life of the Virgin in the Mascoli chapel in San Marco, Venice, begun by him in 1444 and completed by other artists.

The Man of Sorrows
06.180 (Plate 23)

Behind the sarcophagus is a small figure of Saint Francis receiving the stigmata, which come directly from the wounds of Christ rather than from the usual flying seraphic figure. The influence of Gentile da Fabriano is particularly pronounced in this panel, suggesting that the artist painted it early in his career. A similar panel in the Emo Capodilista collection in the Museo Civico in Padua (no. 6) was painted by Giambono at a later time and lacks the figure of Saint Francis.

Tempera on wood; embossed blood and crown of thorns, incised wounds. Over-all size, h. 21 5/8, w. 15 1/4 in. (54.9 × 38.8 cm.); painted surface, h. 18 1/2, w. 12 1/4 in. (47 × 31.1 cm.).

REFERENCES: W. Rankin, *Rass. d'arte*, VIII (1908), no. 3, cronaca, p. iv, attributes this painting to Giambono // L. Testi, *Rass. d'arte*, XI (1911), pp. 93 f., ill., hesitantly attributes it to Giambono; *Rass. d'arte*, XIII (1913), no. 2, cronaca, pp. iii ff.; and *Storia pitt. ven.*, II (1915), pp. 29, 34 f., ill., attributes it to Giambono // R. Fry, *Burl. Mag.*, XX (1912), p. 352, attributes it to Giambono // T. Borenius, ed., in Crowe and Cavalcaselle, *Ptg. in N. Italy*, I (1912), p. 15, note, attributes it to Giambono // L. V[enturi], *L'Arte*, XV (1912), p. 400, considers it an imitation of the panel in Padua // B. Berenson, *Ven. Ptg. in Amer.* (1916), pp. 5 f., note, attributes it to a contemporary of Giambono in Ancona or elsewhere in the Marches; and *Ven. School* (1957), p. 82, lists it as a work by Giambono // G. Fiocco, *Venezia, Rass. d'arte e storia*, I (1920), pp. 9 ff., ill., as Giambono // R. van Marle, *Ital. Schools*, VII (1926), p. 363, attributes it to Giambono and notes the influence of Gentile da Fabriano // R. Offner (verbally, 1935) attributes it to Giambono // E. Sandberg-Vavalà, *Journal of the Warburg and Courtauld Institutes*, X (1947), pp. 21, note 6, 24, attributes it to Giambono // L. Coletti, *Arte veneta*, V (1951), p. 97, hesitantly suggests an attribution to Antonio Orsini.

EX COLL.: Signora Alba (Albina) Barbato di Naduri, Naples (until 1906).

PURCHASE, ROGERS FUND, 1906.

Jacopo Guarana

Jacopo Guarana. Born 1720; died 1808. Guarana studied first under Sebastiano Ricci. Later he became one of the principal followers of Giovanni Battista Tiepolo and assisted him in numerous decorations, including the ceiling in the Villa Pisani in Strà. Among his best works are those in the Palazzo Rezzonico in Venice and in San Vitale (1782) in Ravenna.

The Crowning with Thorns
71.30 (Plate 25)

Oil on canvas. H. 30 5/8, w. 34 1/4 in. (77.7 × 87 cm.).

This painting is a careful copy after the original by Giovanni Battista Tiepolo in the Kunsthalle in Hamburg (no. 644), a work that was repeated in a number of different versions by members of his school. The Museum's example is evidently by Jacopo Guarana, whose abbreviated signature appears on it. Another version of exactly the same size as ours was in the Douine collection (sale, Charpentier, Paris, April 11, 1946, no. 38, as Domenico Tiepolo), but it is uncertain whether it was by Guarana or some other minor follower of Giovanni Battista Tiepolo.

Formerly attributed by the Museum to Giovanni Battista Tiepolo.

Signed (lower right, on slab): GVARA.F.

REFERENCES: F. Harck, *Repert. für Kstwiss.*, XI (1888), p. 73, attributes this painting to Giovanni Battista Tiepolo // B. Berenson, *Ven. Ptrs.* (1897), p. 128, lists it as a work of Giovanni Battista Tiepolo // E. Sack, *Giambattista und Domenico Tiepolo* (1910), pp. 121, 227, no. 556, attributes it to Giovanni Battista Tiepolo and mentions a replica of it in the Seeger collection, Berlin // M. H. Bernath, *New York und Boston* (1912), p. 85, attributes it to Giovanni Battista Tiepolo // J. Breck, *Art in Amer.*, I (1913), p. 12, ill., attributes it to Giovanni Battista Tiepolo // A. McComb, *Baroque Ptrs. of Italy* (1934), p. 127, attributes it to Giovanni Battista Tiepolo // M. Goering (in letters, 1938) notes in it stylistic similarities to the works of Domenico Tiepolo // A. Morassi, *A Complete Catalogue of the Paintings of G. B. Tiepolo* (1962), p. 34, rejects the attribution to Tiepolo and calls it the work of Jacopo Guarana or some other follower of Tiepolo.

EX COLL. the Duchess of Berry, Palazzo Vendramin-Calergi, Venice (until 1870).

PURCHASE, 1871.

Francesco Guardi

Born 1712; died 1793. Guardi, born in Venice of a noble family from Trent, was first trained as a painter in the studio of his elder brother Gianantonio (1698-1760), with whom he collaborated, mostly on figure paintings. The extent of Francesco's contributions to their joint works has not yet been determined, and only in the pictures he painted after the death of Gianantonio does his individual personality as an artist emerge. In 1764

Gradenigo stated that Guardi was a pupil of Canaletto, and his style also shows the influence of his brother-in-law, Giovanni Battista Tiepolo, of Sebastiano Ricci, and possibly Pietro Longhi. Although Guardi painted imaginary landscapes with ruins, marines, figure pieces, and portraits, he is famous primarily for his views of Venice. The dating of his works is difficult because there is little documentary evidence, and because of the many versions, both forgeries and originals, in which his compositions are known. Guardi was not highly regarded by his contemporaries, who considered him a mere follower of Canaletto, and he was not admitted to the Academy until he was seventy-two years old. From the little that is known about his life he seems to have been employed principally by Englishmen living in Venice, among them the picture-restorer Peter Edwards, for whom he painted four scenes recording the festivities held in honor of the visit of Pope Pius VI to Venice in 1782. Although Guardi's style closely follows the rococo formula, he has, in recent times, been considered an innovator, and a forerunner of nineteenth-century impressionism.

Venice: the Grand Canal above the Rialto

71.119 (Plate 26)

This is a view of the Grand Canal showing the bridge of the Rialto with the Palazzo dei Camerlenghi and the Erberia (vegetable market) on the right. It is a pendant to the view of Santa Maria della Salute (see below). In composition it is closely connected with paintings by Canaletto, especially one in the Pillow collection in Montreal; other similar views by Canaletto are at Windsor Castle (engraved by Visentini, s. I.7) and in the collection of the Duke of Richmond and Gordon. Guardi repeated this composition in a signed and much larger canvas now in the collection of the Earl of Iveagh, who also owns a companion to it, a view of the Grand Canal below the Rialto. The Iveagh version of our composition is very likely the one that, according to Gradenigo's diary, was exhibited by Guardi in the Piazza San Marco on April 24, 1764.[1] A version of inferior quality was in the Greve collection (sale, Lepke's, Berlin, October 12-13, 1909). There is a large preparatory drawing connected with our painting that has been cut in two parts; one half is in the Musée Bonnat in Bayonne, the other in the Print Room in Berlin (see Refs., J. Byam Shaw, 1951, pls. XII, XIII). The style of our painting shows clearly the characteristics of Guardi's early period.

Signed (lower left): Fran co De' Guardi.

Inscribed on reverse, upper left: Vuduta del Sante di Rialto / in Venezia / del Guardi.

Oil on canvas. H. 21, w. 33 3/4 in. (53.3 × 85.7 cm.).

1. P. Gradenigo, *Notizie d'Arte* (1942), p. 15.

REFERENCES: The authorities cited below attribute this painting to Guardi. F. Harck, *Repert. für Kstwiss.*, XI (1888), p. 73 // B. Berenson, *Gaz. des B.-A.*, ser. 3, XV (1896), p. 199; and *Ven. Ptrs.* (1897), p. 102 // G. A. Simonson, *Francesco Guardi* (1904), pp. 16, 93, no. 171, ill. opp. p. 14 // J. Byam Shaw, *The Drawings of Francesco Guardi* (1951), pp. 20, 60, connects this painting with the drawings in Bayonne and Berlin and suggests that it might be one of the two pictures exhibited in the Piazza San Marco in 1764; and *Burl. Mag.*, XCVII (1955), p. 15, note 5, connects it with the picture in the collection of the Earl of Iveagh, considering it more likely that the Iveagh picture was the one exhibited in the Piazza San Marco in 1764, mentions the version formerly in the Greve collection, and suggests that the pendant to our picture might be the signed view of the Grand Canal below the Rialto now in the Gulbenkian collection // V. Moschini, *Francesco Guardi* (1952), p. 18, notes the close relationship to similar views by Canaletto // *Art Treasures of the Metropolitan* (1952), p. 231, pl. 132 (in color) // R. Pallucchini, *Arte veneta*, XIX (1965), p. 231 // A. Morassi, *I Guardi* (1973), pp. 41, 233 f., no. 554, fig. 530, suggests that it may have been commissioned by a foreigner, and dates it about 1760-1765.

EXHIBITED: Metropolitan Museum, New York,

1952-1953, *Art Treasures of the Metropolitan*, no. 132; Palazzo Grassi, Venice, 1965, *Mostra dei Guardi*, no. 88; Museum of Fine Arts, Boston, 1970, *Masterpieces of Painting in The Metropolitan Museum of Art* (Cat., p. 32).

EX COLL.: the Earls of Shaftesbury, St. Giles' House, Wimborne, Dorset; Count Cornet, Brussels.

PURCHASE, 1871.

Venice: Santa Maria della Salute
71.120 (Plate 27)

The Seminario Patriarcale and part of the Dogana are to be seen at the left in this view of Santa Maria della Salute from across the Grand Canal. The picture, like its pendant, is an early work by Guardi. It should be noted that this is not the subject that he usually chose for companion pieces to his other versions of the Grand Canal above the Rialto (see comment above).

Inscribed on reverse, upper left: dalla / Veduta Salute in Venezia / del F.ᶜᵒ Guardi.

Oil on canvas. H. 21, w. 33 3/4 in. (53.3 × 85.7 cm.).

REFERENCES: The authorities cited below attribute this painting to Guardi. F. Harck, *Repert. für Kstwiss.*, XI (1888), p. 73 // B. Berenson, *Gaz. des B.-A.*, ser. 3, XV (1896), p. 199; and *Ven. Ptrs.* (1897), p. 102 // G. A. Simonson, *Francesco Guardi* (1904), p. 93, no. 170 // J. Byam Shaw, *Burl. Mag.*, XCVII (1955), p. 15, note 5 // A. Morassi, *I Guardi* (1973), pp. 243, 398, no. 465, fig. 471, dates it in Guardi's mature period, about 1760-1765.

EXHIBITED: Detroit Institute of Arts, 1951; Art Gallery of Toronto, 1951; City Art Museum, St. Louis, 1952; Seattle Art Museum, 1952.

EX COLL.: the Earls of Shaftesbury, St. Giles' House, Wimborne, Dorset; Count Cornet, Brussels.

PURCHASE, 1871.

Landscape
35.40.3 (Plate 28)

This small painting and the following one

are of the type of imaginative landscape (*capriccio*) painted by Guardi during the later period of his life. The extensive number of similar works scattered in private collections and museums in Europe and America raises the question whether such small decorative paintings in which the style is somewhat mannered are indeed by Guardi or by pupils and assistants working with him. Our knowledge of Guardi's workshop and of the apportionment of work there is very limited. However, the good quality and lively execution of these two landscapes, along with certain technical characteristics, seem to indicate Guardi's own hand.

Formerly attributed by the Museum to the workshop of Guardi.

Oil on paper, mounted on canvas; oval. H. 6 1/4, w. 4 3/4 in. (15.8 × 12.1 cm.).

REFERENCES: H. B. W[ehle], *Met. Mus. Bull.*, XXX (1935), p. 91 // A. Morassi, *I Guardi* (1973), p. 496, nos. 1007, 1006, figs. 905, 904, agrees with the attribution to Guardi.

EX COLL. Mrs. Cooper Hewitt, New York.

BEQUEST OF LUCY WORK HEWITT, 1935.

Landscape
35.40.4 (Plate 29)

See comment above under Landscape.

Oil on paper, mounted on canvas; oval. H. 6 1/4, w. 4 3/4 in. (15.8 × 12.1 cm.).

REFERENCE: See above under Landscape.

EX COLL. Mrs. Cooper Hewitt, New York.

BEQUEST OF LUCY WORK HEWITT, 1935.

Fantastic Landscape
41.80 (Plates 30, 31)

This picture and the two following, which are among Guardi's finest achievements in landscape painting, came from the castle of

Colloredo, near Udine, in the region of Friuli, where they were installed in a *salotto*, or drawing room, added to the castle in the eighteenth century. The paintings do not, however, appear to have been designed for this room, and the circumstances surrounding the commission are unknown. The style suggests a date in the 1760's. Close examination of the pictures and a study of their composition show that changes were made in all three, either during their execution or slightly later. A section was added at the top of the large painting, following more or less the original outline but making it considerably taller. This addition was almost certainly filled in by Guardi himself, although in places, especially along the right side, there is a certain roughness, suggesting the hand of a pupil or imitator. The smaller paintings show more extensive changes. Besides additions at the top, roughly preserving the original shape, both of them have added strips at the bottom, and Guardi introduced various figures and landscape elements to conceal the seams. A much smaller (16 × 32 1/4 in.) rectangular version by Guardi of the large landscape, which differs only in minor details from the Museum's picture, appeared in the James Speyer sale (Parke-Bernet, New York, April 10, 1942, no. 18), and subsequently in the Gustave Pierre Bader sale (Kende Gallery, New York, Dec. 11, 1942, no. 264). It had a companion piece, a fantastic landscape with an obelisk, which had no connection with our smaller landscapes.

Oil on canvas. H. 61 1/4, w. 107 1/2 in. (155.5 × 273 cm.).

REFERENCES: The authorities cited below attribute this painting to Guardi. D. Mantovani, *Italia Artistica e Industriale*, I (1893-1894), no. 6, pp. 9 ff., ill. p. 10 // G. A. Simonson, *Art in Amer.*, II (1914), p. 99, note I // G. Fraenckel, in Thieme-Becker, XV (1922), p. 170 // G. Fiocco, *Francesco Guardi* (1923), pp. 45, 68, 73 f., no. 93, pl. LXXX // M. Tinti, *Guardi* (1930), pl. LVI // V. N. Lazarev, *Burl. Mag.*, LXV (1934), p. 68, tentatively dates the series in the 1760's // H. B. Wehle, *Met. Mus. Bull.*, XXXVI (1941), pp. 153 ff., ill. // M. Goering, *Francesco Guardi* (1944), p. 49, pl. 94, dates it be-

tween 1765 and 1776 // V. Moschini, *Francesco Guardi* (1952), pl. 116 // C. Donzelli, *I Pittori veneti del settecento* (1957), p. 109 // F. Haskell, *Journal of the Warburg and Courtauld Institutes*, XXIII (1960), p. 265, suggests that the three paintings were executed in 1782 // R. Pallucchini, *La Pittura veneziana del settecento* (1960), p. 245, pl. 641, dates the series in the seventh decade of the XVIII century; and *Arte veneta*, XIX (1965), pp. 227, 234, dates this painting in the 1780's // A. Morassi, *I Guardi* (1973), pp. 272, 279, 481, no. 924, figs. 817, 818 (det.), 820 (det.), 822 (det.), dates the three paintings between 1775 and 1780, perhaps 1782 as suggested by Haskell.

EXHIBITED: Benjamin Altman Gallery, New York, 1915, *Loan Exhibition of Fifty-Nine Masterpieces of Ancient and Modern Schools*, no. 24 (as a View along the Adriatic Coast, lent by Mr. Charles B. Alexander); Palazzo Grassi, Venice, 1965, *Mostra dei Guardi*, no. 121.

PROVENANCE: Castello di Colloredo, near Udine, Alto Friuli.

EX COLL.: the Colloredo family, Castello di Colloredo; Count Camillo di Colloredo Mels, Castello di Colloredo (until about 1906); [Steinmeyer, Cologne, about 1906]; [Stefan Bourgeois, Cologne, about 1910]; [Trotti, Paris]; Baron Maurice de Rothschild, Paris; [Gimpel and Wildenstein, Paris and New York, 1912]; Mrs. Charles B. Alexander, New York (1912-1941); Mrs. Arnold Whitridge, Mrs. Winthrop W. Aldrich, Mrs. Sheldon Whitehouse, New York (1941).

PURCHASE, ROGERS FUND, 1941.

Fantastic Landscape

53.225.3 (Plate 32)

For comment see above.

Oil on canvas. H. 61 1/4, w. 74 1/2 in. (155.5 × 189.2 cm.).

REFERENCES: The authorities cited below attribute this painting to Francesco Guardi. D. Mantovani, *Italia Artistica e Industriale*, I (1893-1894), no. 6, pp. 9 ff. // G. A. Simonson, *Art in Amer.*, II (1914), p. 99, note I // G. Fraenckel, in Thieme-Becker, XV (1922), p. 170 // G. Fiocco, *Francesco Guardi* (1923), pp. 45, 68, 73 f., no. 92, pl. LXXIX // M. Tinti, *Guardi* (1930), pl. LIV // V. N. Lazarev, *Burl. Mag.*, LXV (1934), p. 68, tentatively dates the series in the 1760's // H. B. Wehle, *Met. Mus. Bull.*, XXXVI (1941), p. 153 ff. // M. Goering, *Francesco Guardi* (1944), p. 49 // V. Moschini, *Francesco Guardi* (1952), pl. 117 // C. Donzelli, *I Pittori veneti*

del settecento (1957), p. 109 // F. Haskell, *Journal of the Warburg and Courtauld Institutes*, XXIII (1960), p. 265, suggests that the three paintings were executed in 1782 // R. Pallucchini, *La Pittura veneziana del settecento* (1960), p. 245, dates the series in the seventh decade of the XVIII century // A. Morassi, *I Guardi* (1973), pp. 272, 279, 480, no. 923, fig. 821, dates the three paintings between 1775 and 1780, perhaps 1782 as suggested by Haskell.

PROVENANCE: Castello di Colloredo, near Udine, Alto Friuli.

EX COLL.: the Colloredo family, Castello di Colloredo; Count Camillo di Colloredo Mels, Castello di Colloredo (until about 1906); [Steinmeyer, Cologne, about 1906]; [Stefan Bourgeois, Cologne, about 1910]; [Trotti, Paris]; Baron Maurice de Rothschild, Paris; [Gimpel and Wildenstein, Paris and New York, 1912]; Edward J. Berwind, New York and Newport (1913-1936); Julia A. Berwind, Newport (1936-1953).

GIFT OF JULIA A. BERWIND, 1953.

Fantastic Landscape
53.225.4 (Plate 33)

For comment see above.

Oil on canvas. H. 61 1/4, w. 74 1/2 in. (155.5 × 189.2 cm.).

REFERENCES: The authorities cited below attribute this painting to Francesco Guardi. D. Mantovani, *Italia Artistica e Industriale*, I (1893-1894), no. 6, pp. 9 ff. // G. A. Simonson, *Art in Amer.*, II (1914), p. 99, note 1 // G. Fraenckel, in Thieme-Becker, XV (1922), p. 170 // G. Fiocco, *Francesco Guardi* (1923), pp. 45, 68, 73 f., no. 94, pl. LXXXI // M. Tinti, *Guardi* (1930), pl. LV // V. N. Lazarev, *Burl. Mag.*, LXV (1934), p. 68, tentatively dates the series in the 1760's // H. B. Wehle, *Met. Mus. Bull.*, XXXVI (1941), pp. 153 ff. // M. Goering, *Francesco Guardi* (1944), p. 49 // V. Moschini, *Francesco Guardi* (1952), pl. 118 // C. Donzelli, *I Pittori veneti del settecento* (1957), p. 109 // F. Haskell, *Journal of the Warburg and Courtauld Institutes*, XXIII (1960), p. 265, suggests that the three paintings were executed in 1782 // R. Pallucchini, *La Pittura veneziana del settecento* (1960), p. 245, dates the series in the seventh decade of the XVIII century // A. Morassi, *I Guardi* (1973), pp. 272, 279, no. 925, fig. 819, dates the three paintings between 1775 and 1780, perhaps 1782 as suggested by Haskell.

PROVENANCE: Castello di Colloredo, near Udine, Alto Friuli.

EX COLL.: the Colloredo family, Castello di Colloredo; Count Camillo di Colloredo Mels, Castello di Colloredo (until about 1906); [Steinmeyer, Cologne, about 1906]; [Stefan Bourgeois, Cologne, about 1910]; [Trotti, Paris]; Baron Maurice de Rothschild, Paris; [Gimpel and Wildenstein, Paris and New York, 1912]; Edward J. Berwind, New York and Newport (1913-1936); Julia A. Berwind, Newport (1936-1953).

GIFT OF JULIA A. BERWIND, 1953.

Venice: Piazza San Marco
50.145.21 (Plate 34)

This view of the Piazza San Marco is known in several versions, including one in the National Gallery, London, and one in the Accademia Carrara in Bergamo (see V. Moschini, *Francesco Guardi*, 1952, pls. 66, 73). The light, clear colors, unaltered by time, and the figure types combine to suggest a date in the 1750's. The composition is undoubtedly based on one or more prototypes by Canaletto. When our picture was in the Castletown collection it had a pendant, also signed, representing the Piazzetta; the present whereabouts of this picture is unknown.

Signed (on painting held by man in lower right corner): *Fran^co / Guardi*

Oil on canvas. H. 27 1/8, w. 33 3/4 in. (68.9 × 85.7 cm.).

REFERENCES: The authorities cited below attribute this painting to Guardi. G. A. Simonson, *Francesco Guardi* (1904), p. 98, mentions this picture and its companion, the Piazzetta, signed F. G.; and *Burl. Mag.*, XXV (1914), p. 267 // H. B. W[ehle], *Met. Mus. Bull.*, XXVIII (1933), p. 12 // *Met. Mus. Bull.*, n.s., X (1951), p. 69, ill. // A. Morassi, *Arte veneta*, VII (1953), p. 61, dates it about 1750, comparing it with the version in the National Gallery, London and *I Guardi* (1973), p. 370, no. 317, figs. 343, 344 (det.) // T. Rousseau, *Met. Mus. Bull.*, n.s., XII (1954), Jan., part. II, p. 40, ill. // R. Pallucchini, *Arte veneta*, XIX (1965), p. 230, dates it about 1760.

EXHIBITED: British Institution, London, 1844, no. 75 (lent by John Wilson Fitzpatrick); Royal Academy, London, 1884, *Old Masters*, no. 175 (lent by Dowager Lady Castletown of Upper Ossory); Metropolitan Museum, New York, 1934, *Landscape*

Paintings, no. 10 (lent by Edward S. Harkness); Detroit Institute of Arts, 1952, *Venice 1700-1800*, no. 25; Herron Museum of Art, Indianapolis, Indiana, 1952, *Venice 1700-1800*, no. 25; Allentown Art Museum, Allentown, Pennsylvania, 1971, *The Circle of Canaletto*, no. 22.

EX COLL.: John Wilson Fitzpatrick, 1st Lord Castletown of Upper Ossory (by 1844-1883); Augusta, Dowager Lady Castletown of Upper Ossory (1883-1899); Bernard Edward Barnaby Fitzpatrick, 2nd Lord Castletown of Upper Ossory (1899-1924; sale, Christie's, London, July 18, 1924, no. 144); [Smith, London, 1924]; [M. Knoedler and Co., New York, 1924-1925]; Edward S. Harkness, New York (1925-1940); Mrs. Edward S. Harkness, New York (1940-1950).

BEQUEST OF MARY STILLMAN HARKNESS, 1950.

Venice from the Sea
65.181.8 (Plate 35)

This panorama of Venice seen from the island of San Giorgio Maggiore shows the Molo, the Doge's palace, and the Riva degli Schiavoni. In the foreground are numerous boats and gondolas, while near the Doge's palace is the large galley in which criminals served their sentences, and which was also used during certain public ceremonies.

This same view was repeated by Guardi in a number of other versions, differing only in size, and in certain details in the foreground. Among these the one at Waddesdon Manor, Hertfordshire, has a pendant showing the view from San Giorgio Maggiore toward the church of Santa Maria della Salute. It is larger than ours (112 × 167 in.) and is probably the largest view of Venice that Guardi ever painted. A similar view (47 1/2 × 79 in.) was formerly in the Musée des Beaux-Arts in Strasbourg but was destroyed during World War II. The foreground of the Strasbourg picture was very like the foreground of the Waddesdon view, although in a different perspective. A third version (25 × 37 5/8 in.) was formerly in the collection of Captain H. E. Rimington-Wilson in London and belongs now to the National Gallery of Ireland in Dublin. Another (33 × 50 1/2

in.) belonged to the George A. Hearn collection in New York until 1918; its present whereabouts is unknown. The Hearn version was very close to the Rimington-Wilson picture, and may have been a copy after it. Finally, a canvas in the Gardner Museum in Boston (20 1/4 × 33 in.) repeats the composition of the Museum's view, omitting most of the gondolas in the foreground.

The picture must be dated after 1755, when the third story was added to the clock tower in the Piazza San Marco. As noted by Watson (see Refs. below), our version and the version once in Strasbourg show the façade of the church of the Pietà completed only in the lowest section, as it remained until 1906, when the half-columns and the pediment were added following the design of the architect Giorgio Massari. In the picture at Waddesdon Manor the façade appears already complete, which would seem to indicate an earlier date. The Waddesdon version was probably undertaken before work on the façade of the church of the Pietà was abandoned and, therefore, Guardi based his representation on drawings showing the façade as it would look when finished; when construction was halted in the early 1760's, the incomplete façade became part of the Venetian landscape, and Guardi then chose to show it as it actually appeared. The picture must, therefore, date from the early 1760's, and is among Guardi's earliest view paintings. The high quality of even the minor details, particularly the boats and figures in the foreground, excludes the possibility of the intervention by assistants in the workshop.

Oil on canvas. H. 48, w. 60 in. (122 × 152.5 cm.).

REFERENCES: The authorities cited below attribute this painting to Francesco Guardi. G. A. Simonson, *Francesco Guardi* (1904), p. 90, no. 117, lists it as in the collection of S. Neumann, London // J. Byam Shaw, *Burl. Mag.*, XCVII (1955), p. 15, calls it a smaller variant of the painting at Waddesdon Manor and dates it a little later, about 1765 // F. Watson, *Arte veneta*, IX (1955), p. 259, calls the

Museum's picture and the canvas once in Strasbourg later variants of the painting at Waddesdon Manor, and discusses the façade of the church of the Pietà // A. Morassi, *Arte veneta*, XIII-XIV (1959-1960), p. 164, fig. 219, calls it one of the finest works of Guardi's middle period, and dates it between 1755 and 1760; and *I Guardi* (1973), pp. 239 f., 384, no. 392, fig. 416, calls it one of the best-preserved works and mistakenly notes that it was formerly in the collection of Robert Lehman // C. Virch, *The Adele and Arthur Lehman Collection* (1965), pp. 52, 55, ill. pp. 53 (in color), 55 (detail), catalogues it and discusses the other versions.

EXHIBITED: Thos. Agnew and Sons, London, 1953, *Loan Exhibition of Thirty-nine Masterpieces of Venetian Painting*, no. 17 (lent by Sir Cecil Newman); Royal Academy, London, 1954-1955, *European Masters of the Eighteenth Century*, no. 33 (lent by Sir Cecil Newman); Metropolitan Museum, New York, 1960, *Paintings from Private Collections*, Summer Loan Exhibition, checklist no. 55 (lent by Mrs. Arthur Lehman); Harvard Club, New York, 1965, *Great Treasures from Private Collections of the Harvard Family*, 1 (lent by Mrs. Arthur Lehman).

EX COLL.: Sir Sigmund Neumann, 1st Bt., London (by 1904-1916); Lady Newman (Neumann), London (1916-1951); Sir Cecil Newman (Neumann), 2nd Bt., Burloes Royston, Herts. (1951-1955); [M. Knoedler and Co., New York, 1955-1958]; Mrs. Arthur Lehman, New York (1958-1965).

BEQUEST OF ADELE L. LEHMAN IN MEMORY OF ARTHUR LEHMAN, 1965.

Francesco Guardi (?)

Still Life

64.272.1 (Plate 36)

This painting and the following one represent bouquets of various kinds of flowers in vases, urns, and baskets, with parrots, melons, and pomegranates, the compositions arranged on rocks against the sky. They were almost certainly part of a room decoration that must have included other canvases, now lost. The compositions are exuberantly arranged, and the truly rococo spirit is emphasized by the sparkling, vivid range of colors, and flickering technique. Stylistically, these two pictures are among the best of a large group of still lifes of various shapes, all representing flowers, fruits, and occasionally birds, that has come to light in recent times, and has been attributed to Francesco Guardi.[1]

The pictures in this group vary in quality but are consistent in style and technique. The weaker examples are apparently from the same workshop from which the best ones, including ours, came. In composition they are evidently inspired by the paintings of Margherita Caffi, who was perhaps born in Vicenza, and worked in Lombardy around the end of the seventeenth century. The rendering of certain plant forms is related to the work of Elisabetta Marchioni, a painter specializing in still lifes of flowers; she was active in Rovigo, where some of her works are still preserved, and died around 1700. Some of the paintings in the group are signed Francesco Guardi, and certain characteristics of the handling of the brush, as well as the pigment, which includes minute grains of sand, are indeed close to the artist's sure works. Nevertheless, the attribution of these pictures to Francesco Guardi or his immediate circle remains extremely doubtful, and the problem cannot be resolved without a careful technical examination of the ones allegedly signed by him. Some of the unpublished paintings have recently been tested, and the signatures proved to be false. Moreover, it should be pointed out that dealers found and bought many of them during the 1950's and 1960's in Malta; the five huge pictures exhibited at the Hallsborough Gallery came from Malta, and less important examples, hitherto unnoticed but from the same hand or workshop, are still in private collections there, as well as in the store-

rooms in the National Museum in Valletta. The still life in the Angelo Rizzoli collection in Milan, bearing on the back of the canvas the inscription Guardi, is totally different in style and technique from other paintings in this group (exhibition catalogue, *Mostra dei Guardi*, Venice, 1965, p. 302, no. 159). It is most similar to two canvases in the sacristy of the parish church of Vigo d'Anaunia, which have been variously attributed to Francesco or Antonio Guardi, and were probably painted by the latter.

Oil on canvas. H. 72, w. 36 in. (182.8 × 91.4 cm.).

1. G. Fiocco, *Arte veneta*, IV (1950), pp. 76 ff. // M. G. Rutteri, *Acropoli*, I (1960-1961), pp. 145 ff. // A. Morassi, *Connaissance des Arts*, no. 129 (1962), pp. 65 ff. // *Exhibition of Flowers by Francesco Guardi*, Hallsborough Gallery, London, 1964 // *La Natura Morte Italiana*, Naples (1965), pp. 115 ff. // *Mostra dei Guardi*, Venice (1965), pp. 295 ff. // E. Martini, *La Pittura veneziana del settecento*, 1964, pp. 278 f., note 270.

REFERENCES: G. Fiocco, *Arte veneta*, IX (1955), pp. 208 f., figs. 240 (64.272.1), 241 (64.272.2), 244 (detail, 64.272.2), attributes both paintings to Francesco Guardi, considers them part of the same decoration as two overdoors in a private collection in Montevideo; *Boll. del Museo Civico di Padova*, LIII (1964), p. 72; and *Guardi* (1965), p. 39, pl. XXV (64.272.2, in color) // T. Pignatti (in a letter, 1964) rejects the attribution to Guardi // F. De' Maffei, in *Arte in Europa, scritti di Storia dell'Arte in onore di Edoardo Arslan* (1966), p. 857, notes the high quality but questions the attribution to Guardi.

EX COLL.: private collection, England (sale, Robinson and Foster, London, October 1, 1953, no. 253, as Campidoglio); [Mario Cellini, Rome, 1953-1954]; [Harold Woodbury Parsons, Rome, 1954]; Mr. and Mrs. Charles Wrightsman, New York (1954-1964).

GIFT OF CHARLES WRIGHTSMAN, 1964.

Still Life

64.272.2 (Plate 37)

See comment above under Still Life.

Oil on canvas. H. 72, w. 36 in. (182.8 × 91.4 cm.).

REFERENCES: See above under Still Life.

EX COLL.: See above under Still Life.

GIFT OF CHARLES WRIGHTSMAN, 1964.

Jacometto Veneziano

Active about 1472; died before 1498. The little information that we have about this painter comes from Marcantonio Michiel (the so-called Anonimo Morelliano), a sixteenth-century chronicler, who lists several paintings by Jacometto in Paduan and Venetian private collections. Two small miniature portraits now in The Robert Lehman Collection (until recently in the Liechtenstein collection) are undoubtedly the ones that Michiel referred to as his works. Using these as a basis for recognizing his style, Johannes Wilde and Martin Davies have attributed to Jacometto two more paintings, a portrait of a boy and one of a man in the National Gallery, London (nos. 2509 and 3121). A portrait of a woman, possibly a nun, in the collection of Lord Clark at Saltwood Castle, is by the same hand. Jacometto must have been a direct follower of Antonello da Messina, if not his assistant during Antonello's Venetian period, to judge by the close relationship between their styles. Some of his works show an equally close relationship to

the style of Giovanni Bellini, especially Bellini's paintings of about 1475. In technique, Jacometto's portraits mark the transition from the minute, almost Flemish, execution of Antonello's work to the broader, more idealized forms of Giovanni Bellini's painting.

Portrait of a Young Man
49.7.3 (Plate 38)

This small painting, so like the works attributed with assurance to Jacometto, is surely by him. In spite of the dominant influence of Antonello, this picture is strongly Venetian in feeling, recalling works painted by Giovanni Bellini in the mid-1470's, such as the Man of Sorrows with Angels in the Museum in Rimini. The fact that this portrait has been attributed at various times to Antonello, Giovanni Bellini, and Alvise Vivarini, shows the circle in Venetian painting to which Jacometto properly belongs and is proof of his significance and importance in the history of the Venetian school.

Formerly attributed by the Museum to Giovanni Bellini.

Tempera and oil on wood. H. 11, w. 8 1/4 in. (27.9 × 21 cm.).

REFERENCES: L. Venturi, *L'Arte*, XI (1908), p. 449, fig. 4, rejects the attribution of this painting to Antonello da Messina given to it in the Schickler collection and calls it a work by Alvise Vivarini, comparing it with the Portrait of a Boy in the Salting collection (now in the National Gallery, London); and *Ital. Ptgs. in Amer.* (1933), pl. 380, rejects the attribution to Alvise Vivarini and accepts the earlier attribution to Antonello // B. Berenson, *Gaz. des B.-A.*, ser. 4, IX (1913), p. 477, ill. p. 476, rejects the attribution to Antonello da Messina and calls it a work by Alvise Vivarini, comparing it with the Salting portrait; *Study and Criticism*, III (1916), p. 59, ill., calls it a work by Alvise Vivarini; *Dedalo*, V (1924-1925), p. 768, attributes it to Giovanni Bellini; (in a letter, 1928) attributes it to Giovanni Bellini; *Ital. Pictures* (1932), p. 71, lists it as a work by Giovanni Bellini; and *Ven. School* (1957), p. 32, lists it as a work by Giovanni Bellini // A. Venturi, *Storia*, VII, part IV (1915), pp. 422 f., fig. 252, calls it a work by Alvise Vivarini, compares it with the Salting portrait, which he dates 1488, and emphasizes the combined influences of Antonello and Giovanni

Bellini // R. Offner, *The Arts*, V (1924), p. 264, ill. p. 263, calls it a work attributed to Giovanni Bellini // W. R. Valentiner, *A Catalogue of early Ital. Ptgs.* (1926), no. 42, ill., attributes it to Giovanni Bellini // C. H. Collins Baker, *Burl. Mag.*, L (1927), pp. 24 ff., fig. II B, rejects the attribution to Alvise, notes the close connection with the Salting portrait, but doubts whether either painting is by Giovanni Bellini, suggests that both are by an unknown painter influenced by Giovanni Bellini and Antonello // D. von Hadeln, *Burl. Mag.*, LI (1927), pp. 4, 7, note 8, attributes this painting to Giovanni Bellini // G. Gronau, *Giovanni Bellini* (*Kl. der Kst.*) (1930), p. 205, pl. 70, attributes it to Giovanni Bellini // H. E. Wortham, *Apollo*, XI (1930), p. 350, ill., calls it a work by Giovanni Bellini // A. L. Mayer, *Pantheon*, VI (1930), pp. 541 f., calls it a work by Giovanni Bellini // R. van Marle, *Ital. Schools*, XVII (1935), p. 233, fig. 132, calls it a work by Giovanni Bellini // L. Dussler, *Giovanni Bellini* (1935), pp. 99, 142, mentions it among the works attributed to Giovanni Bellini, notes the close connection with the Salting portrait, which he judges perhaps slightly later, and with a drawing in the Städelsches Kunstinstitut in Frankfurt; and *Giovanni Bellini* (1949), p. 126, pl. 126, compares it with the Salting portrait and mentions it among the works attributed to Giovanni Bellini // C. Gamba, *Giovanni Bellini* (1937), p. 84, pl. 76, attributes it to Giovanni Bellini, notes the influence of Antonello and dates it not much later than 1476 // *Duveen Pictures* (1941), no. 81, ill., attributes it to Giovanni Bellini, notes the similarity with the Salting portrait, and dates it about 1475 // H. B. Wehle, *Met. Mus. Bull.*, n.s., I (1943), p. 285, calls it a late work by Bellini // V. Moschini, *Giambellino* (1943), p. 23, pl. 83, attributes it to Giovanni Bellini and observes the influence of Antonello // P. Hendy and L. Goldscheider, *Giovanni Bellini* (1945), p. 27, pl. 39, attribute it to Giovanni Bellini and note the influence of Antonello // F. Heinemann, *Giovanni Bellini e i Belliniani* (1962), p. 245, no. v.179, fig. 859, lists it among the works of Lorenzo Lotto // G. Robertson, *Giovanni Bellini* (1968), p. 107, rejects the attribution to Giovanni Bellini.

EXHIBITED: Duveen Galleries, New York, 1924, *Early Italian Paintings*, no. 42 (as Giovanni Bellini, lent by Andrew W. Mellon); Petit Palais, Paris, 1935, *L'Art Italien de Cimabue à Tiepolo*, no. 42 (as Giovanni Bellini, lent by Jules S. Bache); M. Knoedler and Co., New York, 1937, *Exhibition of Fifteenth Century Portraits*, no. 7 (as Giovanni Bellini, lent by Jules S. Bache); Metropolitan Museum, New York, 1943, *The Bache Collection*, no. 3 (as Giovanni Bellini, lent by Jules S. Bache).

Antonio Joli

Antonio Joli; also spelled Jolli or Gioli. Born about 1700; died 1777. Joli, who was active both as a stage designer and as a painter of views and contemporary events, cannot be classified as a member of a particular Italian school. He was born in Modena and received his early training there, but by 1720 he was established in Rome, working in Pannini's shop and making copies of some of his master's most famous Roman views. In 1725 he was in Modena and in Perugia, where he executed the background of a large ceiling in which the figures had been painted by Sebastiano Ceccarini. Joli was in Venice preparing theatrical designs around 1740; four years later he visited London, where he painted views of the city. He may also have spent some time in Lombardy. Around 1750 he was working in Madrid, but by 1755 he had returned to Venice, where he was admitted to the Academy as a painter of perspectives, landscapes, and ornaments. Joli's last years were spent in Naples. He settled there some time after 1762, worked for the Royal Theatre of San Carlo, and painted views of the region and events from the lives of the Neapolitan royalty of his time. His style, which reflects his theatrical activity, was based on that of Pannini and other contemporary artists, and his landscapes and historical pictures are more remarkable as documents than as works of art.

London: St. Paul's and Old London Bridge

1970.212.2 (Plate 39)

This is a view of the north bank of the Thames river, with the terrace and water gate of Somerset House, St. Paul's, the Monument, and Old London Bridge. In the distance are the spires of the city churches and, to the right of center, the characteristic silhouette of the Tower of London. This compositional device, in which an actual, if somewhat compressed, view of the city is seen through the lofty arcades of an imaginary building in the late Baroque style, is typical of Joli's repertoire; he used it in various paintings of Rome, Venice, and other European capitals. Although the figures are clad in contemporary English costumes they show, along with the architecture and the view, the influence of Pannini, whom Joli rather superficially imitated throughout his prolific career. The picture should be dated about 1744, when Joli is known to have been active in London.

Formerly attributed by the Museum to Samuel Scott.

Oil on canvas. H. 42, w. 47 in. (106.7 × 119.3 cm.).

Alessandro Longhi

Real name Alessandro Falca. Born 1733; died 1813. Alessandro Longhi was the son of Pietro Longhi, but unlike his father he devoted himself especially to portraiture and was sent to study under the portrait painter Giuseppe Nogari. The noble Venetian family of the Pisani became his patron, and he was chosen official portrait painter to the Venetian academy. He was also an engraver and in 1763 published a book on contemporary Venetian artists, which he illustrated with engraved likenesses.

Count Carlo Aurelio Widmann
15.118 (Plate 44)

Count Carlo Widmann (1750-1799), the grandnephew of Pope Clement XIII, held the important office of Provveditore Generale da Mar. His official residence was Corfu, where he was in command in 1797, when the French overthrew Venice. Corfu appears in the background of the portrait. The style is that of Longhi's advanced period, and it was possibly painted in the mid 1790's.

Oil on canvas. H. 90 1/4, w. 53 3/4 in. (229.2 × 136.6 cm.).

REFERENCES: J. P. Richter, *Met. Mus. Studies*, IV, part I (1932), pp. 39 ff., fig. I, attributes this painting to Alessandro Longhi and identifies the subject as Count Widmann // H. Voss (in a letter, 1931) assigns it tentatively to Alessandro's early period // A. Moschini, *L'Arte*, XXXV (1932), pp. 145 f., note, fig. 19, attributes it hesitantly to Alessandro Longhi and dates it about 1780 // R. Longhi (unpublished opinion, 1937) attributes it to Alessandro Longhi // C. Donzelli, *I Pittori veneti del settecento* (1957), p. 132, lists it as a work by Alessandro Longhi // E. Martini, *La Pittura veneziana del settecento* (1964), p. 292, note 290, accepts the attribution to Alessandro Longhi, dates it about 1765, but rejects the identification of the sitter suggested by Richter.

EX COLL. Henry White Cannon, Villa Doccia. Fiesole (until 1915).

GIFT OF HENRY W. CANNON, 191⁵

Pietro Longhi

Real name Pietro Falca. Born 1702; died 1785. Pietro Longhi, trained by his father to be a goldsmith, began the study of painting as a pupil of Antonio Balestra in Venice and then went to Bologna, where he studied under Giuseppe Maria Crespi. Soon after his return to Venice (1732) he executed decorations in the Palazzo Sagredo (see p. 25), but it is not as a fresco painter that Longhi is remembered. Under Crespi's influence, he turned to painting episodes of daily life in small genre scenes. These charming and vivacious pictures, which became very popular in Venice, are his most typical work. In 1763 Longhi was appointed teacher and director of the school of art established by the Pisani family, and three years later he was made a member of the newly founded Venetian academy of painting.

The Letter

14.32.1 (Plate 40)

This painting, with the three following, is said to have belonged to a series of twenty scenes painted by Longhi for the Gambardi family of Florence around 1746, the date appearing on the back of the Visit. Some of the series were bequeathed to Marchese Freschi of Padua, and it has been suggested that these are the ones in the National Gallery in London (nos. 1100 and 1101) and the Brera in Milan (nos. 780 and 781). This has not been verified. Others were left to Count Miari de Cumani, also of Padua, and these include our four and a group of six formerly in the collection of Lionello Perera in New York (see Sale Catalogue of the E. Volpi collection, American Art Galleries, New York, Dec. 17-19, 1917, nos. 441-446 and introductory notes). The Perera paintings were sold at Sotheby's (London, June 24, 1964, nos. 31-34; April 19, 1967, nos. 18 and 19). A replica of this painting is in the collection of Brinsley Ford, London.

Oil on canvas. H. 24, w. 19 1/2 in. (60.9 × 49.5 cm.).

REFERENCES: The authorities cited below attribute this painting to Longhi. *Met. Mus. Bull.*, IX (1914), pp. 75 ff., ill. // A. Ravà, *Pietro Longhi* (1923), ill. p. 98 // L. Venturi, *Ital. Ptgs. in Amer.* (1933), pl. 602 // M. D. Sloane, *Met. Mus. Bull.*, XXXI (1936), p. 52 // M. Davis, *Worcester Art Museum Annual*, V (1946), pp. 60 f., fig. 12, accepts the connection with the paintings in the Brera in Milan, in the National Gallery in London, and in the collection of Lionello Perera in New York, dating the series between 1750 and 1770 // M. Levey, *The Eighteenth Century Italian Schools* (*National Gallery Catalogue*) (1956), p. 72, notes 7, 10 // V. Moschini, *Pietro Longhi* (1956), pl. 64 // C. Donzelli, *I Pittori veneti del settecento* (1957), p. 135 // R. Pallucchini, *La Pittura veneziana del settecento* (1960), p. 181 // T. Pignatti, *Pietro Longhi* (1969), pp. 81 f., pl. 103, calls the picture the Milliner, reproduces an engraving after it by Cattini, and an almost identical painting in the Brinsley Ford collection, suggests that it belongs to the Temptation series, and thus should be dated somewhat earlier than 1746.

EX COLL.: the Gambardi family, Florence; Count Giacomo Miari de Cumani, Padua (until 1912); [Carlo Balboni, Venice, 1912]; [Antonio Carrer, Venice, 1912].

PURCHASE, HEWITT FUND, 1912.

The Visit

14.32.2 (Plate 41)

See comment above under the Letter.

Signed and dated (on back of canvas, now covered by relining): Pietrus Longhi 1746.

Oil on canvas. H. 24, w. 19 1/2 in. (60.9 × 49.5 cm.).

REFERENCES: The authorities cited below attribute this painting to Longhi. *Met. Mus. Bull.*, IX (1914), pp. 75 ff., ill. // A. Ravà, *Pietro Longhi* (1923), ill. p. 35 // M. D. Sloane, *Met. Mus. Bull.*, XXXI (1936), p. 52 // M. Davis, *Worcester Art Museum Annual*, V (1946), pp. 60 f., fig. 13, accepts the connection with the paintings in the Brera in Milan, in the National Gallery in London, and in the collection of Lionello Perera in New York, dating the series between 1750 and 1770 // A. Morassi, *Arte veneta*, VII (1953), p. 55 // M. Levey, *The Eighteenth Century Italian Schools* (*National Gallery Catalogue*) (1956), p. 72, notes 7, 10 // V. Moschini, *Pietro Longhi* (1956), pp. 22, 60, pl. 65 // C. Donzelli, *I Pittori veneti del settecento* (1957), p. 135 // R. Pallucchini, *La Pittura veneziana del settecento* (1960), p. 181 // T. Pignatti, *Pietro Longhi* (1969), pp. 49, 81, pl. 76, mentions a preparatory study for the rear wall in the Museo Correr (no. 547).

EXHIBITED: Detroit Institute of Arts, 1952, *Venice 1700-1800*, no. 46; Herron Museum of Art, Indianapolis, Indiana, 1952, *Venice 1700-1800*, no. 46.

EX COLL.: the Gambardi family, Florence; Count Giacomo Miari de Cumani, Padua (until 1912); [Carlo Balboni, Venice, 1912]; [Antonio Carrer, Venice, 1912].

PURCHASE, HEWITT FUND, 1912.

The Temptation

17.190.12 (Plate 42)

The painting on the wall in the background is apparently a Venetian work of the sev-

enteenth century, recalling the manner of Pietro Liberi. See also comment above under the Letter.

Oil on canvas. H. 24, w. 19 1/2 in. (60.9 × 49.5 cm.).

REFERENCES: The authorities cited below attribute this painting to Longhi. *Met. Mus. Bull.*, IX (1914), pp. 75 ff., ill. // A. Ravà, *Pietro Longhi* (1923), ills. pp. 34, 153, reproduces an engraving after it by Gutwein // M. D. Sloane, *Met. Mus. Bull.*, XXXI (1936), p. 52 // R. Longhi, *Viatico per cinque secoli di pittura veneziana* (1946), p. 69, pl. 156 // M. Davis, *Worcester Art Museum Annual*, V (1946), pp. 60 f., accepts the connection with the paintings in the Brera in Milan, in the National Gallery in London, and in the collection of Lionello Perera in New York, dating the series between 1750 and 1770 // M. Levey, *The Eighteenth Century Italian Schools (National Gallery Catalogue)* (1956), p. 72, notes 7, 10 // V. Moschini, *Pietro Longhi* (1956), p. 22, pl. 66, says it was engraved in 1794 // C. Donzelli, *I Pittori veneti del settecento* (1957), p. 135 // R. Pallucchini, *La Pittura veneziana del settecento* (1960), p. 181, pl. 467, calls it the Visit to the Lord // T. Pignatti, *Pietro Longhi* (1969), p. 82, pl. 84, suggests that Longhi referred to the painting in a letter to the printer Remondini dated May 13, 1749, and notes that the painting on the back wall seems to be in the style of Amigoni.

EXHIBITED: Detroit Institute of Arts, 1951; Art Gallery of Toronto, 1951; City Art Museum, St. Louis, 1952; Seattle Art Museum, 1952; Museum of Fine Arts, Boston, 1970, *Masterpieces of Painting in The Metropolitan Museum of Art* (Cat., p. 30).

EX COLL.: the Gambardi family, Florence; Count Giacomo Miari de Cumani, Padua (until 1912); [Carlo Balboni, Venice, 1912]; [Antonio Carrer, Venice, 1912]; J. Pierpont Morgan, New York (1914-1917).

GIFT OF J. PIERPONT MORGAN, 1917.

The Meeting
36.16 (Plate 43)

The two men at left and right wear the Venetian *bautta*, a mask attached to a short mantle of black silk. There is a rather crude copy in the Pushkin Museum in Moscow (N2698, 71 × 54 cm.); the additions to the interior decoration and the treatment of perspective indicate that it was painted in the late nineteenth century. See also comment above under the Letter.

Oil on canvas. H. 24, w. 19 1/2 in. (60.9 × 49.5 cm.).

REFERENCES: The authorities cited below attribute this painting to Longhi. *Met. Mus. Bull.*, IX (1914), pp. 75 ff., ill. // A. Ravà, *Pietro Longhi* (1923), ills. pp. 29, 152, reproduces an engraving after it by Flipart and an old copy (painting) after it made from the Flipart engraving // M. D. Sloane, *Met. Mus. Bull.*, XXXI (1936), pp. 51 ff., ill. p. 49 // M. Davis, *Worcester Art Museum Annual*, V (1946), pp. 60 f., accepts the connection with the paintings in the Brera in Milan, in the National Gallery in London, and in the collection of Lionello Perera in New York, dating the series between 1750 and 1770 // M. Levey, *The Eighteenth Century Italian Schools (National Gallery Catalogue)* (1956), p. 72, notes 7, 10 // V. Moschini, *Pietro Longhi* (1956), p. 22, pls. 8 (in color), 67, calls the subject the meeting of a procurator with his wife // C. Donzelli, *I Pittori veneti del settecento* (1957), p. 135 // R. Pallucchini, *La Pittura veneziana del settecento* (1960), p. 181 // T. Pignatti, *Pietro Longhi* (1969), p. 81, pl. 78, reproduces engravings by Flipart and Hayd, notes that this picture is the prototype for many other versions and copies of the same subject.

EXHIBITED: Metropolitan Museum, New York, 1914-1935 (lent by Henry Walters).

EX COLL.: the Gambardi family, Florence; Count Giacomo Miari de Cumani, Padua (until 1912); [Carlo Balboni, Venice, 1912]; [Antonio Carrer, Venice, 1912]; Henry Walters, Baltimore (1914-1931; sale, American Art Association, New York, Jan. 10, 1936, no. 50); Samuel H. Kress, New York (1936).

GIFT OF SAMUEL H. KRESS, 1936.

Lorenzo Lotto

Born about 1480; died 1556. Lotto was a pupil of Alvise Vivarini, and his early work also indicates that he was deeply impressed by the paintings of Giovanni Bellini. Later he developed a very personal style, in which it is possible to discern the influence of Giorgione, Titian, and Raphael, as well as Dürer and other painters of northern Europe. Little is known about the beginnings of Lotto's career, but there are signed works and many documents from his later years, including an expense book that he began to keep in 1538, listing in detail his commissions, with dates, and payments made and received. At various times during his long career Lotto was active in the Marches, and throughout his life he moved from one city to another; especially noteworthy were his stays in Treviso, Rome (1508), Bergamo, and Venice. Lotto's style remains unique in sixteenth-century Italian painting. His deeply lyrical imagery reveals a tormented spirit, sincerely religious, but also reflecting the crisis of contemporary Catholicism. The transition from the classic models of the Renaissance toward mannerism is apparent in his work.

Brother Gregorio Belo of Vicenza
65.117 (Plate 45)

Brother Gregorio Belo of Vicenza, whose name is inscribed on the stone at the lower right, is represented holding in his left hand a small book, whose binding shows on the back a title, "Homelie d greg," that is, the preaching of Gregory the Great. With his right hand he is beating his breast. The wild landscape, with a representation of the Crucifixion on the summit of a distant hill, and the gesture of the right hand allude to Saint Jerome, who went out into the wilderness to do penance and study the scriptures. In fact, Fra Gregorio Belo belonged to the community of the Hieronymites, the poor hermits of Saint Jerome, a congregation founded by the Blessed Pietro de' Gambacorti of Pisa, which had as its seat in Venice the church and monastery of San Sebastiano. The commission for the portrait, which was to include a small Crucifixion, the Madonna, Saint John, and the Magdalen, is quoted in Lotto's account book on December 9, 1546, and the final payment was made on October 11, 1547. Our painting corresponds in every detail, including the date 1547, with the picture mentioned in Lotto's *Libro di Spese*. Brother Gregorio wears the habit of his order, a brown robe and a black girdle. In this picture, which is among the most characteristic portraits of Lotto's mature style, the religious fervor of the monk is subtly indicated, and emphasized by the somber palette. The small Crucifixion in the background should be compared with the tiny picture formerly belonging to the collection of Prince Borromeo in Milan, and now in the Berenson collection in Florence.

Inscribed and dated (lower right): F. Gregorii belo de Vicentia / eremite in hieronimi Ordinis beati / fratris Petri de pisis Anno / eius. LV. M.D.XLVIII ("Fra Gregorio Belo of Vicenza hermit in Hieronymite Order of Blessed Fra Pietro of Pisa, at the age of 55, 1547").

Inscribed (lower left), two inventory numbers: 353 (in red), 101 (in white).

Oil on canvas. H. 34 3/8, w. 28 in. (87.3 × 71.1 cm.).

REFERENCES: L. Lotto, *Libro di Spese Diverse, 1538-1556*, in A. Venturi, ed., *Le Gallerie nazionali italiane notizie e documenti*, I (1894), pp. 126, 155, lists the commission on December 9, 1546, and payments on December 13, 1546, and April 27, March [May ?] 5 and 7, and October 11, 1547; and *Il Libro di, Spese Diverse con aggiunta di lettere e d'altri documenti*, P. Zampetti, ed. (1969), pp. 74 f., 343 // G. Gronau (unpublished opinion, 1924) identifies this picture as the work of Lorenzo Lotto, and notes that the attribution is confirmed by the account book of the artist // B. Berenson, *Lotto* (1955), pp. 164 f., pl. 361, identifies this portrait with the entries in Lotto's account book concerning a portrait of Fra Gregorio of Vicenza, painted in 1546; *Lorenzo Lotto* (1956), pp. 126, 471; and *Ven. School* (1957), p. 107, pl. 787.

EXHIBITED: Museum of Fine Arts, Boston, 1970, *Masterpieces of Painting in The Metropolitan Museum of Art* (Cat., p. 21); Metropolitan Museum, New York, 1970-1971, *Masterpieces of Fifty Centuries*, no. 211.

EX COLL. [Jean Marchig, Geneva, 1965].

PURCHASE, ROGERS FUND, 1965.

Maggiotto (?)

Real name Domenico Fedeli. Born 1713; died 1794. Maggiotto was a pupil of Piazzetta and during the earlier part of his life imitated his master's style but with less intensity and power. Although he painted altarpieces, he was at his best in genre and narrative scenes. Many of his pictures of this type are still attributed to Piazzetta. Gradually his master's influence on him lessened, and his late style was colder and more formal.

Joseph Sold by His Brethren
29.70 (Plate 46)

Though this picture is surely by some artist working in the immediate following of Piazzetta, the treatment of forms and the composition preclude an attribution to him. A figure similar to that of Joseph appears in a signed drawing by Giulia Lama (collection of T. Fitzroy Fenwick, Cheltenham, Gloucestershire), but our painting, as a whole, is more in the style of Maggiotto than of Lama, even though an ascription to Maggiotto is not quite convincing.

Formerly attributed by the Museum to Piazzetta.

Oil on canvas. H. 43 3/4, w. 67 in. (111.1 × 170.1 cm.).

REFERENCES: F. Mason Perkins (unpublished opinion, 1927) attributes this painting to Piazzetta // W. Suida (in a letter, 1928) attributes it to Piazzetta // U. Gnoli (in a letter, 1929) calls it one of the most significant works of Piazzetta // H. B. Wehle, *Met. Mus. Bull.*, XXIV (1929), pp. 187 ff., ill., attributes it to Piazzetta // G. Fiocco, in Thieme-Becker, XXVI (1932), p. 570, attributes it to Maggiotto // R. Pallucchini, *Rivista di Venezia*, XI (1932), p. 492, fig. 13, attributes it to Maggiotto and notes its similarity to a drawing in the Correr Museum, Venice; and *Arte veneta*, XXIV (1970), p. 291, fig. 428, rejects his earlier attribution to Maggiotto, calls it a work by Giuseppe Angeli, and compares it with the Rape of the Sabine Women in the Art Institute in Chicago // M. Goering (in a letter, 1935) attributes it to Maggiotto // E. Panofsky (verbally, 1935) rejects the attribution to Piazzetta // J. Byam Shaw (verbally, 1935) attributes it to Giulia Lama on the basis of a drawing in the Fitzroy Fenwick collection // H. Voss (in a letter, 1935) attributes it to Giuseppe Angeli // H. Tietze, *Meisterwerke Europäischer Malerei in Amerika* (1935), p. 332, pl. 114, attributes it to Piazzetta // C. Donzelli, *I Pittori veneti del settecento* (1957), p. 139, lists it as a work of Maggiotto // T. Pignatti, *Eighteenth-century Venetian Drawings from the Correr Museum* (Washington, 1963-1964), p. 40, no. 42, notes that there is a drawing of the head of a priest by Maggiotto in the Correr Museum which, according

to Pallucchini, corresponds to a detail in this painting; (London, 1965), p. 20, no. 48; and (verbally, 1965) // A. Ballarin (verbally, 1970) tentatively attributes it to Giulia Lama and notes that there is a drawing for the head of Joseph in the Fenwick Owen collection.

EXHIBITED: Newark Museum, Newark, New Jersey, 1967, *Italian Paintings of Four Centuries*; Allentown Art Museum, Allentown, Pennsylvania, 1971, *The Circle of Canaletto*, no. 30.

EX COLL.: private collection, London (about 1926); [Eugenio Ventura, Florence, 1927-1929].

PURCHASE, FLETCHER FUND, 1929.

Master of Helsinus

Active in the late fourteenth and early fifteenth centuries. A number of paintings were identified as the work of one unknown artist by Roberto Longhi in 1946 (*Viatico per cinque secoli di pittura veneziana*, p. 48). The name given to this anonymous painter was taken from the most important of these pictures, an altarpiece in the National Gallery, London (no. 4250), in which two scenes from the life of the English abbot Helsinus are represented. The earliest paintings in the group show the influence of certain late fourteenth-century Venetian painters, especially Lorenzo Veneziano and Jacobello di Bonomo; gradually, however, the Master of Helsinus developed a more simplified, individual style which has certain characteristics in common with the schools of the Romagna and the Marches. It should be noted that one of his earliest works, a polyptych, is in the gallery in Fermo, and there are also some fragmentary frescoes in the church of the Servi in Rimini. More recently, a number of paintings by this master have been discovered along the Dalmatian coast of the Adriatic. It has been suggested that he was born in Dalmatia, possibly in Zara (Zadar), and he has been tentatively identified with two different painters, Lovro Mithetič and Meneghella de Canali (see G. Gamulin, *Madonna and Child in Old Art of Croatia*, 1971, pp. 132 f.).

The Madonna and Child with Saint James the Less and Saint Lucy
32.100.87 (Plate 47)

The bright colors and stylized forms are typical of the late work of the Master of Helsinus, in which reminiscences of late fourteenth-century Venetian painting are modified by a suggestion of Gothic feeling. Another very similar work by the Master of Helsinus is the diptych representing Saint Anthony Abbot and the Man of Sorrows formerly in the Chillingworth collection (sale, Fischer-Muller, Lucerne, Sept. 5, 1922, no. 95, ill., as Italian Master about 1400). Both our panel and the diptych should probably be dated about 1410; they are surely later than the altarpiece in the National Gallery, London, the Madonna in the church of the Holy Rood in Sebenico (Šibenik), and another Madonna Enthroned with Angels formerly in the art market in Rome.

Formerly attributed by the Museum to an unknown Venetian painter of the last quarter of the XIV century (Cat., 1940).

Tempera on wood, gold ground. H. 12 1/4, w. 17 1/4 in. (31.1 × 43.8 cm.).

REFERENCES: B. Berenson, in Cat. of Friedsam Coll. (unpublished, n. d.), p. 63, attributes this painting to a follower of Guariento of Padua and dates it about 1375 // B. Burroughs and H. B. Wehle, *Met. Mus. Bull.*, xxvII (1932), Nov., sect. II, p. 31 // R. Offner (verbally, 1935) calls it Ve-

netian and dates it about 1400 // F. Zeri (in a letter, 1948) attributes it to the Master of Saint [sic] Helsinus // L. Coletti (in a letter, 1949) ascribes it to the painter of the National Gallery altarpiece, called by Longhi the Master of Saint Helsinus, and identifies him as Jacobello Bonomo // F. Bologna, *Arte veneta*, VI (1952), p. 17, fig. 13, attributes it to the Master of Saint Helsinus, suggesting a date between 1380 and 1390 // R. Pallucchini, *La Pittura veneziana del Trecento* (1964), p. 209, attributes it to the Master of Saint Helsinus.

EX COLL. Michael Friedsam, New York (until 1931).

THE MICHAEL FRIEDSAM COLLECTION. BEQUEST OF MICHAEL FRIEDSAM, 1931.

Giustino Menescardi

Giustino Menescardi; also spelled Manescardi. Known activity 1748-1776. Menescardi came from Milan and settled in Venice, where he developed a style closely dependent on the early work of Tiepolo. He executed decorations in the Scuola del Carmine from designs by Gaetano Zompini, and painted with Tiepolo, Maggiotto, and Guarana for the Cancelleria of the Scuola della Carità.

Esther before Ahasuerus
94.4.364 (Plate 48)

Esther is shown fainting before King Ahasuerus after approaching him with her petition at the command of Mordecai, who sits at the left of the throne. Haman, seated at the king's right, raises his hand in disapproval of Esther's effrontery. This painting is closely related to a large picture of the same subject by Gaetano Zompini, executed in 1748-1749 in the Stanza degli Archivi in the Scuola del Carmine in Venice. Since Menescardi was working at the same time in the same room, it is very likely that this painting is a sketch that he provided for the wall painting that had been originally commissioned from him but was later given to Zompini.

Formerly attributed by the Museum to Giovanni Battista Tiepolo and later to Sebastiano Ricci.

Oil on canvas. H. 18, w. 51 in. (45.7 × 129.5 cm.).

REFERENCES: E. Sack, *Giambattista und Domenico Tiepolo* (1910), p. 227, no. 557, lists this painting as a work by Giovanni Battista Tiepolo // J. Breck, *Art in Amer.*, I (1913), p. 14, fig. 6, refers to it as a work attributed to Ricci // J. Byam Shaw (verbally, 1935) attributes it to Menescardi // H. Voss (in a letter, 1935) attributes it to an imitator of Ricci and Tiepolo, perhaps Menescardi or Zugno // G. Fiocco (in a letter, 1936) tentatively attributes it to Menescardi, comparing it with figures by him in the decoration of the Doge's Palace // L. Coletti (in a letter, 1949) tentatively attributes it to Gaetano Zompini // M. Levey, *Arte veneta*, X (1956), p. 208, accepts the attribution to Menescardi, connects it with the decoration of the Stanza degli Archivi in the Scuola del Carmine in Venice, considers it possible that the subject was first assigned to Menescardi and that either the arrangement was later changed by Zompini or the two painters agreed to redistribute the work, mentions the sketch by Zompini in the collection of the Duke of Bedford at Woburn Abbey // A. Morassi, *A Complete Catalogue of the Paintings of G. B. Tiepolo* (1962), p. 34, rejects the attribution to Tiepolo and calls it probably the work of Menescardi.

EXHIBITED: Metropolitan Museum, New York, 1971, *Oil Sketches by 18th Century Italian Artists*, no. 18.

EX COLL.: private collection (sale, Paris, Galeries de l'Universelle, March 13-15, 1893, no. 30, as attributed to Tiepolo); William Baumgarten, New York (sale, New York, American Art Galleries, April 6, 1894, no. 61, as Tiepolo); Henry G. Marquand, New York (1894).

GIFT OF HENRY G. MARQUAND, 1894.

Francesco Montemezzano

Francesco Montemezzano. Born about 1540; died after 1602. Little is known about Montemezzano except that he was born in Verona. The lack of subtlety in his color and his way of handling paint betray his provincial origin and suggest that he began his training in his native town in the workshop of an artist who painted in the early sixteenth-century style. Authenticated works by Montemezzano, most of them done for Venice, and for several localities near Verona, show that he became a faithful imitator of Veronese, with whom he must have collaborated for a rather long time.

Portrait of a Woman
29.100.104 (Plate 49)

This picture is close in style to Veronese's late work, and was once called a portrait of his wife. It follows his portraits in composition but lacks his breadth and refinement. The painting of the flesh and the treatment of the costume, however, are characteristic of Montemezzano's best work.

Formerly attributed by the Museum to Paolo Veronese (Cat., 1940).

Oil on canvas. H. 46 3/4, w. 39 in. (118.7 × 99 cm.) (including added strip of 5 1/2 in. at top).

REFERENCES: The authorities cited below, with the exception of Mather, Longhi, and Marini, attribute this painting to Veronese. D. von Hadeln, *Art in Amer.*, XV (1927), p. 251 // F. J. Mather, *The Arts*, XVI (1930), p. 457, mentions it as possibly by Badile // B. Berenson, *Ital. Pictures* (1932), p. 423; and *Ven. School* (1957), p. 134 // L. Venturi, *Ital. Ptgs. in Amer.* (1933), pl. 570; and *L'Arte*, XXXVI (1933), p. 46, fig. 1, dates it in Veronese's middle period // G. Fiocco, *Paolo Veronese* [1934], pp. 32, 127 // R. Longhi (unpublished opinion, 1937) attributes it to Francesco Montemezzano // R. Marini, *L'Opera completa del Veronese* (1968), p. 134, no. 369, ill., lists it among pictures traditionally given to Veronese, but accepts the attribution to Montemezzano.

EXHIBITED: Metropolitan Museum, New York, 1930, *The H. O. Havemeyer Collection*, no. 104; McIntosh Memorial Gallery, University of Western Ontario, London, Canada, 1956, *Loan Exhibition – Italian Masters*.

EX COLL.: Donna Rosalia Velluti-Zati, Countess Fossi, Florence (until 1903); H. O. Havemeyer, New York (1903-1907); Mrs. H. O. Havemeyer, New York (1907-1929; Cat., 1931, p. 8).

BEQUEST OF MRS. H. O. HAVEMEYER, 1929. THE H. O. HAVEMEYER COLLECTION.

Niccolò di Pietro

Known activity 1394-1427 or 1430. At one time wrongly identified with the Paduan painter Niccolò Semitecolo. Niccolò sometimes signed his works "Nicolaus Paradixi," because he lived near the Bridge of Paradise in Venice. He was slightly influenced by the Venetian painters of the late fourteenth century, and he became one of the leading figures working in the Gothic style that flourished in and around Venice during the first three decades of the fifteenth century. In addition to the Italian influence, his early

works show a connection with the contemporary schools of central and northern Europe, often recalling the styles of painters of Bohemia and the Rhenish region. Later he was influenced by Gentile da Fabriano, who was active in Venice from 1408 to 1409, and by the artists of the Emilian region.

Saint Ursula and her Maidens
23.64 (Plate 50)

This panel, which should be dated in the first years of the fifteenth century, is one of Niccolò's finest achievements. The gay, brilliant colors and the sumptuous decorative patterns are strictly confined in flat areas, outlined by the continuous curves of the design. The delicate fused modeling of the heads against the scarlet background does not detract from the pronounced effect of a two-dimensional space, emphasized by the grass which resembles millefleur tapestry.

Inscribed (on background): SANTA URSULA; (on belt): [AVE] MARIA GRATIA PL[ENA].

Formerly attributed by the Museum to an unknown Venetian painter of the early XV century (Cat., 1940).

Tempera and gold on wood; embossed crowns and ornaments. H. 37, w. 31 in. (93.9 × 78.7 cm.).

REFERENCES: O. Sirén, *Burl. Mag.*, XXXIX (1921), pp. 169 f., ill., attributes this painting to Guariento; and (in a letter, 1923) attributes it to Niccolò di Pietro // B. B[urroughs], *Met. Mus. Bull.*, XVIII (1923), pp. 144 f., ill., calls it Venetian, dates it about 1400, and observes that it may be the work of Niccolò di Pietro, as Lionello Venturi had suggested // R. van Marle, *Ital. Schools*, IV (1924), p. 118, note, and VII (1926), pp. 335 f., fig. 223, calls it Venetian, dates it about 1400, and notes

the influence of Francesco del Fiore and Guariento // L. Coletti, *Riv. d'arte*, XII (1930), pp. 330, 360, calls it a Rhenish work of the fifteenth century; *Arte veneta*, II (1948), pp. 39 f., hesitantly accepts the attribution to Niccolò di Pietro in his early period; and *Pittura veneta del quattrocento* (1953), p. vii, pl. 4, definitely accepts the attribution to Niccolò, suggesting a date in his late period // E. Sandberg-Vavalà, *Jahrb. der Preuss. Kstsmlgn.*, LI (1930), p. 108, ill. p. 107, attributes it to Niccolò di Pietro in his latest period; and *Art Quarterly*, II (1939), pp. 287 f., fig. 6 // L. Venturi, *Ital. Ptgs. in Amer.* (1933), pl. 126, attributes it to Niccolò di Pietro // R. Longhi (unpublished opinion, 1937) attributes it to Niccolò di Pietro; and *Viatico per cinque secoli di pittura veneziana* (1946), p. 48, compares it with Niccolò di Pietro's Crucifix of 1404 in Verucchio, dating it not far from that year // R. Offner (verbally, 1937) attributes it to Niccolò di Pietro // P. Toesca, *Il Trecento* (1951), p. 147, note, attributes it to Niccolò di Pietro // G. Fiocco, *Boll. d'arte*, XXXVII (1952), pp. 13, 18, attributes it to Niccolò di Pietro // O. Ferrari, *Commentari*, IV (1953), p. 230, note 11, attributes it to Niccolò di Pietro // R. Pallucchini, *Arte veneta*, X (1956), p. 47, attributes it to Niccolò di Pietro, perhaps in his late period // F. Zeri (verbally, 1957) attributes it to Niccolò di Pietro // B. Berenson, *Ven. School* (1957), p. 122, lists it as Niccolò di Pietro // V. N. Lazarev, *The Origins of the Italian Renaissance*, II (1959, Russian edit.), p. 244, attributes it to Niccolò di Pietro // C. Huter (in a letter, 1964) rejects an attribution to Niccolò di Pietro // B. Klesse, *Seidenstoffe in der italienischen Malerei des vierzehnten Jahrhunderts* (1967), p. 317, no. 240, dates the painting at the beginning of the XV century by the type of textile worn by Saint Ursula, and reproduces a sketch of the pattern of the robe.

EX COLL.: private collection, Zurich (1921); [F. Steinmeyer, Lucerne, 1921-1922]; [R. Langton Douglas, London, 1922-1923].

PURCHASE, ROGERS FUND, 1923.

Jacopo Palma the Younger

Jacopo Palma, called Palma Giovane. Born 1544; died 1628. Jacopo Palma was the son of the painter Antonio Palma and the great-nephew of the more famous painter Jacopo Palma, called Palma Vecchio. Palma Giovane was both a painter and an engraver. He

was at one time in the service of Duke Guidobaldo of Urbino, and he visited Rome in 1568. He was a prolific artist who worked mostly in Venice, where his canvases still decorate many churches and some of the main rooms of the Ducal Palace. His renown, extending beyond the borders of the Venetian state, brought him commissions from many patrons of central Europe, among them the Emperor Rudolph II. The work of Palma Giovane, often overlooked or dismissed as secondary, shows that he was one of the best artists working in the Venetian mannerist style. He was much indebted to Jacopo Tintoretto, but his compositions and his types show that he also studied paintings by Francesco Salviati, the sculptures of Alessandro Vittoria, and the work of a number of other artists of the schools of Rome and Florence. Palma's sense of space and his pictorial treatment of forms were fundamental in the later development of Venetian baroque painting.

The Crucifixion

57.170 (Plate 52)

The size and vertical format clearly indicate that this Crucifixion was executed as an altarpiece for a church or chapel, and the figure of the Roman centurion who gallops away pointing toward Christ, the fainting Virgin, and the stormy sky allude to the moment of His death. Near the lower right corner is a sepulchral stone slab, and a half-length male nude whose hands are joined and who turns toward the cross. This figure must be Adam who, according to medieval legend, was resurrected by means of the blood of the Redeemer. From the twelfth to the fourteenth century this theme had enjoyed a certain popularity; it was revived during the Counter Reformation, especially in Venice, possibly under the influence of some medieval Byzantine prototype, and it appears in such works of Jacopo Palma the Younger as the large Crucifixion in the Pinacoteca in Bologna (inv. no. 161). In style and technique our painting is a good example of Palma Giovane's mature period. Mannerist motifs such as the mounted centurion, derived from Tintoretto and artists of the Roman school, are realized with a palette reminiscent of Titian's late works.

Signed (on marble slab near lower right): JACOBUS PALMA. F.

Oil on canvas. H. 85, w. 53 1/4 in. (215.9 × 135.3 cm.).

REFERENCE: *Met. Mus. Bull.*, n.s., XVII (1958), pp. 55, 58, ill. p. 57, notes that it is a signed work by Jacopo Palma the Younger.

EXHIBITED: Arkansas Art Center, Little Rock, 1963, *Five Centuries of European Painting* (Cat., p. 15); Vanderbilt University, Nashville, Tennessee, 1968-1969.

EX COLL. Robert Lehman, New York (by 1955-1957).

GIFT OF ROBERT LEHMAN, 1957.

The Ecstasy of Saint Francis

62.257 (Plate 53)

The large size and rectangular shape of the canvas, as well as the foreshortening and broad brushwork, suggest that this painting was intended to be seen from far below and was almost certainly part of the ceiling of a church. The style shows a strong link with the work of Tintoretto, particularly his compositions for the ceilings of the upper floor of the Scuola di San Rocco in Venice. The pictorial treatment, however, and the broad handling of forms, indicate that it was painted by Palma Giovane, assisted by members of his workshop. The date would seem to fall in the artist's early period, possibly around 1570. There is evidence that the canvas has been cut along the upper edge.

Formerly attributed by the Museum to Jacopo Tintoretto.

Oil on canvas. H. 73, w. 108 1/2 in. (185.4 × 275.6 cm.).

REFERENCES: E. von der Bercken, *Pantheon*, XV (1935), p. 30, ill. p. 27, attributes it to Tintoretto, calls it a ceiling decoration and dates it between 1568 and 1578; and *Die Gemälde des Jacopo Tintoretto* (1942), p. 132, no. 536, pl. 134 // L. Coletti, *Il Tintoretto* (1940), p. 25, pl. 90, attributes it to Tintoretto, and dates it at the same time as the Last Supper in the church of San Polo, Venice // J. Schulz, *Venetian Painted Ceilings of the Renaissance* (1968), pp. 126 f., no. 62, calls it a ceiling painting, and attributes it to Palma Giovane // P.

De Vecchi, *L'opera completa del Tintoretto* (1970), p. 114, no. 210, ill., attributes it to Jacopo Tintoretto with assistants, and dates it about 1574-1575.

EXHIBITED: Cincinnati Art Museum, 1959, *The Lehman Collection*, no. 100 (as Jacopo Tintoretto, lent by Robert Lehman).

EX COLL.: Baron Alfred Buschmann (sale, Glückselig and Wärndorfer, Vienna, Oct. 26-29, 1920, no. 91, as Jacopo Tintoretto); [Italico Brass, Venice, by 1935-after 1940]; Robert Lehman, New York (by 1955-1962).

GIFT OF ROBERT LEHMAN, 1962.

Paolo Veneziano

Also called Paolo da Venezia. Active by 1333; died between 1358 and 1362. There are a number of signed and dated works by Paolo Veneziano. In his late years he had many assistants, including his sons Luca and Giovanni, and it is difficult to determine which pictures are by the master himself, and which were painted by members of his workshop. Paolo's style was based on the late Byzantine tradition; he seems to have had some knowledge of contemporary Riminese painting, and his more advanced works indicate that he was profoundly affected by Gothic art. He can be considered the founder of the Venetian school and his influence was deeply felt throughout the fourteenth century, especially by Lorenzo Veneziano.

The Madonna and Child Enthroned
1971.115.5 (Plate 51)

The Madonna, seated on a marble throne, holds the standing Child on her left knee; perched on her right hand is a green parrot, a medieval symbol of the virgin birth of Christ.[1] This painting is characteristic of Paolo's late phase, in which Byzantine forms are subdued to a certain Gothic linear rhythm, and it should be dated 1350 or somewhat later. The panel was apparently the center of an altarpiece, but it would be difficult to reconstruct the entire work, owing to the fact that many other panels from dismembered polyptychs have survived, panels of the same shape, with identical tooling of the gold ground. Two

panels representing Saint John the Baptist and Saint Mary Magdalen in the Yale University Museum, New Haven (nos. 1959.15.4 a and b), may have belonged to the left side of the same polyptych which included our Madonna. They are of the right size and date, and their earlier provenance from Austria, whence they came to New York through the firm of Silberman and Co., may be an indication that they came from the same complex.

Tempera on wood; gold ground. Over-all, h. 32 1/4, w. 19 3/4 in. (82 × 50.2 cm.); painted surface, h. 31 1/2, w. 18 3/4 in. (80 × 47.6 cm.).

1. For the meaning of the parrot see E. Panofsky, *Problems in Titian* (1969), pp. 28 f.

REFERENCES: The authorities cited below, with the exception of Lazarev and Muraro, attribute this painting to Paolo Veneziano. B. Berenson (in a letter, 1917) // E. Sandberg-Vavalà, *Burl. Mag.*, LVII (1930), p. 178, no. 27, pl. VIII c, notes that the composition is similar to that of the Madonna in Padua, emphasizes the Gothic qualities of the picture, and dates it in the artist's late period // R. Langton Douglas (in a letter, 1942) believes that this picture, in which Byzantine and Gothic elements are combined, is one of Paolo's latest works, and suggests that he may have gone to Florence and been influenced by the paintings of Bernardo Daddi // G. M. Richter (in a letter, 1942) compares it to the Madonna of 1347 in Carpineta, notes that the Gothic quality of the design is more pronounced, and dates the picture in the 1350's // L. Venturi (in a letter, 1942) dates it about 1350, and calls it an ideal synthesis of Byzantine and Gothic elements // W. Suida (in a letter, 1942) compares it to the Madonna of 1347 in Carpineta, calls it an early work and dates it about 1303 // G. Fiocco, *Dedalo*, XI (1931), p. 878 // V. N. Lazarev, *Arte veneta*, VIII (1954), pp. 83 f., 89, dates it in the second half of the 1340's and calls it one of the latest pictures from Paolo Veneziano's workshop // R. Pallucchini, *La Pittura veneziana del trecento* (1964), pp. 41, 43, 49, fig. 119 (wrongly as in the Wildenstein collection, New York), notes the similarity in composition to the Madonnas in Carpineta and Budapest, dates it between 1347 and 1349 // M. Muraro, *Paolo da Venezia* (1969), pp. 42, 121, fig. 1 (wrongly as in the Norton Simon Foundation, Los Angeles), notes that the figure of the Child is similar to the Child in the Carpineta picture, but that the Museum's painting is much weaker, attributes it to a follower of Paolo Veneziano rather than to the master himself, and dates it about 1340-1350.

EXHIBITED: Cincinnati Art Museum, 1921, *Loan Exhibition of Painting and Sculpture by Italian Artists* (lent by Duveen Brothers); Matthiesen Galleries, London, 1939, *Exhibition of Venetian Paintings in Aid of Lord Baldwin's Fund*, no. 1 (lent by Duveen Brothers); Nationalmuseum, Stockholm, 1962-1963, *Konstens Venedig*, no. 38 (lent by Duveen Brothers).

EX COLL.: Carl Anton Reichel, Grossgmain, Austria (1912); [Giuseppe Grassi, Rome, 1917]; [Duveen Brothers, Paris, New York and London, 1917-after 1963]; Edward Fowles, New York (after 1963-1971).

BEQUEST OF EDWARD FOWLES, 1971.

Piazzetta

Giovanni Battista Piazzetta. Born 1683; died 1754. Piazzetta, the son of a woodcarver, spent his early years in his father's workshop, but at the same time he trained in painting in the following of such Venetian artists as Antonio Molinari and Antonio Zanchi. Around 1703 Piazzetta became the pupil of the Bolognese painter Giuseppe Maria Crespi, and he returned to Venice around 1710. There are many documented or signed works by him, as well as a large number of drawings, some of which were made by Piazzetta to be etched by his friend Marco Pitteri.

Piazzetta's style strongly reflects that of Guercino, whose works he had seen during his stay in Bologna. His treatment of light and shadow recalls that of his teacher Crespi. After his return to Venice the paintings of Johann Lys and the mature works of Bernardo Strozzi made an impression on him. Some of Piazzetta's works, such as the Glory of Saint Dominic in the church of SS. Giovanni e Paolo in Venice, have been wrongly attributed to Giovanni Battista Tiepolo, who exerted an influence on Piazzetta and was also in turn influenced by him.

Saint Christopher Carrying the Infant Christ

67.187.90 (Plate 54)

This painting shows the half-length figure of Saint Christopher carrying on his left shoulder the Infant Christ; the saint, leaning on a staff, is understood to be crossing a river. The style is that of Piazzetta, at a date around 1730. The head of the saint

appears again, with more or less substantial changes, in a number of small paintings, representing various saints, either by Piazzetta or his immediate followers.

Oil on canvas. H. 28 1/4, w. 22 1/8 in. (71.7 × 56.1 cm.).

REFERENCES: The authorities cited below attribute this painting to Piazzetta. R. Pallucchini, *L'Arte di Giovanni Battista Piazzetta* (1934), pp. 41, 45 f., note 7, fig. 47, dates it about 1739 or 1740; *Giovanni Battista Piazzetta* (1942), p. 13, pl. 21, dates it shortly after 1727; and *Piazzetta* (1956), p. 28, pl. 54 // H. B. Wehle, *Met. Mus. Bull.*, n.s., VI (1948), pp. 264, 267, ill. // C. Donzelli, *I Pittori veneti del settecento* (1957), p. 188.

EXHIBITED: Museum of Fine Arts, Springfield, Massachusetts, 1934, *Five Eighteenth Century Venetians*, no. 3 (lent by Jacques Seligmann); City Art Museum, St. Louis, 1936, *Special Loan Exhibition of Venetian Painting*, no. 32 (lent by Italico Brass); Cleveland Museum of Art, 1936, *Twentieth Anniversary Exhibition*, no. 163 (lent by Italico Brass).

EX COLL.: [Italico Brass, Venice, by 1934-after 1936]; [Mortimer Brandt, New York]; Miss Adelaide Milton de Groot, New York (1941-1967).

BEQUEST OF MISS ADELAIDE MILTON DE GROOT (1876-1967), 1967.

Carlo Saraceni

Carlo Saraceni; also called Carlo Veneziano. Born 1579 (?); died 1620. After receiving his early training in Venice, where he was born, Saraceni traveled to Rome in 1598, and he remained there until 1619, the year before his death. The large Annunciation in the parish church of the village of Santa Giustina, near Feltre in the Veneto, which is signed by Saraceni and dated 1621, was probably begun by him and finished by his close follower and assistant, the French painter Jean Le Clerc, who also completed a colossal canvas for the Ducal palace in Venice. There are only a few signed works by Saraceni, but many more are given to him in contemporary sources, and these include large altarpieces, as well as highly finished works executed in oil on copper. Saraceni's style reveals the early influence of the sixteenth-century schools of Venice and Brescia, especially the work of the Bassanos, Palma Giovane, Romanino and Savoldo. In Rome Saraceni was at first impressed by the work of Giuseppe Cesari and other local representatives of late Mannerism. Later he became a close follower of the German painter Adam Elsheimer, combining his influence with that of Caravaggio and some of his early followers. His work is related to that of certain Italian Caravaggesque painters, such as Orazio Gentileschi, as well as to the style of the Netherlandish artists of the generation before Rembrandt, such as Jan and Jacob Pynas and Peter Lastman.

Paradise

1971.93 (Plate 55)

In this small painting of Paradise the community of the blessed and the choirs of angels gather around the Trinity. The Father and Son guard the globe of the universe, which is in turn supported by a cherub and an eagle, symbols of the Evangelists Matthew and John. The lion and the bull, alluding to Saints Mark and Luke, flank the two main figures, and on either side kneel the Virgin and John the Baptist. In the foreground and middle distance are the saints and prophets, and it is noteworthy that the female saints, at the left center,

are strictly divided from the male ones. In the center of the picture are Cecilia, playing an organ, and Paul, holding a sword and speaking to Peter, the old bearded man who stands behind him. To the right are Moses, pointing to the tablets of the Ten Commandments, and Lawrence, who is seen from the back, holding the handle of the gridiron. The four Doctors of the Church occupy the left foreground, and it seems likely that the one at the extreme left is a portrait of the man who commissioned the picture. The figure in the center with the banner is George, and to the right is Christopher, wearing a short cloak and carrying a wooden staff. Though the typology and execution are typical of Saraceni, the picture does not show the influence of Elsheimer, or of Caravaggio and his followers, and it was probably painted shortly after the artist arrived in Rome in 1598. The composition is based on that of a large altarpiece by Francesco Bassano, which was installed in its present location in the church of the Gesù in Rome during the pontificate of Clement VIII (1592-1605). The arrangement of the main group and of the symbols of the evangelists, and the treatment of the half-length figure of Moses are further evidence of the influence of Bassano's painting, while the arrangement of the foreground, particularly the disposition of the saints to

the left and right, suggests the influence of late Mannerist prototypes. The Saint Christopher should be compared with a much later painting by Saraceni representing Saint Roch, which is now in the Museum in Naples (no. 857).

Oil on copper. Over-all, h. 21 3/8, w. 18 7/8 in. (54.3 × 48 cm.); painted surface, h. 20 7/8, w. 18 3/8 in. (53 × 46.6 cm.).

REFERENCES: The authorities cited below attribute this painting to Saraceni. P. Pouncey (verbally, 1970) // B. Nicolson, Burl. Mag., CXII (1970), p. 314, fig. 53 (in color), dates the picture in the earliest years of the XVII century, notes the connection with Titian's Gloria in the Prado, and identifies the figure in the lower right corner as Saint Roch, observing that this figure was reused in a later painting now in the Capodimonte Museum, Naples // W. Alt (unpublished opinion, 1971) notes that the design is based upon Francesco Bassano's Adoration of the Trinity in the Gesù in Rome, which he dates 1592, compares the lower part of the composition with a Pentecost by Niccolò Circignani, also in the Gesù, and dates our picture in the first five years of the XVII century.

EX COLL.: the Earl of Harewood, Chesterfield House, London (sale, Sotheby's, London, April 7, 1932, no. 55, as attributed to the Flemish School); private collection (sale, Sotheby's, London, July 16, 1969, no. 128); Patch, London (1969); [Julius H. Weitzner, London, by 1970-1971].

EXCHANGE, BEQUEST OF THEODORE M. DAVIS, 1971.

Andrea Schiavone

Real name Andrea Medulich, or Meldolla. Born 1522 (?); died 1563. Meldolla was nicknamed Schiavone (the Slavonian) because he was of Slav descent and was born in the town of Zadar (Zara) in Dalmatia. He was mainly active in Venice, where his presence is documented from about 1541-1542. The reconstruction of Schiavone's oeuvre is based on three circular pictures in the Libreria in Venice, executed between 1556 and 1560; other pictures ascribed to him in contemporary sources do not seem to fit his accepted artistic personality. Schiavone was also an engraver, and his output in this field is fundamental to the definition of his career, and to his production as a painter. His style combines elements from Titian and from early Italian mannerists. Both his paintings

and his engravings show the influence of Parmigianino, whose pupil or assistant he may have been, but his technique and his treatment of form are based upon the works of Titian from the late 1520's and the 1530's.

The Marriage of Cupid and Psyche
1973.116 (Plates 56, 57)

The subject of this picture is taken from the *Golden Ass* (books iv-vi) by the late antique writer Apuleius, a novel which was extremely popular in cultivated circles in the Italian Renaissance. It represents the marriage of Cupid, the God of Love, with Psyche, in the presence of many gods of Olympus. From their attributes or their positions they should be identified as follows (left to right): Juno, Jupiter, Mars, Venus, and, behind the figure of Psyche, Hebe, an unidentified river god, and an elderly female figure, possibly Vesta. The traditional attribution to Schiavone has never been questioned, but the dating remains doubtful, owing to our present lack of knowledge about the artist's development. This panel would seem to have been executed before the works in the Libreria, that is during the late 1540's or the early 1550's.

The original octagonal shape of the picture suggests that it was part of a ceiling decoration, the corners having been added in the eighteenth century. There is good reason to believe that the ceiling should be identified with one mentioned by Carlo Ridolfi in 1648.[1] Ridolfi describes Schiavone's work in the Castello of San Salvatore di Collalto, commissioned by the counts of Collalto: one of the smaller of the five ceilings represented the story of Psyche and had as a central compartment the Marriage of Cupid and Psyche. Though the other pictorial elements from this ensemble are missing, the identification seems almost certain. The story of Psyche was a favorite subject for ceiling decorations in the sixteenth century. One major example is the Sala di Psiche in the Palazzo del Te in Mantua, which was executed by Giulio Romano and his pupils about 1528. Eight compartments of the

ceiling are octagonal like our painting, while the central one, which is square, shows the marriage of Cupid and Psyche. Schiavone may have seen Giulio's work and imitated certain details, such as the woman carrying a tray with flowers in the scene showing Psyche worshipped as a goddess. The artist chose a related theme, but a different composition, for an unusually large drawing in the Metropolitan Museum (63.93; J. Bean and F. Stampfle, *Drawings from New York Collections*, I, *The Italian Renaissance*, 1965, p. 69, no. 116, ill.).

Oil on wood. Over-all, h. 51 1/2, w. 61 7/8 in. (130.8 × 157.2 cm.); painted surface (with added corners), h. 50 1/2, w. 61 1/2 in. (128.3 × 156.2 cm.).

1. C. Ridolfi, *Delle Meraviglie dell'Arte*, 1648, I, p. 237. For further references to the Castello San Salvatore di Collalto see D. M. Federici, *Memorie trevigiane sulle opere di disegno*, 1803, II, p. 15; L. Crico, *Lettere sulle belle arti trivigiane*, 1833, p. 209; A. Moschetti, *I Danni ai monumenti e alle opere d'arte delle venezie nella guerra mondiale*, II, 1929, p. 27. R. Pallucchini, *Pittura veneziana del cinquecento*, 1944, II, p. IX, pl. 11, attributed a painting of the same subject, now in the Istituto Nazionale di Studi sul Rinascimento, Florence, to Schiavone. J. Schulz, *Venetian Painted Ceilings of the Renaissance*, 1968, p. 124, attributed it to Schiavone's studio and suggested that it might be a relic of the Castello San Salvatore cycle, but neither he nor Pallucchini realized that it was an earlier variant of the present painting.

REFERENCES: The authorities cited below attribute this painting to Schiavone. *London and Its Environs* (1761), II, p. 123, mentions it as being in the dining room at Chiwick House // T. Martyn, *The English Connoisseur* (1766), I, p. 40, mentions it among paintings in the new dining room at Chiswick // B. Berenson, *Ven. Ptrs.* (1897), p. 125, lists it as belonging to the Devonshire collection at Chatsworth; and *Ven. School* (1957), p. 159, pl. 1162 // A. Venturi, *Storia*, IX, part, IV (1929), p. 741 // L. Frölich-Bum, in Thieme-Becker, XXIV (1930), p. 459 // C. Gilbert, *Major Masters of the Renaissance* (Waltham, 1963), pp. 25 f., ill., notes that the theme, a favorite during the Renaissance, combines the

learned and the erotic, and that the forms are reminiscent of Parmigianino, while the color qualities are exclusively Venetian // F. Richardson, *Andrea Schiavone* (doctoral dissertation, New York University, 1971), pp. 259, 389, 435 ff., 683 f., no. 265, fig. 79, calls the picture a larger and substantially elaborated variant of the painting in the Istituto Nazionale di Studi sul Rinascimento, dates it about 1550, and connects it tentatively with the decoration of the Castello San Salvatore; and (unpublished opinion, 1973).

EXHIBITED: Rose Art Museum, Brandeis University, Waltham, Massachusetts, 1963, *Major Masters of the Renaissance*, no. 18 (lent by F. Kleinberger & Co.); Vassar College Art Gallery, Poughkeepsie, New York, 1964, *Sixteenth Century Paintings From American Collections*, no. 16 (lent by F. Kleinberger & Co.).

EX COLL.: Richard Boyle, 3rd Earl of Burlington, Chiswick House, near London (until 1753); Charlotte Elizabeth Boyle, Duchess of Devonshire, Chiswick House (1753-1754); William Cavendish, 4th Duke of Devonshire, Chiswick House (1754-1764); the dukes of Devonshire, Chiswick House and Chatsworth (1764-1950); Andrew Cavendish, 11th Duke of Devonshire, Chatsworth (1950-1958; sale, Christie's, London, June 27, 1958, no. 19); [F. Kleinberger & Co., New York, 1958-1966]; [Lawrence Fleischman, New York, 1966-1973]; [Frederick Mont, New York, 1973].

PURCHASE, GIFT OF MARY V. T. EBERSTADT, 1973.

Sebastiano del Piombo

Real name Sebastiano Luciani. Born about 1485; died 1547. Sebastiano was a close follower of Giorgione, whose style of painting he fully assimilated. After Giorgione's death in 1510 he went to Rome, where he became a friend of Raphael. Later, however, he was won over to the rival faction led by Michelangelo, whose heroic forms continued to dominate Sebastiano's style for the rest of his life. In 1531, in competition with Benvenuto Cellini, Pope Clement VII awarded him the lucrative office of *piombo*, or keeper of the leaden seals, which accounts for the name by which he was always called. Sebastiano was deeply affected by the spiritual crisis in Roman society in the second quarter of the sixteenth century, and, long before the Counter Reformation, a deep and sincere interest in sacred themes was evident in his religious pictures. His style tended toward gravity and simplicity. A number of sixteenth-century Italian artists found ideal models in his dignified portraits, and some of his innovations in the field of portraiture were adopted by foreign schools.

Christopher Columbus
00.18.2 (Plate 58)

According to its inscription this picture represents Christopher Columbus (about 1446-1506); it is considered by some historians to be the most authentic likeness among the many extant and is known as the Talleyrand version. Other likenesses of Columbus have been based upon it. Because of the date on the picture it could not have been painted from life, and the face must have been copied from another portrait, possibly a drawing, since lost. An engraving of the head after a copy apparently of the Museum's portrait of Columbus was made by De Bry in 1595.

The Latin inscription, written in two hexameters, may have been composed for the painter by a poet or man of letters. The composition of the portrait is typical of Sebastiano's artistic repertory.

Signed (at right): SEBASTIANVS/VENETVS FACIT; inscribed and dated (at top): HAEC EST EFFIGIES LIGVRIS MIRANDA COLVMBI ANTIPODVM PRIMVS / RATE QVI PENETRAVIT IN ORBEM 1519 ("This is the admirable portrait of the Ligurian Columbus, the first to enter by ship into the world of the Antipodes, 1519").

Oil on canvas. H. 42, w. 34 3/4 in. (106.6 × 88.3 cm.).

REFERENCES: G. de Jouy, *Le Franc Parleur*, I (1815), p. 151, attributes this painting to Sebastiano and considers it the only authentic likeness of Columbus // A. Neri, *I Ritratti di Cristoforo Colombo* (1893), p. 19, pl. XXIII, attributes it to Sebastiano but does not consider it a portrait of Columbus // N. Ponce de Léon, *The Columbus Gallery* (1893), p. 19, assumes that it is an old copy of a portrait of Columbus // J. B. Thacher, *Christopher Columbus* (1904), pp. 48 ff., ill., assumes that if it is by Sebastiano it must be dated after the death of Columbus // G. Bernardini, *Sebastiano del Piombo* (1908), p. 62, ill. opp. p. 16, considers it a late work by Sebastiano, perhaps a copy of an earlier portrait of Columbus // M. H. Bernath, *New York und Boston* (1912), p. 82, mentions it as a famous portrait of Christopher Columbus // A. de Hevesy, *Christophe Colomb ou l'heureux génois* (1927), pp. 201 f., attributes it to Sebastiano, dates it in his Roman period and doubts whether it represents Columbus // A. Venturi, *Storia*, IX, part V (1932), p. 82, lists it as a portrait of Columbus by Sebastiano // L. Venturi, *Ital. Ptgs. in Amer.* (1933), pl. 503, attributes it to Sebastiano but regards it as derived from another portrait of Columbus // G. Gombosi, in Thieme-Becker, XXVII (1933), p. 73, attributes it to Sebastiano and refers to it as the so-called Portrait of Columbus // H. Tietze, *Meisterwerke Europäischer Malerei in Amerika* (1935), pp. 329 f., pl. 84, attributes it to Sebastiano, assuming that the inscription is not by the painter's hand // B. Berenson, *Pitt. ital.* (1936), p. 449, lists it as a work of Sebastiano and calls it the supposed portrait of Christopher Columbus; *Lotto* (1955), p. 51, calls it a work by Sebastiano and accepts the identification of the sitter as Columbus, comparing it with a portrait of the same subject signed and dated 1512 by Lorenzo Lotto, now in the Ellsworth collection in New York, tentatively suggesting that both artists worked from an older painting or from a drawing, probably in the Vatican in the early XVI century; and *Ven. School* (1957), p. 163, lists it as the so-called portrait of Columbus by Sebastiano // L. Dussler, *Sebastiano del Piombo* (1942), p. 137, fig. 44, attributes it to Sebastiano, as the so-called portrait of Columbus // R. Pallucchini, *Sebastian Viniziano* (1944), pp. 62, 163, pl. 46, attributes it to Sebastiano // N. von Holst, *Die Weltkunst*, XXIII (1953), Jan. 15, p. 7., identifies this portrait with a portrait of Columbus by Sebastiano del Piombo recorded in the inventory of 1685 in the Residenzschloss, Heidelberg; and *Creators, Collectors, and Connoisseurs* (1967), p. 83, fig. 99, suggests that it may have been acquired by Ottheinrich, Prince Elector of the Palatinate (1502-1559).

EXHIBITED: Palais Royal, Paris, 1814, no. 107 (lent by Talleyrand); Chicago, 1893, *World's Columbian Exposition* (lent by the Duke of Valençay); Detroit Institute of Arts, 1951; Art Gallery of Toronto, 1951; City Art Museum, St. Louis, 1952; Seattle Art Museum, 1952; Expo 67, Montreal, 1967, *Man and his World, International Fine Arts Exhibition*, no. 19.

EX COLL.: Otto Heinrich Wittelsbach, Elector Palatine, Heidelberg (died 1559) (?); the Wittelsbachs, Electors Palatine, Heidelberg (?); Karl Ludwig Wittelsbach, Elector Palatine, Residenzschloss, Heidelberg (inventory, 1685); Charles Maurice de Talleyrand-Périgord, Prince of Bénévent (by 1814-1838); Napoléon Louis de Talleyrand-Périgord, Duke of Valençay and Prince of Sagan, Château de Valençay, Indre (1838-1899; sale, Paris, Galerie Georges Petit, May 29-June 1, 1899, no. 14); [T. Lawrie and Co., London, 1899]; [Thos. Agnew and Sons, London, 1900]; J. Pierpont Morgan, New York (1900).

GIFT OF J. PIERPONT MORGAN, 1900.

Lambert Sustris

Also called Zustris, Süster, and Lamberto Fiammingo. Born in Amsterdam between 1515 and 1520; active until 1568. Like many of his Flemish and Dutch contemporaries Lambert Sustris went to Italy, visiting Rome and settling in Venice, probably before 1545. He was a pupil of Titian and is known to have assisted his master, painting landscapes in the backgrounds of his pictures. Old sources mention him as a landscape painter highly appreciated by his contemporaries, and he also painted some fine portraits. In 1548 and 1550 Sustris was in Titian's retinue at the Imperial Diet in Augsburg; later he seems to have settled in Padua. His style combines Titian's classicism with the elegant

mannerism of the painters of Parma and Rome, particularly Francesco Salviati. His works also show a connection with Jacopo Tintoretto, with whom he collaborated, and with such Venetian mannerists as Andrea Schiavone and Bonifazio Veronese.

Portrait of a Nobleman
49.7.14 (Plate 59)

This portrait, once unanimously attributed to Titian, shows in the general composition, as well as in the treatment of the head and hands and in the landscape, a strong link with the art of Lambert Sustris. However, there are certain features of the work that prevent accepting this attribution without reservation: though a large portion of the surface has suffered from old overcleaning, it remains difficult to explain the lack of modeling and the awkward proportions of the forms of the body. Moreover, the execution of the accessories, the chain, the buttons, and the sword pommel, is extremely poor and mechanical. It is not unlikely that the lower part of the picture, with the exception of the hands, was altered or completely repainted by a less competent artist at a rather early date. From the parts of this painting which can be linked with Sustris, the date would seem to fall in the artist's late period, during the 1560's.

Oil on canvas. H. 47 1/2, w. 36 1/2 in. (120.7 × 92.7 cm.).

that G. Fogolari, in a letter, 1925, attributes it to the circle of Moroni, rejecting an attribution to Titian // H. E. Wortham, *Apollo*, XI (1930), p. 350, ill., attributes it to Titian // A. L. Mayer, *Pantheon*, VI (1930), p. 542, ill. p. 544, attributes it to Titian // L. Venturi, *Ital. Ptgs. in Amer.* (1933), pl. 522, attributes it to Titian and dates it about 1552 // W. Suida, *Tizian* (1933), pp. 109, 167, pl. CLXXXIV, attributes it to Titian and dates it in the 1550's // J. Wilde, *Jahrb. der ksthist. Smlgn. Wien*, N. F., VIII (1934), p. 172, note 27, judging from reproductions, hesitantly suggests an attribution to Lambert Sustris // *Duveen Pictures* (1941), no. 158, ill. nos. 158, 159 (detail), attributes it to Titian and dates it around 1550-1555 // R. Pallucchini, *La Giovinezza di Tintoretto* (1950), p. 164, attributes it to Titian, comparing it with Tintoretto's Portrait of a Man, formerly in the Lionel Straus collection and now in the Metropolitan Museum (see p. 00); and *Tiziano* (1969), I, p. 217, accepts Ballarin's attribution (see below) to Lambert Sustris // F. Valcanover, *Tutta la pittura di Tiziano* (1960), II, p. 65, pl. 154, includes it among the works attributed to Titian, but does not consider it autograph; and *L'Opera completa di Tiziano* (1969), p. 140, no. 612, ill., finds Ballarin's attribution to Sustris most convincing // A. Ballarin, *Arte veneta*, XVI (1962), pp. 73, 77, fig. 89, attributes it to Lambert Sustris, notes the influence of Titian, and dates it after 1561; *Atti dell'Istituto Veneto di Scienze, Lettere ed Arti*, CXXI (1963), p. 365, lists it among the works of Sustris; and (verbally, 1970) compares it with two portraits by Sustris dated 1552 in Munich // H. E. Wethey, *The Paintings of Titian*, II (1971), p. 167, pl. 229, rejects the attribution to Titian and believes the picture may be by Sustris // F. Heinemann (verbally, 1973) considers it a work of the XVII century.

REFERENCES: B. Berenson, *Ven. Ptrs.* (1894), p. 126, attributes this painting to Titian; (in a letter, 1925) attributes it to Titian, rejects the identification of the subject as Tommaso Contarini and calls him a general of the Giovanelli family; *Ital. Pictures* (1932), p. 573, lists it as a late work; and *Ven. School* (1957), p. 189 // G. Lafenestre and E. Richtenberger, *La Peinture en Europe, Venise* (n.d.), p. 317, attributes it to Titian // U. Ojetti, *Dedalo*, VI (1925-1926), pp. 133 ff., ill., attributes it to Titian // G. Gronau (in a letter, 1926) attributes it to Titian // F. E. W. Freund, *International Studio*, XC (1928), pp. 40 f., ill. p. 38, attributes it to Titian, and dates it around 1555; and *Cicerone*, XX (1928), p. 254, ill. // C. Ricci, *Rivista del R. Istituto d'Archeologia e Storia dell'Arte*, I (1929), pp. 259 f., note 1, rejects the attribution to Titian, and notes

EXHIBITED: Detroit Institute of Arts, 1928, *Sixth Loan Exhibition of Old Masters*, no. 17 (as Titian, lent by Frank P. Wood); World's Fair, New York, 1939, *Masterpieces of Art*, no. 382 (as Titian, lent by Jules S. Bache); Metropolitan Museum, New York, 1943, *The Bache Collection*, no. 14 (as Titian, lent by Jules S. Bache).

EX COLL.: Prince Alberto Giovanelli, Venice (by 1894-1925); [Italico Brass, Venice, 1925]; [Duveen Brothers, New York, 1925-1927]; Frank P. Wood, Toronto (1927-1928); [Duveen Brothers, New York, 1928]; Jules S. Bache, New York (1928-1944; Cat., 1929, no. 14).

THE JULES S. BACHE COLLECTION, 1949.

Giovanni Battista Tiepolo

Born 1696; died 1770. Tiepolo's style was formed under the influence of Paolo Veronese, Sebastiano Ricci, and Piazzetta, but at an early age he revealed his independent genius as a painter and decorator. His instant popularity won him many commissions, and his prolific activity in Italy, Germany, and Spain was of special significance in the development of the rococo style. In Venice he painted important decorations in the church of the Gesuati, in the Palazzo Rezzonico and the Palazzo Labia, and in the Scuola dei Carmini; he also worked in Vicenza, Udine, Milan, Bergamo, Verona, and elsewhere. His art reached its culmination in the decorations executed between the years 1751 and 1753 in the Residenz (the Prince Bishop's palace) in Würzburg, which are unsurpassed for buoyancy of color and brilliance of draughtsmanship, and astonishing in their treatment of perspective and light. After another period of work in Venice, Tiepolo left in 1762 for Spain, where he spent the remaining years of his life painting for King Charles III in the royal palaces in Madrid and Aranjuez. Tiepolo's work is the last great expression of the Venetian school. He had a number of followers, the best being his son Domenico.

The Investiture of Bishop Harold as Duke of Franconia (sketch)
71.121 (Plate 60)

This picture shows the Emperor Frederick I (Barbarossa) investing Harold of Hochheim, Bishop of Würzburg, with the Dukedom of Franconia (1168). It is closely related to a fresco of the same subject painted in 1751 and 1752 in the Kaisersaal of the Residenz in Würzburg, but there are a number of differences, the most important of which is the vertical, rather than horizontal, format. These differences, however, need not mean that our painting is a version made after the fresco, and it is more than probable that it is the preparatory sketch painted shortly before the large painting. A picture in the Gardner Museum in Boston, representing the Marriage of Frederick I to Beatrice of Burgundy, also related to one of the frescoes in the Kaisersaal, may be considered the companion piece of our picture. Like ours it is vertical, and it is almost identical in size (27 3/4 × 21 1/4 in.) and comparable in quality. A painting in the National Gallery in London (no. 2100), showing the same theme as the Gardner picture, is not by Giovanni Battista Tiepolo but almost certainly by his son Domenico, and it therefore must have been painted after the fresco or after its preparatory sketch. (For Würzburg frescoes and preparatory drawings see P. Molmenti, *G. B. Tiepolo*, 1909, pp. 161 ff., ill.; E. Sack, *Giambattista und Domenico Tiepolo*, 1910, fig. 85; D. von Hadeln, *The Drawings of G. B. Tiepolo*, II, 1928, pls. 132, 133; and A. Morassi, *A Complete Catalogue of the Paintings of G. B. Tiepolo*, 1962, p. 68).

Formerly entitled by the Museum the Triumph of Ferdinand III.

Oil on canvas. H. 28 1/4, w. 20 1/4 in. (71.7 × 51.4 cm.).

REFERENCES: The authorities cited below, with the exception of Sack, attribute this painting to Giovanni Battista Tiepolo. F. Harck, *Repert. für Kstwiss.*, XI (1888), p. 73 // B. Berenson, *Gaz. des B.-A.*, Ser. 3, XV (1896), p. 199; and *Ven. Ptrs.* (1897), p. 128 // E. Sack, *Giambattista und Domenico Tiepolo*

(1910), p. 227, confuses this painting with 07.225. 300, attributed to a follower of Giaquinto, formerly in the Museum's collection // M. H. Bernath, *New York und Boston* (1912), p. 85, calls it the Triumph of Ferdinand III // J. Breck, *Art in Amer.*, I (1913), p. 8, fig. 3 // P. Hendy, *Gardner Mus. Cat.* (1931), pp. 358 f., dates it before 1751 and calls it the companion piece to the Gardner painting // A. McComb, *Baroque Ptrs. of Italy* (1934), p. 127 // M. Goering (in a letter, 1938) dates it about 1750; in Thieme-Becker, XXXIII (1939), pp. 149, 153; and *Pantheon*, XXXII (1944), p. 102, ill. p. 106, calls it a preliminary sketch for the fresco at Würzburg and dates it 1751, shortly before the final version // D. C. Rich, *Paintings, Drawings and Prints by the Tiepolos, Catalogue of the Loan Exhibition* (1938), p. 24, no. 19, calls it not a sketch but a repetition // H. B. Wehle, *Met. Mus. Bull.*, n. s., IV (1946), p. 206, ill. // M. Levey, *The Eighteenth Century Italian Schools* (*National Gallery Catalogue*) (1956), pp. 103 f., calls it perhaps a repetition of the fresco by the artist himself and suggests that there may be some connection in origin between this picture and a painting in the National Gallery in London (no. 2100), which he attributes to Domenico Tiepolo // M. von Freeden and C. Lamb, *Die Fresken der Würzburger Residenz* (1956), pp. 47 f., fig. 32, call it a preparatory sketch for the fresco at Würzburg // A. Morassi, *A Complete Catalogue of the Paintings of G. B. Tiepolo* (1962), p. 33, fig. 316, calls it probably the first idea for the fresco at Würzburg and suggests that the Gardner painting might be its companion piece // A. Pallucchini, *L'Opera completa di Giambattista Tiepolo* (1968), p. 115, fig. 199b, calls it a sketch for the fresco at Würzburg // A. Rizzi, *Mostra del Tiepolo* (1971), p. 124, ill. // G. Passavant, *Kunstchronik*, XXIV (1971), pp. 364 f., fig. 6.

EXHIBITED: Art Institute, Chicago, 1938, *The Two Tiepolos*, no. 19; Honolulu Academy of Arts, Honolulu, Hawaii, 1949-1950, *Four Centuries of European Painting*, no. 14; Art Gallery of Toronto, 1950, *Four Centuries of European Painting*, no. 14; Detroit Institute of Arts, 1951; Art Gallery of Toronto, 1951; City Art Museum, St. Louis, 1952; Seattle Art Museum, 1952; Metropolitan Museum, New York, 1971, *Oil Sketches by 18th Century Italian Artists*, no. 31; Villa Manin, Passariano, 1971, *Mostra del Tiepolo*, no. 57.

EX COLL.: private collection, France; [Léon Gauchez, Paris (?)].

PURCHASE, 1871.

The Glorification of Francesco Barbaro (ceiling)

23.128 (Plate 61)

This picture was painted for the ceiling of a room in the Palazzo Barbaro in Venice and remained in its original position until 1874. For the same room Tiepolo painted four ovals on canvas, now dispersed in various collections: the Offer of Gifts to Juno Lucina, in the Necchi collection in Pavia; Timocleia and the Thracian Commander, in the National Gallery in Washington (Kress coll., K458); Tarquinius and Lucretia, in the Museum in Augsburg; and the Betrothal, in the Museum in Copenhagen. The fact that the subjects of these four paintings are apparently related to marriage is confirmation that the Barbaro represented in our picture is the illustrious Francesco (1398-1454), who wrote a treatise about marriage (*De re uxoria*) which he dedicated to Lorenzo de' Medici. Francesco Barbaro, besides being an eminent scholar, was famous as the defender of Brescia against Milan, served in Venice as a Procurator of Saint Mark, and was chosen Podestà by the cities of Treviso, Vicenza, and Verona. In this picture he holds the baton of a condottiere in his right hand and rests his left hand on the Brescian lion. At his right is Virtue, with a crown of laurel, and above him Fame holds an olive branch and blows a trumpet. Behind the lion is Abundance, or Fortune, with a cornucopia. Further to the right a winged putto holds Barbaro's helmet and armor, while at the left are two women. The figure with two faces, a serpent twined around her arm, and a vase represents Prudence; the other may be Wisdom, who is a frequent companion of Prudence. She holds a seated statuette that probably represents Minerva. A preparatory sketch for the painting was in the Sartorio collection in Trieste (P. Molmenti, *G. B. Tiepolo*, 1909, p. 214, ill.); another sketch, also related to this subject but showing a quite different composition, was in the art market in New York in 1972 (A. Morassi, *A Complete Catalogue of the Paintings of G. B. Tiepolo*, 1962, p. 42, fig. 332). There is an engraving after it by Domenico Tiepolo (A. de Vesme, *Le Peintre-Graveur italien*, 1906, pp. 426 f., no. 104). The style of this picture and the four ovals from the same room indicates a date about 1745-1750.

Oil on canvas. H. 96, w. 183 3/4 in. (253.8 × 466.8 cm.).

REFERENCES: The authorities cited below attribute this painting to Giovanni Battista Tiepolo. H. de Chennevières, *Les Tiepolo* [1898], p. 118 // P. Molmenti, *G. B. Tiepolo* (1909), pp. 83, 258, dates it before 1734 // E. Sack, *Giambattista und Domenico Tiepolo* (1910), pp. 113, 150, no. 6, fig. 101, dates it about 1753, identifies the subject as either Francesco or Marco Barbaro // B. B[urroughs], *Met. Mus. Bull.*, XIX (1924), pp. 14 ff., ill., dates it between 1754 and 1761 // A. McComb, *Baroque Ptrs. of Italy* (1934), pp. 102, 127, fig. 108, dates it shortly after 1753 // M. Goering (in a letter, 1938); and in Thieme-Becker, XXXIII (1939), pp. 148, 153 // A. Morassi, *Tiepolo* (1943), p. 26, dates it in the second half of the 1740's; *G. B. Tiepolo* (1955), p. 21, fig. 27; and *A Complete Catalogue of the Paintings of G. B. Tiepolo* (1962), p. 33, mentions a sketch related to it in a private collection in Paris // W. Suida (verbally, 1945) quotes Sack's doubt as to the identification of the subject // J. Cailleux, *Tiepolo et Guardi* (Paris, 1952), p. 41, publishes the sketch for our ceiling, and notes that there are two other paintings of the same subject, one in the Musée des Arts décoratifs, and the other formerly (1910) in the collection of Eugène Schweitzer in Berlin // A. Pallucchini, *L'Opera completa di Giambattista Tiepolo* (1968), p. 114, fig. 190 A, dates it about 1750 and notes that it is contemporaneous with the frescoes in Palazzo Labia // G. Knox and C. Thiem, *Tiepolo, Zeichnungen von Giambattista, Domenico und Lorenzo Tiepolo* . . . (Stuttgart Exh., 1970), pp. 77, no. 72, 180, no. 205, publish a drawing in the Staatsgalerie in Stuttgart for a ceiling representing the Apotheosis of Francesco Morosini, noting that there is a similarity in composition of the drawing, the ceiling, our painting, and a drawing from the third Würzburg sketchbook, which they attribute to Domenico and Lorenzo Tiepolo, after the allegorical figure to the lower left // A. Rizzi, *Le Acqueforti dei Tiepolo* (Udine Exh., 1970), no. 109, publishes the engraving by Domenico Tiepolo after our painting; *The Etchings of the Tiepolos* (1971), no. 113; and *Mostra del Tiepolo* (1971), pp. 85, 94, fig. 56.

EXHIBITED: Metropolitan Museum, New York, 1938, *Tiepolo and his Contemporaries*, no. 14, and 1970-1971, *Masterpieces of Fifty Centuries*, no. 324.

PROVENANCE: Palazzo Barbaro, Santo Stefano, Venice.

EX COLL.: the Barbaro family, Palazzo Barbaro, Venice; Marcantonio Barbaro, Palazzo Barbaro (until 1860); Elisa Bassi, Palazzo Barbaro (1860-1866); [Vicenzo Favenza, Venice, 1866]; private collection, France (sale, Paris, Hotel Drouot, Feb. 9, 1874, no. 1); Count Isaac de Camondo, Paris (1874-1893; sale, Paris, Galerie Georges Petit,

Feb. 1, 1893, no. 25); Camille Groult, Paris (1893-1908); Manuel de Yturbe, Paris (about 1910); [Heilbrönner, Paris (?)]; [Stanford White, New York, about 1910]; Col. Oliver H. Payne, New York (about 1917).

ANONYMOUS GIFT IN MEMORY OF OLIVER H. PAYNE, 1923.

The Adoration of the Magi (sketch) 37.165.1 (Plate 62)

A similarity in some details has suggested to several scholars that this painting is the preliminary sketch for the large altarpiece that Tiepolo painted in 1753 for the Benedictine abbey in Schwarzach in Franconia, now in the Alte Pinakothek in Munich (no. 1159). Only a few elements are similar, however, and the style is that of a more advanced stage in Tiepolo's development, though possibly still in the 1750's.

Oil on canvas. H. 23 3/4, w. 18 3/4 in. (60.4 × 47.6 cm.).

REFERENCES: The authorities cited below attribute this painting to Giovanni Battista Tiepolo. E. Sack, *Giambattista und Domenico Tiepolo* (1910), pp. 106, 219, no. 498, fig. 92 // P. Molmenti, *Tiepolo* (1911), p. 204, pl. 174, reproduces a drawing after it in the library in Parma // M. Goering (in a letter, 1938); in Thieme-Becker, XXXIII (1939), p. 153; and *Pantheon*, XXXII (1944), pp. 102 ff., ill. p. 107, calls it a sketch for the Adoration of the Magi in Munich and dates it about 1752 // A. Morassi, *Tiepolo* (1943), p. 32, pl. 90; *G. B. Tiepolo* (1955), pp. 29, 147, fig. 40, notes its connection with the Munich picture of 1753 but suggests dating it slightly later; and *A Complete Catalogue of the Paintings of G. B. Tiepolo* (1962), p. 33, observes that it is also close in composition to an engraving signed *Tiepolo* which is said to be based on an altarpiece that the artist painted for Aranjuez // G. Knox, *Catalogue of the Tiepolo Drawings in the Victoria and Albert Museum* (1960), pp. 31, 89, no. 286, connects one of the figures with a drawing in the Victoria and Albert, tentatively concluding that the picture is not a sketch for the Munich altarpiece but an independent work of the late 1750's or the early 1760's // A. Pallucchini, *L'Opera completa di Giambattista Tiepolo* (1968), p. 132, fig. 280, notes that it may be a sketch for a lost painting and dates it about 1763 // G. Passavant, *Kunstchronik*, XXIV (1971), p. 367.

EXHIBITED: Metropolitan Museum, New York,

1938, *Tiepolo and His Contemporaries*, no. 13; Detroit Institute of Arts, 1951; Art Gallery of Toronto, 1951; City Art Museum, St. Louis, 1952; Seattle Art Museum, 1952; Metropolitan Museum, New York, 1971, *Oil Sketches by 18th Century Italian Artists*, no. 26.

EX COLL.: P. A. B. Widener, Ashbourne, Philadelphia (Cat., 1885-1890, part II, pp. 264f., ill., no. 264); [Sedelmeyer Gallery, Paris]; [Sulley and Co., London, 1909]; [Thos. Agnew and Sons, London, 1909-1910; sale, Christie's, London, April 23, 1910, no. 146]; [Gimpel and Wildenstein, Paris, 1910-1911]; the Marquis de Biron, Paris and Geneva (1911-1937).

PURCHASE, ROGERS FUND, 1937.

Saint Thecla Praying for the Plague-stricken (sketch)
37.165.2 (Plate 63)

This is a sketch for the immense painting by Tiepolo commissioned in June, 1758, and installed above the high altar in the cathedral in Este, near Padua, on Christmas day, 1759. Saint Thecla is shown delivering the people of Este from the plague of 1630. In the background is a view of the town of Este with Monselice rising beyond. A drawing for the upper part of the painting showing the group of God the Father and angels was formerly in the collection of Prince Alexis Orloff (D. von Hadeln, *The Drawings of G. B. Tiepolo*, 1928, II, pl. 100). The subject was engraved by Lorenzo Tiepolo (A. de Vesme, *Le Peintre-Graveur italien*, 1906, p. 441, no. 3). A copy after the picture was at one time in the collection of Felix Boix in Madrid, and later in the New York art market.[1]

Oil on canvas. H. 32, w. 17 5/8 in. (81.3 × 44.8 cm.).

1. Sale, Parke-Bernet Galleries, New York, January 23, 1947, no. 240. Its measurements are 31 × 17 1/4 inches, and it was published as the original by F. J. Sánchez Cantón, *Archivio Español de Arte y Arqueologia*, v, 1929, pp. 137 f., fig. 1, and by A. Mendez Casal, *Pantheon*, x, 1932, p. 224, ill. p. 226.

REFERENCES: The authorities cited below attribute this painting to Giovanni Battista Tiepolo. H. de

Chennevières, *Les Tiepolo* (1898), p. 113 // E. Sack, *Giambattista und Domenico Tiepolo* (1910), pp. 132, 167, 216, no. 479 // M. Goering (in a letter, 1938); and in Thieme-Becker, XXXIII (1939), pp. 151, 153, lists it as a sketch for the altarpiece at Este // M. Dazzi, *Arte veneta*, V (1951), p. 184 // F. J. Sánchez Cantón, *J. B. Tiepolo en España* (1953), pp. 25 f., pl. 46, mistakenly identifies our painting with the one formerly in the Boix collection // T. Rousseau, *Met. Mus. Bull.*, n. s., XII (1954), part II, p. 41, ill. // A. Morassi, *G. B. Tiepolo* (1955), pp. 33, 151, 155, pl. VIII (in color), calls it the model for the Este altarpiece and mentions another sketch, by an imitator, in the Kleinberger collection in Paris, and a drawing for the group of the Holy Father with Angels in the Orloff collection; and *A Complete Catalogue of the Paintings of G. B. Tiepolo* (1962), p. 33, calls the Boix version the work of an imitator // A. Pallucchini, *L'Opera completa di Giambattista Tiepolo* (1968), p. 126, fig. 248a, pl. LIV // A. Rizzi, *Mostra del Tiepolo* (1971), p. 135, fig. 69.

EXHIBITED: Metropolitan Museum, New York, 1938, *Tiepolo and His Contemporaries*, no. 16; Palazzo Ducale, Venice, 1951, *Mostra del Tiepolo*, no. 92, and 1969, *Dal Ricci al Tiepolo*, no. 180; Museum of Fine Arts, Boston, 1970, *Masterpieces of Painting in The Metropolitan Museum of Art* (Cat., p. 31); Metropolitan Museum, New York, 1970-1971, *Masterpieces of Fifty Centuries*, no. 325.

EX COLL.: the Infanta Maria Amalia de Borbón, Naples (before 1860); the Infante Don Sebasttán Gabriel de Borbón y Braganza (before 1860-1875); Prince Pedro de Borbón, Duke of Durcal, Paris (1875-1890; sale, American Art Galleries, New York, April 10-11, 1889, no. 60, bought in; sale, Hotel Drouot, Paris, Feb. 3, 1890, no. 47); Schiff, Paris (1890-about 1910); the Marquis de Biron, Paris and Geneva (after 1910-1937).

PURCHASE, ROGERS FUND, 1937.

The Apotheosis of the Spanish Monarchy (ceiling sketch)
37.165.3 (Plate 64)

This painting is the first sketch for the ceiling that Tiepolo painted in the so-called Saleta, or antechamber, in the Royal Palace in Madrid, after completing the throne-room decoration (1764); it must have been done shortly before the ceiling (1764-1766). The subject is an elaborate allegory of the Spanish monarchy, represented in the center as a female figure seated between two lions, probably symbols of the province of Leon.

Below her, by a castle tower, is an old woman personifying Old Castile, and at the extreme right there is a female figure with a caduceus, probably representing Justice. In the group below the castle are Venus, Mars, and Saturn. At the bottom toward the left is Hercules, mythological protector of Spain, with a column symbolizing Gibraltar. Further left a female figure with an elephant's trunk represents Africa while two other personages beside her, with dark skin and feathered headdresses, are probably the two Americas. Above them is Neptune bearing the treasures of the sea, and at the extreme left is a personification of Europe with the attributes of a horse and a temple. The upper part of the painting shows various gods and allegorical figures, among them Fame blowing a trumpet, Jupiter with Aeolus, Victory, Bacchus, and Mercury bringing the royal crown to Spain. The final composition of the fresco shows important changes from this painting. There is a second sketch, formerly in the De Becker-Rothschild collection in New York and now in the collection of Mr. and Mrs. Charles Wrightsman, which is more like the final fresco, but not identical to it. The ceiling, it should be noted, is among those most severely criticized by A. R. Mengs and other exponents of neo-classical taste because of its elaborate allegory.[1]

Oil on canvas. H. 32 1/8, w. 26 1/8 in. (81.6 × 66.4 cm.).

1. For a discussion of the ceiling see A. Ponz, *Viaje de España*, VI, 1776, pp. 19-20, and F. J. Fabre, *Descripción de las alegorías . . . del Real palacio . . .*, 1829, pp. 99-105.

REFERENCES: The authorities cited below attribute this painting to Giovanni Battista Tiepolo. H. de Chennevières, *Les Tiepolo* (1898), p. 111 // E. Sack, *Giambattista und Domenico Tiepolo* (1910), pp. 140, 209, 218, no. 492 // M. Goering (in a letter, 1938); and in Thieme-Becker, XXXIII (1939), pp. 151, 153, lists it as a sketch for the decoration of the guardroom of the Royal Palace in Madrid // F. J. Sánchez Cantón, *J. B. Tiepolo en España* (1953), p. 17, pl. 14, calls the subject the Greatness of Spanish Monarchy and considers it a sketch

for the Saleta in the Royal Palace // A. Morassi, *G. B. Tiepolo* (1955), p. 150; and *A Complete Catalogue of the Paintings of G. B. Tiepolo* (1962), pp. 21, 33, fig. 320, calls it a sketch for the Saleta in the Royal Palace // A. Pallucchini, *L'Opera completa di Giambattista Tiepolo* (1968), p. 132, fig. 279d, calls it a first idea for the Saleta in the Royal Palace.

EXHIBITED: Art Institute, Chicago, 1938, *The Two Tiepolos*, no. 36; Metropolitan Museum, New York, 1938, *Tiepolo and His Contemporaries*, no. 18; Vassar College Art Gallery, Poughkeepsie, New York, 1946, *Seventeenth and Eighteenth Century Italian Paintings*; Society of the Four Arts, Palm Beach, Florida, 1950, *European Masters of the XVII and XVIII Centuries*, no. 26; Colorado Springs Fine Arts Center, 1950-1953; National Gallery of Canada, Ottawa, 1960, *Masterpieces of European Painting, 1490-1840*, no. 31; Metropolitan Museum, New York, 1971, *Oil Sketches by 18th Century Italian Artists*, no. 29.

EX COLL.: Guillaume Dubufe, Paris (until about 1900); [Gimpel and Wildenstein, Paris, 1901]; the Marquis de Biron, Paris and Geneva (1901-1937).

PURCHASE, ROGERS FUND, 1937.

Neptune and the Winds (sketch)
37.165.4 (Plate 65)

This sketch has not been connected with any known painting by Tiepolo, and it may be a study for a ceiling decoration that was never executed. At the left Neptune is shown in his chariot. Below, struggling with his ship and nearly overwhelmed by the pursuing Winds, is a figure, probably Aeneas, whom Neptune saved from shipwreck by ordering the Winds to cease (Virgil, *Aeneid*, I, lines 124 ff.). Above, under the cornice of a circular temple, are Jupiter, a goddess, possibly Juno, and three cupids. The style is that of a very late period in Tiepolo's career.

Oil on canvas. H. 24 1/2, w. 24 1/2 in. (62.2 × 62.2 cm.).

REFERENCES: The authorities cited below attribute this painting to Giovanni Battista Tiepolo. M. Goering (in a letter, 1938); and in Thieme-Becker, XXXIII (1939), pp. 151, 153, calls it a sketch for an unknown ceiling picture of Tiepolo's Spanish

period // G. Knox, *Catalogue of the Tiepolo Drawings in the Victoria and Albert Museum* (1960), p. 92, no. 303, connects the figure of Neptune with a drawing showing Neptune and Tritons // A. Morassi, *A Complete Catalogue of the Paintings of G. B. Tiepolo* (1962), p. 33, fig. 255, calls it a sketch for an unknown ceiling picture of Tiepolo's Spanish period // A. Pallucchini, *L'Opera completa di Giambattista Tiepolo* (1968), p. 133, fig. 283, calls it a sketch for an unknown ceiling picture of Tiepolo's Spanish period.

EXHIBITED: Metropolitan Museum, New York, 1938, *Tiepolo and his Contemporaries*, no. 13; Detroit Institute of Arts, 1951; Art Gallery of Toronto, 1951; City Art Museum, St. Louis, 1952; Seattle Art Museum, 1952; Allentown Art Museum, Allentown, Pennsylvania, 1971, *The Circle of Canaletto*, no. 40.

EX COLL.: Madrazo, Madrid; [Gimpel and Wildenstein, Paris, 1912]; the Marquis de Biron, Paris and Geneva (1912-1937).

PURCHASE, ROGERS FUND, 1937.

The Triumph of Marius
65.183.1 (Plate 68)

This very large canvas represents the triumph of the Roman general Gaius Marius over the African king Jugurtha, an event that took place on January 1, 104 B.C. The Latin inscription in the cartouche at the top of the painting, which identifies the subject precisely, is taken from the work of the Roman writer Lucius Annaeus Florus (*Epitome rerum romanorum*, xxxvi, 17) of the second century A.D. Marius is shown riding a triumphal chariot drawn by four horses; in his right hand he holds the general's baton, in his left a palm leaf, symbolizing victory. The defeated king Jugurtha, his hands bound in chains, walks before the chariot. A young boy playing a tambourine leads a group of Romans carrying the spoils of victory: a metal vase, and, on a litter covered with an oriental carpet, dishes in precious metals, a bowl containing coins, and a marble bust of a woman crowned with diminutive walls and towers, representing one of the conquered towns. The figures to the left carry other precious art objects. Behind the chariot

walk several soldiers, one of them blowing a trumpet, while on the walls in the distance is a group of onlookers from the Roman populace. Flaming torches, insignia of the Roman army, spears and standards, one including the initials of the Roman power, S.P.Q.R., are silhouetted against the sky. Other details, such as the branches of laurel and olive and the medallion attached to the spear in the center, allude to the victorious conclusion of the war. As noted by Morassi (see Refs. below, 1941), the half-length male figure at the extreme left looking out toward the spectator is surely a self-portrait of Giovanni Battista Tiepolo, who, at the time of the execution of this work, was thirty-three years old.

This picture and the two following are part of a cycle of ten paintings executed by Tiepolo for the *salone* of the Ca' Dolfin, the palace of the Dolfin family in Venice, near S. Pantaleone. The palace was the seat of Dionisio Dolfin (died 1734), Patriarch of Aquileja, one of Tiepolo's early patrons, for whom he executed various important commissions in Udine. Three of the series are now in the Metropolitan, five are in the Hermitage in Leningrad (nos. 7471-7475), and two are in the Kunsthistorisches Museum in Vienna (nos. 6797, 6798). The subjects are no. 1, the Triumph of Marius, here catalogued; no. 2, the Triumph of a Roman General or Emperor (Hermitage, no. 7475); no. 3, Volumnia and her Children before Coriolanus (Hermitage, no. 7472); no. 4, Mucius Scaevola before Porsenna (Hermitage, no. 7473); no. 5, Quintus Fabius Maximus before the Senate of Carthage (Hermitage, no. 7471); no. 6, the Dictatorship offered to Cincinnatus (Hermitage, no. 7474); no. 7, the Death of Lucius Junius Brutus (often called the Death of Eteocles and Polyneices, Vienna, no. 6798); no. 8, Hannibal contemplating the severed Head of Hasdrubal (Vienna, no. 6797); no. 9, the Capture of Carthage (65.183.2); no. 10, the Battle of Vercellae (no. 65.183.3). The inscriptions, where they are preserved, follow the Epitome of Florus more or less faithfully. Some are missing (see nos. 9, 10), and in others the lettering is partially

effaced, making the exact identification of the subject very difficult (see no. 2). The iconographic significance of the subjects has not been investigated and remains obscure, but it is more than likely that the choice was Dionisio Dolfin's, and that the series was intended to show outstanding examples of military valor and moral virtue drawn from the history of the ancient Romans, whom the Venetians claimed as their ancestors, and whose deeds they sought to emulate. In fact, subject matter of this kind enjoyed considerable popularity throughout the first half of the eighteenth century.

The shaped stucco frames that originally surrounded the pictures still exist, and it has been possible to ascertain, in the main, their original disposition in the hall. The two most important paintings (nos. 1, 2) were at the centers of the main walls. On either side of each of them was one of the narrow uprights, all of the same size and shape, which are now divided between Vienna and Leningrad, while the remaining two were placed on the outer wall between the three windows overlooking the canal (see Refs., E. de Liphart, 1910). The Museum's square canvases (nos. 9, 10) were placed on the fourth wall on either side of the entrance door. The Triumph of Marius bears the date 1729, written in the oval medallion attached to a spear in the upper center of the composition, and the entire series is mentioned in situ by 1732. The boy with the tambourine and the other figures in the same group at the lower right show the influence of Piazzetta. Several preparatory models for canvases in this series have been identified. One, for the Mucius Scaevola, is in the Musée Magnin in Dijon; a second, for the Dictatorship offered to Cincinnatus, was formerly in the Caspari collection in Munich, and a third one, with Fabius Maximus before the Senate of Carthage, was in the collection of Mrs. Derek Fitzgerald and later in the London art market. When Fragonard visited Venice in July of 1774 he made at least four drawings after the decorations in the Ca' Dolfin, which are now in the collection of the Norton Simon Foundation in Los Angeles. Two of them record details from the Triumph of Marius and the Capture of Carthage.[1] The paintings are the most significant documents of Tiepolo's early period, and are among the major achievements of his entire career.

Inscribed (on cartouche top center): CO-PERTVM CATENIS/IVGHVRTAM/POPVLVS RO-MANVS ASPEXIT ("The Roman people behold Jugurtha covered by chains").

Dated (on oval medallion, upper center): 1729.

Oil on canvas, mounted on a rectangular stretcher. Over-all, h. 214 3/4, w. 127 3/4 in. (545.5 × 324.5 cm.).

1. A. Ananoff, *L'oeuvre dessiné de Jean-Honoré Fragonard*, IV (1970), p. 215, nos. 2634 (as the Triumph of Aurelius), and 2635 (as the Siege of Palmyra), figs. 667, 668.

REFERENCES: The authorities cited below attribute these paintings to Giovanni Battista Tiepolo. V. da Canal, *Vita di Gregorio Lazzarini* (1732), 1809 ed., p. xxxiiii, mentions that in the main hall of the Ca' Dolfin there are ten very large pictures of different heights in which are represented the battles and triumphs of Coriolanus and other scenes from Roman history, but does not name the artist // P.-J.-O. Bergeret de Grancourt and H. Fragonard, *Journal inédit d'un voyage en Italie* (1773-1774), 1895 ed., p. 386, mention ten pictures by Tiepolo in the Palazzo Dolfin // G. Moschini, *Della letteratura veneziana* (1806), III, p. 75, calls them early works // H. de Chennevières, *Les Tiepolo* [1898], p. 18, calls them early works // H. Modern, *Giovanni Battista Tiepolo* (1902), pp. 22 f., 53, notes the influence of Piazzetta and dates the series in Tiepolo's early period // P. Molmenti, *Tiepolo* (1909), pp. 276 f., ills. opp. p. 266, discusses the ten pictures formerly in the Palazzo Dolfin, notes their present location, and quotes a reference to them in the period between 1780 and 1792 in the letters of Luigi Ballarini, Andrea Dolfin's agent, which are preserved in the Museo Correr in Venice // E. Sack, *Giambattista und Domenico Tiepolo* (1910), pp. 33 ff., 151, 203, figs. 17, 18, 20, dates the series about 1720, suggests that an oil sketch in the Brera in Milan might be an early study for the Battle of Vercellae, which he identifies as a Battle between Romans and Asians, notes that there is a later drawing by Tiepolo after one of the figures in the Capture of Carthage, which he calls the Storming of Palmyra, and describes Tiepolo's relations with the Dolfin family // E. de Liphart,

in *Les anciennes Ecoles de Peinture dans les Palais et Collections privées Russes* ... (1910), p. 38, gives the history of the sale of the ten paintings from the Ca' Dolfin, notes that they were in situ in 1870, considers them early works by Tiepolo still showing the influence of Piazzetta // J. V. Derschau, *Der Cicerone*, VII (1915), pp. 13 ff., figs. 1-3, identifies the Triumph of Marius as the Triumph of Aurelianus and the Capture of Carthage as the Taking of Palmyra, dates the series about 1720 // P. M. Arese, *Illustrazione italiana*, LII (1925), pp. 259 ff., ills. describes the paintings when they were in the Castiglioni collection, dating them about 1720 // G. Fiocco, *La Pittura veneziana del seicento e del settecento* (1929), p. 58, dates them about 1725; and *Burl. Mag.*, LVIII (1931), pp. 168 ff., ills., erroneously speaks of twelve pictures, notes the alterations in their dimensions, and calls them early works // M. Goering, *Italienische malerei des siebzehnten und achtzehnten jahrhunderts* [1936], p. 31, pl. 81 (Capture of Carthage), dates the series about 1720 // W. Arslan, *Critica d'arte*, I (1936), p. 250, dates the series 1725-1726 // M. I. Shcherbacheva, *Tiepolo's Pictures of the Venice Dolfino Palace at the Hermitage Museum* (1941), pp. 3 ff., pls. 9-11, discusses the history of the series, notes the connection between the family history of the Dolfins and the heroic subject matter, accepts Fiocco's dating, and mentions the engravings by St. Non and the drawings by Fragonard // A. Morassi, *Le Arti*, IV (1941-1942), pp. 259 ff., figs. 2-4, 12-15 (details), discusses the history of the series, which he dates between 1726 and 1730, notes the alteration in size of certain of the canvases, deduces their original positions from the stucco frames still to be seen in Palazzo Dolfin, and identifies the self-portrait of Tiepolo in the Triumph of Marius; *Tiepolo* (1943), p. 16, figs. 30 (Capture of Carthage), 31 (detail, Capture of Carthage); *G. B. Tiepolo* (1955), pp. 11 f., fig. 15 (Battle of Vercellae); and *A Complete Catalogue of the Paintings of G. B. Tiepolo* (1962), pp. 15, 34, figs. 294 (Triumph of Marius), 306 (Capture of Carthage) // R. Pallucchini, *La Pittura veneziana del settecento* (1960), p. 71, accepts Morassi's dating of the series // T. Pignatti, *Disegni dei Guardi* (1967), no. XXIX v, pl. XXIX v, publishes a drawing by Guardi in the Museo Horne in Florence, inv. no. 5653, after a group of soldiers in the Capture of Carthage // A. Pallucchini, *L'Opera completa di Giambattista Tiepolo* (1968), pp. 91 f., nos. 48c-e, ills., dates them between 1725 and 1730 // G. Knox and C. Thiem, *Tiepolo, Zeichnungen von Giambattista, Domenico und Lorenzo Tiepolo* ... (Stuttgart, 1970), p. 127, no. 146, publish the drawing in the Staatsgalerie in Stuttgart related to the rider to the right in the Capture of Carthage, mention two others in the Heinemann and von Hirsch collections, note that the drawings should not be dated earlier than 1740, and that the Capture of Carthage and the Battle of Vercellae might have been painted a good deal later than the other canvases in the series // J. Cailleux, in *Atti del Congresso internazionale di studi sul Tiepolo* [1972], pp. 96, 100, note

29, ills. pp. 87, 89, 91, discusses the alterations in the sizes of the canvases, mentions the date of 1729 on the Triumph of Marius, and refers to Tiepolo's association with the Dolfin family // F. Stampfle and C. D. Denison, *Drawings from the collection of Lore and Rudolf Heinemann* (1973), pp. 51 f., no. 82, attribute the drawing after the fallen warrior in the Capture of Carthage to Giovanni Domenico Tiepolo after his father's work, dating it about 1754.

PROVENANCE: Palazzo Dolfin, San Pantaleone, Venice (until 1870).

EX COLL.: Dionisio Dolfin, Patriarch of Aquileja, Palazzo Dolfin, Venice (until 1734); the Dolfin family, Venice (from 1734); [Guggenheim, Venice, 1870]; Eugen Miller von Aichholz, Vienna (1870-after 1915; sale, Paris, Hotel Drouot, April 15, 1876, nos. 1, 2, 4; bought in if sold); Camillo Castiglioni, Vienna (by 1925-after 1931); Stefan Mendl, Saranac Lake, New York (by 1934-1955); Estate of Stefan Mendl, New York (1955-1965).

PURCHASE, ROGERS FUND, 1965.

The Capture of Carthage
65.183.2 (Plate 66)

This canvas has traditionally been thought to represent the capture of Carthage by the Romans under the leadership of Publius Cornelius Scipio Emilianus, an event which took place in 146 B.C., and, although the Latin inscription in the cartouche at the top has been obliterated, making a precise identification impossible, the presence of the insignia indicates that the theme was drawn from Roman history. It is, however, more probable that in this picture and the following one, the only two battle scenes in the series, Tiepolo depicted events from the life of a Roman hero of the early fifth century B.C., Gaius Marcius Coriolanus. Vicenzo da Canal, writing in 1732, shortly after the completion of the series, described the subject matter as the battles and triumphs of Coriolanus and other Roman histories, and Coriolanus is represented with Volumnia and her children in one of the paintings in the Hermitage (no. 7472). The figure on horseback at the extreme right as well as the dead soldier in the left foreground were copied by Giandomenico Tiepolo in a large mural in the church of

Saints Faustino and Giovita in Brescia, representing the two saints defending the town against the army of Niccolò Piccinino. This fresco, which can be dated 1745-1755, includes other direct borrowings from the work of Gianbattista: the figure of one of the saints derives from that of Queen Zenobia in a canvas in the National Gallery, Washington (no. 1404), and three of the soldiers in the lower left corner are drawn from another picture from the Ca' Dolfin now in the Metropolitan Museum (65.183.3). A drawing in the Graphische Sammlung in the Staatsgalerie in Stuttgart (inv. no. 1469) is closely related to the two larger figures on the right of our canvas, while another drawing, in the collection of Dr. Rudolf J. Heinemann in New York, is related to the dead soldier in the foreground. The style of these two drawings, as well as of a third sheet connected with our number 65.183.3, is not characteristic of Giovanni Battista Tiepolo's early period, and they should be dated much later, possibly around the middle of the century. It is likely that they are copies made by the artist himself after his own paintings, and that they were used by the workshop, as by Giandomenico for the fresco in Brescia. There is also a drawing by Guardi in the Museo Horne in Florence (inv. no. 5653) after the group of soldiers in the center of the picture.

Oil on canvas, mounted on a rectangular stretcher. Over-all, h. 169 1/2, w. 148 1/4 in. (430.5 × 377.2 cm.).

REFERENCES: See above under the Triumph of Marius.

PROVENANCE: See above under the Triumph of Marius.

EX COLL.: See above under the Triumph of Marius.

PURCHASE, ROGERS FUND, 1965.

The Battle of Vercellae
65.183.3 (Plate 67)

The subject of this picture has been identified as the battle of Vercellae, where Gaius Marius, the Roman general, defeated the invading Cimbrian Gauls in 101 B.C. Without an inscription the identification cannot be conclusive, but it should be noted that the same hero is represented in another painting from the series (65.183.1). The group of two soldiers fighting in the lower left corner and the figure on horseback behind them were also used by Giandomenico Tiepolo in his fresco in the church of Saints Faustino and Giovita (see above, 65.183.2). A drawing in the Robert von Hirsch collection in Basel is connected with the large figure of a rider on the left; it is characteristic of Giambattista's work around 1750 (for the problems raised by this drawing see above, 65.183.2).

Oil on canvas, mounted on a rectangular stretcher. Over-all, h. 170, w. 148 in. (431.8 × 375.9 cm.).

REFERENCES: See above under the Triumph of Marius.

PROVENANCE: See above under the Triumph of Marius.

EX COLL.: See above under the Triumph of Marius.

PURCHASE, ROGERS FUND, 1965.

Workshop of Giovanni Battista Tiepolo

Thirteen Allegorical Frescoes
43.85.12-24 (Plates 69-79)

These frescoes, all in the same style, were presumably painted at about the same time as part of one commission. They may be minor elements from a much larger decorative ensemble, now dispersed, of which

the major sections are still unidentified. The frescoes, painted in tones of gray or brown with rosy touches in the large panels, include a circular painting (Virtue and Abundance), almost certainly, from its size, the center of a ceiling; four large upright panels (Liberal Arts); four horizontal panels (the four Continents), possibly overdoors in the same room as the ceiling; and four oval panels (four Virtues), probably, because of their different coloring, part of a different scheme in another room, as overdoors or ceiling decorations. Some idea as to the placing of the large panels is given by differences in the shadows cast by the bases of the pedestals, in the shadows and shape of the rectangular openings under the architraves, and, in Geometry and Grammar, in the shadows cast by the figures. These differences make it possible to group Geometry with Grammar and Metaphysics with Arithmetic as balancing pairs. In addition, Grammar and Geometry each show at one edge the tips of the capital and base of another column in front. It seems likely that these two panels flanked a prominent architectural element, possibly the main doorway of the room, and that Tiepolo tried to merge the ornament with the actual architecture. Metaphysics and Arithmetic were probably on the facing wall; the bas-reliefs above the figures are not clear enough to permit identification of their subjects. It is said that these frescoes came from a villa near the Brenta River and were removed in 1914 or 1915, when buildings in this locality were threatened with destruction in the war, but this cannot be verified, nor is the suggested provenance from the Villa Valier Bembo at Mira (see Refs., M. Precerutti Garberi, 1968) sustained by any documentary evidence.

The style of the paintings is very close to Giovanni Battista Tiepolo's during the 1750's, and they may have been designed by him, but the quality of the execution and certain characteristics of the forms indicate the work of pupils or assistants. The allegories of the four Continents and the four ovals, which are of inferior quality,

are in the manner of Domenico Tiepolo. The architectural elements in the large panels were certainly executed by a specialist in painted perspectives. It should be noted that the surface of the overdoor representing the allegory of America has been hammered in the way customary to attach a new layer of plaster. This may indicate that the section of the room where this fresco was placed had been altered, or that the fresco itself had been redone, with a different subject or composition.

69 - 12. Virtue and Abundance. The winged figure of Virtue, with a sun on her breast, follows the same iconography that Tiepolo used in the Glorification of Francesco Barbaro (see p. 56), except that here she carries a lance (as she does in Domenico Tiepolo's Virtue and Wisdom; see p. 66). The figure of Abundance may also be Fortune, in accordance with the Latin motto, *Virtute duce, comite Fortuna* (With Virtue in command, Fortune follows). Diam. 114 in. (289.6 cm.).

70 - 13. Metaphysics. Inscribed (on base of statue): *METAFISICA*. H. 146, w. 57 7/8 in. (370.8 × 147 cm.).

70 - 14. Arithmetic. Inscribed (on base of statue): *ARITMETICA*. H. 146, w. 57 7/8 in. (370.8 × 147 cm.).

71 - 15. Geometry. Inscribed (on base of statue): *GEOMETRIA*. H. 146, w. 57 7/8 in. (370.8 × 147 cm.).

71 - 16. Grammar. Inscribed (on base of statue): *GRAMMATICA*. H. 146, w. 57 7/8 in. (370.8 × 147 cm.).

72 - 17. Asia. H. 32 1/4, w. 41 3/4 in. (81.9 × 106.1 cm.).

73 - 18. Africa. H. 32 1/4, w. 42 3/4 in. (81.9 × 108.6 cm.).

74 - 19. Europe. H. 32 1/4, w. 42 3/4 in. (81.9 × 108.6 cm.).

75 - 20. America. H. 32 1/4, w. 42 3/4 in. (81.9 × 108.6 cm.).

76 - 21. Prudence. Inscribed with Greek and Latin characters along the upper edge.

Oval; h. 49 1/8, w. 36 1/4 in. (124.8 × 92.1 cm.).

77 - 22. A Virtue, possibly Patriotism. Patriotism is usually represented as a female figure holding two crowns, one of oak leaves and the other of weeds. The crowns here are too sketchy to identify the leaves. Inscribed with Greek characters along the upper edge. Oval; h. 49 3/8, w. 36 1/4 in. (125.4 × 92.1 cm.).

78 - 23. Temperance. Inscribed with Greek characters along the upper edge. Oval; h. 55 7/8, w. 48 in. (142 × 121.9 cm.).

79 - 24. Fortitude. The attribute of this figure is rather unusual, a broken obelisk or a corner of a pyramid, instead of a column. It may therefore symbolize the Glory of Princes, according to baroque iconography derived from a medal (coin?) of the emperor Hadrian. Inscribed with Greek and Latin characters along the upper edge. Oval; h. 45 5/8, w. 33 1/2 in. (115.9 × 85.1 cm.).

REFERENCES: A. Morassi, *A Complete Catalogue of the Paintings of G. B. Tiepolo* (1962), p. 33, figs. 375 (Arithmetic), 376 (Grammar), 377 (Metaphysics), 378 (Geometry), 406 (Virtue and Abundance), calls these frescoes the work of Domenico Tiepolo, possibly with other assistants in the ornamental parts, after sketches or drawings by Giovanni Battista Tiepolo and done under his direction, notes the similarity to the feigned statues formerly in the Palazzo Trento-Valmarana at Vicenza, destroyed in 1945, and to the one from the Villa Cornaro now in the Treviso Museum, dates the group

tentatively between 1750 and 1760, and calls the circular composition the Allegory of Truth and Abundance, suggesting hesitantly that it was originally an overdoor // T. Pignatti (verbally, 1965) attributes the four Continents and four ovals to Domenico Tiepolo // G. B. Tiozzo, *Gli affreschi delle ville del Brenta* (1968), p. 86, tentatively suggests that the frescoes once decorated the central room of the Villa Valier alla Chitarra // M. Precerutti Garberi, *Affreschi settecenteschi delle Ville Venete* (1968), pp. 141 f., figs. 89 (Allegory of Truth and Abundance), 90 (Geometry), 91 (Grammar), 92 (Vanity), 93 (Fortitude), quotes Prof. Tiozzo's hypothesis that the frescoes were painted for a wing, now destroyed, of the Villa Valier Bembo at Mira, notes the difference in quality of the various frescoes, agrees with Morassi that they were executed by Domenico Tiepolo and assistants working from designs of Giovanni Battista Tiepolo, dates them with Tiepolo's mature works, about 1754-1757, and believes that they were completed in the years just prior to the Tiepolos' departure for Spain // A. Mariuz, *Giandomenico Tiepolo* (1971), p. 128, pls. 134-137 (four Continents), tentatively attributes the four uprights and the circular painting, which he calls Truth and Abundance, to Giovanni Battista Tiepolo, gives the four ovals and the four horizontal pictures to Domenico Tiepolo, and dates the complex about 1757-1760; compares the four Continents with the overdoors of the Stanza dell'Olimpo in the Foresteria of the Villa Valmarana ai Nani // A. Pallucchini, *L'Opera completa di Giambattista Tiepolo* (1968), p. 136, lists them among works variously attributed, noting that Morassi gave the designs to Giovanni Battista Tiepolo.

PROVENANCE: Villa Valier Bembo, Mira (?) (until about 1915).

EX COLL.: [Durr Freedley, New York, about 1915]; Mrs. Grace Rainey Rogers, New York (about 1915-1943).

BEQUEST OF GRACE RAINEY ROGERS, 1943.

Giovanni Domenico Tiepolo

Giovanni Domenico Tiepolo. Born 1727; died 1804. Domenico, the son of Giovanni Battista Tiepolo, imitated the style of his father and assisted him in many of his principal decorations, including those in Udine and in the Villa Valmarana in Vicenza. He accompanied him in 1751 to Würzburg and in 1762 to Spain. Domenico also had numerous independent commissions, including work in Dresden and Genoa and a notable series of scenes illustrating the Way of the Cross for the Oratorio di San Paolo in Venice. While his types and compositions are derived directly from those of Giovanni Battista, Do-

menico never achieved the clear tonality or the brilliance and exuberance of his father's work. However, Domenico's own artistic nature seems to have developed in the years after his father's death. His drawings reveal a new feeling for composition, more fantastic and witty subject matter, and a cultural background and experience outside the Venetian tradition.

The Sacrifice of Isaac
71.28 (Plate 80)

Although this painting is in some respects similar to the work of Giovanni Battista Tiepolo, the execution and the range of color, as well as certain characteristic passages, reveal the hand of Domenico. It was probably painted in the late 1750's. The subject is taken from the Old Testament (Genesis, 22.9-13). Mariuz (see Refs., below) has suggested that it may be the companion piece of the Sacrifice of Iphigenia in the Schloss Museum in Weimar and, indeed, the two paintings are very close in style and pictorial treatment. However, such a conclusion seems unlikely in view of the vertical format and pagan theme of the Weimar picture.

Formerly attributed by the Museum to Giovanni Battista Tiepolo.

Oil on canvas. H. 15 3/8, w. 21 in. (30 × 53.3 cm.).

REFERENCES: F. Harck, *Repert. für Kstwiss.*, XI (1888), p. 73, attributes this painting to Giovanni Battista Tiepolo // B. Berenson, *Ven. Ptrs.* (1897), p. 128, lists it as a work by Giovanni Battista // E. Sack, *Giambattista und Domenico Tiepolo* (1910), p. 308, no. 65, attributes it to Domenico Tiepolo and dates it 1753 // M. H. Bernath, *New York und Boston* (1912), p. 85, calls it the Sacrifice of Abraham, and attributes it to Giovanni Battista // J. Breck, *Art in Amer.*, I (1913), p. 12, ill., attributes it to Giovanni Battista // L. Venturi, *Ital. Ptgs. in Amer.* (1933), pl. 599, calls it a late work by Domenico // A. McComb, *Baroque Ptrs. of Italy* (1934), p. 127, attributes it to Giovanni Battista // H. Voss (in a letter, 1935) attributes it to Domenico, closely imitating the style of Giovanni Battista, and dates it at the time of the Würzburg frescoes // M. Goering (in a letter, 1938) considers it close to Domenico but not by him; and in Thieme-Becker, XXXIII (1939), p. 160, hesitantly lists it among the works of Domenico //

R. Pallucchini, *La Pittura veneziana del settecento* (1960), p. 260, pl. 686, attributes it to Domenico, tentatively suggesting a date shortly before his departure for Spain in 1762 // A. Mariuz, *Giandomenico Tiepolo* (1971), pp. 32 f., 128, 151, pl. 53, accepts it as the work of Domenico, dates it about 1753, and believes it may be a companion piece to the Sacrifice of Iphigenia in the Schloss Museum in Weimar.

EXHIBITED: Metropolitan Museum, New York, 1938, *Tiepolo and his Contemporaries*, no. 31; Allentown Art Museum, Allentown, Pennsylvania, 1971, *The Circle of Canaletto*, no. 42.

EX COLL. the Duchess of Berry, Palazzo Vendramin-Calergi, Venice.

PURCHASE, 1871.

Virtue and Wisdom
07.225.297 (Plate 81)

In the center of this allegorical group are winged Virtue with the sun on her breast, holding a lance, and Wisdom, holding a scepter and a burning lamp. At their right, half hidden by clouds, is the figure of Abundance or Fortune, holding a cornucopia. Below, a despairing woman, possibly representing Sin or Vice, is tormented by Cupid with a torch. There are vague figures of gods and goddesses in the background. In this painting Domenico's style is very close to that of his father.

Formerly attributed by the Museum to the workshop of Giovanni Battista Tiepolo.

Oil on canvas. H. 21, w. 15 3/4 in. (53.3 × 40 cm.).

REFERENCES: J. Breck, *Art in Amer.*, I (1913), pp. 12 ff., fig. 6, calls this painting a sketch by Giovanni Battista Tiepolo for a ceiling in the Palazzo Barbarigo in Venice and dates it about 1740, probably earlier than a similar sketch in the Poldi-

Pezzoli Museum in Milan // M. Goering (in a letter, 1938) calls it a work from Tiepolo's shop, but suggests that the lower group may be by Domenico Tiepolo; and in Thieme-Becker, xxxiii (1939), p. 160, lists it among the works of Domenico Tiepolo // A. Morassi, *A Complete Catalogue of the Paintings of G. B. Tiepolo* (1962), p. 33, rejects the attribution to Giovanni Battista Tiepolo, and agrees with Goering's attribution to Domenico.

EXHIBITED: Metropolitan Museum, New York, 1971, *Oil Sketches by 18th Century Italian Artists*, no. 36.

EX COLL.: Georges Hoentschel, Paris; J. Pierpont Morgan, New York.

GIFT OF J. PIERPONT MORGAN, 1906.

The Glorification of the Giustiniani Family (ceiling sketch)
13.2 (Plates 82, 83)

This painting is the sketch, or modello, that won for Giandomenico Tiepolo the commission to paint the central portion of the ceiling in the Salone del Maggior Consiglio of the Ducal Palace in Genoa, the seat of the Genoese Doge, also called the Royal Palace. The fresco, described in detail in contemporary documents, is an allegorical representation of the deeds of the Genoese branch of the Giustiniani family, who patronized this major artistic enterprise, paying for the contest and for the execution of the work.[1]

The central figure, a personification of the Ligurian Republic, is seated on a throne at the head of the stairs, flanked by Justice and by the famous Lanterna, the lighthouse at the entrance to the port of Genoa. At the top of the staircase are marble statues of Hercules and Minerva and just below, to the left, is the kneeling figure of Jacopo Giustiniani, dressed in armor, and accompanied by winged Victory. He presents to the Ligurian Republic the sword surrendered to him by King Alfonso of Aragon, after the defeat of the king in the naval battle of Ponza in 1435. To the right are two banners with the coats-of-arms of the Giustiniani family (a crowned eagle over a tower), and of the city of Genoa (a crowned

red cross). The turbaned female figure in Greek costume near the lower left corner represents the island of Chios; to her left are the heraldic emblems of the Giustiniani family, and she stands in front of the tower of an imposing fortress, alluding to the fortifications built on the island when it was under their rule. The emblems and inscriptions on her scroll, the initials "V. I.", and the date 1562 surely refer to the rule of Vincenzo Giustiniani, who was the governor of the town on the island before it fell to the Turks. Near the upper left corner are the eighteen Giustiniani youths who were massacred by the Turks in 1566 because they refused to abandon their Christian faith, and above them are angels with the palms of martyrdom. The pediment of a church, at the left center, and the allegorical figure of Christian Faith, holding a cross and chalice, are symbols of the many churches the Giustiniani erected on Chios before its capture by the Muslims. In the upper right corner a ship full of rich merchandise is unloaded at the foot of a great rock that must stand for the Appennine mountains. Seated on this rock is the double-faced god Janus, symbol of the city of Genoa, and near him are the three female allegorical figures of Justice (holding a balance and a sword), Commerce (holding a cock), and Fortitude (holding two columns). The figure with the cock could also be interpreted as Vigilance or Watchfulness. Just below, Neptune offers Janus the treasures of the sea. Other minor allegorical figures scattered about the center of the ceiling include Virtue, blowing a trumpet and holding another trumpet in her left hand, and, seated on the clouds near her feet, a woman holding a mirror who may be Prudence. The figures in oriental costumes grouped along the right side allude to the commercial enterprises and military feats of the Giustiniani, in Asia Minor and in the islands of the Greek Archipelago.

The Sala del Maggior Consiglio and the adjoining room, the Minor Consiglio, had been ravaged by fire on November 2, 1777, and the flames had entirely destroyed the

sumptuous decoration, including frescoes by Marcantonio Franceschini and Francesco Solimena. The reconstruction of the gutted palace was subsidized by several noble Genoese families, among them the Giustiniani, who, on March 26, 1782, offered to commission a painting for the vaulted ceiling of the Sala del Maggior Consiglio. On August 13, 1782, a contest was proclaimed; regulations specified the subject of the painting and its size, and described the lighting of the room. Models and sketches were to be sent to Angelo Maria Niccolò Granara, chancellor of the Giustiniani family. The contest, originally scheduled to last four months, was extended until the end of May, and the arrival of ten of the fifteen sketches is recorded in the *Avvisi* of the Genoese Republic between December 21, 1782, and July 5, 1783.

After the close of the contest the fifteen sketches, the names of whose authors were kept secret, were exhibited for twelve days starting on August 24, 1783, in the cloister of the church of Santa Maria di Castello. On September 9 in the Ducal Palace there was a meeting of the commission, including the Doge, Giovanni Battista Ayroli, four representatives of the Giustiniani family, fourteen members of the Academia Ligustica, and the painters Antonio Villi and Giovanni Battista Gnecco. In a secret vote three of the artists were chosen as finalists: Giovanni Cristoforo Unterberger and the Englishman James Durno, both of whom were residing in Rome, and Giandomenico Tiepolo. The other twelve sketches were returned, and the names of the competitors are not recorded. On August 23, 1784, Tiepolo's sketch was chosen by four members of the Giustiniani family and by the doge. Tiepolo went to Genoa on March 3, 1785 and set to work early in April of the same year. By November 14 the huge ceiling was completed, and the public was admitted to see it. It should be noted that the description of the finished ceiling, as recorded in the *Avvisi* of November 19, 1785, page 389, no. 47, indicates that the artist made several changes and additions from his earlier sketch. Though the fresco

had been received with enthusiasm by Tiepolo's contemporaries, it was allowed to fall into decay in the early nineteenth century, and was eventually destroyed. In 1866 it was replaced by a new allegorical fresco of a quite different sort by the Genoese painter Giuseppe Isola.

The sketch for this decoration, one of Domenico's most ambitious and elaborate projects, shows that he was still dependent on his father's style more than a decade after the latter's death (see P. Molmenti, *G. B. Tiepolo*, 1909, pp. 327, 345, note 17). A drawing attributed to Domenico is believed to be a preliminary sketch for this painting (see *Burl. Mag.*, CVII, 1965, Sept., p. xxiii, ill.), and six additional sheets of drawings were recently in the art market in London (sale, Christie's, London, June 15, 1965, from the collection of Earl Beauchamp).

Formerly attributed by the Museum to Giovanni Battista Tiepolo.

Inscribed (on log): MZ; (on bale): M$_A^T$-; (on box): -$_I$T; (on banner of trumpet): VIRTUS; (on scroll): CIVITAS CHY/$_B$VI/1562.

Oil on canvas. H. 46, w. 32 1/2 in. (116.8 × 82.5 cm.).

1. S. Rebaudi, *Giornale storico e letterario della Liguria*, XVI, 1940, pp. 63 ff., gives a full account of the contest, and of the execution of the fresco by Domenico Tiepolo, as recorded in contemporary documents, without apparent knowledge of the existence or whereabouts of the preliminary sketch.

REFERENCES: B. B[urroughs], *Met. Mus. Bull.*, VIII (1913), pp. 70 f., ill., attributes this sketch to Giovanni Battista Tiepolo // S. De Vito Battaglia, *R. Istituto d'Archeologia e Storia dell'Arte* (1931), III, pp. 8 f., pl. VI, identifies it as the sketch by Domenico Tiepolo for the Doge's Palace, Genoa // A. McComb, *Baroque Ptrs. of Italy* (1934), p. 127, attributes it to Giovanni Battista // M. Goering, in Thieme-Becker, XXXIII (1939), p. 160, lists it among the works of Domenico // C. Donzelli, *I Pittori veneti del settecento* (1957), p. 231, lists it

among the works of Domenico // R. Pallucchini, *La Pittura veneziana del settecento* (1960), p. 261, pl. 693, attributes it to Domenico, dates it 1783, and calls it a sketch for the Ducal Palace in Genoa // A. Rizzi, *Mostra del Tiepolo* (1971), pp. 167, 179, ill., attributes it to Domenico // A. Mariuz, *Giandomenico Tiepolo* (1971), pp. 128, 154, pl. 322, observes that it is derived from the allegorical ceilings of Giovanni Battista Tiepolo, especially the throne room of the Royal Palace in Madrid // G. Passavant, *Kunstchronik*, xxiv (1971), pp. 368 f., fig. 8b, attributes it to Domenico Tiepolo, calls it a sketch for the Ducal Palace in Genoa, and suggests that there might be political overtones in the treatment of the allegorical figure of Chios.

EXHIBITED: Santa Maria di Castello, Genoa, 1783; Palazzo Ducale, Venice, 1951, *Tiepolo*, no. 129; Akron Art Institute, Akron, Ohio, 1952; McIntosh Memorial Gallery, University of Western Ontario, London, Canada, 1956, *Loan Exhibition - Italian Masters*; Baltimore Museum of Art, 1959, *Age of Elegance: The Rococo and Its Effect*, no. 206; Metropolitan Museum, New York, 1971, *Oil Sketches by 18th Century Italian Artists*, no. 35; Villa Manin, Passariano, 1971, *Mostra del Tiepolo*, no. 85.

EX COLL.: Enrico Osnago (?), Milan (until 1913); [Trotti and Co., Paris, 1913].

PURCHASE, KENNEDY FUND, 1913.

Tintoretto

Real name Jacopo Robusti. Born 1518; died 1594. Tintoretto, or " Little Dyer," was the son and assistant of a dyer. He entered the workshop of Titian and, although he remained there only a short time, was permanently influenced by his master's treatment of color. He continued his studies independently, making drawings of casts from the antique and of sculptures by his contemporary Michelangelo. He also used wax models to experiment with perspective and effects of strong light and shadow. Through the works of Giuseppe Porta, called Salviati, and other painters possibly also from central Italy, he developed a personal style that combined mannerist and Venetian elements; it is as a mannerist that he occupies one of the most prominent positions in the history of painting. His life, one of ceaseless activity, was spent almost entirely in Venice, except for a brief stay in Mantua in 1580, when he was in the service of Duke Guglielmo Gonzaga. The speed with which he painted enabled him to carry out many commissions for churches and public buildings in Venice and to paint numerous portraits, although it was in some cases responsible for a certain lessening of quality. Some of his major works were done with the help of a large group of pupils and assistants, among them his two sons and his daughter Marietta.
Tintoretto found his most constant employment in the Doge's Palace and in the Scuola di San Rocco, for which he executed between the years 1564 and 1577 the grandiose cycles of paintings on which his fame largely rests. His violent chiaroscuro, the tumultuous movement of his compositions, and his inexhaustible imagination created a style from which numerous other painters, including El Greco and the mannerist artists of northern Europe, drew deeply for their inspiration.

Doge Alvise Mocenigo Presented to the Redeemer
10.206 (Plates 84, 85)

This sketchy picture can be considered the preparatory model for a large painting that Tintoretto carried out, with the help of assistants, for the Sala del Collegio in the Doge's Palace in Venice. The doge represented is Alvise (also called Luigi) Mocenigo, who was born in 1507 and served as doge from 1570 until his death seven years later. He is shown kneeling before Christ, who is surrounded by angels. Saint

Mark's lion, emblem of the Venetian Republic, lies near the marble steps of the loggia in which the scene takes place, and in the background can be seen the Piazzetta, with the Doge's Palace on the left and the Libreria Vecchia of Sansovino on the right. Behind the doge are Saint John the Baptist, Saint Louis of Toulouse, and two other saints, the one on the right possibly Gregory, a patron of the Mocenigo family. The final version of the same theme executed by Tintoretto for the Sala del Collegio shows a number of basic changes: on the right of the doge is the standing Saint Mark; the saints on his left are different, the last one being certainly Nicholas of Myra with his miter upheld by angels; the doge's two brothers occupy a prominent position at the extreme right behind the saints, replacing the two figures in the sketch whose heads and shoulders appear between the doge and John the Baptist. The final canvas in Venice is in a rather poor state; large areas of it have been altered by repeated overpaintings. X-rays of the Museum's painting showed that a sketchy figure of Saint Mark had originally been placed between the symbolic lion and the doge. This detail, done in Tintoretto's most fluid manner, was painted over, apparently by the artist himself. Two figures in the area of the sky to the left of the doge, possibly further ideas for the figure of Saint Mark, had also been painted over at a much later date. They have been revealed by a recent cleaning. The bearded head on the right is highly finished, while the body is barely delineated. The one on the left, which is executed broadly and with a loaded brush, recalling Jacopo Tintoretto's autograph drawings, is not unlike the figure of Saint Mark in the final canvas. The commission for a painting with such a subject is to be connected with the plague that ravaged Venice from 1575 to July 1577; in September 1576, when the epidemic was at its height, Doge Mocenigo vowed to build a church in honor of the Redeemer, Il Redentore, in the Giudecca. The date of the painting must therefore be 1577 or slightly later.

Oil on canvas. H. 38 1/4, w. 78 in. (97.2 × 198.2 cm.).

REFERENCES: The authorities cited below attribute this painting to Tintoretto. J. Ruskin, *Works* (Library ed., 1903-1912): "Venetian Index" (1853), and letters to his father (1852-1853), vol. XI, p. 375 and note; "*Instructions in the Preliminary Exercises*" (1872), vol. XXI, pp. 170 f., and note; and "*The Art of England, Lectures Given in Oxford*" (1883), vol. XXXIII, p. 369 // R. A. M. Stevenson, *Athenaeum*, (1896), p. 255 // J. B. S. Holborn, *Jacopo Robusti Called Tintoretto* (1930), p. 107 // R. L. Douglas (in a letter, 1910) believes that the picture commemorated the dedication of the city to Christ before the battle of Lepanto, and discusses the provenance // B. B[urroughs], *Met. Mus. Bull.*, VI (1911), pp. 6 f., ill., doubts whether it is a study for the picture in the Doge's Palace // F. P. B. Osmaston, *The Art and Genius of Tintoret* (1915), II, pp. 177, 204, calls it a study by Tintoretto for the painting in the Doge's Palace, which was executed, according to him, by assistants // D. von Hadeln, *Jahrb. der preuss. Kstsmlgn.*, XLII (1921), p. 188, fig. 29, dates it about 1577 or slightly later, calling it not an actual sketch but a model to be submitted to the commissioners of the work, stating that the final painting in the Doge's Palace was executed with the help of assistants // E. von der Bercken and A. L. Mayer, *Jacopo Tintoretto* (1923), I, pp. 106, 229, II, p. 135, ill., call it a study for the painting in the Doge's Palace, date it about 1577-1584, and consider it superior to the painting; E. von der Bercken, in Thieme-Becker, XXXIII (1939), p. 194, lists it among the works of Tintoretto; and *Die Gemälde des Jacopo Tintoretto* (1942), p. 118, no. 251, ill. pp. 157, 158 (detail), dates it about 1577 or slightly later // M. Pittaluga, *Tintoretto* (1925), p. 281, calls it a study for the painting in the Doge's Palace and dates it 1577-1584 // F. Stock, *Jahrb. der preuss. Kstsmlgn.*, XLVI (1925), Beiheft, p. 75, note 176, fig. 20 // F. Fosca, *Tintoret* (1929), p. 144 // B. Berenson, *Ital. Pictures* (1932), p. 562, dates it not later than 1581; and *Ven. School* (1957), p. 176, pl. 1318, calls it a sketch for the painting in the Doge's Palace, dating it not later than 1581 // H. Tietze, *Tintoretto* (1948), pp. 57, 356, pl. 234, dates it around 1577-1584; and *Arte veneta*, V (1951), pp. 61 ff., figs. 58, 59 (detail of X-rays), calls it a sketch for the painting in the Doge's Palace, observing the changes made in the sketch and the differences between it and the final version // H. B. Wehle, *Met. Mus. Bull.*, n.s., VII (1949), pp. 173 ff., ill. pp. 174, 176, 177 (X-ray details), discusses the changes in the picture and its relation to the final version // L. Coletti, *Il Tintoretto* (1951), p. 42, calls it the first idea for the painting in the Doge's Palace // R. Pallucchini, *Arte veneta*, VIII (1954), p. 224, fig. 238, calls it a sketch, dates it about 1576, observing its connections with the figure of Doge Mocenigo painted in reverse in a picture by Tintoretto in the S. H.

Kress Foundation, New York (now National Gallery of Art, Washington), which he dates about 1573, and with a tapestry *paliotto*, dated 1571, in the Museum of Saint Mark in Venice in which the figures of Doge Mocenigo and of Saint Alvise are very similar to those in our painting // J. Dearden, *Connoisseur*, CLXXVIII (1971), pp. 27 ff., mentions it among the Italian paintings in John Ruskin's collection at Brantwood // P. de Vecchi, *L'Opera completa del Tintoretto* (1970), pp. 127 f., no. 261 e, ill., calls it a sketch for the painting in the Palazzo Ducale, which he dates 1581-1584.

EXHIBITED: University Galleries, Oxford (lent by John Ruskin); Royal Academy, London, 1870, *Old Masters*, no. 140 (lent by John Ruskin), and 1896, *Old Masters*, no. 103 (lent by John Ruskin); Art Gallery of Toronto, 1960, *Titian, Tintoretto, Veronese*, no. 8.

EX COLL.: Baron Karl Friedrich von Rumohr, Dresden (until 1843?); Friedrich Nerly, Venice (after 1843?-1852); John Ruskin, Denmark Hill and Brantwood, Coniston, Lancs. (1852-1900); Mrs. Arthur Severn, Brantwood, Coniston, Lancs. (1900-about 1910); [R. Langton Douglas, London, 1910].

PURCHASE, KENNEDY FUND, 1910.

The Miracle of the Loaves and Fishes
13.75 (Plate 86)

This painting and one of Christ Washing the Disciples' Feet, now in the Art Gallery in Toronto, Canada (no. 58/51), were together in the collection of the Barons Farnham from 1839 until 1913 when the Museum's picture was sold. They are of the same size and were probably companion pieces, but it is not known for what church or institution they were made.[1] The subject matter and the large size of the two pictures seem to indicate that they were intended to decorate a hall or refectory in a confraternity or convent. In the center of our painting Christ is seen handing Saint Andrew the loaves and fishes to be distributed to the multitude. The style points to a fairly early period in the artist's career, possibly the late 1540's. A smaller picture of the same subject is in the Contini Bonacossi collection in Florence, formerly in the Palazzo Giovanelli in Venice, and another version is in the Scuola di San Rocco, Venice.

Oil on canvas. H. 61, w. 160 1/2 in. (155 × 407.6 cm.).

1. Carlo Ridolfi, *Vita di Giacopo Robusti*, 1642, pp. 12, 72, mentions a Miracle of the Loaves and Fishes in the collection of the senators Carlo and Domenico Ruzini in Venice and also cites a Washing the Disciples' Feet that had been in the church of San Marcuola but had been replaced by a copy.

REFERENCES: The authorities cited below attribute this painting to Tintoretto. J. P. Richter (unpublished opinion, 1913) // R. L. Douglas (in a letter, 1913) notes that it dates from the artist's late period and is in a perfect state of preservation // *Met. Mus. Bull.*, VIII (1913), pp. 100 f., ill., dates it in the artist's late period and notes its similarity to his Gathering of Manna in San Giorgio Maggiore in Venice // A. L. Mayer, *Art in Amer.*, II (1914), pp. 342 ff., fig. 1, dates it before 1560 and considers it a pendant to a lost picture of Moses Striking the Rock known only through a sketch in the Städelsches Kunstinstitut in Frankfurt; and (in a letter, 1914) dates it before 1550 // F. P. B. Osmaston, *The Art and Genius of Tintoret*, II (1915), p. 177 // D. von Hadeln, *Burl. Mag.*, XLI (1922), p. 287, note 8 // E. von der Bercken and A. L. Mayer, *Jacopo Tintoretto* (1923), I, pp. 54, 178, 199 f., II, p. 14, ill., date it 1544-1547 and assume that it was ordered for some brotherhood, call the Frankfurt painting a sketch for a companion picture; E. von der Bercken, in Thieme-Becker, XXXIII (1939), p. 194; and *Die Gemälde des Jacopo Tintoretto* (1942), pp. 64, 98, note 25, 118, no. 250, pl. 124, dates it around 1566-1572 and considers it the companion piece of Moses Striking the Rock in Frankfurt // M. Pittaluga, *Tintoretto* (1925), p. 281, dates it before 1548 // F. Fosca, *Tintoret* (1929), p. 144 // B. Berenson, *Ital. Pictures* (1932), p. 562; and *Ven. School* (1957), p. 176, lists it as an early work // H. Tietze, *Tintoretto* (1948), pp. 36, 356, pl. 9, dates it around 1544-1547; and *Art veneta*, V (1951), p. 60, calls it an early work // L. Coletti, *Il Tintoretto* (1951), p. 22, compares it with a similar painting in the Contini Bonacossi collection in Florence // P. de Vecchi, *L'Opera completa del Tintoretto* (1970), p. 101, no. 140, ill., dates it about 1560 and compares it with the painting in the Contini Bonacossi collection.

EX COLL.: Joshua Reynolds (?), London (sale, Christie's, London, March 12, 1795, no. 49, as Tintoretto, from the church of Sant'Ermagora in Venice); [Offley, London, 1795?]; [Nairne, Dublin, until 1839]; Henry, 7th Baron Farnham, Farnham, Cavan, Ireland (1839-1868); the Barons Farnham,

Farnham, Cavan, Ireland (1868-1900); Arthur, 11th
Baron Farnham, Farnham, Cavan, Ireland (1900-
1913); [R. Langton Douglas, London, 1913].

The Finding of Moses
39.55 (Plate 87)

This painting is one of the few that seem
to be entirely by Tintoretto, without the
help of his numerous assistants, even in
the details of the background. The main
figures are painted with a typically man-
neristic sketchiness, as in the rendering of
the garment folds. The mannerist technique
is also obvious in the background, ap-
parently inspired by similar passages in Ti-
tian. The chronological arrangement of
Tintoretto's work is often problematical;
our painting is perhaps to be placed around
1570, even though the color might suggest
an earlier date.

Oil on canvas. H. 30 1/2, w. 52 3/4 in.
(77.4 × 134 cm.).

REFERENCES: The authorities cited below, with the
exception of Coletti, attribute this painting to Tin-
toretto. G. D. Leslie, *Diary* (May, 1859) records
that he bought it in 1856 // J. B. S. Holborn,
Jacopo Robusti called Tintoretto (1903), p. 103 // F.
P. B. Osmaston, *The Art and Genius of Tintoret*
(1915), I, note p. 48, II, pp. 15, 188, describes it
as unfinished, painted in tempera with oil glazes
// B. Berenson (unpublished opinion, 1930); *Ital.
Pictures* (1932), p. 559; and *Ven. School* (1957), p.
176, pl. 1282, lists it as an early work and calls it
unfinished // L. Venturi, *Ital. Ptgs. in Amer.*
(1933), pl. 549, considers it finished and dates it
about 1570 // E. von der Bercken, in Thieme-
Becker, XXXIII (1939), p. 194; and *Die Gemälde des
Jacopo Tintoretto* (1942), pp. 99, 118, no. 252, fig.
54, rejects Coletti's attribution to Schiavone, ac-
cepts a dating of around 1550-1555, admitting the
possibility that it might be slightly later // H. B.
Wehle, *Met. Mus. Bull.*, XXXIV (1939), pp. 274 ff.,
ill., dates it about 1550-1555 // L. Coletti, *Il Tin-
toretto* (1940), p. 15, rejects the attribution to Tin-
toretto and calls it a work of Schiavone imitating
Tintoretto's manner // A. L. Mayer (in a letter,
1940) agrees with the dating of about 1550-1555

// H. Tietze, *Tintoretto* (1948), p. 357, pl. 287,
accepts as probable a dating in the 1550's // R.
Pallucchini, *La Giovinezza del Tintoretto* (1950), p.
152, accepts Venturi's dating of about 1570 //
Art Treasures of the Metropolitan (1952), p. 228, pl.
110 (in color) // P. de Vecchi, *L'Opera completa
del Tintoretto* (1970), p. 112, no. 188, ill. p. 113,
dates it about 1570.

EXHIBITED: Royal Academy, London, 1902, *Old
Masters*, no. 149 (lent by George Dunlop Leslie);
Durlacher Brothers, New York, 1939, *Loan Ex-
hibition of Paintings by Jacopo Robusti, Il Tintoretto*,
no. 3; Detroit Institute of Arts, 1951; Art Gallery
of Toronto, 1951; City Art Museum, St. Louis,
1952; Seattle Art Museum, 1952; Metropolitan
Museum, New York, 1952-1953, *Art Treasures of
the Metropolitan*, no. 110; National Gallery of Ca-
nada, Ottawa, 1960, *Masterpieces of European Paint-
ing, 1490-1840*, no. 32.

EX COLL.: Richard Westall, R. A., London; [Smith,
London, 1856]; George Dunlop Leslie, R. A.,
London and Lindfield, Sussex (1856-1921; sale,
Christie's, London, July 1, 1921, no. 58); Oldfield,
London (1921); [R. Langton Douglas, London];
[Durlacher Brothers, New York, 1929]; Kurt M.
Hirschland, Essen (1929-1933); [Durlacher Brothers,
New York, 1933-1939].

PURCHASE, GWYNNE M. ANDREWS FUND, 1939.

Portrait of a Man
41.100.12 (Plate 88)

Painted with an extremely limited palette
giving almost the effect of a monochrome
and emphasizing only the features of the
face and of the hands, this portrait must
be considered a rather early work. The
composition is closely connected with por-
traits painted by Titian in the 1530's; the
sharp definition of the sitter's face points
again to an early date when Tintoretto's
portraits were not yet circumscribed by
the constantly repeated formula of his more
advanced style. There is a drawing copied
after this portrait in the Atger Collection,
Montpellier University.

Oil on canvas. H. 44 3/8, w. 35 in. (112.7
× 88.9 cm.).

REFERENCES: W. Bode (verbally, n.d.) attributes this painting to Titian // A. L. Mayer (in a letter, 1914) calls it a work close to the late Titian, rejecting attributions to Jacopo Bassano or Tintoretto; with E. van der Bercken, *Münchner Jahrb.*, x (1916-1918), pp. 254 f., fig. 11 (detail), rejects the attribution to Titian and calls it a work by Tintoretto, observing in it Titian's influence; and *Jacopo Tintoretto* (1923), I, p. 58, attributes it to Tintoretto; E. van der Bercken, *Die Gemälde des Jacopo Tintoretto* (1942), p. 118, no. 254, attributes it to Tintoretto, tentatively suggesting a date around 1568-1572 // *Met. Mus. Bull.*, xv (1920), p. 159, mentions it as a work by Bassano, quoting Bode's opinion that it is by Titian // B. Berenson, *Ital. Pictures* (1932), p. 562, lists it as an early work by Tintoretto; and *Ven. School* (1957), p. 176 // L. Venturi, *Ital. Ptgs. in Amer.* (1933), pl. 559, calls it one of Tintoretto's most impressionistic works, close in style to the portrait of Luigi Cornaro in the Pitti // W. Suida (verbally, 1941) considers it a sure work by Tintoretto // P. Rossi, *Arte veneta*, XXIII (1969), pp. 71, 82, note 3, fig. 77, attributes it to Tintoretto and dates it about 1561 // P. de Vecchi, *L'Opera completa del Tintoretto* (1970), p. 112, no. 180, ill., attributes it to Tintoretto and dates it about 1568.

EXHIBITED: Metropolitan Museum, New York, 1920, *Fiftieth Anniversary Exhibition*, pl. 8 (as Leandro Bassano, lent by George and Florence Blumenthal); 1923, *Loan Exhibition of the Arts of the Italian Renaissance*, no. 44 (as Tintoretto, lent by George and Florence Blumenthal); and 1943, *Masterpieces in the Collection of George Blumenthal*, no. 23 (as Tintoretto).

EX COLL.: George and Florence Blumenthal, New York (by 1914-1941; Cat., 1926, I, pl. XLV, as Titian (?)).

GIFT OF GEORGE BLUMENTHAL, 1941.

Portrait of a Young Man
58.49 (Plate 89)

This portrait, painted at the end of Tintoretto's early period, shows how much the artist was indebted to Titian. Its composition is, in fact, based upon some Titianesque prototype, though transformed through the influence of central Italian mannerism and realized with a very personal economy of colors. Though the identity of the sitter is unknown, it is traditionally assumed that he is a member of the Spinola family of Genoa.

Oil on canvas. H. 54 1/2, w. 42 in. (138.4 × 106.7 cm.).

Dated (on marble pedestal at left): M.D.L/I Inscribed (below): AETATIS. SVAE/ ANNO. [X?]xx

REFERENCES: The authorities cited below attribute this painting to Tintoretto. W. Bode (in a letter, 1912) calls it an early work and notes the influence of Titian // B. Berenson, *Ital. Pictures* (1932), p. 562, calls it a Portrait of a Young Man aged Twenty; and *Ven. School* (1957), p. 176, pl. 1277 // R. Pallucchini, *La Giovinezza di Tintoretto* (1950), pp. 141, 164, fig. 233, reads the sitter's age as thirty and notes the connection of the composition with Titian's portraits, especially the Portrait of a Man in the Bache collection (now attributed to Sustris) // H. Tietze (verbally, 1952) // P. de Vecchi, *L'Opera completa del Tintoretto* (1970), p. 95, no. 85, ill. p. 94, wrongly lists it as belonging to the Gary collection.

EX COLL.: the Marchesi Spinola, Genoa (until 1911); [Dowdeswell and Dowdeswell Ltd., London, 1911]; [M. Knoedler and Co., New York, 1911-1912]; Judge Elbert H. Gary, New York (1912-1928; sale, American Art Association, New York, April 20, 1928, no. 35, bought in); Mrs. Elbert H. Gary, New York (1928-1934); Mr. and Mrs. Lionel F. Straus, New York (1934-1953; sale, Parke-Bernet, New York, March 11, 1953, no. 10, bought in); Lionel F. Straus, Jr., New York (1953-1958).

GIFT OF LIONEL F. STRAUS, JR., IN MEMORY OF HIS PARENTS, 1958.

Titian

Tiziano Vecelli. Born about 1488; died 1576. According to an early chronicler, Lodovico Dolce, Titian studied first under Gentile Bellini. Afterward, in the workshop of Giovanni Bellini, he must have been the fellow pupil of Giorgione, whose poetic style and free,

yet subtle technique strongly affected his development. In 1511 he painted frescoes in Padua, and shortly thereafter he was engaged to work in the Sala del Gran Consiglio of the Doge's Palace in Venice. His services were constantly sought by the Venetian state and he also enjoyed the patronage of the courts of Ferrara, Mantua, and Urbino, and worked for the Emperor Charles V and his son Philip II of Spain. With equal genius Titian painted portraits, religious subjects, and pagan myths. During his extraordinarily long career his style progressed from the pristine clarity of his early Sacred and Profane Love (Borghese Gallery, Rome) and Bacchanal (Prado, Madrid), to the swift sureness of brushwork and the deeper tonality of his profound late style. His noble breadth of form, his free use of the oil medium with delicate scumbles and glazes, and the rich and magnificent range of his color led the entire art of painting into new fields. In his own time, and without interruption since, Titian has held his place as one of the greatest of European painters.

Portrait of a Man
14.40.640 (Plate 90)

This portrait, which has long been regarded as a work by Giorgione, is very similar in conception and execution to such works of Titian as the signed portrait called Ariosto in the National Gallery in London (no. 1944), the unfinished Portrait of a Musician in the Spada Gallery in Rome (no. 194), and the Sacred and Profane Love in the Borghese Gallery. The handling and the composition indicate that it was painted about 1515. The picture may originally have been larger, showing the complete right hand, and possibly there was a marble parapet below.

Formerly called by the Museum a work by Giorgione or Titian (Cat., 1940).

Oil on canvas. H. 19 3/4, w. 17 3/4 in. (50.2 × 45.1 cm.).

REFERENCES: B. Berenson, *Study and Criticism*, I (1901), p. 145, rejects the attribution to Giorgione given this painting in the New Gallery Exhibition of 1895 and tentatively calls it an early work by Titian or a copy after him made by Polidoro Lanzani; (in a letter, 1912) attributes it to Giorgione and tentatively suggests that it may represent Ludovico Ariosto; *Ital. Pictures* (1932), p. 233, lists it as a work by Giorgione and doubts whether it is a portrait of Ariosto; (in a letter, 1936) attributes it to Giorgione or Titian and dates it not earlier than 1510; and *Ven. School* (1957), p. 84, pl. 647, lists it as a work by Giorgione and doubts whether it is a portrait of Ariosto // W. Bode,

Art in Amer., I (1913), pp. 225 ff., ill., attributes it to Giorgione // G. Gronau, in Thieme-Becker, XIV (1921), p. 88, lists it as a contested work by Giorgione // F. Monod, *Gaz. des B.-A.*, ser, 5, VIII (1923), p. 192, doubts whether it is by Giorgione and questions the authenticity of the picture // A. Venturi, *Vita artistica*, II (1927), p. 129, fig. 3, attributes it to Giorgione; and *Storia*, IX, part III (1928), p. 30, fig. 13 // R. Longhi, *Vita artistica*, II (1927), p. 220, note 2, rejects the attribution to Giorgione and tentatively calls it an early work by Titian; and (unpublished opinion, 1937) attributes it to Titian and dates it about 1510-1512 // W. S. Spanton, *An Art Student and His Teachers in the Sixties* (1927), p. 80, describes how Fairfax Murray saw this picture in the Landor collection in Florence and concluded that it was not by Titian but by Cariani // E. V. Lucas, *A Wanderer in Florence* (1928), p. 332, notes that Landor was thought to have bought it from a member of the Grimani family // F. Heinemann, *Tizian: Die zwei ersten Jahrzehnte seiner künstlerischen Entwicklung* (1928), pp. 59, 82, lists it among the lost works of Titian, dating it about 1510-1512 // W. Suida, *Tizian* (1933), pp. 32, 153, pl. XXXI B, attributes it to Titian // F. Hermanin, *Il Mito di Giorgione* (1933), p. 155, ill. p. 149, attributes it to Giorgione, comparing it with an unfinished Portrait of a Musician by Titian in the Palazzo Venezia in Rome (now in the Spada Gallery, Rome) // L. Venturi (verbally, 1936) attributes it to Titian and dates it perhaps as early as 1505-1506 // H. Tietze (in a letter, 1936) attributes it to Giorgione rather than to Titian and notes a suggestion of Palma Vecchio's style // A. L. Mayer (in a letter, 1937) attributes it tentatively to Titian and dates it earlier than the so-called Ariosto in the National Gallery in London, because of the weak painting of the hands; and (in a letter, 1940) ascribes it to Titian, about 1510 // D. Phillips, *The Leadership of Giorgione* (1937), p. 69, ill. p. 117, attributes it to Giorgione, suggests that Titian may have retouched the head, dates it in the same year as the Concert, 1508-1509, in the Pitti Gallery, and doubts whether it represents Ariosto // G. M. Richter, *Giorgio da*

Castelfranco (1937), p. 230, suggests attributing it to Palma Vecchio and dates it about 1508-1510; and (in a letter, 1939) calls it an early portrait by Titian, painted perhaps in Giorgione's studio // F. Mason Perkins (in a letter, 1938) attributes it to Giorgione // A. Morassi (unpublished opinion, 1940); and *Giorgione* (1942), pp. 133, 180, pl. 152, calls it an early work by Titian, painted under the strong influence of Giorgione // *Duveen Pictures* (1941), no. 151, as Giorgione, painted about 1510 // W. Arslan (in a letter, 1952) calls it a copy of a XVI century original // R. Pallucchini, *Tiziano*, I (1953), pp. 53 f., attributes it to Titian and considers it painted before the so-called Ariosto in the National Gallery in London; and *Tiziano* (1969), I, pp. 13, 233, II, pl. 15, attributes it to Titian, and dates it about 1508-1510 // F. Zeri, *La Galleria Spada* (1954), p. 144, attributes it to Titian, dating it about 1515-1520 // T. Pignatti, *Giorgione* (1955), p. 132, attributes it to Titian; and *Giorgione* (1971), pp. 40, 68, 115, 120, 125, 130, pl. 178, attributes it to the young Titian // L. Coletti, *Giorgione* (1956), p. 67, calls it a Portrait of a Grimani (?) and lists it among works wrongly attributed to Giorgione; and *All the Paintings of Giorgione* (1961), p. 57, lists it as a Portrait of a Grimani (?) by Titian // F. Valcanover, *Tutta la pittura di Tiziano* (1960), I, p. 49, pl. 32, calls it an early work by Titian, dating it about 1511; and *L'Opera completa di Tiziano* (1969), pp. 94 f., no. 37, ill., dates it about 1512 // R. Salvini, *Pantheon*, XIX (1961), p. 237, fig. 11, calls it the most Giorgionesque of Titian's early portraits // G. Mariacher, *Palma il Vecchio* (1968), p. 103, notes that it is now attributed by most authorities to Titian // H. E. Wethey, *The Paintings of Titian*, II (1971), p. 186, no. X-110, pl. 216, attributes it to a Giorgionesque painter and dates it about 1510.

EXHIBITED: New Gallery, London, 1894-1895, *Venetian Art*, no. 15 (as Giorgione, lent by A. H. Savage Landor).

EX COLL.: the Grimani family (?), Venice; Walter Savage Landor, Villa Gherardesca, Florence (until 1864); the Savage Landor family, Florence (1864-about 1894); Alfred Humbert Savage Landor (in 1894); the Countess of Turenne, Scandicci, Florence; [Luigi Grassi, Florence, 1912]; [Duveen Brothers, London and New York, 1912]; Benjamin Altman, New York (1912-1913).

In the Altman Galleries.

BEQUEST OF BENJAMIN ALTMAN, 1913.

Filippo Archinto, Archbishop of Milan 14.40.650 (Plate 91)

Filippo Archinto (about 1500-1558), a noble Milanese, was active in the service of Fran-

cesco II Sforza, Duke of Milan, and later in that of Pope Paul III, who made him Governor of Rome and Archbishop of Milan, an office he was never able actually to assume, because of local opposition. Political enemies contrived to banish him, and he lived in exile, first in Venice and then in Bergamo, where he died. He is known for his support of the cause of Ignatius Loyola and the Jesuit Order and for his violent defense of the Curia's claims at the Council of Trent. An almost identical portrait in the John G. Johnson collection in the Philadelphia Museum (no. 204) shows Archinto in the same pose but partly veiled by a sheer curtain. It is generally believed that the Johnson painting is a second version by Titian and that the curtain alludes to Archinto's disgrace in his last years. It is more probable, however, from both external and internal evidence, that it is a copy after ours, and that since Archinto held this appointment *de jure* but was never in charge *de facto* the copy was modified to allude to this odd situation. Our painting can be dated from stylistic evidence around the middle of the 1550's, which is in accord with the facts of Archinto's life; between 1554 and 1556 he was sent as papal legate to Venice. The execution is not entirely by Titian, and the quality of some of the details betrays the hands of assistants.

Oil on canvas. H. 46 1/2, w. 37 in. (118.1 × 94 cm.).

REFERENCES: B. Berenson (in a letter, 1913, and unpublished opinion, 1913) attributes this painting to Titian, dates it 1554-1555, calls it earlier than the Johnson version, and compares it with the Beccadelli portrait of 1552 in the Uffizi; *Catalogue of the John G. Johnson Collection*, I (1913), pp. 127 f.; *Ital. Pictures* (1932), p. 573, dates it 1554-1556; and *Ven. School* (1957), p. 189 // F. Monod, *Gaz. des B.-A.*, ser. 5, VIII (1923), p. 191, dates it around 1543, at the time of Titian's portrait of Paul III, or 1545-1546, during his sojurn in Rome, before Archinto went to Venice // O. Fischel, *Tizian* (*Kl. der Kst.*) (n.d.), p. 319, ill. p. 184, attributes it to Titian and dates it about 1554 // W. Suida, *Tizian* (1933), pp. 107, 169, pl. CCVI B, attributes it to Titian // J. Zarnowski, *Dawna Sztuka*, I

(1938), p. 129, attributes it to Girolamo Dente and calls the Philadelphia picture a workshop replica // *Duveen Pictures* (1941), no. 160, ill., attributes it to Titian and dates it about 1554-1556 // R. Pallucchini, *Tiziano*, II (1954), pp. 62 f., judges it from a photograph, observes the connections with the portrait of Ludovico Beccadelli, and suggests that it was started by Titian but finished by his workshop; and *Tiziano* (1969), I, pp. 302 f., II, pl. 398, attributes it to Titian with the intervention of the workshop, and dates it about 1554-1556 // F. Valcanover, *Tutta la pittura di Tiziano* (1960), II, p. 71, ill. p. 174, includes it among the pictures attributed to Titian and quotes Pallucchini's opinion that it is largely a workshop product; and *L'Opera completa di Tiziano* (1969), p. 126, no. 392, ill., dates it about 1554-1556 // G. Bazin (verbally, 1965) attributes it to a Roman mannerist // *John G. Johnson Collection, Catalogue of Italian Paintings* (1966), p. 76, no. 204, calls it a version of the portrait in the Johnson collection // R. Betts, *Art. Bull.*, XLIX (1967), pp. 59 ff., calls it a copy of the Johnson picture and suggests an attribution either to Leandro Bassano, on the basis of the tentative identification of the painting with number four in the Archinto sale (1863), or to the workshop of Titian // H. E. Wethey, *The Paintings of Titian*, II (1971), p. 71, pl. 163, calls it a variant of the painting in the Johnson collection, and attributes it either to the workshop of Titian or to Leandro Bassano.

EX COLL.: the Archinto family, Milan; Count Giuseppe Archinto, Milan (sale, Hôtel Drouot, Paris, May 18, 1863, no. 4 (?), as Leandro Bassano); private collection, Italy (until 1913); [Italico Brass, Venice, 1913]; [Duveen Brothers, New York, 1913]; Benjamin Altman, New York (1913).

In the Altman Galleries.

BEQUEST OF BENJAMIN ALTMAN, 1913.

Doge Andrea Gritti
32.100.85 (Plate 92)

Andrea Gritti (1455-1538) became doge in 1523. In this picture there is an obvious discrepancy in quality between the doge's face and some minor details, which are skillful enough to be by Titian's own hand, and the crude and summary treatment of his mantle and the curtain in the background, which seem to have been added later by an inferior painter of the late sixteenth century or the first half of the seventeenth. It is quite reasonable to be-

lieve that the picture was only a sketch from life made by Titian for use in portraits to be painted in his workshop. The style suggests a date in the late 1520's. Titian painted Gritti several times, for example in a votive picture of 1531, representing him kneeling before the Madonna and Child, that was destroyed in the great fire in the Doge's Palace in 1574. There is an old version of our portrait, very similar to it, in the collection of Nathan Allen in Kenosha, Wisconsin (formerly in the Madrazo collection). A very good copy (canvas, 29 1/2 × 21 5/8 in.), with the name of the sitter inscribed at the top, was in the famous Giovio collection at Como in the late sixteenth century. In 1969 it was in a private collection at Chiasso and on the back of the canvas it had an inscription relating to one of the previous owners, Bartolomeo Giovio. Of the other portraits of Gritti that have been attributed to Titian the best is the one in the National Gallery in Washington (Kress coll., K 486; formerly in the Czernin collection, Vienna), which has a different composition and the style of a much later period in Titian's work. The portraits in the National Gallery in London (no. 5751) and in the Fitzwilliam Museum in Cambridge (formerly in the Holford collection), once called Titian's work, have now been rightly related to Vincenzo Catena and to his workshop. The attribution of our painting to Titian is strengthened by the fact that it is evidently one of the paintings that the Barbarigo family bought from Titian's son, together with Titian's house and effects, after the artist's death, and by Ridolfi's mention of it in the seventeenth century as by Titian. The portrait has been cut at each side and at the bottom (for former measurements see Refs., Selvatico, 1875), thus removing the inscription recorded in 1881 by Crowe and Cavalcaselle, which may have been painted at the time that the mantle and the background were added to make the sketch into a formal portrait.

Oil on canvas. H. 40 1/4, w. 31 3/4 in. (102.2 × 80.7 cm.).

REFERENCES: C. Ridolfi, *Le Maraviglie dell'arte* (1648), I, p. 181, mentions this painting, then in the possession of the Barbarigo family, as a work by Titian and refers to numerous copies // A. de Marchi, *Guide*, 1856, p. 413, lists it as a work by Titian // P. Selvatico, *Di alcuni abbozzi di Tiziano e di altri dipinti nella Galleria del Conte Sebastiano Giustiniani Barbarigo in Padova* (extract from *Giornale di Padova*, Dec. 15, 1874) (1875), p. 13, mentions a sketch by Titian for a portrait of Gritti in the collection of Count Sebastiano Giustiniani Barbarigo, giving its dimensions as 120 × 100 cm. // G. B. Cavalcaselle (ms., c. 1875, Biblioteca Marciana, Venice) notes that the background is repainted, that the inscription is new, and that the hand is the best preserved part; and with J. A. Crowe, *Life and Times of Titian* (1881), I, pp. 299 ff., identifies it with the one mentioned by Ridolfi, suggesting that it may be a genuine work by Titian changed and retouched after his death, and mentions the inscription at the bottom (since removed) ANDREAS GRITTI VENETIA DUX. // G. Lafenestre, *Rev. de l'art*, XXV (1909), pp. 17 f., ill., attributes it to Titian // W. Bode (unpublished opinion, 1910) calls it one of the various repetitions of the portrait of Andrea Gritti, whom Titian painted several times, and observes that it was among Titian's effects // D. von Hadeln, ed., in C. Ridolfi, *Le Maraviglie dell'arte* (1914), I, p. 200, note, regards it as a work of Titian's shop; and *Pantheon*, VI (1930), p. 490, ill. p. 493, attributes it to Titian // B. Berenson, in Cat. of Friedsam Coll. (unpublished, n.d.), pp. 85 f., attributes it to Titian and dates it shortly before 1538, the time of Gritti's death; *Ital. Pictures* (1932), p. 573; and *Ven. School* (1957), p. 189, lists it as a work by Titian // O. Fischel, *Tizian (Kl. der Kst.)* (n.d.), pp. 311 f., ill. p. 95, considers the ascription to Titian strengthened by the Barbarigo provenance // B. Burroughs and H. B. Wehle, *Met. Mus. Bull.*, XXVII (1932), Nov., sect. II, p. 40, attribute it to Titian // W. Suida, *Tizian* (1933), p. 81, attributes it to Titian and notes its sketchy character; and (verbally, 1939) calls it a work by Titian finished by another hand // L. Venturi, *Ital. Ptgs. in Amer.* (1933), pl. 515, considers it a late work by Titian painted after Gritti's death // H. Tietze, *Tizian: Leben und Werk* (1936), I, p. 133, II, p. 303, calls it perhaps a work of Titian's shop and dates it about 1540; and *Tizian* (1950), p. 387, pl. 168, attributes it to Titian // A. L. Mayer, *Gaz. des B.-A.*, ser. 6, XVIII (1937), p. 308, considers it an unfinished work by Titian and agrees with Venturi in dating it in the artist's late period // E. Tietze-Conrat, *Art Bull.*, XXVIII (1946), p. 81, considers it a sketch by Titian, painted from life, suggests that it was completed later, before it was sold to the Barbarigo family, and notes that the Allen version is based upon this one // R. Pallucchini, *Tiziano*, I (1953), p. 205, considers the Allen version an original by Titian, painted before 1543; and *Tiziano* (1969), I, pp. 82 f., 274, II, pl. 250, attributes it to Titian and dates it about 1538-1540 // G. Dell'Acqua, *Tiziano* (1955), p. 120, calls the picture

a work ascribed to Titian // F. Valcanover, *Tutta la pittura di Tiziano* (1960), I, p. 102, pl. 215, calls it a workshop product; and *L'Opera completa di Tiziano* (1969), p. 112, no. 216, ill., dates it about 1540 // S. Savini-Branca, *Il Collezionismo Veneziano nel '600* (1964), p. 186, lists the painting in the Barbarigo collection, San Polo // H. E. Wethey, *The Paintings of Titian*, II (1971), p. 109, pl. 234, calls it a workshop replica, partly based on the Washington picture // E. E. Gardner, *Saggi e memorie di storia dell'arte*, VIII (1972), p. 74, figs. 29-31, publishes Cavalcaselle's drawings after the painting and gives the history of its ownership.

EXHIBITED: Columbus Gallery of Fine Arts, Columbus, Ohio, 1956; Arkansas Art Center, Little Rock, Arkansas, 1963, *Five Centuries of European Painting*, (Cat., p. 13).

EX COLL.: Pomponio Vecellio, Venice (until 1581); Cristoforo Barbarigo, Venice (1581-1600); the Barbarigo family, Palazzo Barbarigo, San Polo, Venice; Count Sebastiano Giustiniani Barbarigo, Padua (by 1874-after 1881); Franz von Lenbach, Munich; General Baron von Heyl zu Herrnsheim, Darmstadt; [Kleinberger Galleries, Paris, by 1914]; Michael Friedsam, New York (1931).

THE MICHAEL FRIEDSAM COLLECTION. BEQUEST OF MICHAEL FRIEDSAM, 1931.

Venus and the Lute Player
36.29 (Plate 93)

The subdued tonality, atmospheric treatment of the landscape, deliberately unfinished portions, and easy, fluid brushwork indicate that the Museum's Venus and the Lute Player was probably painted by Titian in the first half of the 1560's. The earliest representation of the reclining Venus is the so-called Venus of Urbino, executed in 1538 and now in the Uffizi in Florence (no. 1437). The background is entirely different; the nude, although in reverse, is very similar to this one in pose. Titian painted the reclining Venus with a musician several times. In the picture done in Augsburg in 1548 for Cardinal Antoine Perrenot de Granvelle (Prado, Madrid, no. 421) the goddess is accompanied by Cupid and an organ player. Another very similar version is also in the Prado (no. 420). A painting in the Berlin Museum (no. 1849), apparently done in the early 1550's, shows Venus with

Cupid and an organ player, who turns toward her, and another painting in the Uffizi (no. 1431) shows Venus accompanied by Cupid only. The picture most similar to ours is in the Fitzwilliam Museum in Cambridge (no. 129), and recent cleaning has shown it to be an autograph work by Titian of the 1560's. It now seems likely that our painting, which has also been cleaned, was based on the Fitzwilliam version, that it was begun by Titian himself and left unfinished in his atelier. In some areas, such as the landscape, the degree of finish is typical of Titian's late style, but other portions, especially the curtains and the figure of Venus, remained unfinished and in some places almost sketchy. Our picture must have been finished, in the late sixteenth or early seventeenth century, by a Venetian artist influenced by both Titian and Tintoretto, and seeking to imitate Titian's late technique.

The pictures of Venus with a musician are apparently related to the Neo-Platonic theme of the rivalry between sight and sound as instruments for the apprehension of beauty (see Refs., E. Wind, 1958, and A. P. de Mirimonde, 1966). It should be noted that a painting of Venus and a lute player answering the description of ours belonged to Joachim van Sandrart and was attributed by him to Jacopo Tintoretto the Younger (see Refs., E. Tietze-Conrat, 1944). This picture, now lost, may have been by Jacopo Palma the Younger, as Jacopo Tintoretto had no son with his father's baptismal name. An old copy of our Venus and the Lute Player is in the Gemäldegalerie in Dresden (no. 177).

Oil on canvas. H. 65, w. 82 1/2 in. (165 × 209.4 cm.).

REFERENCES: Margaret, Countess of Leicester, *Inventory of Holkham* (1765), lists this painting as a work by Titian and gives its provenance as the collection of Prince Pio di Savoia in Rome // R. Beatniffe, *The Norfolk Tour* (1773), p. 22, lists it as a work by Titian at Holkham // J. D. Burnham, *Stranger's Guide to Holkham* (1817), p. 106, mentions it as a portrait of Philip II and his mistress by Titian, acquired from the collection of Prince

Pio in Rome // A. Hume, *Notices of the Life and Works of Titian* (1829), pp. 67, 95 f., notes that it is by Titian, and that it is similar to the picture in the Fitzwilliam Museum, calls it Philip II and his mistress // Crowe and Cavalcaselle, *Life and Times of Titian* (1881), II, p. 159, misquote Hume as having called it a copy of the Fitzwilliam picture // W. Bode (unpublished opinion, 1928) attributes it to Titian // B. Berenson (in a letter, 1930) attributes it to Titian; (in a letter, 1936) calls it a late work; and *Ven. School* (1957), p. 189, pl. 1009 // G. M. Richter, *Burl. Mag.*, LIX (1931), pp. 53 ff., ill. p. 52, considers it the original by Titian from which the versions in the Fitzwilliam Museum and Dresden were copied, and dates it about 1560 // D. von Hadeln, *Pantheon*, X (1932), pp. 273 ff., ill., thinks Titian began it between 1540 and 1550 and finished it about 1560 and calls it the prototype of the Fitzwilliam picture and other versions of the theme // W. Suida, *Tizian* (1933), pp. 115 f., 171, pl. CCXX, attributes it to Titian and calls the Fitzwilliam version a replica and the Dresden one a later copy; and *Arte veneta*, XI (1957), pp. 71 ff., ill. pp. 72 (detail), 73, rejects Titetze-Conrat's identification (see below) of our painting with the one described by van Sandrart, which he suggests may have been by Palma Giovane; identifies our painting with a Venus at one time in the collection of Prince Pio in Rome, tentatively suggesting that it might have belonged to Cardinal Rodolfo Pio (died 1565), who was known as a collector and patron of the arts; agrees with von Hadeln that it was begun in 1540 and finished, notably the landscape, around 1560; recognizes the mountains as those of Titian's native region, and mentions copies in Dresden and in the former Auspitz collection in Vienna // L. Venturi, *Ital. Ptgs. in Amer.* (1933), pl. 524, attributes it to Titian, dates it about 1560, and calls the Fitzwilliam version a school work // H. B. Wehle, *Met. Mus. Bull.*, XXXI (1936), pp. 182 ff., ill., attributes it to Titian, and identifies the Fitzwilliam picture as an early copy; and *Art Bull.*, XXVII (1945), pp. 82 f., rejects Tietze-Conrat's attribution (see below) to Domenico Tintoretto, as well as the attempts to identify our painting with a Venus mentioned by van Sandrart as the work of Jacopo Tintoretto the Younger // H. Tietze, *Tizian* (1936), I, pp. 192, 216, II, p. 303, pl. 183, attributes it to Titian, possibly aided by assistants, and dates it about 1560 // T. Hetzer, in Thieme-Becker, XXXIV (1940), p. 164, considers the Venus in the Uffizi the only original by Titian, calls the various versions in the Prado and the Berlin Museum school repetitions, and judges ours farthest from the painter's conceptions and perhaps without any relation to him // *Duveen Pictures* (1941), no. 163, ill., dates it about 1562-1565 // E. Tietze-Conrat, *Art Bull.*, XXVI (1944), pp. 266 ff., pl. I, rejects the attribution to Titian and identifies our painting with a recumbent Venus with Cupid and a Lute Player described by Joachim van Sandrart as a work by Jacopo Tintoretto the Younger, whom she identifies with certainty as

Domenico Tintoretto; and *Art Bull.*, XXVII (1945), p. 83, reaffirms the attribution to Domenico Tintoretto // *Met. Mus. Bull.*, n.s., V (1946), ill. on cover (detail in color) and opp. p. 73, attributes it to Titian, dates it 1562-1565 // O. Brendel, *Art Bull.*, XXVIII (1946), pp. 65 ff., fig. 1, calls the Fitzwilliam picture a variant of ours, and suggests that there is a close concordance between the theme of Venus with a musician and the concept of beauty expressed in Neo-Platonic texts // G. Evans, *Art Bull.*, XXIX (1947), pp. 123 ff., attributes the painting to Titian, at least in large part, but believes that it was retouched or finished in Tintoretto's workshop; accepts Tietze-Conrat's identification of it with the painting mentioned by van Sandrart, and notes that the landscape appears later in style than the figures // D. von Bothmer, *Met. Mus. Bull.*, n.s., VII (1949), ill. p. 214, attributes it to Titian // *Art Treasures of the Metropolitan* (1952), pp. 74, 228, pl. 109 (in color), attributes it to Titian // T. Rousseau, *Met. Mus. Bull.*, n.s., XII (1954), p. 1, ill. p. 22, attributes it to Titian // R. Pallucchini, *Tiziano*, II (1954), pp. 45, 115, rejects the attribution to Domenico Tintoretto, accepts it as a genuine work by Titian, dates it around 1562, and observes the similarity of the landscape to the landscape in the Rape of Europa in the Gardner Museum in Boston; and *Tiziano* (1969), I, pp. 126, 170 f., 316, II, pls. 478, 479, attributes the Fitzwilliam picture to Titian and his workshop, and notes that it is earlier than the Museum's painting, which was begun by Titian around 1562-1564, left unfinished, and completed by a Venetian artist at the end of the seventeenth century // W. G. Studdert-Kennedy, *Burl. Mag.*, C (1958), pp. 349, 351, calls our painting a copy after the Fitzwilliam picture, and discusses the iconography of the theme // E. Wind, *Pagan Mysteries in the Renaissance* (1958), p. 123, note 1, attributes our painting to Titian, discusses the iconography, connecting it with Platonic ideas // F. Valcanover, *Tutta la pittura di Tiziano* (1960), II, pp. 41 f., pl. 72, attributes it to Titian, dates it about 1560, considers the Fitzwilliam version a repetition partly by Titian, and mentions the copy in Dresden; and *L'Opera completa di Tiziano* (1969), p. 129, no. 426, ill. p. 128, attributes it to Titian with assistants // J. W. Goodison, *Burl. Mag.*, CVII (1965), pp. 521 ff., fig. 33, notes that the recent cleaning and the pentimenti revealed by X-rays indicate that the Fitzwilliam picture was painted by Titian almost throughout, and that it is earlier than the Museum's picture, which was left unfinished and later partially repainted; and with G. H. Robertson, *Catalogue of Paintings, Fitzwilliam Museum*, II (1967), pp. 168 ff. // A. P. de Mirimonde, *Gaz. des B.-A.*, ser. 6, LXVIII (1966), pp. 271 f., fig. 10, discusses the iconography of music in the allegory of love, notes that the swans are attributes of music, and that the sword worn by the musician is an allusion to the loves of Mars and Venus // E. Panofsky, *Problems in Titian* (1969), pp. 124 f., pl. 139, accepts the Fitzwilliam version as earlier and as from Titian's hand almost throughout, notes that our painting was never finished and was altered, about the end of the sixteenth century, by a Venetian artist not to be identified with Domenico Tintoretto.

EXHIBITED: Art Institute, Chicago, 1933, *Century of Progress*, no. 140 (as Titian, lent by Duveen Brothers); National Gallery of Canada, Ottawa, 1933 (as Titian, lent by Duveen Brothers); Palazzo Pesaro, Venice, 1935, *Mostra di Tiziano*, no. 101 (as Titian, lent by Duveen Brothers); Worcester Art Museum, Worcester, Massachusetts, 1948, *Fiftieth Anniversary Exhibition*, no. 2; Metropolitan Museum, New York, 1949, *The Classical Contribution*; Philadelphia Museum of Art, 1950-1951, *Diamond Jubilee Exhibition*, no. 23; Metropolitan Museum, New York, 1952-1953, *Art Treasures of the Metropolitan*, no. 109; Museum of Fine Arts, Boston, 1970, *Masterpieces of Painting in The Metropolitan Museum of Art* (Cat., p. 23); Metropolitan Museum, New York, 1970-1971, *Masterpieces of Fifty Centuries*, no. 210.

EX COLL.: Prince Pio di Savoia, Rome (until about 1718); Sir Thomas Coke, later Earl of Leicester, Holkham Hall, Norfolk (about 1718-1759); Margaret, Countess of Leicester, Holkham Hall (1759-1775); Wenman Roberts Coke, Holkham Hall (1775-1776); Thomas William Coke, Earl of Leicester, Holkham Hall (1776-1842); Thomas William Coke, 2nd Earl of Leicester, Holkham Hall (1842-1909); Thomas William Coke, 3rd Earl of Leicester, Holkham Hall (1909-1931); [Duveen Brothers, London, Paris and New York, 1931-1936].

PURCHASE, FRANK A. MUNSEY FUND, 1936.

The Madonna and Child
49.7.15 (Plate 94)

This picture is one of the most significant works of Titian's early period, since it shows both his close link with Giorgione, especially in the figure of the Madonna, and the strength of his own genius, in the color and brushwork and in the landscape. His treatment of landscape initiates a trend that continues down to the seventeenth century in the landscape paintings of Nicolas Poussin, Pierfrancesco Mola, and Gaspard Dughet. Although the arrangement of the figures in this painting is apparently based on Giorgione's models, the way they are set against the asymetrical background and integrated with it by completely painterly means is entirely new in the history of Venetian painting. It was probably

painted about 1510, and possibly even be-
fore, while Giorgione was still alive. The
figure of the Child is damaged by old
restorations. The removal of added strips
during a recent cleaning restored the panel
to its original dimensions.

Oil on wood. Over-all, h. 18, w. 22 in.
(45.7 × 55.9 cm.); painted surface, h. 17,
w. 21 1/2 in. (43.2 × 54.6 cm.).

REFERENCES: G. B. Cavalcaselle (unpublished opin-
ion, 1865) attributes this painting to Titian; and,
with J. A. Crowe, *Tiziano*, I (1877), p. 90, attributes
it to Titian, comparing it with the Madonna and
Child with Saint Ulfo and Saint Bridget in the
Prado and dating it about 1511 or even earlier //
B. Berenson, *Ven. Ptrs.* (1897), p. 98, hesitantly
lists it as an early work by Domenico Caprioli;
Art in Amer., XVI (1928), pp. 153 f., fig. 7, attributes
it to Titian, dating it about 1511; *Ital. Pictures*
(1932), p. 573, lists it as an early work by Titian;
and *Ven. School* (1957), p. 189, pl. 948 // G. Gronau,
Gaz. des B.-A., ser. 3, XIII (1895), p. 432, rejects
the attribution to Titian, calling it the work of
an anonymous painter and observing its connections
with the late works of Giovanni Bellini and with
Palma Vecchio; (unpublished opinion, 1928) at-
tributes it to the young Titian under Giorgione's
influence, dating it between 1505 and 1510; and,
in W. R. Valentiner, *Unknown Masterpieces* (1930),
no. 22, ill. // C. Phillips, *Titian* (1898), pp. 25 f.
(reprinted in *The Earlier Work of Titian*, 1906,
pp. 25 f.), rejects the attribution to Titian, ascribing
it to an anonymous painter between the young
Giorgione and the young Titian // H. F. Cook,
Giorgione (1900), pp. 97, 101, 128, ill. opp. p. 100,
rejects the attribution to Titian, giving it to Gior-
gione and comparing it with a Madonna in the
Accademia Carrara in Bergamo and with the so-
called Gypsy Madonna in Vienna // L. Cust, *Les
Arts*, VI (1907), Oct., pp. 12 f., ill. p. 27, attributes
it to Titian, observing its connection with the
Madonna with Saint Ulfo and Saint Bridget in
the Prado // C. J. Ffoulkes, *L'Arte*, XIII (1910),
p. 305, calls it an anonymous work // T. Borenius,
Burl. Mag., XVI (1910), p. 347, accepts the attri-
bution to Domenico Caprioli, observing the Gior-
gionesque accent and an affinity to Lorenzo Lotto
// C. Ricketts, *Titian* (1910), pp. 29, 177, pl. III,
attributes it to Titian, dating it about 1504-1506,
slightly later than the so-called Gypsy Madonna
in Vienna // D. von Hadeln (unpublished opinion,
1927) calls it a very fine early Titian, dating it at
the same time as the Three Ages of Man in the
Bridgewater collection // F. E. W. Freund, *Cice-
rone*, XIX (1927), pp. 497, 502, ill. p. 500, attributes
it to Titian // F. Heinemann, *Tizian: Die zwei
ersten Jahrzehnte seiner künstlerischen Entwicklung*
(1928), pp. 43, 72, quotes Crowe and Cavalcaselle's

description and lists it among the lost works by
Titian; rejects the attribution to Titian, giving it
to an anonymous pupil whom he calls the Master
of the Benson Madonna and grouping it with a
Holy Family in Bridgewater House, London, a
Portrait of a Man in the Frick Collection, New
York, and a Head of a Young Man in the Städel
Institute, Frankfurt // A. L. Mayer, *Pantheon*, VI
(1930), p. 542, calls it an early work by Titian //
L. Venturi, *Ital. Ptgs. in Amer.* (1933), pl. 506,
attributes it to Titian and dates it about 1510 //
W. Suida, *Tizian* (1933), pp. 25, 158, pl. LXXV,
attributes it to Titian, dating it between 1512 and
1518, before the painting in the Prado; and *Le
Titien* (1935), pp. 25, 162, pl. LXXV // *Duveen
Pictures* (1941), no. 152, ill., as Titian, about 1510
// R. Longhi, *Viatico per cinque secoli di pittura
veneziana* (1946), p. 64, pl. 109 (detail), attributes
it to Titian, dating it about 1510 or slightly before
// F. Bologna, *Paragone*, II (1951), no. 17, pp. 23,
28, attributes it to Titian, dating it before 1511 //
R. Pallucchini, *Tiziano*, I (1953), p. 51, attributes
it to Titian, dating it about 1510; and *Tiziano*
(1969), I, pp. 12, 37, 240, II, pl. 59 // G. A. Del-
l'Acqua, *Tiziano* (1955), pp. 52, 105, pl. 3, calls
it an early work by Titian // F. Valcanover, *Tutta
la pittura di Tiziano* (1960), I, pp. 15, 46, pl. 13,
attributes it to Titian, dating it before 1511; and
L'Opera completa di Tiziano (1969), p. 92, no. 20,
ill. // H. E. Wethey, *The Paintings of Titian*, I
(1969), pp. 98 f., no. 48, pl. 5, hesitantly attributes
it to Titian, and dates it about 1511 // S. J. Freed-
berg, *Painting in Italy 1500 to 1600* (1971), p. 478,
attributes the painting, with reserve, to the early
Titian, and dates it about 1509-1510.

EXHIBITED: New Gallery, London, 1894-1895, *Ve-
netian Art*, no. 1 (as by an unknown artist, lent by
Mrs. R. H. Benson); Burlington Fine Arts Club,
London, 1905, *Winter Exhibition*, no. 44 (as Titian,
lent by Robert H. Benson); Royal Academy, Lon-
don, 1910, *Old Masters*, no. 57 (as ascribed to
Titian, lent by R. H. Benson); Burlington Fine
Arts Club, London, 1914, *Venetian School*, no. 26
(as attributed to Titian, lent by R. H. Benson);
Manchester Art Gallery, 1927, *Loan Exhibition of
the Benson Collection of Old Italian Masters*, no. 31
(as attributed to Titian, lent by R. H. Benson);
Detroit Institute of Arts, 1928, *Sixth Loan Exhi-
bition of Old Masters*, no. 1 (as Titian, lent by Andrew
W. Mellon); Metropolitan Museum of Art, New
York, 1943, *The Bache Collection*, no. 15 (lent by
Jules S. Bache).

EX COLL.: Jean de Jullienne, Paris (by about 1750;
sale, Paris, P. Remy, March 30-May 22, 1767, no.
41); Brownlow Cecil, 9th Earl of Exeter, Burghley
House, Stamford, Lincs. (after 1767-1793); Henry
Cecil, 1st Marquess of Exeter (1793-1804); Brown-
low Cecil, 2nd Marquess of Exeter (1804-1867;
Guide to Burghley House, 1815, p. 117); William
Alleyne Cecil, 3rd Marquess of Exeter (1867-1888;
sale, Christie's, London, June 9, 1888, no. 303,
as Titian); Robert H. and Evelyn Benson, London

(1888-1927; Cat. 1914, pp. 181 f., no. 90, ill., as ascribed to Titian); [Duveen Brothers, New York, 1927-1928]; Andrew W. Mellon, Washington, D.C. (1928); [Duveen Brothers, New York, 1928]; Jules S. Bache, New York (1928-1944; Cat. 1929, no. 15).

THE JULES S. BACHE COLLECTION, 1949.

Venus and Adonis
49.7.16 (Plate 95)

This picture represents the goddess Venus trying to restrain her lover, the mortal Adonis, at the moment of his departure for the hunt during which he was killed by a boar. The literary source followed is probably Ovid (*Metamorphoses*, book 10). The subject was painted by Titian and his assistants a number of times. Apart from shop versions, later copies, and old engravings, the main examples can be divided into two types. The earlier has a square composition with Cupid asleep at full length on the left and Adonis holding three hounds. This arrangement is seen in a painting in the Prado in Madrid (no. 422) and in one in the National Gallery in London (no. 34). The Prado version was sent by Titian to Philip II, who received it toward the end of 1554. The second type, which includes our painting, is wider than its height and shows, among other minor changes, only two hounds and Cupid half-length and awake. A version by Titian that is very close to ours is in the National Gallery, Washington (no. 680, Widener collection); another, now lost but known from an engraving, was made for the Farnese family and was in the royal collection in Naples until the early nineteenth century. Our picture and the related one in Washington belong to Titian's late period and probably were painted toward the end of the 1560's. Although some parts, especially areas in the landscape, are too weak to have been painted by Titian himself, the major part, including the three figures, can be considered his work.

Oil on canvas. H. 42, w. 52 1/2 in. (106.7 × 133.3 cm.).

REFERENCES: The authorities cited below, with the exception of Crowe and Cavalcaselle and H. Tietze, attribute this painting to Titian. W. Buchanan, *Memoirs of Painting* (1824), I, p. 123, II, p. 153, relates the purchase of the painting in Rome // G. F. Waagen, *Treasures-Gr. Brit.* (1854), III, pp. 18 f. // Crowe and Cavalcaselle, *Tiziano, la sua vita e i suoi tempi* (1878), II, pp. 95 f., note, judge it a copy or an imitation by an artist later than Titian; and *The Life and Times of Titian* (1881), II, pp. 151 f., note, call it an imitation of Titian by a later artist // C. Stryienski, *La Galerie du Régent* (1913), p. 46 // A. L. Mayer, *Münchner Jahrb.*, N. F., II (1925), pp. 276 ff., fig. 7; and *Pantheon*, VI (1930), p. 542 // F. E. W. Freund, *International Studio*, XC (1928), p. 39, ill. p. 41, regards it as superior in some ways to the Prado version and notes that the action is more concentrated; and *Cicerone*, XX (1928), p. 258 // L. Burchard, in W. R. Valentiner, *Unknown Masterpieces* (1930), no. 24, puts it in the second group of paintings of the same subject along with the Widener version and dates it in the artist's late period, but before the Widener picture // W. Suida, *Belvedere*, XI (1932), p. 166, fig. 147, groups it with the Widener version and a smaller example in a private collection in Paris and considers it in great part by Titian // B. Berenson, *Ital. Pictures* (1932), p. 573; and *Ven. School* (1957), p. 189, pl. 997 // H. Tietze, *Tizian* (1950), p. 403, calls it a workshop replica of the Widener version // W. Arslan (in a letter, 1952) considers it a school work // R. Pallucchini, *Tiziano*, II (1954), p. 77, dates it after 1560; and *Tiziano* (1969), I, pp. 142, 315, II, pl. 475, dates the Museum's picture 1560-1565, calls the Madrid picture the earliest, the London picture slightly later, and the National Gallery picture a replica from the workshop // C. Gould, *The Sixteenth Century Venetian Schools* (*National Gallery Catalogue*) (1959), pp. 99 ff., calls it later than the National Gallery and Prado pictures and exhaustively discusses the two groups of versions and the problems connected with their provenance and dating // F. Valcanover, *Tutta la pittura di Tiziano* (1960), II, p. 44, pl. 91, dates it about 1557; and *L'Opera completa di Tiziano* (1969), p. 129, no. 428, ill. p. 128, attributes it to Titian with assistants // E. Panofsky, *Problems in Titian* (1969), pp. 149 ff., discusses the iconography of the two groups of paintings of this subject, following the classification suggested by Gould, and investigates the classical sources both of the literary theme and of the figure of Venus.

EXHIBITED: British Institution, London, 1816, no. 125 (lent by the Earl of Darnley); Royal Academy, London, 1876, *Old Masters*, no. 119 (lent by the Earl of Darnley); Detroit Institute of Arts, 1928, *Sixth Loan Exhibition of Old Masters*, no. 19 (lent by Jules S. Bache); Art Gallery of Toronto, 1935, *Loan Exhibition of Paintings*, no. 26 (lent by Jules S. Bache); California Palace of the Legion of Honor, San Francisco, 1938, *Venetian Painting*, no. 71 (lent by the Bache collection); World's Fair, New York,

1939, *Masterpieces of Art*, no. 384 (lent by Jules S. Bache); Metropolitan Museum, New York, 1943, *The Bache Collection*, no. 16 (lent by Jules S. Bache); Nationalmuseum, Stockholm, 1962-1963, *Konstens Venedig*, no. 97.

EX COLL.: the Mariscotti family, Rome (until about 1804); [V. Camuccini, Rome, 1804]; [W. Buchanan, London, 1804]; the Earls of Darnley, Cobham Hall, Gravesend, Kent (by 1816; sale, Christie's, London, May 1, 1925, no. 79); [M. Knoedler and Co., New York, 1925-1927]; Jules S. Bache, New York (1927-1944; Cat., 1929, no. 16).

THE JULES S. BACHE COLLECTION, 1949.

XVII Century Copy after Titian

Alfonso d'Este, Duke of Ferrara
27.56 (Plate 96)

Alfonso d'Este (1486-1534) is shown in this portrait with his hand resting on a cannon to indicate his pride in his munitions foundry and artillery corps. A portrait of Alfonso by Titian, admired by Michelangelo in Ferrara in 1529 (see G. Vasari, *Vite*, 1568, Milanesi ed., VII, 1906, p. 199), was ceded in 1533 by Alfonso to the Emperor Charles V, then the dominant power in Italy, in return for the emperor's favor and his intercession with the Pope on behalf of Alfonso's territorial claims. For a time Charles kept the portrait in Bologna; later it was taken to Spain, and it is listed in the inventories made in 1666 and 1686 of pictures in the Royal Palace in Madrid. After the seventeenth century there is no further mention of it (see L. Dolce, *L'Aretino*, Edelberger ed., 1871, p. 31; Crowe and Cavalcaselle, *Titian*, I, 1877, p. 298; G. Gruyer, *L'Art ferrarais*, I, 1897, p. 138; C. Justi, *Jahrb. der Preuss. Kstmslgn.*, XV, 1894, pp. 72 ff.). Documents indicate that Titian made a second portrait of Alfonso about 1535 at the request of his son and successor, Ercole II. This was almost identical to the first, and was based on a sketch that Titian had kept in his workshop (see G. Campori, *Nuova Antologia*, XXVII, 1874, p. 604). The main difference was the inclusion of the badge of the order of Saint Michael, which Louis XII had conferred upon Alfonso in Grenoble in 1502 (see Diario ferrarese dall'anno 1490 sino al 1502, in Muratori, *Rerum italicarum scriptores*,

XXIV, part VII, pp. 287, 289). In order to have the decoration represented accurately, Ercole had his father's collar of Saint Michael sent to Titian. An old copy of this second version is in the Pitti Gallery in Florence (no. 311); in it the duke, wearing the collar of Saint Michael, is resting his hand on a cannon, but the composition and the dress are slightly different from our portrait, and his hair and beard are shown turned grey. A painting in the Royal Museum in Copenhagen (no. 843) representing the duke's head and shoulders is also an old copy, but it is obvious that it was taken from the first version; it shows not the order of Saint Michael but the same jewel he wears in ours (see M. Krohn, *Italienske Billeder in Danmark*, 1910, pp. 129 ff., 231, fig. 54). A version that belonged to a Milanese dealer and was exhibited in Ferrara in 1933 (probably the one now in the Fine Arts Gallery, San Diego, no. 50.114), shows Alfonso in different dress, without the jewel or the finger ring. The Museum's picture certainly follows Titian's first portrait and is probably a faithful reproduction of it. Although its quality is high, the brushwork and handling are not Titian's. Moreover, the pigment looks more recent than the first half of the sixteenth century, and a comparison with Titian's authentic works suggests some non-Italian early baroque painter. The problem of authorship must be left open, but it should be noted that, even though a copy, the picture shows in the rendering of forms and particularly in the details of the head, a close link with the

early style of Peter Paul Rubens. It is worth recalling that Rubens, during his early stay in Spain, copied many pictures by Titian then in the royal collections in Madrid, among them the portrait of Alfonso d'Este, for such a copy is listed in the inventory of his estate (no. 58).

Formerly attributed by the Museum to Titian (Cat., 1940).

Oil on canvas. H. 50, w. 38 3/4 in. (127 × 98.4 cm.).

REFERENCES: A. L. Mayer (unpublished opinion, 1925) attributes this painting to Titian, dating it about 1529-1530; *Münchner Jahrb.*, II (1925), pp. 279 ff., ill. p. 283, fig. 8, publishes this portrait, then in a French private collection, attributes it to Titian, dating it in the late 1520's or in the early 1530's, and identifies it tentatively with the picture inventoried in Madrid in 1666 and 1686; and (in a letter, 1927) // G. Gronau (unpublished opinion and letter, 1925) attributes it to Titian, identifying it with his first portrait, subsequently presented to the Emperor Charles V; and *Jahrb. der Ksthist. Smlgn.*, II (1928), pp. 233 ff., pl. XII, publishes the original documents, identifies it with Titian's first portrait of Alfonso, and dates it about 1523 // B. Berenson (in a letter, 1926) attributes it to Titian; *Ital. Pictures* (1932), p. 573, lists it as a work by Titian, finished in 1534; and *Ven. School* (1957), p. 189 // B. Burroughs, *Met. Mus. Bull.*, XXII (1927), pp. 98 ff., ill. p. 97, identifies it with Titian's first portrait of Alfonso and dates it 1523-1525 // H. B. Wehle, *The Arts*, XI (1927), pp. 225 f., ills. pp. 222, 224, identifies it with Titian's first portrait of Alfonso // A. Venturi, *Storia*, IX, part III (1928), p. 977, lists it as a copy by Dosso Dossi of the lost portrait by Titian // P. Hendy, *Gardner Mus. Cat.* (1931), p. 367, calls it a copy of Titian's original portrait of Alfonso // W. Suida, *Tizian* (1933), pp. 44, 157, pl. LXIX, attributes it to Titian and dates it about 1523; (verbally, 1939) rejects his earlier attribution to Titian; and *Gaz. des B.-A.*, ser. VI, XXIX (1946), p. 142, note 6,

observes that it is not by Titian, but that it is his invention // N. Quilici, *Rivista di Ferrara*, I (1933), no. 9, pp. 16 f., considers it superior to the version shown in the Ferrara exhibition // H. Tietze, *Tizian: Leben und Werk* (1936), pp. 138, 303, pl. 75, identifies it with Titian's first portrait of Alfonso and dates it about 1522; and *Tizian* (1950), p. 390, reaches no conclusion as to whether it is a copy or an original // G. M. Richter (verbally, 1940) considers it a Flemish copy of high quality after Titian // R. Pallucchini, *Tiziano*, I (1953), pp. 147f., states that, not having seen the original, he cannot judge its authenticity // G. A. Dell'Acqua, *Tiziano* (1955), pp. 70, 116, pl. 65, considers it by Titian // E. Wind, *Pagan Mysteries in the Renaissance* (1958), p. 97, fig. 62, suggests that it may be a copy after Titian, and discusses the iconography of the cannon // F. Valcanover, *Tutta la pittura di Tiziano*, I (1960), p. 98, pl. 206, lists it among works attributed to Titian but not by him; and (verbally, 1973) calls it an Italian copy, probably Venetian, of the second half of the XVI century // J. Shearman (verbally, 1965) finds the suggestion that it might be a copy by Rubens reasonable // H. Wethey, *Paintings of Titian*, II, *Portraits* (1971), pp. 94f., no. 26, pl. 40, identifies it as Titian's original, dating it about 1523-1525 // M. Jaffe (verbally, 1971, 1972) attributes it to Rubens about 1602 // [J. Pope-Hennessy], *Times Literary Supplement*, (Feb. 25, 1972), p. 222, rejects Wethey's attribution to Titian and attributes the painting to Rubens // S. Freedberg (verbally, 1972) attributes it to Rubens // M. Hirst (verbally, 1972) attributes it to Rubens // J. Müller Hofstede (in a letter, 1973) from the photograph doubts that the portrait is by Rubens // W. Stechow (in a letter, 1973) from the photograph doubts that it is by Rubens // H. von Sonnenburg (verbally, 1973) on technical grounds doubts that it is by Rubens, considering it a work of an Italian artist of the second half of the XVI century.

EX COLL.: Countess Arthur de Vogüé, Château de Commarin, Commarin, Dijon; Countess Charles de Vogüé, Château de Commarin (by 1925); [Loebl, Paris]; Sir Robert H. E. Abdy, Newton Ferrers, Callington, Cornwall; [A. S. Drey, Munich, 1927].

PURCHASE, MUNSEY FUND, 1927.

Veronese

Real name Paolo Caliari. Born 1528 (?); died 1588. Paolo Caliari, originally from Verona, is no doubt the "Paulus" who in 1541 is mentioned as a pupil and assistant of the Veronese painter Antonio Badile (1518-1560). He was influenced by Badile, as well as by Titian, Parmigianino, and Giulio Romano. It seems likely that Veronese visited Rome.

By 1554 he was established as one of the leading painters of Venice, where he decorated many of the halls of the Doge's Palace with scenes and allegories glorifying the Venetian state, and painted portraits of the dignitaries of his day. In the altarpieces and decorations that he made for many Venetian churches he treated religious subjects in terms of the colorful, luxurious life of his own time with such a free use of genre that in 1573 he was called before the Inquisition on a charge of irreverence. The classical grandeur of his compositions is often enhanced by architectural settings that strongly resemble the buildings of his contemporary, the architect Andrea Palladio. Veronese is one of the main representatives of the high Renaissance; his treatment of textures is brilliant and the richness of his palette is the high point in the use of color in the Venetian school. His style was imitated by his brother Benedetto and his sons Carlo and Gabriele, who carried on the work in his studio after his death. Veronese also had followers and imitators throughout the seventeenth century, and in the eighteenth century Giovanni Battista Tiepolo was deeply indebted to him.

Mars and Venus United by Love
10.189 (Plate 97)

The gestures of the man and woman are not satisfactorily explained by the traditional title, Mars and Venus United by Love, and the picture, which must illustrate some elaborate allegorical concept, has been variously interpreted. Robert Eisler believed that it represented the Adoption of Hercules by Juno,[1] while Edgar Wind suggested that the woman pressing milk from her breast might symbolize Chastity Transformed by Love into Charity.[2] The horse held back by armed Cupid would then be the emblem of Passion Restrained. Wind's explanation seems more plausible, but it leaves many points unclear, and until the specific literary source has been identified, the meaning of the painting will remain problematical. In color and style, and especially in the quality of the brushwork, this picture is a splendid and characteristic work of Veronese, and X-rays show fundamental changes in the composition that could only have been made by the artist himself as the work progressed. It should be dated in the 1570's. A number of copies of the painting are known, the best being that in the Hermitage in Leningrad,[3] and there is also a drawing after it by Jacob Jordaens, made in Antwerp in 1654.

The Museum's painting can be traced with certainty in the catalogues of the Orléans collection, and before that in the inventories of works of art belonging to Queen Christina of Sweden. The nucleus of her collection was the group of paintings taken from the Imperial gallery in Prague in 1648, when Swedish forces sacked the city, and this picture, which probably belonged to Rudolf II, may even have been commissioned by him.[4] It has, however, been wrongly identified with a painting recorded by Borghini (Il Riposo, 1584, p. 563) as commissioned by him, as well as with a Mars and Venus that Carlo Ridolfi, the seventeenth-century Venetian art historian, mentioned as belonging to his collection (Delle Maraviglie dell'Arte, 1648, 1, p. 320). The Mars and Venus mentioned by Ridolfi was later described in detail in one of Queen Christina's inventories, and was last heard of in 1800, when it was exhibited in London prior to the second sale of the Orléans collection. It is known through two fragments and a copy in the Kunsthistorisches Museum in Vienna.[5] Three other large paintings by Veronese were owned by Rudolf II, Queen Christina, and the dukes of Orléans: the Allegory of Wisdom and Strength and the Allegory of Virtue and Vice in the Frick Collection, New York (nos. 12.1.128, 12.1.129), and the Hermes, Herse and Aglauros in the Fitzwilliam Museum in Cambridge (no. 143). Though the pictures are similar in size and all have complicated allegories for subject matter, there is as yet no conclusive

evidence that they originally constituted a series.

Signed (on marble fragment at bottom): PAVLVS VERONENSIS.F.

Oil on canvas. H. 81, w. 63 3/8 in. (205.7 × 161 cm.).

1. In a letter (1934); see also *Vorträge*, 1922-1923 (Bibl. Warburg), part. II, sect. II: *Orphisch-Dionysische Mysterien* (pub. 1925), pp. 362 ff.

2. See also the engraving called Peace by Marcantonio Raimondi (Bartsch, 393, copy C), and the supposed portrait of Simonetta, school of Botticelli, formerly in the Cook collection, Richmond, which shows a girl pressing milk from her breast.

3. See Hermitage, Leningrad, Cat., 1891, no. 151; another copy is in the collection of M. Bourdon, Château de Bourré, Bourré, Loire et Cher, France. Many less important copies, some apparently from engravings, are in private collections.

4. See Refs., H. Zimmerman, 1905, for the inventory dated December 6, 1621 (Vienna, Reichsfinanzarchiv), which was compiled a few months after the death of Emperor Rudolf II. If the Museum's picture is not no. 1151 (Eine schönes stuck, Venus und Mars, vom Paul Ferones), it might possibly be no. 929 (Pauli Veronensis contrafect, seine aigene hand). The inventory of the paintings taken from Prague by the Swedes in 1648 was probably prepared by order of the commander, Field Marshal von Königsmark; it was published by Granberg (see Refs., 1897), and was at that time in the collection of Count Nils de Brahe, Skokloster, Sweden. Nos. 248 (Venus Vnd Mars mit einem Ross, welches Cupido hält) and 450 (Mars, Venus vnd zwey Cupido dorbey ein Pfert) must be our painting and the one of Mars in armor, which is more fully described in the inventory of 1689 (no. 9), but it is not possible to determine which is which. The same is true of nos. 79 (Un grand tableau représentant un homme accompagné d'une femme et d'un Cupidon avec un cheual derrière) and 88 (Dito, ou est peint un homme, une femme nue et un cheual) in the inventory of Queen Christina's collection compiled in 1652 (Stockholm, Royal Library). A French translation of the Swedish text was made for Raphaël Trichet du Fresne, keeper of paintings, and is signed by him and dated September 24, 1653 (Stockholm, Royal Library, see Refs., Dudik, 1852, Geffroy, 1855, and Granberg, 1897). Another catalogue of the Queen's pictures (Rome, Archivio di Stato) was probably compiled immediately after her death in 1689 by the notary Lorenzo Belli (see Refs., Campori, 1870, and Granberg, 1897). Here the Museum's picture (no. 5) is described at length: Un quadro con bel paese con Marte a sedere, e in piedi una Venere ignuda, che posa la sinistra mano sopra la spalla di Marte, con l'altra preme una poppa facendo cadere il latte sopra un Amorino, e lega lei e Marte per le gambe, e dietro il cavallo di Marte con altro Amorino, che tiene la spada di esso, figure grandi al naturale, opera insigne di *Paolo Veronese*, in tela, in piede, alta palmi otto e un quarto e larga palmi sei e mezzo in cornici liscia indorata. The collection, which the Queen had left to Cardinal Decio Azzolini, later passed to the Odescalchi family and the last catalogue (see Refs., Granberg, 1897, no. 39, P. Veronese. Venere e Marte con veduto di paese, cavallo, ed Amorini, misura simile alla sapienza [no. 37 of the same inventory] e cornice comes.[a]) was prepared in 1721, just before it was sold to the duke of Orléans.

5. See Refs., F. Zeri, 1959, and C. Briganti, 1960.

REFERENCES: L. F. Dubois de Saint Gelais, *Tableaux du Palais Royal* (1727), pp. 373 f., lists a picture by Veronese answering the description of ours and gives the size as 6 *pieds*, 3 *pouces* × 5 *pieds* (about 79 3/4 × 63 3/4 in.) // [J. A. Crozat], *Recueil d'estampes d'après les ... tableaux ... dans le cabinet ... de Monseigneur le duc d'Orléans* (2nd ed.) (1763), II, p. 34, pl. 159, reproduces an engraving by Michel Aubert after the Orléans picture, on which no signature of Veronese appears, and calls it Mars et Venus liés par l'Amour // *Galerie du Palais Royal* (1786), II, reproduces an engraving by Jacques Couché after the Orléans picture, on which no signature of Veronese appears, and calls it Mars et Venus liés par l'Amour // W. Buchanan, *Memoirs* (1824), I, p. 135, lists this picture as belonging to Elwyn and notes that it came from the Orléans collection // G. F. Waagen, *Works of Art - England* (1838), I, p. 335, lists it as belonging to Elwyn, sold to him in 1792, and notes that it came from the Orléans collection; and *Treasures - Gr. Brit.* (1854), II, p. 498 // B. Dudik, *Forschungen in Schweden für Mährens Geschichte* (1852), p. 104, publishes excerpts from the inventory of 1652, in which a painting by Veronese answering the description of ours is mentioned // M. A. Geffroy, *Notices et extraits des manuscrits concernant l'histoire ... de la France* (1855), pp. 166 f., publishes the inventory of 1652, in which paintings by Veronese answering the description of ours are mentioned // G. Campori, *Raccolta di cataloghi* (1870), p. 337, publishes the inventory of 1689, in which a painting by Veronese answering the description of ours is mentioned // O. Granberg, *Galerie de tableaux de la Reine Christine de Suède* (1897), pp. 15, 36, no. 42, X, XV, XXIX, XXX, LIII, XCVI, publishes the inventories of about 1648, 1652, 1689, and 1721, in which paintings by Veronese answering the description of ours are mentioned, and wrongly identifies the version in the Hermitage with the picture sold to Elwyn // V. Champier, *Le Palais Royal* (1900), I, p. 513, ill. p. 233, quotes a list, prepared in 1788, of the paintings that the Duke of Orléans intended to sell in London, together with the prices and the names of the buyers // *Athenaeum*, no. 3926 (1903), pp. 120 f., in a review of the Burlington House exhibition, describes our

picture as an outstanding example of Veronese's work // L. M. Richter, *Zeitschr. für bild. Kst.*, N. F., xiv (1903), pp. 265 f., ill., calls it an early work, suggests that it might be a portrait of a lady with her lover, and associates it with the same series as the Fitzwilliam painting and the seven other pictures mentioned by Crozat; and *Connoisseur*, vi (1903), pp. 118 f., ill. // H. Zimmermann, *Jahrbuch d. kunsthist. Sammlungen d. allerh. Kaiserhauses*, xxv (1905), pp. xl, xlv, publishes the inventory of 1621, in which paintings by Veronese answering the description of ours are mentioned // P. Caliari, *Paolo Veronese* [1909], p. 256, lists it among the paintings formerly in the collection of Queen Christina // B. B[urroughs], *Met. Mus. Bull.*, v (1910), pp. 287 f., ill. p. 265, identifies our picture with the one in the collections of Queen Christina and the dukes of Orléans, dates it about 1575, and considers the Hermitage version a replica or copy // G. Cagnola, *Rass. d'arte*, xi (1911), p. 8, ill., identifies it with the painting in the collections of Queen Christina and the dukes of Orléans, and interprets the subject as Martial Force nourished by Beauty // K. Cox, *Scribner's Magazine*, xlix (1911), pp. 637 ff., ill., notes the difference in size between our picture and the one in the Hermitage // T. von Frimmel, *Blätter für Gemäldekunde*, vi (1911), p. 158, ill., wrongly identifies this painting with the one mentioned by Ridolfi as belonging to the collection of Rudolf II // C. Stryienski, *Galerie du Régent Philippe, Duc d'Orléans* (1913), pp. 56, 155, no. 91, identifies our picture with the one in the collections of Queen Christina and the dukes of Orléans, and calls the version in the Hermitage and the one in the Bourdon collection, Paris, copies after it // D. von Hadeln, *Art in Amer.*, i (1913), pp. 235 ff., fig. 9, identifies our picture with the one in the collections of Rudolf, Queen Christina, and the dukes of Orléans, dates it shortly after 1576, and considers it the companion piece to the picture in the Fitzwilliam Museum, Cambridge // A. Burroughs, *Met. Mus. Bull.*, xxii (1927), pp. 191 ff., ill., reproduces the X-ray shadowgraphs of our picture, which reveal changes made by Veronese; and *Met. Mus. Studies*, iii, part i (1930), pp. 47 ff., figs. 1-7 // P. H. Osmond, *Paolo Veronese* (1927), p. 88, pl. 58 A, hesitantly rejects the attribution to Veronese // G. Fiocco, *Paolo Veronese* (1928), pp. 101, 111, note 3, 198, 202, identifies it with the one in the collections of Rudolf, Queen Christina, and the dukes of Orléans; and *Paolo Veronese* [1934], p. 127 // A. Venturi, *Storia*, ix, part iv (1929), p. 950, lists it as a work by Veronese // B. Berenson, *Ital. Pictures* (1932), p. 423, lists it as a work by Veronese; and *Ven. School* (1957), p. 134, pl. 1090, dates it between 1576 and 1584 and calls the subject Venus and Mars United by Love // L. Venturi, *Ital. Ptgs. in Amer.* (1933), pl. 571, identifies it with the picture in the collections of Rudolf, Queen Christina, and the dukes of Orléans, and dates it 1576-1584 // H. Tietze, *Meisterwerke europäischer Malerei in Amerika* (1935), p. 331, pl. 105, attributes it to Veronese // R. Pallucchini, *Veronese* (1943),

p. 40, fig. 121, attributes it to Veronese, notes that it was painted between 1576 and 1584 for Rudolf II, and that it belongs to the same series as the two pictures in the Frick Collection; and *Pittura veneziana del cinquecento* (1944), ii, p. xxxi, pl. 85 // Sir R. C. Jebb, *Met. Mus. Bull.*, n.s., v (1946), ill. p. 79, attributes it to Veronese // *Art Treasures of the Metropolitan Museum* (1952), p. 228, pl. 111 (in color), attributes it to Veronese // T. Rousseau, *Met. Mus. Bull.*, n.s., xii (1954), Jan., part ii, p. 23, ill., attributes it to Veronese // R. A. d'Hulst, *De Tekeningen van Jakob Jordaens* (1956), pp. 201, 263, 354, no. 83, publishes a drawing after our picture by Jordaens, and describes it as a copy of a picture by Veronese which exists in several versions // G. Briganti, *Arte veneta*, xii (1958), p. 91, calls it an allegory painted for Rudolf II, along with the paintings in the Frick Collection and the Fitzwilliam Museum; and *Paragone*, xi (1960), no. 125, pp. 32 f., accepts Zeri's identification (see below) of the picture mentioned by Ridolfi with the lost one from this series, and publishes another fragment of the original, a half-length figure of Mars // E. Wind, *Pagan Mysteries in the Renaissance* (1958), p. 84, fig. 56, interprets the subject as Strength restraining Virtue, suggests that the woman's gesture of pressing milk from her breast symbolizes chastity transformed into charity, and discusses some of the minor implications of the subject // F. Zeri, *Paragone*, x (1959), no. 117, pp. 43 f., fig. 27, rejects the identification of our picture with the work mentioned by Ridolfi, which he believes to be a painting now lost, except for a fragment, but known through a copy, and leaves the problem of the iconography of the picture unsolved // E. Tietze-Conrat, *Arte veneta*, xiii-xiv (1959-1960), pp. 96 f., rejects the connection of our painting with the one in the Fitzwilliam, and considers it the pendant to the picture discussed by Zeri // A. Ballarin, *Arte veneta*, xix (1965), p. 80, calls it Juno adopting Hercules and dates it around 1580 // *Christina Queen of Sweden* (Stockholm, 1966), pp. 431 f., 485 f., publishes the Jordaens drawing, as well as an important series of copies of the Frick, Fitzwilliam and Metropolitan Museum pictures // E. Waterhouse, in *Queen Christina of Sweden Documents and Studies* (1966), p. 375, lists it among the Italian paintings once owned by Queen Christina that later formed part of English collections // J. W. Goodison and G. H. Robertson, *Catalogue of Paintings, Fitzwilliam Museum*, ii (1967), pp. 125 ff., accept the identification of this picture with the one mentioned by Borghini, note that it is thought to have been painted between 1576 and 1584, and to have formed part of a series including the paintings in the Frick Collection and in the Fitzwilliam Museum, but emphasize the disparity in size between the four pictures and the circumstantial nature of the evidence // M. Jaffé, *Jacob Jordaens 1593-1678* (Ottawa, 1968), pp. 216 f., notes that the Jordaens drawing was made from the painting when it was displayed as part of Queen Christina's collection in Antwerp in 1654 // R. Marini, *L'Opera completa*

del *Veronese* (1968), p. 120, no. 205, ill., pl. LIX (in color), attributes the painting to Veronese and dates it about 1580 // S. J. Freedberg, *Painting in Italy 1500 to 1600* (1971), pp. 307, 382, attributes the painting to Veronese, calling it part of the series with the paintings in the Frick Collection and Fitzwilliam Museum, painted between 1576 and 1584.

EXHIBITED: Royal Academy, London, 1881, *Old Masters*, no. 146 (lent by Lord Wimborne); and 1903, *Old Masters*, no. 55 (lent by Lord Wimborne); Grafton Galleries, London, 1909-1910, *National Loan Exhibition*, no. 55 A (lent by Asher Wertheimer); Metropolitan Museum, New York, 1952-1953, *Art Treasures of the Metropolitan*, no. 111, and 1967, *In the Presence of Kings*, no. 27; Museum of Fine Arts, Boston, 1970, *Masterpieces of Painting in The Metropolitan Museum of Art*, (Cat., p. 25); Metropolitan Museum, New York, 1970-1971, *Masterpieces of Fifty Centuries*, no. 215.

EX COLL.: Emperor Rudolf II, Prague (until 1612; Invs. 1621 and about 1648); the Imperial collections, Prague (1612-1637); Emperor Ferdinand III, Prague (1637-1648); Queen Christina of Sweden, Stockholm, Antwerp and Rome (1648-1689; Invs. 1652 and 1689); Cardinal Decio Azzolini, Rome (1689); Marchese Pompeo Azzolini, Rome (1689-1696); Prince Livio Odescalchi, Rome (1696-1713; Inv. 1713-1714); Marchese Baldassare Odescalchi-Erba, later Prince Odescalchi, Rome (1713-1721; Inv. 1721); Duke Philippe d'Orléans, Palais Royal, Paris (1721-1723); the Dukes of Orléans, Paris (1723-1785); Duke Louis Philippe Joseph d'Orléans, Paris (1785-1792); Vicomte Edouard de Walckiers, Brussels (1792); François de Laborde de Méréville, Paris (1792-1798); Jeremiah Harman, London (1798); [Syndicate: Lord Bridgewater, Lord Carlisle, and Lord Gower, through Bryan; exhibited for sale, Lyceum, Strand, London, 1798-1799, no. 273]; Hastings Elwyn, Booton, Norfolk (1799-1806; sale, Phillips's, London, May 23, 1806, no. 23); Campbell, London (1866); Lord Wimborne, Canford Manor, Wimborne, Dorset (1866-1903; Cat., 1888, no. 31; sale, Christie's, London, May 23, 1903, no. 75); [Lepper]; [Asher Wertheimer London, 1909-1910].

PURCHASE, KENNEDY FUND, 1910.

Boy with a Greyhound

29.100.105 (Plate 98)

According to the Martinengo family of Brescia, who once owned this picture, the boy portrayed is a member of the Colleoni family. The Colleoni and Martinengo families were connected by marriage. A bust portrait of this boy in the same attitude is now in the J. Paul Getty Museum in Malibu (formerly in the collection of Baron von Hadeln in Venice). The Museum's portrait, which has been somewhat altered by old repainting, seems to be by Veronese with the help of one or more assistants, and dates perhaps from the 1570's. It is possible that the picture was originally one of a number of portraits, similar to the series at the Villa Barbaro (now Volpi) at Maser. In this case it would have been the right section of a decorative unit, and would have been balanced at the far left by a painting with a figure turned toward the right.

Oil on canvas. H. 68 3/8, w. 40 1/8 in. (173.6 × 101.9 cm.).

REFERENCES: The authorities cited below attribute this painting to Veronese. D. von Hadeln, *Art in Amer.*, XV (1927), pp. 247, 251 f. // F. J. Mather, Jr., *The Arts*, XVI (1930), p. 457, ill. p. 479 // B. Berenson, *Ital. Pictures* (1932), p. 423; and *Ven. School* (1957), p. 134 // L. Venturi, *Ital. Ptgs. in Amer.* (1933), pl. 569, dates it 1560-1570 // G. Fiocco, *Paolo Veronese* (1934), p. 55, pl. 99 B, notes that the figure resembles one in a fresco in the Palazzo Chiericati in Vicenza // R. Marini, *L'Opera completa del Veronese* (1968), p. 108, no. 111, ill.

EXHIBITED: Metropolitan Museum, New York, 1930, *The H. O. Havemeyer Collection*, no. 105.

EX COLL.: the Martinengo family, Brescia (until about 1904); H. O. Havemeyer, New York (about 1904-1907; Cat., 1931, p. 11); Mrs. H. O. Havemeyer, New York (1907-1929).

BEQUEST OF MRS. H. O. HAVEMEYER, 1929.
THE H. O. HAVEMEYER COLLECTION.

Alessandro Vittoria

46.31 (Plate 99)

Alessandro Vittoria, the famous sculptor, was born in Trent in 1524 or 1525 and was active mostly in Venice, where he died in 1608. He was one of the main representatives of the Venetian classical style of the late sixteenth century and collaborated with Veronese in the decoration of the Villa Barbaro at Maser (about 1560-1562). The subject of our portrait shows a strong resemblance to two busts of Vittoria at a more advanced age, one

on his tomb in the church of San Zaccaria in Venice, and another in the Berlin Museum. The marble statuette held by the sculptor offers a further proof of the identification, for it is identical, except for a slight difference in the position of the head, with a small bronze of Saint Sebastian signed by Vittoria, and now in the Metropolitan Museum (no. 40.24; a later and somewhat modified version is now in the Los Angeles County Museum). The pose of the statue, which recalls one of Michelangelo's Dying Slaves in the Louvre, is similar to that of the marble Saint Sebastian executed between 1561 and 1563 for an altar in the church of San Francesco della Vigna. Vittoria noted in his diary that he had a bronze statuette of Saint Sebastian cast in 1566 while another bronze of the same subject was made by him in 1575. The Museum's bronze is presumably the one of 1566 and the close relationship between it and the marble in this painting suggests that the marble must have been made about the same time. The age of the sitter, who would have been forty-one or forty-two, and the style also indicate a date for the painting of about 1566. There is a sixteenth-century copy of this portrait in the Museo Civico in Vicenza (no. 68). A half-length portrait of a man holding a statuette, painted by Palma Giovane and now in the Gemäldegalerie in Vienna, which may be a portrait of Vittoria at the end of his life, is perhaps identical with the one mentioned by Carlo Ridolfi (*Delle Maraviglie dell'Arte*, 1648, II, p. 192).

Oil on canvas. H. 43 1/2, w. 32 1/4 in. (110.5 × 81.9 cm.).

REFERENCES: The authorities cited below attribute this painting to Veronese. A. Frankfurter (unpublished opinion, 1937) identifies the sitter as Alessandro Vittoria when about forty-four and dates the painting 1568 or 1569 // A. Venturi, *L'Arte*, XL (1937), pp. 210 ff., fig. 2, tentatively identifies the man as Vittoria; and *Critica d'arte*, II (1937), p. 40, pl. 33, fig. 2 // W. R. Valentiner, *Art Quarterly*, V (1942), pp. 149 ff., fig. 5, identifies him as Vittoria and discusses the sculpture in his hands, relating it to the bronzes in the Metropolitan Museum and in the New York art market // M. Salinger, *Met. Mus. Bull.*, n.s., V (1946), pp. 7 ff., ill., calls the man Vittoria and dates the painting around 1580, comparing it with other Venetian portraits of sculptors // E. Panofsky (in a letter, 1946) // B. Berenson, *Ven. School* (1957), p. 134, pl. 1082, calls it a portrait of Vittoria // *Palladio, Veronese, e Vittoria a Maser* (1960), ill. p. 38 // W. Suida, *Arte veneta*, XV (1961), p. 103, calls it a Portrait of a Sculptor, and compares it with the Portrait of an Architect in a private collection // F. Cessi, *Alessandro Vittoria Scultore*, II Parte (1962), p. 2, ill., identifies it as a portrait of Vittoria // R. Marini, *L'Opera completa del Veronese* (1968), p. 116, no. 177, ill., calls it a Portrait of a Sculptor (Alessandro Vittoria?) // W. Timofiewitsch, *Girolamo Campagna* (1972), pp. 32 ff., fig. 125, identifies the subject of this portrait as the sculptor Girolamo Campagna, holding in his hands the model for the Atlas figure at the left of the fireplace in the Sala dell'Anticollegio in the Doge's Palace, and dates it at the time of the execution of this work, 1587-1588.

EXHIBITED: Detroit Institute of Arts, 1951; Art Gallery of Toronto, 1951; City Art Museum, St. Louis, 1952; Seattle Art Museum, 1952.

EX COLL.: 3rd Earl Brownlow, Ashridge, Berkhamstead (sale, Christie's, London, May 4, 1923, no. 70); [A. L. Nicholson, London, 1923]; private collection (sale, Christie's, London, May 23, 1928, no. 231, as Portrait of a Sculptor by Veronese); [Hill, 1928]; [Publio Podio, Bologna, about 1930]; [Umberto Pini, Bologna, about 1936-1937]; [Piero Tozzi, New York, 1946].

PURCHASE, GWYNNE M. ANDREWS FUND, 1946.

Antonio Vivarini

Also called Antonio da Murano. Active by 1441; died between 1476 and 1484. Antonio Vivarini was the elder brother of Bartolomeo Vivarini and the father of Alvise Vivarini. In the earlier part of his career he and his brother-in-law, Giovanni d'Alemagna, worked together and painted for Venetian churches a number of altarpieces set in elaborate architectural frames of Gothic type. Antonio's style is difficult to separate from that of Giovanni and, although it is generally supposed that Giovanni was the lesser

member of the partnership, perhaps even an assistant, the extent of his collaboration is not definitely known. The signatures of both artists appear on many of these altar-pieces, but at least one of their joint works from the early period, a painting in Parenzo, is signed by Antonio alone. After Giovanni d'Alemagna's death (about 1450) Antonio was assisted by his brother Bartolomeo, who seems to have worked on the altarpiece in the Vatican Gallery, though it bears only Antonio's signature and the date 1464. Antonio's style, which evolved very little during his long career, shows the influence of Gentile da Fabriano, Pisanello, and possibly Giovanni d'Alemagna. Beginning in 1447 Antonio worked for several years in Padua, and he was apparently impressed by the markedly individual style of Francesco Squarcione and his pupils. Antonio belonged to a transitional phase of fifteenth-century Italian art and, although his work remained fundamentally Gothic, he employed some of the new themes and motifs of the Renaissance.

Saint Peter Martyr Healing the Leg of a Young Man

37.163.4 (Plate 100)

This small panel shows Saint Peter Martyr of Verona miraculously healing a young man who, remorseful for having kicked his mother, had chopped off his leg (see *Acta Sanctorum*, April, part III (1866), pp. 700, 702 f.). There are six other panels showing episodes from the life of the saint, but the series must be incomplete, since the existing panels do not include a representation of his death. The size and shape of the panels suggest that they were not part of a predella but were placed in two rows on each side of a full-length figure of Saint Peter, either painted or sculptured (for similar arrangements in Venetian altarpieces, see Simone de Cusighe's polyptych in the Accademia in Venice and Quirizio da Murano's Saint Lucy in Rovigo). The other panels are: Peter Martyr Received into the Dominican Order, and Peter Martyr and the Miraculous Fire (Berlin Museum, nos. 65 and 66); Peter Martyr Exorcizing a Woman Possessed by the Devil (George F. Harding collection, Chicago, formerly Paolini, Rome); Peter Martyr Exorcizing the Devil Disguised as the Madonna and Child (formerly Claude Lafontaine collection; sale, Palais Galliera, Paris, April 10, 1962, no. 7); the Virgin with Saints Catherine, Agnes, and Cecilia Appearing to Peter Martyr in a Monastery near Como (collection of Count Leonardo Vitetti, Rome); the Funeral of Peter Martyr (Mario Crespi collection, Milan). Judging from its style our panel seems to have been painted after Antonio's partnership with Giovanni d'Alemagna ended, and it should therefore be dated in the 1450's.

Tempera on wood; gilt halo. H. 20 7/8, w. 13 1/8 in. (53 × 33.3 cm.).

REFERENCES: *Catalogo di quadri esistenti in casa il signor Don Giovanni Dr. Vianelli* (1790), p. 28, attributes this painting to Bartolomeo Vivarini // R. Longhi (unpublished opinion, 1937) attributes it to Antonio Vivarini and dates it about 1460; and *Viatico per cinque secoli di pittura veneziana* (1946), p. 51, pl. 27, dates it between 1450 and 1460 // G. Pudelko, *Pantheon*, x (1937), pp. 283 ff., ill., attributes it to Antonio Vivarini and connects it with the Berlin and Harding (formerly Paolini) panels // G. Fiocco (unpublished opinion, 1937) calls it north Italian, dates it in the first part of the XV century, notes the influence of the Florentine style, and connects it with three panels with martyrdoms of female saints in the picture galleries of Bergamo and Bassano; and *Arte veneta*, II (1948), pp. 20, 25, fig. 20, accepts the attribution to Antonio Vivarini in his early period and the connection with the other panels dedicated to the same saint, suggesting tentatively that the series may come from the church of Santi Giovanni e Paolo in Venice // F. Mason Perkins (unpublished opinion, 1937) attributes it to Antonio Vivarini // W. Suida (unpublished opinion, 1937) attributes it to Antonio Vivarini // A. Venturi (unpublished opinion, 1937) attributes it to Antonio Vivarini // M. Salinger, *Met. Mus. Bull.*, XXXIII (1938), pp. 8 ff., ill. // L. Coletti, *Pittura veneta del quattrocento* (1953), p. XXIX, fig. 52 B, attributes it to Antonio Vivarini and dates it possibly after 1450 // B. Berenson, *Ven. School* (1957), p. 198, fig. 83, lists it as a work by Antonio Vivarini // R. Pallucchini, *I Vivarini* [1962], pp. 27, 98, fig. 22, attributes it to Antonio Vivarini and dates it, along with the other panels of the series, not much later than the Santa Monica altarpiece, around 1441-1445.

EX COLL.: Giovanni Vianelli, Chioggia (1790; as Bartolomeo Vivarini); Achillito Chiesa, Milan (sale, American Art Association, New York, Nov. 22, 1927, no. 109, as a Miracle of Saint Dominic by Jacopo Bellini); [F. Steinmeyer, Lucerne]; [Böhler, Munich]; [Asher, London]; [Count Alessandro Contini Bonacossi, Florence, 1937]; Samuel H. Kress, New York (1937).

GIFT OF THE SAMUEL H. KRESS FOUNDATION, 1937.

Workshop of Antonio Vivarini

Saint Jerome

65.181.6 (Plate 101)

The saint is represented wearing the cardinal's habit and holding a model of a church and a book of his own writings. The rays that emanate from both the door of the church and the leaves of the book are symbolic of his role as doctor of the church and interpreter of the scriptures. The balustrade before which the figure is placed curves in the center, forming a niche; in the lower right corner is the lion, a common attribute of Saint Jerome. In its general composition our painting derives from the main panel of a polyptych, formerly in the church of Santo Stefano in Venice, now in the Kunsthistorisches Museum in Vienna (no. 10 A), signed by Giovanni d'Alemagna and Antonio Vivarini, and dated 1441. Another panel in the Walters Art Gallery in Baltimore (no. 693), signed by Giovanni d'Alemagna alone and dated 1444, is based on a similar scheme, although in it the saint is shown slightly turned to the right. Neither the Vienna nor the Baltimore paintings include the lion. The style of our work is closer to Antonio Vivarini than to his partner Giovanni d'Alemagna, and the quality suggests a workshop product rather than the hand of the master himself. The picture probably dates from the first half of the 1440's, although a very similar scheme occurs in the representations of Saint Jerome executed by Antonio Vivarini later in his career.

Tempera on wood, gold ground. Over-all (with added strips), h. 10 3/4, w. 7 1/8 in. (27.3 × 18.1 cm.); painted surface, h. 10 1/4, w. 6 5/8 in. (26 × 16.8 cm.).

Inscribed (on back of panel, in a later hand): Gian Bellini/Näp. 3.

REFERENCE: C. Virch, *The Adele and Arthur Lehman Collection* (1965), p. 25, ill., attributes it to the workshop of Antonio Vivarini, and notes that in its iconography it follows the representation of Saint Jerome dated 1441 in the Vienna Museum.

EX COLL. Mr. and Mrs. Arthur Lehman, New York (acquired in Europe, through Paul Sachs).

BEQUEST OF ADELE L. LEHMAN IN MEMORY OF ARTHUR LEHMAN, 1965.

Bartolomeo Vivarini

Known activity 1450-1499. Bartolomeo Vivarini was the younger brother of Antonio Vivarini, with whom he collaborated. In his early paintings he followed strictly the style of his elder brother, but later he came under the influence of Paduan painting, especially the work of Andrea Mantegna, and, together with Carlo Crivelli, Bartolomeo Vivarini

can be considered among the chief exponents of the Paduan style in Venice. He was also, to some extent, influenced by the painting of Giovanni Bellini, but, compared with Bellini's fresh and original work, Bartolomeo's always remained archaic and conservative. For the most part his way of painting did not develop greatly after about 1475, but at the end of his career his painting shows some traces of the style of his nephew Alvise Vivarini. Bartolomeo's extensive production, in which he used the elaborate type of Muranese altarpiece, is unequal in quality and shows that he had a large number of assistants working with him.

The Madonna and Child
30.95.277 (Plate 102)

This painting shows Bartolomeo's persistent conservatism, at a date when the leading artist of Venice, Giovanni Bellini, had developed a new, more modern style. The gold background and the restricted scheme of bright, jewel-like colors give the painting an archaic flavor and a certain provincial quality. With various changes and adaptations the same composition of the half-length Madonna and Child reappears in a number of works by Bartolomeo or his workshop. The painting has suffered from overcleaning in the past and from being transferred, especially in the gold ground and in the flesh tones.

Signed and dated (on cartellino at lower right): OPVS FACTVM . . . S . . . BARTHOLE-MEV/ . . . VIVA.R[IN]VM DEMVRIANO 1472.

Tempera on wood (transferred from wood to canvas and back to wood); gold ground. H. 32 3/4, w. 25 3/4 in. (83.2 × 65.4 cm.).

REFERENCES: The authorities cited below attribute this painting to Bartolomeo Vivarini. J. Breck, *Rass. d'arte*, XI (1911), p. 111, doubts the date 1472 in the inscription and suggests placing it around 1480 // B. Berenson, *Ven. Ptg. in Amer.* (1916), pp. 16 f., fig. 9, reads the date as 1472 or 1477 and notes that in the type of the Child the painting recalls Bellini; *Ital. Pictures* (1932), p. 602, reads the date as 147-; and *Ven. School* (1957), p. 202, reads the date as 1470 // B. Burroughs, *Met. Mus. Bull.*, XXVI (1931), Mar., sect. II, p. 14 // L. Venturi, *Ital. Ptgs. in Amer.* (1933), pl. 358 // H. Tietze, *Meisterwerke Europäischer Malerei in Amerika* (1935), p. 327, pl. 62, accepts the date 1472 // R. van Marle, *Ital. Schools*, XVIII (1936), pp. 109 f., accepts the date 1472 // B. Fleischmann, in Thieme-Becker, XXXIV (1940), p. 451 // L. Co-

letti, *Pittura veneta del quattrocento* (1953), p. XLVIII, pl. 97, notes the influence of Giovanni Bellini // R. Pallucchini, *Arte veneta*, XI (1957), p. 198; and *I Vivarini* [1962], pp. 45, 120, fig. 158, notes the poor state of the surface.

EX COLL.: [Durand-Ruel, Paris, 1897]; Theodore M. Davis, Newport (1897-1915).

THE THEODORE M. DAVIS COLLECTION. BEQUEST OF THEODORE M. DAVIS, 1915.

The Death of the Virgin
50.229.1 (Plate 103)

This large altarpiece is a traditional and archaic representation of the subject. The Virgin's catafalque is surrounded by eleven apostles, as in the account of the thirteenth-century writer Jacobus de Voragine. Her soul, represented as a small child, is received by Christ, who is seated in a mandorla of a type frequently seen in medieval and late Gothic painting. The two deacon saints, Lawrence and Stephen, at either side, may have been included as patrons of the donors or because of a connection with the altar or the chapel for which the panel was originally painted. The style is typical of Bartolomeo's conservative and somewhat provincial late period. The hard modeling of the figures, recalling wooden or stone sculpture, and the acid, strident colors show the influence of the Paduan painters: the landscape is in the manner of Mantegna. The death of the Virgin in the lower part of our panel shows marked similarities to two other paintings of the same subject, one by Gerolamo da Treviso the elder, formerly in the Monte di Pietà in Treviso, and another by Andrea Mantegna, now in the Prado. The Redeemer in the mandorla

above possibly depends upon some Venetian source such as the mosaic of the Death of the Virgin in the Mascoli chapel in San Marco in Venice, variously attributed to Mantegna, Andrea del Castagno, and Andrea da Murano. The faulty foreshortening of certain figures in our painting, and the crude expressions of some of the faces suggest that it is partly a workshop product. The date that appeared originally on the cartellino at the lower center has been obliterated by restorations, but since all the elements in the painting suggest that it was painted very late in Bartolomeo's career, it is quite likely that Moschini was correct when he read the date as 1499 (see Refs.). In that case, our painting would be the last known work of Bartolomeo Vivarini.[1]

Signed and dated (in cartellino at lower center): illegible.

Tempera on wood; arched top. H. 74 3/4, w. 59 in. (190 × 149.9 cm.).

1. When the panel was first mentioned by Rossetti in 1765 the date was read as 1475; later it was cleaned and restored in Venice by Giovanni Maria Sasso, and the inscription was transcribed as "Hoc opus factum fuit Venetiis 1499 per/Bartholomeum Viva/rinum de Muriano." At some time, perhaps after the panel had left John Strange's collection, it was altered to read "Giott . . . tum . . . Venethsi pe./ int. . . olomeum vive/ . . . m oi Mu.iano l . . ." In 1865 the inscription read "Opus factum Venetiis per Bartholomeum Vivarinum de Muriano 1480".

REFERENCES: G. Rossetti, *Descrizione delle pitture, sculture et architetture di Padova* (1765), p. 351, describes this painting as a work of Bartolomeo Vivarini and reads the date as 1475; and in 1780 edition, p. 358, notes that it had been taken from Padua to Venice // G. Moschini, *Guida per l'Isola di Murano*, 2nd ed. (1808), pp. 124 ff., refers to it as by Bartolomeo Vivarini, reports that it had been sold to John Strange and taken to London, and says it had been cleaned and restored by Giovanni Maria Sasso, who read the date as 1499 // I. Neümann-Rizzi, *Discorsi letti nella R. Accademia di Belle Arti in Venezia, 1816* (1817), pp. 50, 89 f., calls it one of Bartolomeo Vivarini's best works, painted in 1499 // W. Bürger [E. J. Thoré], *Trésors d'art exposés à Manchester en 1857* (1857), pp. 22 f.,

questions the attribution to Giotto in the exhibition of Art Treasures at Manchester // Crowe and Cavalcaselle, *Ptg. in N. Italy*, 1 (1871), pp. 48 f., reject the attribution to Giotto and consider it a work of Bartolomeo's late period, identifying it with the work recorded by Moschini // G. Gronau, *Gaz. des B.-A.*, ser. 3, XIII (1895), p. 163, notes that it is signed by Bartolomeo Vivarini and dated 1480 // T. Borenius, *Burl. Mag.*, XIX (1911), p. 197, ill. p. 196, attributes it to the workshop of Bartolomeo Vivarini and discusses the date; and in Crowe and Cavalcaselle, *Ptg. in N. Italy* (1912), I, pp. 48 f., note 3 // L. Testi, *Storia pitt. ven.*, II, (1915), pp. 440, 450 ff., 481 ff., ill. p. 485, calls it a work painted by pupils following Bartolomeo's design and perhaps finished after his death // R. van Marle, *Ital. Schools*, XVIII (1936), p. 123, note 3, judging only from reproductions, hesitantly attributes it to Bartolomeo's late period // B. Fleischmann, in Thieme-Becker, XXXIV (1940), p. 451, lists it among the works of Bartolomeo Vivarini, tentatively accepting the date 1499 // E. E. Gardner, *Met. Mus. Bull.*, n.s., x (1952), pp. 287 ff., ill. p. 286, attributes it to Bartolomeo Vivarini // B. Berenson, *Ven. School* (1957), p. 202, lists it as work painted in Bartolomeo's studio // R. Pallucchini, *I Vivarini* [1962], pp. 52, 128 f., fig. 208, compares it with the polyptych of 1485 in the Museum of Fine Arts, Boston, dates it in the second half of the 1480's, and lists it as by Bartolomeo and his workshop.

EXHIBITED: Manchester, 1857, *Art Treasures*, no. 66 (as Giotto, lent by Lord Northwick); Royal Academy, London 1885, *Old Masters*, no. 206 (lent by William Graham); New Gallery, London, 1894-1895, *Venetian Art*, no. 44 (lent by Charles Butler).

PROVENANCE: a church in Padua (?); a chapel in the Certosa, Padua (until after 1765); the Certosa, Venice (until about 1775).

EX COLL.: John Strange, Venice (about 1775-1788) and Ridge, near Barnet, Middlesex (1788-1799); John Rushout, 2nd Baron Northwick, Thirlestane House, Cheltenham (by 1857-1859; Cat., 1858, no. 799, as Giotto; sale, Phillips, Thirlestane House, Cheltenham, August 9, 1859, no. 894, as Giotto); [Pearce, High Holborn, 1859]; William Cox (sale, Foster's, London, March 27, 1861, no. 164, as Giotto); William Graham, London (by 1885-1886; sale, Christie's, London, April 8, 1886, no. 259); [Murray, London]; Charles Butler, London (by 1894-1911; sale, Christie's, London, May 25, 1911, no. 112); [Thos. Agnew and Sons, London, 1911]; Charles Fairfax Murray, London (1911); [L'Art Ancien S. A., Lugano, about 1924]; Philip Lehman, New York (1929); [Duveen Brothers, New York, 1929]; Philip Lehman, New York (1929-1947); Robert Lehman, New York (1947-1950).

GIFT OF ROBERT LEHMAN, 1950.

A Saint Reading (Saint Mark?)
65.181.1 (Plate 104)

The lack of any specific attribute makes it impossible to identify this figure. However, it has traditionally been called Saint Mark, and this identification is supported by the very close similarity of the features in our painting to those of the Saint Mark in the central panel of Bartolomeo Vivarini's triptych of 1474 in the church of the Frari in Venice. Our painting appears to have been altered along all four edges, and there is good reason to believe that originally it represented a full-length figure. The style is that of Bartolomeo Vivarini in the early 1470's. It should be noted that a full-length figure of Saint Mark, no longer traceable, is recorded in old sources as in the lowest portion of a three-tiered polyptych, formerly on the first altar to the left in the church of Santi Giovanni e Paolo in Venice. This altarpiece was dismembered around 1815, and the three panels which remain in the church are now arranged as a triptych, with the figure of Saint Augustine, a signed and dated work of 1473, flanked by representations of two other saints, Dominic and Lawrence.[1] The Museum's panel may have belonged originally to the same complex: it is similar in style, and the tooled halo is identical with the haloes of Saints Lawrence and Dominic.

Tempera on wood, gold ground. Over-all (with added strips), h. 19 1/8, w. 15 1/4 in. (48.5 × 38.4 cm.); painted surface, h. 18 5/8, w. 14 3/4 in. (47.3 × 37.5 cm).

1. See L. Testi, *Storia pitt. ven.*, II (1915), p. 464.

REFERENCE: C. Virch, *The Adele and Arthur Lehman Collection* (1965), p. 27, ill., attributes this painting to Bartolomeo Vivarini and notes that it is similar to the central figure of Saint Mark in the Frari dated 1474.

EX COLL.: M. du Houssaye, Saumur; M. J. Seligman, London (sale, Christie's, London, March 14, 1924, no. 21, under different properties); [Jean Visman, London]; Mr. and Mrs. Arthur Lehman, New York (probably acquired through Paul Sachs, until 1965).

BEQUEST OF ADELE L. LEHMAN IN MEMORY OF ARTHUR LEHMAN, 1965.

Francesco Zuccarelli

Francesco Zuccarelli. Also spelled Zuccherelli. Born 1702; died 1788. Zuccarelli received his early training in Rome; around 1730 he established himself in Venice, where he remained until about 1742, when he went to England for several years. Thereafter he divided his time between Venice and London. Zuccarelli was deeply influenced by the late seventeenth-century Roman landscape painters and by Marco Ricci. He soon became famous for his Arcadian views, simple pastoral scenes without the gods and heroes who typically animate classical landscapes, and he had many pupils working in his style, as well as a number of imitators.

Landscape with Figures
59.189.1 (Plate 106)

This painting of the Italian countryside, with peasants engaged in their everyday activities, is a characteristic example of Zuccarelli's work. The treatment of the trees is reminiscent of Marco Ricci, and the brushwork and color, which does not yet show the pastel-like fusion of the artist's mature period, suggest a rather early date, perhaps in the late 1730's.

Oil on canvas. H. 31 1/4, w. 47 1/2 in. EX COLL. Bernard M. Baruch, New York.
(79.4 × 120.6 cm.).

EXHIBITED: Allentown Art Museum, Allentown, GIFT OF BERNARD M. BARUCH, IN MEMORY OF HIS
Pennsylvania, 1971, *The Circle of Canaletto*, no. 43. WIFE, ANNIE GRIFFEN BARUCH, 1959.

Unknown Painter, Second Quarter of the XV Century

The Madonna and Child
 32.100.93 (Plate 105)

This picture was evidently painted for the
Cornaro family of Venice, whose coat of
arms appears at the base of the panel. Its
style is related to the work of Jacopo Bel-
lini and Donato Bragadin and also to that
of Antonio Vivarini, but our present
knowledge of the Venetian school toward
the end of the second quarter of the fifteenth
century makes a definite attribution impos-
sible. The subject is the Madonna of Hu-
mility surrounded by angels bearing the
instruments of the Passion, with God the
Father above. The theme of the Passion
is also symbolized by the Child's pose,
which recalls the attitude of the Man of
Sorrows, while the veil that the Virgin's
gesture emphasizes alludes to the shroud
of the dead Christ.

Formerly dated by the Museum in the
middle of the XV century (Cat., 1940).

Tempera on wood; arched top. Over-all
size, including added strips at sides and
bottom and added upper corners, h. 15
3/8, w. 10 in. (39.1 × 25.4 cm.); painted
surface, h. 14 1/4, w. 9 in. (36.2 × 22.8
cm.).

REFERENCES: B. Berenson, in Cat. of Friedsam Coll.
(unpublished, n.d.), pp. 66 f., attributes this paint-
ing to the Venetian artist who painted a Madonna

in the Museum in Budapest (no. 103, ascribed to
Giambono) and dates it about 1450; *Ital. Pictures*
(1932), p. 593, lists it as Venetian, dates it in the
XV century, and suggests attributing it to An-
tonio da Negroponte; and *Ven. School* (1957), p.
205, lists it as by an unidentified Venetian of the
XV century // B. Burroughs and H. B. Wehle,
Met. Mus. Bull., XXVII (1932), Nov., sect. II, p. 32,
quote Berenson's attribution // R. Offner (verbally,
1937) calls it a work of the school of Jacopo Bellini
and dates it about 1450 // R. Longhi (unpublished
opinion, 1937) attributes it to Antonio Vivarini
and dates it about 1435-1440, when Antonio was
still under the influence of Gentile da Fabriano //
F. Mason Perkins (in a letter, 1938) attributes it
to a Venetian artist strongly influenced by Antonio
Vivarini // S. A. Callisen, *Art Bull.*, XXI (1939),
p. 177, discusses the iconography of the cock on
the column in the left background // G. Firestone,
Marsyas, II (1942), pp. 43 f., fig. 19, discusses the
iconography of the veil held by the Virgin and
of the Child's pose // L. Coletti (in a letter, 1949)
attributes the picture to Antonio da Negroponte
and observes the influence of Gentile da Fabriano
combined with that of Jacopo Bellini; and *Pittura
veneta del quattrocento* (1953), p. XLIX // C. Volpe,
Arte veneta, IX (1955), pp. 19, 21, accepts the at-
tribution to Antonio Vivarini // M. Röthlisberger,
Saggi e Memorie di storia dell'arte, II (1959), p. 81,
note 50, tentatively suggests an attribution to the
early period of Jacopo Bellini // R. Pallucchini,
I Vivarini [1962], p. 86, rejects the attribution to
Antonio Vivarini and tentatively calls it a work of
the circle of Jacopo Bellini.

EX COLL.: Count della Porta, Gubbio; [Elia Volpi,
Villa Pia, Florence; sale, American Art Galleries,
New York, Nov. 21-27, 1916, no. 992, as Gentile
da Fabriano]; [Kleinberger Galleries, New York,
1916]; Michael Friedsam, New York (1916-1931).

THE MICHAEL FRIEDSAM COLLECTION.
BEQUEST OF MICHAEL FRIEDSAM, 1931.

Unknown Painter, Late XVII Century

The Last Supper

07.150 (Plate 107)

Oil on canvas. H. 25 3/4, w. 38 in. (65.4 × 96.5 cm.).

This is a copy of the Last Supper painted by Jacopo Tintoretto for the church of San Trovaso in Venice (ill. in E. von der Bercken and A. L. Mayer, *Jacopo Tintoretto*, 1923, II, p. 82). The technique, the range of colors, and a certain exaggeration of Tintoretto's forms suggest that this artist worked in the late seventeenth or early eighteenth century. The painting shows some similarity to the early work of Sebastiano Ricci (1660-1734), who is known to have painted copies of the great Venetian masterpieces of the sixteenth century.

Formerly called by the Museum a copy after Tintoretto (Cat., 1940).

REFERENCES: J. Britton, *Historical Account of Corsham House* (1806), p. 46, no. 106, mentions this painting as a work by Tintoretto // G. F. Waagen, *Art and Artists in England* (1838), III, p. 99, attributes it to Giacomo Bassano // *Met. Mus. Bull.*, II (1907), p. 172, ill., attributes it to Tintoretto // E. M. Phillipps, *Tintoretto* (1911), p. 49, mentions it as a sketch by Tintoretto for the San Trovaso Last Supper // M. H. Bernath, *New York und Boston* (1912), p. 84, calls it a sketch by Tintoretto for his famous Last Supper // F. P. B. Osmaston, *The Art and Genius of Tintoret* (1915), II, p. 70, refers to it as a sketch and mentions another in the Caen Museum.

EX COLL.: Lord Methuen, Corsham Court, Wilts. (by 1806); the Methuen family, Corsham Court, Wilts. (until about 1907); [Sulley and Co., London, 1907].

PURCHASE, ROGERS FUND, 1907.

List of Plates

Plate 1	Antonello da Messina: *Young Man*	14.40.645
Plate 2	Antonello da Messina: *Christ Crowned with Thorns*	32.100.82
Plate 3	Antonello de Saliba: *Madonna Adoring the Child*	30.95.249
Plate 4	Giovanni Bellini: *Madonna and Child*	08.183.1
Plate 5	Giovanni Bellini: *Madonna Adoring the Child*	30.95.256
Plate 6	Giovanni Bellini and Workshop: *Madonna and Child with Saints*	49.7.1
Plate 7	Workshop of G. Bellini: *Presentation in the Temple*	68.192
Plate 8	Workshop of G. Bellini: *Madonna and Child*	49.7.2
Plate 9	Jacopo Bellini: *Madonna and Child*	59.187
Plate 10	Bellotto: *View of Vaprio d'Adda*	39.142
Plate 11	Bonifazio Veronese: *Miracle of St. Ambrose*	32.100.78
Plate 12	Canaletto: *Venice, the Piazzetta*	10.207
Plate 13	Canaletto: *Venice, Santa Maria della Salute (and detail)*	59.38
Plate 14	Carpaccio: *Meditation on the Passion*	11.118
Plate 15	Casanova: *Cavalier and Shepherd*	07.225.253
Plate 16	Catena: *Portrait of a Venetian Senator*	30.95.258
Plate 17	Catena: *Adoration of the Shepherds*	69.123
Plate 18	Cima: *Three Saints*	07.149
Plate 19	Cima: *Madonna and Child with Saints*	41.190.11
Plate 20	Crivelli: *St. George, St. Dominic*	05.41.2,1
Plate 21	Crivelli: *The Pietà*	13.178
Plate 22	Crivelli: *Madonna and Child*	49.7.5
Plate 23	Giambono: *Man of Sorrows*	06.180
Plate 24	Diziani: *Dawn*	06.1335.1
Plate 25	Guarana: *Crowning with Thorns*	71.30
Plate 26	Guardi: *Venice: Grand Canal above the Rialto*	71.119
Plate 27	Guardi: *Venice: Santa Maria della Salute*	71.120
Plate 28	Guardi: *Landscape*	35.40.3
Plate 29	Guardi: *Landscape*	35.40.4
Plate 30	Guardi: *Fantastic Landscape*	41.80
Plate 31	Guardi: *Fantastic Landscape (detail)*	41.80
Plate 32	Guardi: *Fantastic Landscape*	53.225.3
Plate 33	Guardi: *Fantastic Landscape*	53.225.4
Plate 34	Guardi: *Venice: Piazza San Marco*	50.145.21
Plate 35	Guardi: *Venice from the Sea*	65.181.8
Plate 36	Guardi (?): *Still Life*	64.272.1
Plate 37	Guardi (?): *Still Life*	64.272.2
Plate 38	Jacometto Veneziano: *Portrait of a Young Man*	49.7.3
Plate 39	Joli: *London: St. Paul's and Old London Bridge*	1970.212.2
Plate 40	P. Longhi: *The Letter*	14.32.1
Plate 41	P. Longhi: *The Visit*	14.32.2
Plate 42	P. Longhi: *The Temptation*	17.190.12
Plate 43	P. Longhi: *The Meeting*	36.16

Plate 44 A. Longhi: *Count Carlo Aurelio Widmann* 15.118
Plate 45 Lotto: *Brother Gregorio Belo* 65.117
Plate 46 Maggiotto (?): *Joseph Sold by his Brethren* 29.70
Plate 47 Master of Helsinus: *Madonna and Child with Saints* 32.100.87
Plate 48 Menescardi: *Esther before Ahasuerus (and detail)* 94.4.364
Plate 49 Montemezzano: *Portrait of a Woman* 29.100.104
Plate 50 Niccolò di Pietro: *St. Ursula and her Maidens* 23.64
Plate 51 Paolo Veneziano: *Madonna and Child* 1971.115.5
Plate 52 Palma Giovane: *The Crucifixion* 57.170
Plate 53 Palma Giovane: *Ecstasy of St. Francis* 62.257
Plate 54 Piazzetta: *St. Christopher* 67.187.90
Plate 55 Saraceni: *Paradise* 1971.93
Plate 56 Schiavone: *Marriage of Cupid and Psyche* 1973.116
Plate 57 Schiavone: *Marriage of Cupid and Psyche (detail)* 1973.116
Plate 58 Sebastiano del Piombo: *Christopher Columbus* 00.18.2
Plate 59 Sustris: *Portrait of a Nobleman* 49.7.14
Plate 60 G. B. Tiepolo: *Investiture of Bishop Harold* 71.121
Plate 61 G. B. Tiepolo: *Glorification of Francesco Barbaro (and detail)* 23.128
Plate 62 G. B. Tiepolo: *Adoration of the Magi* 37.165.1
Plate 63 G. B. Tiepolo: *St. Thecla Praying* 37.165.2
Plate 64 G. B. Tiepolo: *Apotheosis of the Spanish Monarchy* 37.165.3
Plate 65 G. B. Tiepolo: *Neptune and the Winds* 37.165.4
Plate 66 G. B. Tiepolo: *Capture of Carthage* 65.183.2
Plate 67 G. B. Tiepolo: *Battle of Vercellae* 65.183.3
Plate 68 G. B. Tiepolo: *Triumph of Marius* 65.183.1
Plate 69 Workshop of Tiepolo: *Virtue and Abundance* 43.85.12
Plate 70 Workshop of Tiepolo: *Metaphysics; Arithmetic* 43.85.13,14
Plate 71 Workshop of Tiepolo: *Geometry; Grammar* 43.84.15,16
Plate 72 Workshop of Tiepolo: *Asia* 43.85.17
Plate 73 Workshop of Tiepolo: *Africa* 43.84.18
Plate 74 Workshop of Tiepolo: *Europe* 43.85.19
Plate 75 Workshop of Tiepolo: *America* 43.85.20
Plate 76 Workshop of Tiepolo: *Prudence* 43.85.21
Plate 77 Workshop of Tiepolo: *A Virtue* 43.85.22
Plate 78 Workshop of Tiepolo: *Temperance* 43.85.23
Plate 79 Workshop of Tiepolo: *Fortitude* 43.85.24
Plate 80 G. D. Tiepolo: *Sacrifice of Isaac* 71.28
Plate 81 G. D. Tiepolo: *Virtue and Wisdom* 07.225.297
Plate 82 G. D. Tiepolo: *Glorification of the Giustiniani Family* 13.2
Plate 83 G. D. Tiepolo: *Glorification (detail)* 13.2
Plate 84 Tintoretto: *Doge Mocenigo Presented* 10.206
Plate 85 Tintoretto: *Doge Mocenigo Presented (detail)* 10.206
Plate 86 Tintoretto: *Miracle of Loaves and Fishes* 13.75
Plate 87 Tintoretto: *Finding of Moses* 39.55
Plate 88 Tintoretto: *Portrait of a Man* 41.100.12
Plate 89 Tintoretto: *Portrait of a Young Man* 58.49
Plate 90 Titian: *Portrait of a Man* 14.40.640
Plate 91 Titian: *Filippo Archinto* 14.40.650
Plate 92 Titian: *Doge Andrea Gritti* 32.100.85
Plate 93 Titian: *Venus and the Lute Player* 36.29
Plate 94 Titian: *Madonna and Child* 49.7.15

Plate 95 Titian: *Venus and Adonis* 49.7.16
Plate 96 Copy after Titian: *Alfonso d'Este* 27.56
Plate 97 Veronese: *Mars and Venus United by Love* 10.189
Plate 98 Veronese: *Boy with a Greyhound* 29.100.105
Plate 99 Veronese: *Alessandro Vittoria* 46.31
Plate 100 A. Vivarini: *St. Peter Martyr* 37.163.4
Plate 101 A. Vivarini: *St. Jerome* 65.181.6
Plate 102 B. Vivarini: *Madonna and Child* 30.95.277
Plate 103 B. Vivarini: *Death of the Virgin* 50.229.1
Plate 104 B. Vivarini: *Saint Reading (St. Mark ?)* 65.181.1
Plate 105 Unknown Painter: *Madonna and Child* 32.100.93
Plate 106 Zuccarelli: *Landscape with Figures* 59.189.1
Plate 107 Unknown Painter: *Last Supper* 07.150

Books and Periodicals Abbreviated

Arch. stor. dell'arte
Archivio storico dell'arte

Art Bull.
The Bulletin of the College Art Association

Art in Amer.
Art in America

Baroque Ptrs. of Italy
Baroque Painters of Italy

Boll. d'arte
Bollettino d'arte

Bull. of the Cleveland Mus. of Art
The Bulletin of the Cleveland Museum of Art

Burl. Mag.
The Burlington Magazine

Gaz. des B.-A.
Gazette des Beaux-Arts

Gemäldesmlg. - St. Petersburg
Die gemäldesammlung in der Kaiserlichen Eremitage zu St. Petersburg, nebst bemerkungen über andere dortige kunstsammlungen

Ital. Pictures
Italian Pictures of the Renaissance

Ital. Ptgs. in Amer.
Italian Paintings in America

Ital. Schools
Italian Schools of Painting

Jahrb. der Ksthist. Smlgn.
Jahrbuch der kunsthistorischen Sammlungen des allerhöchsten Kaiserhauses

Jahrb. der Preuss. Kstsmlgn.
Jahrbuch der preussischen Kunstsammlungen

Kstkrit. Studien - Berlin
Kunstkritische Studien über Italienische Malerei: Die Galerie zu Berlin

Kstkrit. Stud. - München und Dresden
Kunstkritische Studien über Italienische Malerei: Die Galerien zu München und Dresden

Met. Mus. Bull.
Bulletin of The Metropolitan Museum of Art

Münchner Jahrb.
Münchner Jahrbuch der bildenden Kunst

Origini pitt. ven.
Le origini della pittura veneziana 1300-1500

Ptg. in N. Italy
A History of Painting in North Italy, Venice, Padua, Vicenza, Verona, Ferrara, Milan, Friuli, Brescia, from the Fourteenth to the Sixteenth Century

Rass. d'arte
Rassegna d'arte antica e moderna

Repert. für Kstwiss.
Repertorium für Kunstwissenschaft

Rev. de l'art
Revue de l'art

Riv. d'arte
Rivista d'arte

Storia
Storia dell'arte italiana

Storia pitt. ven.
La storia della pittura veneziana

Study and Criticism
The Study and Criticism of Italian Art

Thieme-Becker
U. Thieme and F. Becker, Allgemeines Lexikon der Bildende Kunst

Treasures - Gr. Brit.
Treasures of Art in Great Britain

Ven. Ptg. in Amer.
Venetian Painting in America

Ven. Ptrs.
The Venetian Painters of the Renaissance

Ven. School
Italian Pictures of the Renaissance, Venetian School

Vite
Le Vite de' più eccellenti Pittori, Scultori ed Architettori

Zeitschr. für bild. Kst.
Zeitschrift für bildende Kunst

Zeitschr. für Kst.
Zeitschrift für Kunstgeschichte

Index of Former Owners

Abdy, Sir Robert H. E.
 Titian, copy after, 27.56

Abdy, Sir William Neville
 Carpaccio, 11.118

Agnew, Thos., & Sons
 G. Bellini workshop, 49.7.2
 Canaletto, 10.207,
 Catena, 69.123
 Sebastiano del Piombo, 00.18.2
 G. B. Tiepolo, 37.165.1
 B. Vivarini, 50.229.1

Aldrich, Mrs. Winthrop W.
 Guardi, 41.80

Alexander, Mrs. Charles B.
 Guardi, 41.80

Alford, Viscount
 Catena, 69.123

Alliata, Don Giulio
 Antonello da Messina, 32.100.82

Altman, Benjamin
 Antonello da Messina, 14.40.645
 Titian, 14.40.640, 650

Archinto, Count Giuseppe A.
 Titian, 14.40.650

Archinto family
 Titian, 14.40.650

L'Art Ancien S. A.
 B. Vivarini, 50.229.1

Ascoli Piceno, church of San Domenico
 Crivelli, 13.178

Ashburton, Louisa, Lady
 Crivelli, 05.41.1,2

Asher
 A. Vivarini, 37.163.4

Azzolini, Cardinal Decio
 Veronese, 10.189

Azzolini, Marchese Pompeo
 Veronese, 10.189

Bache, Jules S.
 G. Bellini & workshop, 49.7.1,2
 Jacometto Veneziano, 49.7.3

Crivelli, 49.7.5
Sustris, 49.7.14
Titian, 49.7.15,16

Balboni, Carlo
 P. Longhi, 14.32.1,2; 17.190.12; 36.16

Barbarigo, Cristoforo
 Titian, 32.100.85

Barbarigo family
 Titian, 32.100.85

Barbarigo, Count Sebastiano Giustiniani
 Titian, 32.100.85

Barbaro family
 G. B. Tiepolo, 23.128

Barbaro, Marcantonio
 G. B. Tiepolo, 23.128

Barbato di Naduri, Signora Alba (Albina)
 Giambono, 06.180

Barberini
 Crivelli, 13.178

Baruch, Bernard M.
 Zuccarelli, 59.189.1

Bassi, Elisa
 G. B. Tiepolo, 23.128

Baumgarten, William
 Menescardi, 94.4.364

Baxendale, Mrs.
 Joli, 1970.212.2

Beckford, William
 G. Bellini workshop, 49.7.2

Benson, Robert H. and Evelyn
 G. Bellini & workshop, 49.7.1
 Titian, 49.7.15

Berry, Duchess of
 D. Tiepolo, 71.28
 Guarana, 71.30

Berwind, Edward J.
 Guardi, 53.225.3,4

Berwind, Julia A.
 Guardi, 53.225.3,4

Beurnonville, Etienne Martin, Baron de
Cima, 41.190.11

Biron, Marquis de
G. B. Tiepolo, 37.165.1,2,3,4

Bisenzo, Count Guido di
Crivelli, 13.178

Blumenthal, George and Florence
Cima, 41.190.11
Tintoretto, 41.100.12

Böhler
A. Vivarini, 37.163.4

Borbón, Infanta Maria Amalia de
G. B. Tiepolo, 37.165.2

Borbón, Prince Pedro de, Duke of Durcal
G. B. Tiepolo, 37.165.2

Borbón y Braganza, Infante Don Sebastián Gabriel de
G. B. Tiepolo, 37.165.2

Borchard, Samuel
G. Bellini workshop, 68.192

Borchard, Stuart J. and Evelyn
G. Bellini workshop, 68.192

Bourgeois, Stefan
Guardi, 41.80; 53.225.3,4

Brandt, Mortimer
Piazzetta, 67.187.90

Brass, Italico
Jacopo Palma the Younger, 62.257
Piazzetta, 67.187.90
Titian, 14.40.650

Brauer, Georges
G. Bellini, 08.183.1
Catena, 30.95.258

Bridgewater, Lord, with Lord Carlisle and Lord Gower, through Bryan
Veronese, 10.189

Bromley, the Rev. Walter Davenport
Crivelli, 05.41.1,2

Brownlow, 5th Baron
Catena, 69.123

Brownlow, 2nd Earl
Catena, 69.123

Brownlow, 3rd Earl
Catena, 69.123

Bryan
See Bridgewater

Buchanan, W.
Titian, 49.7.16

Burlington, Richard Boyle, 3rd Earl of
Schiavone, 1973.116

Buschmann, Baron Alfred
J. Palma the Younger, 62.257

Butler, Charles
Bonifazio Veronese, 32.100.78
B. Vivarini, 50.229.1

Camondo, Isaac, Count de
G. B. Tiepolo, 23.128

Campbell
Veronese, 10.189

Camuccini, V.
Titian, 49.7.16

Cannon, Henry White
A. Longhi, 15.118

Canonici, Roberto
Carpaccio, 11.118

Canonici family
Carpaccio, 11.118

Carlisle, Lord
See Bridgewater

Carpio, Don Gaspar Méndez de Haro y Guzmán, Marquis of
Antonello da Messina, 32.100.82

Carrer, Antonio
Diziani, 06.1335.1
Longhi, 14.32.1,2; 17.190.12; 36.16

Caspari Galleries
Canaletto, 59.38

Castiglioni, Camillo
G. B. Tiepolo, 65.183.1,2,3

Castletown, Augusta, Dowager Lady
Guardi, 50.145.21

Castletown, Bernard Edward, 2nd Baron
Guardi, 50.145.21

Castletown, J. W. F., 1st Baron
Guardi, 50.145.21

Cellini, Mario
Guardi (?), 64.272.1,2

Chiesa, Achillito
A. Vivarini, 37.163.4

Christina, Queen of Sweden
Veronese, 10.189

Coke, Sir Thomas W.
Titian, 36.29

Coke, Wenman Roberts
Titian, 36.29

Colloredo family
Guardi, 41.80; 53.225.3,4

Colloredo Mels, Count Camillo di
Guardi, 41.80; 53.225.3,4

Colnaghi, M.
G. Bellini & workshop, 49.7.1

Colnaghi, P. & D., & Co.
Bonifazio Veronese, 32.100.78
Crivelli, 05.41.1,2
Canaletto, 59.38

Contini Bonacossi, Count Alessandro
Catena, 69.123
A. Vivarini, 37.163.4

Contini Bonacossi, Count Alessandro Augusto
Catena, 69.123

Cornet, Count
Guardi, 71.119,120

Cox, William
B. Vivarini, 50.229.1

Crawshay, Robert
Crivelli, 13.178

Darnley, Earls of
Titian, 49.7.16

Davis, Theodore M.
Antonello de Saliba, 30.95.249
G. Bellini, 30.95.256
Catena, 30.95.258
B. Vivarini, 30.95.277

Devonshire, Andrew Cavendish, 11th Duke of
Schiavone, 1973.116

Devonshire, Charlotte Elizabeth Boyle, Duchess of
Schiavone, 1973.116

Devonshire, William Cavendish, 4th Duke of
Schiavone, 1973.116

Devonshire, Dukes of
Schiavone, 1973.116

Dolfin, Dionisio
G. B. Tiepolo, 65.183.1,2,3

Dolfin family
G. B. Tiepolo, 65.183.1,2,3

Donaldson, Sir George
Canaletto, 10.207

Douglas, R. Langton
Niccolò di Pietro, 23.64
Tintoretto, 10.206, 13.75, 39.65

Dowdeswell & Dowdeswell
Canaletto, 10.207
Crivelli, 05.41.1,2
Tintoretto, 58.49

Drey, A. S.
Titian, copy after, 27.56

Dubufe, Guillaume
G. B. Tiepolo, 37.165.3

Dudley, William Ward, 1st Earl of
Crivelli, 13.178

Dudley, William Humble Ward, 2nd Earl of
Crivelli, 13.178

Durand-Ruel
B. Vivarini, 30.95.277

Durlacher Brothers
Tintoretto, 39.65

Duveen Brothers
Antonello da Messina, 32.100.82
G. Bellini & workshop, 49.7.1,2
Cima, 41.190.11
Crivelli, 49.7.5
Jacometto Veneziano, 49.7.3
Paolo Veneziano, 1971.115.5
Sustris, 49.7.14
Titian, 14.40.640,650; 36.29; 49.7.15
B. Vivarini, 50.229.1

Ellis, Wynn
G. Bellini & workshop, 49.7.1

Elwyn, Hastings
Veronese, 10.189

England, private collection
Guardi (?), 64.272.1,2

Exeter, Brownlow Cecil, 9th Earl of
Titian, 49.7.15

Exeter, Brownlow Cecil, 2nd Marquess of
Titian, 49.7.15

Exeter, Henry Cecil, 1st Marquess of
Titian, 49.7.15

Exeter, William Alleyne Cecil, 3rd Marquess of
Titian, 49.7.15

Farnham, Arthur, 11th Baron
Tintoretto, 13.75

Farnham, Henry, 7th Baron
Tintoretto, 13.75

Farnham, Barons
Tintoretto, 13.75

Farr, Daniel H.
Joli, 1970.212.2

Farrer
Crivelli, 05.41.2; 49.7.5

Favenza, Vincenzo
D. Tiepolo, 23.128

Ferdinand III, Emperor
Veronese, 10.189

Fesch, Cardinal
Crivelli, 05.41.1,2

Fleischman, Lawrence
Schiavone, 1973.116

Florence, private collection
 Antonello de Saliba, 30.95.249

Fol, Walther
 G. Bellini, 30.95.256

Foresti, Count Carlo
 J. Bellini, 59.187

Fossi, Donna Rosalia Velluti-Zati, Countess
 Montemezzano, 29.100.104

Fowles, Edward
 Paolo Veneziano, 1971.115.5

France, private collections
 Menescardi, 94.4.364
 G. B. Tiepolo, 71.121, 23.128

Freedley, Durr
 G. B. Tiepolo workshop, 43.85.12-24

Friedsam, Michael
 Antonello da Messina, 32.100.82
 Bonifazio Veronese, 32.100.78
 Master of Helsinus, 32.100.87
 Titian, 32.100.85
 Unknown Venetian, 32.100.93

Gambardi family
 P. Longhi, 14.32.1,2; 17.190.12; 36.16

Gary, Judge Elbert H.
 Tintoretto, 58.49

Gary, Mrs. Elbert H.
 Tintoretto, 58.49

Gauchez, Léon
 G. B. Tiepolo, 71.121

Gimpel & Wildenstein
 Guardi, 41.80; 53.225.3,4
 G. B. Tiepolo, 37.165.1,3,4

Giovanelli, Prince Alberto
 Sustris, 49.7.14

Giustiniani de' Vescovi
 Catena, 69.123

Goldsmith
 Crivelli, 05.41.1

Gower, Lord
 See Bridgewater

Graham, William
 G. Bellini & workshop, 49.7.1
 B. Vivarini, 50.229.1

Grassi, Giuseppe
 Paolo Veneziano, 1971.115.5

Grassi, Luigi
 Titian, 14.40.640

Gresso, Duke of
 Antonello da Messina, 32.100.82

Grimani family
 Titian, 14.40.640

de Groot, Adelaide Milton
 Piazzetta, 67.187.128

Groult, Camille
 G. B. Tiepolo, 23.128

Guggenheim
 G. B. Tiepolo, 65.183.1,2,3

Haberstock
 G. Bellini workshop, 68.192

Hainauer, Frau Julie
 Cima, 41.190.11

Hainauer, Oscar
 Cima, 41.190.11

Hamilton, Duchess of (Susan Euphemia Beckford)
 G. Bellini workshop, 49.7.2

Hamilton, 11th Duke of
 G. Bellini workshop, 49.7.2

Hamilton, 12th Duke of
 G. Bellini workshop, 49.7.2

Harewood, Earl of
 Saraceni, 1971.93

Harkness, Edward S.
 Guardi, 50.145.21

Harkness, Mrs. Edward S.
 Guardi, 50.145.21

Harman, Jeremiah
 Veronese, 10.189

Haro
 Antonello da Messina, 32.100.82

Havemeyer, H. O.
 Montemezzano, 29.100.104
 Veronese, 29.100.105

Havemeyer, Mrs. H. O.
 Montemezzano, 29.100.104
 Veronese, 29.100.105

Heilbrönner (?)
 G. B. Tiepolo, 23.128

Heimann, Jacob M.
 Bellotto, 39.142

Hesse, Prince Chlodwig of
 G. Bellini workshop, 68.192

Hesse, Princes of
 G. Bellini workshop, 68.192

Hewitt, Mrs. Cooper
 Guardi, 35.40.3,4

Heyl, General Baron von
 Titian, 32.100.85

Hill
Veronese, 46.31

Hirschland, Kurt M.
Tintoretto, 39.55

Hoentschel, Georges
Casanova, 07.225.253
D. Tiepolo, 07.225.297

Hoogendijk, C.
Antonello da Messina, 14.40.645

Houssaye, M. de
B. Vivarini, 65.181.1

Hume, Sir Abraham
Catena, 69.123

Imperial collections
Veronese, 10.189

Italy, private collection
Titian, 14.40.650

Jones, William
Crivelli, 49.7.5

Julienne, Jean de
Titian, 49.7.15

Kleinberger, F., & Co.
Antonello da Messina, 14.40.645, 32.100.82
Bonifazio Veronese, 32.100.78
Schiavone, 1973.116
Titian, 32.100.85
Unknown Venetian, 32.100.93

Knoedler, M., & Co.
Guardi, 50.145.21; 65.181
Tintoretto, 58.49
Titian, 49.7.16

Kress, Samuel H.
P. Longhi, 36.16
A. Vivarini, 37.163.4

Laborde de Méréville, François de
Veronese, 10.189

Landor, Alfred Humbert Savage
Titian, 14.40.640

Landor, Walter Savage
Titian, 14.40.640

Landor family
Titian, 14.40.640

Lawrie, T., & Co.
Sebastiano del Piombo, 00.18.2

Lazzari, Don Dionisio
Antonello da Messina, 32.100.82

Lazzari, Count Giacomo
Antonello da Messina, 32.100.82

Leggatt Brothers
Canaletto, 59.38

Lehman, Mrs. Arthur
Guardi, 65.181.8
A. Vivarini workshop, 65.181.6
B. Vivarini, 65.181.1

Lehman, Philip
B. Vivarini, 50.229.1

Lehman, Robert
J. Palma the Younger, 57.170; 62.257
B. Vivarini, 50.229.1

Leicester, Margaret, Countess of
Titian, 36.29

Leicester, Thomas William Coke, Earl of
Titian, 36.29

Leicester, Thomas William Coke, 2nd Earl of
Titian, 36.29

Leicester, Thomas William Coke, 3rd Earl of
Titian, 36.29

Lenbach, Franz von
Titian, 32.100.85

Lenti, Pier Giovanni
Crivelli, 49.7.5

Lepper
Veronese, 10.189

Leslie, George Dunlop
Tintoretto, 39.55

Leuchtenberg, Dukes of
Cima, 07.149

Loebl
Titian, copy after, 27.56

London, private collections
Bonifazio Veronese, 32.100.78
Maggiotto (?), 29.70
Veronese, 46.31

Madrazo
G. B. Tiepolo, 37.165.4

Marchig, Jean
Lotto, 65.117

Mariscotti family
Titian, 49.7.16

Marquand, Henry G.
Menescardi, 94.4.364

Martinengo family
Veronese, 29.100.105

Mellon, Andrew W.
Jacometto Veneziano, 49.7.3
Titian, 49.7.15

Mendl, Stefan
G. B. Tiepolo, 65.183.1,2,3

Methuen, Lord
 Unknown Venetian, 07.150

Methuen family
 Unknown Venetian, 07.150

Metzger, Evelyn B.
 G. Bellini workshop, 68.192

Miari de Cumani, Count
 P. Longhi, 14.32.1,2; 17.190.12; 36.16

Miller von Aichholz, Eugen
 G. B. Tiepolo, 65.183.1,2,3

Minneapolis Institute of Arts
 Canaletto, 59.38

Mont, Frederick
 Schiavone, 1973.116

Morgan, J. Pierpont
 Casanova, 07.225.253
 P. Longhi, 17.190.12
 Sebastiano del Piombo, 00.18.2
 D. Tiepolo, 07.225.297

Murray, Charles Fairfax
 B. Vivarini, 50.229.1

Murray
 B. Vivarini, 50.229.1

Nairne
 Tintoretto, 13.75

Nerly, Friedrich
 Tintoretto, 10.206

Neumann, Sir Sigmund, 1st Bt.
 Guardi, 65.181.8

Newman (Neumann), Sir Cecil, 2nd Bt.
 Guardi, 65.181.8

Newman (Neumann), Lady
 Guardi, 65.181.8

Northbrook, Francis George Baring, 2nd Earl of
 Crivelli, 49.7.5

Northbrook, Thomas George Baring, 1st Earl of
 Crivelli, 49.7.5

Northwick, John Rushout, 2nd Baron
 B. Vivarini, 50.229.1

Odescalchi, Prince Livio
 Veronese, 10.189

Odescalchi Erba, Prince Baldassare
 Veronese, 10.189

Offley
 Tintoretto, 13.75

Oldfield
 Tintoretto, 39.55

Orléans, Louis Philippe, Duke d'
 Veronese, 10.189

Orléans, Philippe, Duke d'
 Veronese, 10.189

Orléans, Dukes d'
 Veronese, 10.189

Osnago, Enrico
 D. Tiepolo, 13.2

Paris, private collection
 Menescardi, 94.4.364

Parsons, Harold Woodbury
 Guardi (?), 64.272.1,2

Patch
 Saraceni, 1971.93

Paterson
 G. Bellini workshop, 49.7.2

Payne, Oliver H.
 G. B. Tiepolo, 23.128

Pearce
 B. Vivarini, 50.229.1

Pillsbury, Alfred
 Canaletto, 59.38

Pini, Umberto
 Veronese, 46.31

Pio di Savoia, Prince
 Titian, 36.29

Podio, Publio
 Veronese, 46.31

della Porta, Count
 Unknown Venetian, 32.100.93

Pourtalès, Countess de
 Antonello da Messina, 32.100.82
 Jacometto Veneziano, 49.7.3

Private collection
 Menescardi, 94.4.364
 Veronese, 46.31

Quintavalle family
 Bellotto, 39.142

Reichel, Carl Anton
 Paolo Veneziano, 1971.115.5

Reid, Mrs. Whitelaw
 Canaletto, 59.38

Reynolds, Joshua (?)
 Tintoretto, 13.75

Richter, Jean Paul
 Bellini, 30.95.256

Rogers, Mrs. Grace Rainey
 G. B. Tiepolo workshop, 43.85.12-24

Rosenberg & Stiebel
 Canaletto, 59.38

Rothschild, Baron Maurice de
 Guardi, 41.80; 53.225.3,4

Rudolf II, Emperor
 Veronese, 10.189

Rumohr, Baron Karl Friedrich von
 Tintoretto, 10.206

Ruskin, John
 Tintoretto, 10.206

Sagredo family
 Diziani, 06.1335.1

Salomon, William
 Jacometto Veneziano, 49.7.3

Salomon, Mrs. William
 Jacometto Veneziano, 49.7.3

Sasso, Giovanni Maria
 Catena, 69.123

Schickler, Baron Arthur de
 Antonello da Messina, 32.100.82
 Jacometto Veneziano, 49.7.*p*

Schiff
 G. B. Tiepolo, 37.165.2

Sedelmeyer
 Antonello da Messina, 14.40.645
 G. B. Tiepolo, 37.165.1

Seligman, M. J.
 B. Vivarini, 65.181.1

Severn, Mrs. Arthur
 Tintoretto, 10.206

Shaftesbury, Earls of
 Guardi, 71.119,120

Shaw-Stewart, Sir Michael Robert, Bt.
 G. Bellini workshop, 49.7.2

Shaw-Stewart, Walter Richard
 G. Bellini workshop, 49.7.2

Simonetta, Count Antonio
 Bellotto, 39.142

Simonetta family
 Bellotto, 39.142

Smith
 Guardi, 50.145.21

Smith
 Tintoretto, 39.55

Spinola, Marchesi
 Tintoretto, 58.49

Steinmeyer, Niklaus
 Guardi, 41.80; 53.225.3,4
 Niccolò di Pietro, 23.64
 A. Vivarini, 37.163.4

Strange, John
 G. Bellini workshop, 49.7.2
 B. Vivarini, 50.229.1

Straus, Jesse Isidor
 J. Bellini, 59.187

Straus, Mrs. Jesse Isidor
 J. Bellini, 59.187

Straus, Mr. & Mrs. Lionel F.
 Tintoretto, 58.49

Straus, Lionel F., Jr.
 Tintoretto, 58.49

Sulley & Co.
 Carpaccio, 11.118
 Cima, 07.149
 Crivelli, 13.178
 G. B. Tiepolo, 37.165.1
 Unknown Venetian, 07.150

Talleyrand-Périgord, Charles Maurice de
 Sebastiano del Piombo, 00.18.2

Talleyrand-Périgord, Napoléon Louis de
 Sebastiano del Piombo, 00.18.2

Tarsia, Ferdinando Maria Spinelli, Prince of
 Antonello da Messina, 32.100.92

Torazzini, Signora Eleonora
 Antonello da Messina, 32.100.82

Tozzi, Piero
 Veronese, 46.31

Trotti, Count
 Guardi, 41.80; 53.225.3,4
 D. Tiepolo, 13.2

Turenne, Countess of
 Titian, 14.40.640

Valier-Bembo (?)
 G. B. Tiepolo workshop, 43.85.12-24

Vecellio, Pomponio
 Titian, 32.100.85

Venice, private collection
 G. Bellini workshop, 49.7.2

Ventura, Eugenio
 Jacopo Bellini, 59.187
 Maggiotto (?), 29.70

Verona, Papal Nuncio (?)
 G. Bellini workshop, 49.7.2

Vianelli, Giovanni
 A. Vivarini, 37.163

Visman, Jean
 B. Vivarini, 65.181.1

Vogüé, Countess Arthur de
 Titian, copy after, 27.56

Vogüé, Countess Charles de
　　Titian, copy after, 27.56

Volpi, Elia
　　Unknown Venetian, 32.100.93

Walckiers, Viscount Edouard de
　　Veronese, 10.189

Walters, Henry
　　P. Longhi, 36.16

Ward, F. H.
　　Canaletto, 10.207

Waters
　　G. Bellini & workshop, 49.7.1

Weitzner, Julius H.
　　Canaletto, 59.38
　　Saraceni, 1971.93

Wendland, Dr. Hans
　　Antonello da Messina, 32.100.82

Wertheimer, Asher
　　Veronese, 10.189

Westall, Richard
　　Tintoretto, 39.55

White, Stanford
　　G. B. Tiepolo, 23.128

Whitehouse, Mrs. Sheldon
　　Guardi, 41.80

Whitridge, Mrs. Arnold
　　Guardi, 41.80

Willett, Henry
　　Antonello da Messina, 14.40.645

Wimborne, Lord
　　Veronese, 10.189

Wittelsbach, Karl Ludwig, Elector Palatine
　　Sebastiano del Piombo, 00.18.2

Wittelsbach, Otto Heinrich, Elector Palatine
　　Sebastiano del Piombo, 00.18.2

Wittelsbachs, Electors Palatine
　　Sebastiano del Piombo, 00.18.2

Wood, Frank P.
　　Sustris, 49.7.14

Woolsey, Alice Bradford
　　Joli, 1970.212.2

Woolsey, Judge John M.
　　Joli, 1970.212.2

Wrightsman, Mr. & Mrs. Charles
　　Guardi (?), 64.272.1,2

Yturbe, Manuel de
　　G. B. Tiepolo, 23.128

Zir, Gaetano
　　Antonello da Messina, 32.100.82

Zurich, private collection
　　Niccolò di Pietro, 23.64

Index

A

Abundance, Virtue and, from the Workshop of G. B. Tiepolo
Adam, see *Crucifixion,* by Jacopo Palma the Younger
Adonis, Venus and, by Titian
Adoration of the Magi, by G. B. Tiepolo
Adoration of the Shepherds, by Vincenzo Catena
Africa, from the Workshop of G. B. Tiepolo
Ahasuerus, see *Esther before Ahasuerus,* by Menescardi
Alessandro Vittoria, by Veronese
Alfonso d'Este, copy after Titian
Ambrose, Saint, Miracle of, by Bonifazio Veronese
America, from the Workshop of G. B. Tiepolo
Andrew, St., see *Miracle of the Loaves and Fishes,* by Tintoretto
Anthony Abbot, St., see *Three Saints,* by Cima
Apostles, see *Death of the Virgin,* by Bartolomeo Vivarini
Apotheosis of the Spanish Monarchy, by G. B. Tiepolo
Archinto, Filippo, Archbishop of Milan, by Titian
Arithmetic, from the Workshop of G. B. Tiepolo
Asia, from the Workshop of G. B. Tiepolo

B

Barbaro, Francesco, Glorification of, by G. B. Tiepolo
Battle of Vercellae, by G. B. Tiepolo
BELLINI, GIOVANNI, see *Madonna and Child,* from the Workshop of Giovanni Bellini; *Madonna and Child with Saints,* by Giovanni Bellini and Workshop; *Portrait of a Young Man,* by Jacometto Veneziano; *Presentation in the Temple,* from the Workshop of Giovanni Bellini
Belo, Brother Gregorio, of Vicenza, by Lorenzo Lotto
Bishop Harold, Investiture of, as Duke of Franconia, by G. B. Tiepolo
Boy with a Greyhound, by Veronese
Brother Gregorio Belo of Vicenza, by Lorenzo Lotto

C

Capture of Carthage, by G. B. Tiepolo
Carthage, Capture of, by G. B. Tiepolo
Catherine of Alexandria, St., see *Madonna and Child with Saints,* by Giovanni Bellini and Workshop

Cavalier and Shepherd, by Francesco Casanova
Cecilia, St., see *Paradise,* by Saraceni
Christ, see *Adoration of the Magi,* by G. B. Tiepolo; *Adoration of the Shepherds,* by Vincenzo Catena; *Brother Gregorio Belo of Vicenza,* by Lorenzo Lotto; *Crowning with Thorns,* by Guarana; *Crucifixion,* by Jacopo Palma the Younger; *Death of the Virgin,* by Bartolomeo Vivarini; *Doge Alvise Mocenigo Presented to the Redeemer,* by Tintoretto; *Last Supper,* by a Venetian Painter, late XVII century; *Madonna,* by Antonello de Saliba; by Giovanni Bellini; by Giovanni Bellini and Workshop; from the Workshop of Giovanni Bellini; by Jacopo Bellini; by Cima; by Carlo Crivelli; by the Master of Helsinus; by Paolo Veneziano; by Titian; by Bartolomeo Vivarini; by a Venetian Painter, second quarter of the XV century; *Man of Sorrows,* by Michele Giambono; *Meditation on the Passion,* by Carpaccio; *Paradise,* by Saraceni; *Presentation in the Temple,* from the Workshop of Giovanni Bellini
——, *Crowned with Thorns,* by Antonello da Messina
——, *Saint Christopher with the Infant,* by Piazzetta
Christopher, St., see *Paradise,* by Saraceni
——, *with the Infant Christ,* by Piazzetta
Christopher Columbus, by Sebastiano del Piombo
Clare, St., see *Madonna,* by Cima
Columbus, Christopher, by Sebastiano del Piombo
Count Carlo Aurelio Widmann, by Alessandro Longhi
Crowning with Thorns, by Guarana
Crucifixion, by Jacopo Palma the Younger; see *Brother Gregorio Belo of Vicenza,* by Lorenzo Lotto
Cupid and Psyche, Marriage of, by Schiavone

D

Dawn, by Gaspare Diziani
Death of the Virgin, by Bartolomeo Vivarini
Doge Alvise Mocenigo Presented to the Redeemer, by Tintoretto
Doge Andrea Gritti, by Titian
Dominic, Saint, by Carlo Crivelli

E

Ecstasy of Saint Francis, by Jacopo Palma the Younger
Este, Alfonso d', copy after Titian
Esther before Ahasuerus, by Menescardi
Europe, from the Workshop of G. B. Tiepolo

F

Fantastic Landscapes, by Francesco Guardi
Filippo Archinto, Archbishop of Milan, by Titian
Finding of Moses, by Tintoretto
Fortitude, from the Workshop of G. B. Tiepolo
Francis, St., see *Madonna*, by Cima; *Man of Sorrows*, by Michele Giambono
——, *Ecstasy of*, by Jacopo Palma the Younger

G

Geometry, from the Workshop of G. B. Tiepolo
George, Saint, by Carlo Crivelli; see *Paradise*, by Saraceni
GIORGIONE OR TITIAN, see *Portrait of a Man*, by Titian
GIROLAMO DI BERNARDINO DA UDINE, see *Three Saints*, by Cima
Giustiniani Family, Glorification of the, by Domenico Tiepolo
Glorification of Francesco Barbaro, by G. B. Tiepolo
Glorification of the Giustiniani Family, by Domenico Tiepolo
God the Father, see *Paradise*, by Saraceni
Grammar, from the Workshop of G. B. Tiepolo
Grand Canal, see *Venice: the Grand Canal above the Rialto*, by Francesco Guardi
Gregory, St., see *Doge Mocenigo Presented to the Redeemer*, by Tintoretto
Gritti, Doge Andrea, by Titian
GUARDI, WORKSHOP OF, see *Landscapes*, by Francesco Guardi

H

Hebe, see *Marriage of Cupid and Psyche*, by Schiavone

I

Infant Moses in Pharaoh's Palace, see *Miracle of Saint Ambrose*, by Bonifazio Veronese
Investiture of Bishop Harold as Duke Franconia, by G. B. Tiepolo
Isaac, Sacrifice of, by G. D. Tiepolo

J

James, St., see *Madonna*, by the Master of Helsinus
Jerome, Saint, from the Workshop of Antonio Vivarini; see *Meditation on the Passion*, by Carpaccio
Job, see *Meditation on the Passion*, by Carpaccio
John the Baptist, St., see *Brother Gregorio Belo of Vicenza*, by Lorenzo Lotto; *Doge Mocenigo Pre-*

sented to the Redeemer, by Tintoretto; *Madonna*, by Giovanni Bellini and Workshop
Joseph, St., see *Adoration of the Magi*, by G. B. Tiepolo; *Adoration of the Shepherds*, by Vincenzo Catena; *Presentation in the Temple*, from the Workshop of Giovanni Bellini
Joseph Sold by His Brethren, by Maggiotto (?)
Juno, see *Marriage of Cupid and Psyche*, by Schiavone
Jupiter, see *Marriage of Cupid and Psyche*, by Schiavone

L

Landscapes, by Francesco Guardi
Landscape with Figures, by Zuccarelli
Last Supper, by a Venetian Painter, late XVII century
Lawrence, St., see *Death of the Virgin*, by Bartolomeo Vivarini; *Paradise*, by Saraceni
Letter, by Pietro Longhi
London: St. Paul's and Old London Bridge, by Joli
Louis of Toulouse, St., see *Doge Mocenigo Presented to the Redeemer*, by Tintoretto
Lucy, St., see *Madonna*, by the Master of Helsinus; by Giovanni Bellini and Workshop; *Three Saints*, by Cima

M

Madonna, see *Adoration of the Magi*, by G. B. Tiepolo; *Adoration of the Shepherds*, by Vincenzo Catena
Madonna Adoring the Child, by Antonello de Saliba
Madonna Adoring the Sleeping Child, by Giovanni Bellini
Madonna and Child, by Giovanni Bellini; from the Workshop of Giovanni Bellini; by Jacopo Bellini; by Carlo Crivelli; by Titian; by Bartolomeo Vivarini; by a Venetian Painter, second quarter of the XV century
——, *Enthroned*, by Paolo Veneziano
——, *with Saints*, by Giovanni Bellini and Workshop
——, *with Saint Francis and Saint Clare*, by Cima
——, *with Saint James the Less and Saint Lucy*, by the Master of Helsinus
Man of Sorrows, by Michele Giambono
Marius, Triumph of, by G. B. Tiepolo
Mark, Saint, Reading, by Bartolomeo Vivarini
Mars, see *Marriage of Cupid and Psyche*, by Schiavone
Mars and Venus United by Love, by Veronese
Meditation on the Passion, by Carpaccio
Meeting, by Pietro Longhi
Metaphysics, from the Workshop of G. B. Tiepolo
Miracle of the Loaves and Fishes, by Tintoretto
Miracle of Saint Ambrose, by Bonifazio Veronese
Mocenigo, Doge Alvise, Presented to the Redeemer, by Tintoretto
Moses, see *Paradise*, by Saraceni
——, *Finding of*, by Tintoretto

——, *Infant, in Pharaoh's Palace*, see *Miracle of Saint Ambrose*, by Bonifazio Veronese

N

Neptune and the Winds, by G. B. Tiepolo

P

Paradise, by Saraceni
Patriotism (?), from the Workshop of G. B. Tiepolo
Paul, St., see *Paradise*, by Saraceni
Peter, St., see *Madonna*, by Giovanni Bellini and Workshop; *Paradise*, by Saraceni
Peter Martyr, Saint, Healing the Leg of a Young Man, by Antonio Vivarini
Piazza San Marco, see *Venice: Piazza San Marco*, by Francesco Guardi
PIAZZETTA, see *Joseph Sold by His Brethren*, by Maggiotto (?)
Pietà, by Carlo Crivelli
Portrait of a Man, by Tintoretto; by Titian
——, *of a Nobleman*, by Lambert Sustris
——, *of a Venetian Senator*, by Vincenzo Catena
——, *of a Woman*, by Montemezzano
—— *of a Young Man*, by Antonello da Messina; by Jacometto Veneziano; by Tintoretto
Presentation in the Temple, from the Workshop of Giovanni Bellini
Prudence, from the Workshop of G. B. Tiepolo
Psyche, Marriage of Cupid and, by Schiavone

R

Rialto, see *Venice: the Grand Canal above the Rialto*, by Francesco Guardi
RICCI, SEBASTIANO, see *Esther before Ahasuerus*, by Menescardi
Roch, St., see *Three Saints*, by Cima

S

Sacrifice of Isaac, by Domenico Tiepolo
Saint Christopher with the Infant Christ, by Piazzetta
Saint Dominic, by Carlo Crivelli
Saint George, by Carlo Crivelli
Saint Jerome, from the Workshop of Antonio Vivarini
St. Paul's, see *London: St. Paul's and Old London Bridge*, by Joli
Saint Peter Martyr Healing the Leg of a Young Man, by Antonio Vivarini
Saint Reading (*Saint Mark?*), by Bartolomeo Vivarini

Saint Thecla Praying for the Plague-stricken, by G. B. Tiepolo
Saint Ursula and her Maidens, by Niccolò di Pietro
Santa Maria della Salute, see *Venice: Santa Maria della Salute*, by Canaletto: by Francesco Guardi
SCOTT, SAMUEL, see *London: St. Paul's and Old London Bridge*, by Joli
Stephen, St., see *Death of the Virgin*, by Bartolomeo Vivarini
Still Lifes, by Francesco Guardi (?)

T

Temperance, from the Workshop of G. B. Tiepolo
Temptation, by Pietro Longhi
Thecla, Saint, Praying for the Plague-stricken, by G. B. Tiepolo
Thirteen Allegorical Frescoes, from the Workshop of G. B. Tiepolo
Three Saints: Roch, Anthony Abbot, and Lucy, by Cima
TIEPOLO, GIOVANNI BATTISTA, see *Crowning with Thorns*, by Guarana; *Esther before Ahasuerus*, by Menescardi; *Glorification of the Giustiniani Family*, by Domenico Tiepolo; *Sacrifice of Isaac*, by Domenico Tiepolo; *Virtue and Wisdom*, by Domenico Tiepolo
TINTORETTO, JACOPO, see *Ecstasy of Saint Francis*, by Jacopo Palma the Younger; copy after, see *Last Supper*, by a Venetian Painter, late XVII century
Triumph of Ferdinand III, see *Investiture of Bishop Harold as Duke of Franconia*, by G. B. Tiepolo
Triumph of Marius, by G. B. Tiepolo

U

Ursula, Saint, and Her Maidens, by Niccolò di Pietro

V

Vaprio d'Adda, by Bernardo Bellotto
VENETIAN PAINTER, LAST QUARTER OF XVI CENTURY, see *Madonna*, by the Master of Helsinus
——, EARLY XV CENTURY, see *Saint Ursula and Her Maidens*, by Niccolò di Pietro
——, MID XV CENTURY, see *Madonna*, by a Venetian Painter, second quarter of XV century
Venice: the Grand Canal above the Rialto, by Francesco Guardi
—— *Piazza San Marco*, by Francesco Guardi
—— *the Piazzetta*, by Canaletto
—— *Santa Maria della Salute*, by Canaletto; by Francesco Guardi
——, *View of, from the Sea*, by Francesco Guardi
Venus, see *Marriage of Cupid and Psyche*, by Schiavone

—— *and Adonis,* by Titian
—— *and the Lute Player,* by Titian
——, *Mars and, United by Love,* by Veronese
Vercellae, Battle of, by G. B. Tiepolo
VERONESE, see *Portrait of a Woman,* by Monte-
 mezzano
Vesta, see *Marriage of Cupid and Psyche,* by Schia-
 vone
View of Venice from the Sea, by Francesco Guardi
Virgin, see *Adoration of the Shepherds,* by Vincenzo
 Catena; *Brother Gregorio Belo of Vicenza,* by Lo-
 renzo Lotto; *Crucifixion,* by Jacopo Palma the
 Younger; *Pietà,* by Carlo Crivelli; *Presentation in
 the Temple,* from the Workshop of Giovanni
 Bellini

——, *Death of the,* by Bartolomeo Vivarini
Virtue and Abundance, from the Workshop of G.
 B. Tiepolo
Virtue and Wisdom, by Domenico Tiepolo
Visit, by Pietro Longhi
Vittoria, Alessandro, by Veronese

W

Widmann, Count Carlo Aurelio, by Alessandro
 Longhi
Wisdom, Virtue and, by Domenico Tiepolo

Illustrations

PLATE 2 ANTONELLO DA MESSINA 32.100.82

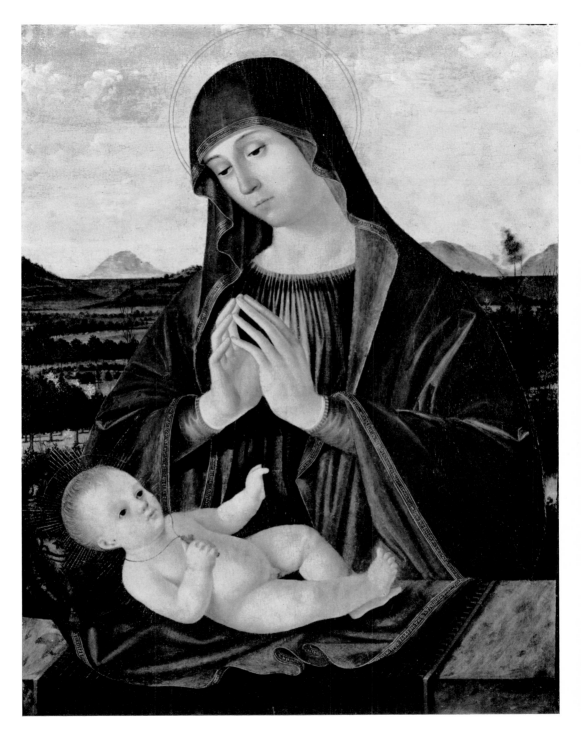

ANTONELLO DE SALIBA 30.95.249 PLATE 3

IOANNES BELLINVS

PLATE 4 GIOVANNI BELLINI 08.183.1

GIOVANNI BELLINI 30.95.256

PLATE 5

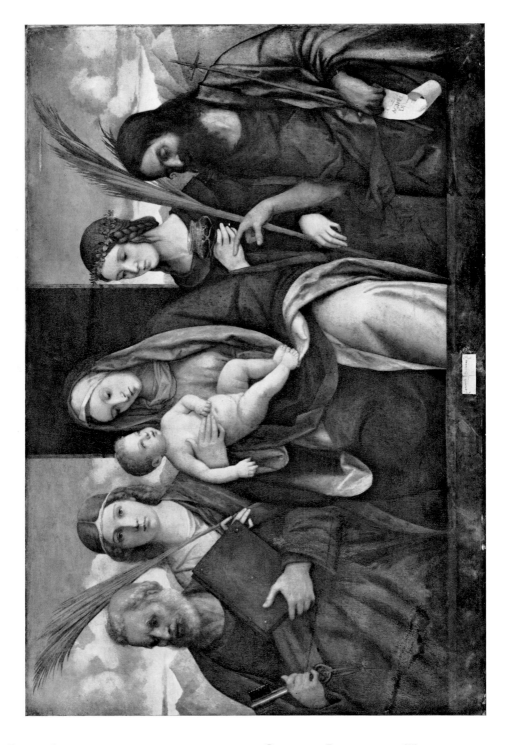

Plate 6 Giovanni Bellini and Workshop 49.7.1

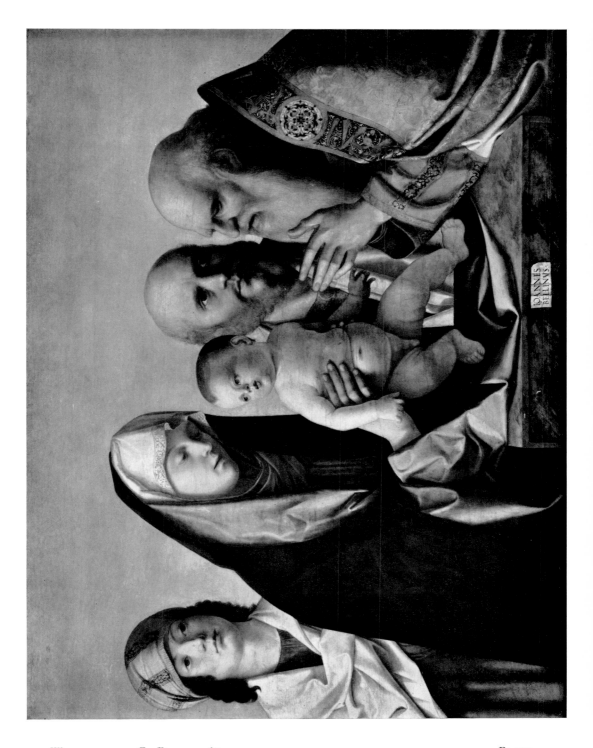

WORKSHOP OF G. BELLINI 68.192 PLATE 7

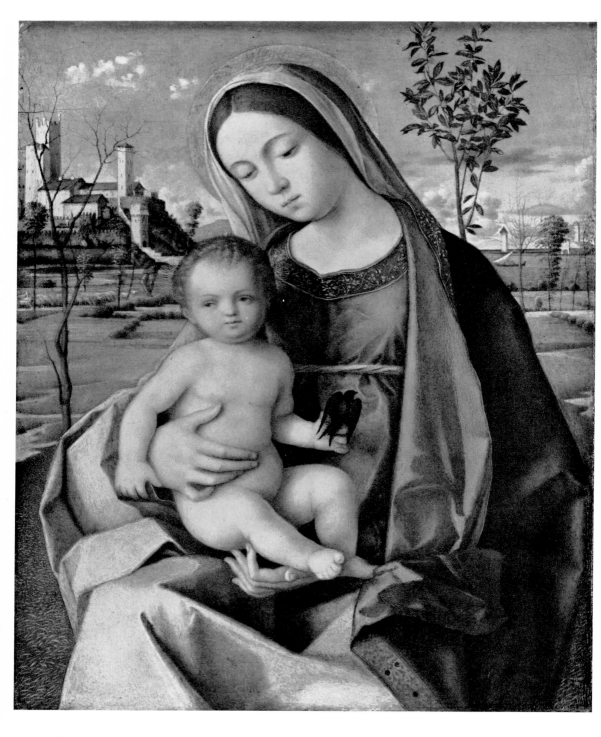

PLATE 8 WORKSHOP OF G. BELLINI 49.7.2

JACOPO BELLINI 59.187 PLATE 9

PLATE 10

BELLOTTO 39.142

PLATE 12 CANALETTO 10.207

PLATE 16

PLATE 17

PLATE 18

JOANNES BELLINVS FACIEBAT

PLATE 20 CRIVELLI 05.41.2,1

 PLATE 21

PLATE 22

OPVS·KAROLI·CRIVELLI·VENETI

PIETA
MICHELE GIAMBONO
VENETIAN SCHOOL, EARLY 15TH CENTURY
ROGERS' FUND, 1906

PLATE 24

PLATE 26

 PLATE 27

PLATE 28 GUARDI 35.40.3

PLATE 30

GUARDI 41.80

PLATE 32

PLATE 34

GUARDI 65.181.8 PLATE 35

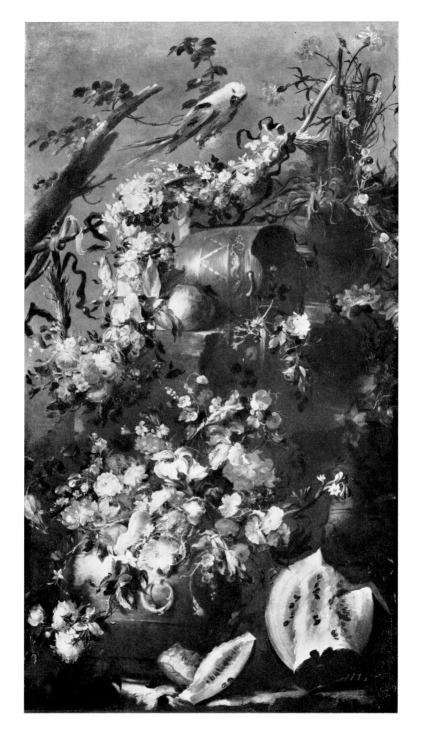

PLATE 36 GUARDI (?) 64.272.1

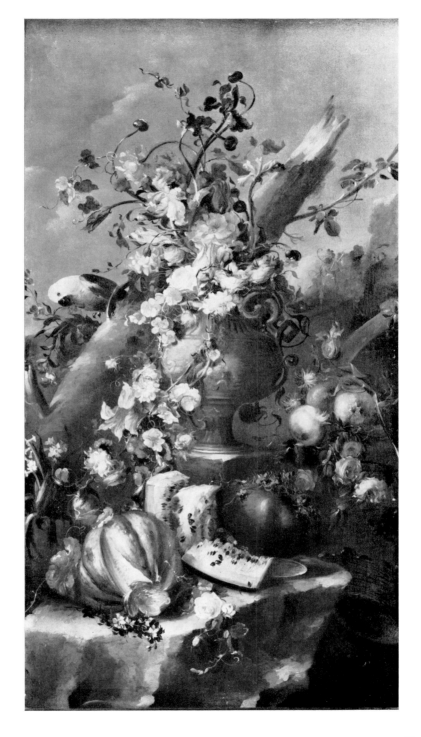

GUARDI (?) 64.272.2 PLATE 37

PLATE 38

JACOMETTO VENEZIANO 49.7.3

PLATE 40

P. LONGHI 14.32.1

PLATE 42

PLATE 44

A. LONGHI 15.118

PLATE 46

PLATE 48

MONTEMEZZANO 29.100.104 PLATE 49

PLATE 50

PAOLO VENEZIANO 1971.115.5 PLATE 51

PLATE 52 PALMA GIOVANE 57.170

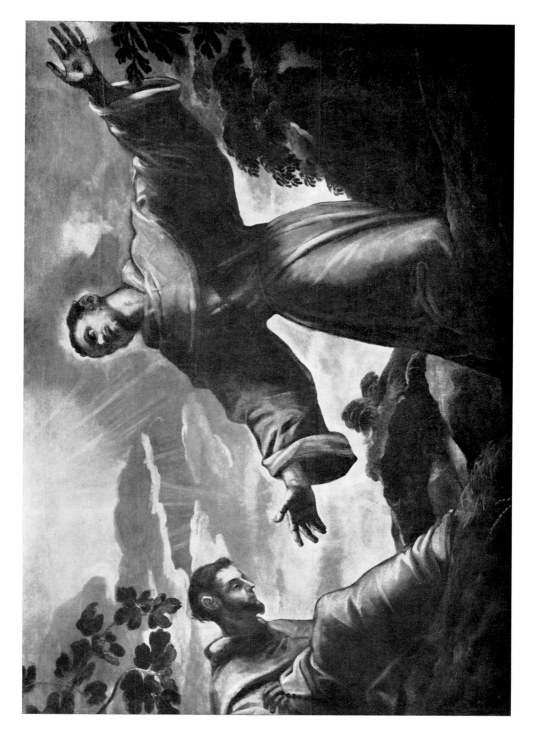

PALMA GIOVANE 62.257 PLATE 53

PLATE 54

PLATE 56

SCHIAVONE 1973.116 PLATE 57

PLATE 58

SEBASTIANO DEL PIOMBO 00.18.2

PLATE 60

PLATE 62

G. B. TIEPOLO 37.165.1

PLATE 64 G. B. TIEPOLO 37.165.3

G. B. TIEPOLO 37.165.4 PLATE 65

PLATE 66

G. B. TIEPOLO 65.183.2

G. B. TIEPOLO 65.183.3 PLATE 67

PLATE 70 WORKSHOP OF TIEPOLO 43.85.13,14

PLATE 72

PLATE 74 WORKSHOP OF TIEPOLO 43.85.19

PLATE 76

WORKSHOP OF TIEPOLO 43.85.21

WORKSHOP OF TIEPOLO 43.85.22 PLATE 77

PLATE 78 WORKSHOP OF TIEPOLO 43.85.23

AVL

IVLIA

VLO

PLATE 80

G. D. TIEPOLO 71.28

G. D. TIEPOLO 07.225.297　　　　　　　　　　　　　　　　PLATE 81

PLATE 82

G. D. Tiepolo 13.2 PLATE 83

PLATE 84

PLATE 86

PLATE 87

PLATE 88 TINTORETTO 41.100.12

TINTORETTO 58.49 PLATE 89

PLATE 90

PLATE 92

PLATE 93

PLATE 94

PLATE 96

COPY AFTER TITIAN 27.56

Plate 97

PLATE 98

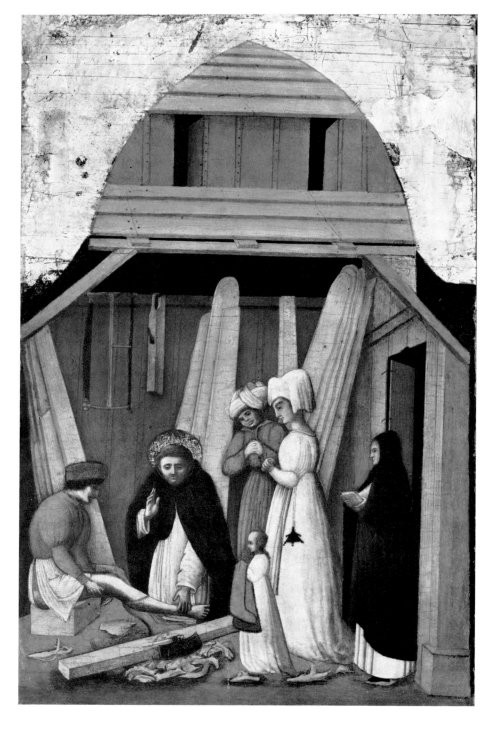

PLATE 100

A. VIVARINI 37.163.4

A. VIVARINI 65.181.6 PLATE 101

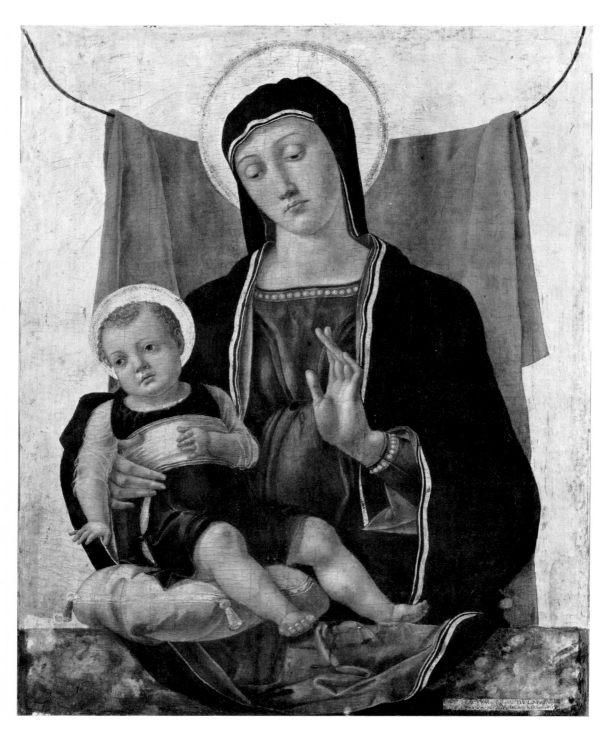

PLATE 102 B. VIVARINI 30.95.277

PLATE 104

Plate 106

 Plate 107